W9-AQV-391

The ART BIZ

The Covert World of Collectors, Dealers, Auction Houses, Museums, and Critics

ALICE GOLDFARB MARQUIS

CB
CONTEMPORARY
BOOKS
CHICAGO

Library of Congress Cataloging-in-Publication Data

Marquis, Alice Goldfarb.
 The art biz : the covert world of collectors, dealers, auction
houses, museums, and critics / Alice Goldfarb Marquis.
 p. cm.
 Includes bibliographical references.
 ISBN 0-8092-4283-4 (cloth) : $22.95
 1. Art—Marketing. I. Title.
N8600.M38 1991
706′.8′8—dc20 90-24788
 CIP

Published by Contemporary Books, Inc.
180 North Michigan Avenue, Chicago, Illinois 60601
Manufactured in the United States of America
International Standard Book Number: 0-8092-4283-4

For my son, John Blankfort,
with affection and admiration

CONTENTS

ACKNOWLEDGMENTS

This book has been on my mind for fifteen years, at first like a friendly ghost lurking behind research on other matters, and more recently in the forefront, assuming the aspect of a demanding demon. The art world is small in size, so they say, but crisscrossing it via readings, archives, and interviews proved to be a challenging journey, both physically and intellectually.

Fortunately, most of the people I encountered in my research were lavish with their time and information. The notes cite only some of the many art insiders I interviewed; others asked to remain anonymous, and still others provided background essential for my understanding of their world. I am particularly grateful to Eli Broad for giving me unrestricted access to all the papers dealing with the founding of the Los Angeles Museum of Contemporary Art, for copiously answering all my questions, and for introducing me to others who were helpful. Ivan Karp proved to be especially zestful in sharing information; he sat still for hours of interviews and hooked me into a whole network of art insiders.

Long before this book took its present shape, too many friends and colleagues were subjected, I fear, to the false starts, dead ends, and fruitless speculations that inevitably complicate a historian's quest. This sturdy network included not only patient listeners but active participants: they sent clippings, telephoned helpful leads, suggested new ideas, humored my obsession. Here, I want to thank publicly Steve Allen, Suzanne and Richard Atkins, Betty and Seymour Cain, Ann Elwood, Jane Ford, Janet Goff, Reva and Gerson Greenburg, Dorothy

and David Hewes, Gerry and Robert Horwitz, Brian Keliher, Paul and Luisa Larson, Betty Lubin, Jean Mayer, Freda and James Polak, John Sedgwick, Charlotte and Martin Stern, Therese Whitcomb, Dennis Wills, Dorothy Woolfolk, and Georgia Wright. My first critical reader, as for my previous books, was Ariss Treat-Sedgwick, while Aline Hornaday, Norma Sullivan, and Sue Whitman contributed extraordinarily sage advice and support.

For research my principal resource continues to be the Central Library at the University of California at San Diego, where chief librarian Dorothy Gregor and reference librarian Sue Galloway are uncommonly helpful friends. The Archives of American Art promptly supplied primary materials in its rich collection, and Barbara Wilson at the Huntington Library branch of the archives took a personal interest in my needs. Sharon McQueen and Lauri Taylor saw to my every comfort as I perused the Eli Broad Archive.

The Department of History at UCSD has made me a perennial visiting scholar, an enviable position with many privileges and few duties. This book, like my previous works, has been written with H. Stuart Hughes in mind; he was my teacher and continues as gentle critic and firm friend. This work has benefited enormously from my "surrogate department," San Diego Independent Scholars, whose witty, insightful, and bountiful contributions cannot be measured. SDIS, along with the La Jolla Atheneum, kindly provided a forum for some of my notions along the way.

Throughout this book's gestation, my editor, Bernard Shir-Cliff, proved to be an imaginative resource; in the final manuscript, his touch was decisive, always there with *le mot juste*. I was fortunate, too, in having my publisher, Harvey Plotnick, as a helpful reader, Kathy Willhoite as a thoughtful production shepherd, and India Cooper as a conscientious copyeditor. For bringing me together with these kind guides, I must thank my agent, Julie Castiglia of Waterside Productions.

La Jolla, California
August 1990

1
MEET THE ART BIZ

The architecture of this book tells its own story about today's world of fine art. Fewer than one-fifth of its pages deal with that mythical prime mover of the visual universe, the artist. Around this figure, so shrouded in legend, history, mystery, reverence, and celebration, swirls a tumult of unseemly commerce. The person whose role since before recorded history has been to show us who and what we are, and what sort of world we inhabit, today practices his or her magic, if any, in the center of a jostling marketplace. There, words once used to describe the marvelous now attach to the mundane, the meaningless, the mediocre, the mercenary. Around the artist now is gathered an indecorous throng, collectively styled the art world, whose activities have come to overshadow whatever the artist produces.

Throughout the present century, this world has been proliferating in numbers and strengthening its ability to gain public attention. Today the nonartists—the critics and scholars, the art press, the collectors, the dealers, and the museums—far outweigh artists in their ability to shape the fine art scene. Paradoxically, these seeming auxiliaries, who might be collectively termed the Art Industrial Complex, relish their association with the enigma of the creative impulse, which the artist represents. An uncanny number of its inhabitants and hangers-on initially wanted to be artists, only to confront modest talent, paucity of subject matter, or perhaps a lack of the obsession required to succeed. Many entered the art world because they

1

believed it to be different from ordinary pursuits—nobler, more dignified, more creative—only to falter and stumble into a morass of conflicts of interest and naked greed. One of New York's most successful dealers, Robert Miller, who still paints watercolors in his spare time, expected the art world to be liberal and intelligent, "full of light and joy and goodness." Instead, he has found it "bitter, nasty, full of anger and rage and frustration."

A hammer falls in New York or London or Zürich or Tokyo, and reporters rush to tell the world of yet another record auction sale of a van Gogh or a Renoir, of a Jasper Johns or a Frank Stella. Anguished postmortems follow in an entirely predictable pattern. The seller maintains that the price was reasonable—unless, as happens increasingly often, he or she prefers to remain anonymous. The buyer is also pleased—unless he or she, too, is anonymous. Several dealers denounce the sale as invading their turf—unless this dealer happens to represent this artist . . . unless that dealer secretly owned all or part of the sold object . . . unless this other dealer has transactions pending with the buyer or seller. Art writers and scholars lament the horrible commercialism of the current art scene—unless they also, privately, advise collectors. And museum professionals ritually wring their hands over the ugly dollar signs defiling the sacred body of art—unless they are about to dig fresh masterpieces out of their storage bins to consign to the next auction.

During the past half century or so, the Art Industrial Complex has developed in a manner and direction that hardly any of its participants willed toward an outcome that many deplore and some still deny. The sedate language of connoisseurship now veils the most vulgar transactions of the marketplace. The measured tones of critics and scholars mask flagrant conflicts of interest. The respected discourse of art patronage conceals within its noble folds the dull gleam of naked greed. The sober prose of critics and scholars obscures a seething bazaar. Within this labyrinth, artists, except for a handful of art stars, are but appendages, of no more significance than the maker of some other novelty, say, Mickey Mouse T-shirts.

There is a difference, though, between the industry that makes, promotes, sells, and speculates in what is often described in pious tones as the finest expression of human sensibility and the industries that produce, say, automobiles, houses, or breakfast food. In the Art Biz anything goes: secret deals, undisclosed prices, concealed partnerships, furtive financing. There is also a difference between investment in fine art and investment in stocks and bonds. The marketplace in stocks and bonds operates under stringent regulations against insider trading and conflicts of interest and insists on considerable openness about buyers, sellers, and prices. Despite occasional lapses, trading is constantly monitored; violators of the rules could end up being frog-marched down the center of Wall Street in handcuffs. By contrast, the art marketplace tolerates—indeed fosters—a sleazy, robber-baron style of capitalism not seen on Wall Street since the Great Depression.

Secrecy in the art world breeds the most sordid manipulation. Gossip, rumor, misrepresentation, and downright falsehood must drive out honesty and fairness as inexorably as bad money drives out good. Conflicts of interest run rampant in this milieu, so rampant that no insider is any longer shocked by them. So-called critics publish admiring reviews while also preparing museum exhibitions of the same artists. Nor have they scruples about writing dealer-subsidized monographs on these same artists or accepting gifts of art from them. Collectors, some of them well-known speculators, also serve as trustees of museums, where they participate in decisions about future exhibitions. Having bought works by certain artists, they are overwhelmingly tempted to encourage the museum to exhibit them; the museum seal of aesthetic approval means a good deal more than endorsement of the collector's fine "eye"— it also means a jump in prices. Dealers "donate" works by artists in their stables to museums and lend other works to museum exhibitions, often anonymously, to garner the prestige (read "enhanced value") that museum display brings. From their tenured university posts, academic art historians prepare dealer-sponsored *catalogues raisonnées*, act as curators of exhibitions, advise collectors, and occasionally fire off salvos of let-

ters to legislators to keep the public money coming to their favorite artists and institutions. If they were dealing in securities rather than one of humankind's noblest endeavors—art— the perpetrators of such egregious conflicts would be in jail.

Instead, the elaborate and powerful complex of art writers, collectors, dealers, scholars, and museums interlocks to support the cash nexus in which contemporary art now dwells, apparently impervious to criticism. A surprising number of insiders frankly express revulsion that money has become the measure of contemporary art—but not for attribution. The museum director who complains publicly may be risking his or her job. The dealer who objects finds his or her artists overlooked when museums show surveys of contemporary art. The art writer who exposes insider dealing suddenly confronts ostracism by the sources he or she depends on. The arts complex likes to describe itself as the "arts community," evoking an image of creative dreamers and their patrons laboring together to discover the finest art of our time and to bring aesthetic delight to the masses. The reality, as the chapters that follow demonstrate, is quite different. For most artists it is a Darwinian jungle, where talent makes way for cunning and vision bows before cynicism. For the buyer taste is overrun by fashion; pleasure, by the quicksilver mood of the mob. From the dealer this system demands impossible feats of promotion, both to establish a new artist as "bankable" and to hold on to established artists by steadily pumping up their prices. For museum professionals this jolly community means trudging on a treadmill of fund-raising and amusing social events for insiders while devising special exhibitions that will please collectors and attract sponsors. Privately directors of contemporary art museums indicate that they are spending more than half their time soliciting money and humoring trustees. No wonder that education, the real task of museums, continues to be a stepchild, fobbed off on the weakest and worst-paid staff members and that innovative programs stay on the back burner.

To critics of this bleak landscape, many inhabitants of the art community reply that it really doesn't matter all that much; in the greater scheme, the art world is so small, and so is the

art market. The private dealer Jeffrey Deitch identifies only a hundred or so artists as currently "important," only fifteen who since the early 1960s could be called great international figures. Of collectors, he estimates only twenty have "an original eye, superior knowledge, and ability to talk art professionally." In his view the fewer than twenty critics who wielded influence thirty years ago have vanished completely: "I can't identify anyone today with real clout," he says. Richard Koshalek, director of the Los Angeles Museum of Contemporary Art, estimates that a thousand individuals control the international art world.

Such power in the hands of so few reinforces the baleful effect of secrecy; it deprives the art public of the vital information it needs to form its own taste. The Art Biz constantly muddles what interests the wide art public—aesthetic value— with the central concern of the arts complex—money value. It shields those objects possessing monetary worth because they are rare from comparisons with the multitude of other aesthetic visual products that are not. With its hype based on the personality of the artist, not the work, it plants a sticky finger upon the scales of artistic worth. The veil of secrecy—often masquerading as discretion—protects the speculator, the manipulator, the high flier, as it impedes the sincere connoisseur. To lift this curtain and to suggest the rich array of alternatives available in this age of visual glut is the purpose of this book.

This book began in 1976 on a sidewalk on Seventy-Fifth Street just east of Madison Avenue. I had just interviewed Xavier Fourcade, an art dealer specializing in avant-garde works of the twentieth century. I was particularly interested in some Marcel Duchamp items he carried because I was then researching a biography of this artist. What Fourcade had for sale had hardly been touched by the artist, who had died in 1968. He was offering replicas of the "ready-mades": the *Bicycle Wheel* of 1913, the *Bottle Dryer* of 1914, the snow shovel called *In Advance of the Broken Arm* of 1915, the urinal titled *Fountain* of 1917. All

were machine-made objects, transformed by the artist into works of art simply by signing his name to them. All had later been lost, and now Fourcade was selling *replicas* lovingly re-created by hand in Italy in limited editions of eight, for $25,000 each!

Nothing in my art education had prepared me for this staggering first encounter with the art market. Not once in four years of undergraduate study as an art major and in two years of further study for a master's degree in art history had anyone breathed a word about the monetary value of works of art or of the brisk market in which they were traded. Few university libraries carry the publications dealing with art as a business in which prices are mentioned, or catalogs of auction sales. The indexes of periodicals consulted by art scholars list the most obscure publications in every corner of the world, but none (such as *Art & Auction* or *Art & Antiques*) that specifically devote themselves to reporting news of the art market. Indeed, most art historians coast comfortably toward a Ph.D. without contact with the vulgar world of commerce.

Furthermore, no museum I had ever visited gave the slightest indication that the aesthetic value of the paintings and sculptures on display had any relationship whatsoever to their monetary value. No book about an artist, an art movement, or various periods in the history of art even hinted that the most "important" artists of the past or present were also those who now commanded the highest prices. Nor did anyone mention that museum exhibitions, articles, or books about an artist or movement enhanced prices or that the rarefied realm of art history decorously averted its gaze from the art marketplace precisely because it was, inevitably, intimately involved with it. While the exact numbers remained decently shrouded in high-minded discretion, the word *priceless* was attached to such treasures as the *Mona Lisa* or Michelangelo's *David*. Obviously, what the guards and alarms at the Met or the Louvre were protecting was valuable because it was the patrimony of our civilization, unique and irreplaceable. The divine inspiration of the artist, so read the subtext of all these experiences, was outside the mundane commerce of mere mortals, immune from

manipulations, far above the money pits where the sharp scrabbled for profit.

But there on the sidewalk in the crisp sunshine of an early fall day, I reflected that an object neither unique nor irreplaceable—an article, indeed, that the artist had never even touched—was yet priced at $25,000. A Milan art dealer named Arturo Schwartz had written and lectured widely on Duchamp, had caused the replicas of his ready-mades to be built, had actually manufactured a market for these objects, which were no more than souvenirs of the artist, his autograph. They seemed to harbor minimal aesthetic value. Not rare, not beautiful, not original, of questionable historic interest, profound only in its extreme irony, this class of object nevertheless could command a pedestal in a posh East Side gallery and a high price to boot. (A complete set of replicas of Duchamp ready-mades was going for $200,000.) I began to wonder how this marketplace operated: what was its history, who participated in it and how, and, most avidly, what effect did it have on contemporary art? The research on the Duchamp biography, which was also my doctoral thesis in modern European history, first drew my attention to the busy marketplace indissolubly attached to art. I became fascinated with the role played by all the residents of the art world—the artists, critics, publications, collectors, dealers, scholars, and museums—in enhancing or diminishing the money values of art, often without any relationship to its quality.

Duchamp had been a notoriously lazy artist, content to slide through life by producing an occasional ironic artifact for purchase by his wealthy patrons and by locating for them more conventional kinds of art to buy. Endowed with artistic talent considerably inferior to that of his two much older brothers, Jacques Villon and Raymond Duchamp-Villon, he took sardonic delight in upsetting their aesthetic applecart with brilliantly intellectual ploys. A chess player of near-grand master caliber, Duchamp's lightning attacks on art resembled a brilliant endgame, forever locking what was thoughtful, profound, original, or moving into his nihilistic checkmate. Consider the snow shovel purchased in a New York hardware store in 1915, in-

scribed on the handle "In advance of the broken arm," and signed. With this trivial act, Duchamp was asserting that anything could be a work of art, not because of its aesthetic quality, its craftsmanship, its insight into the human condition, its decorativeness, but purely because he said it was. With a gesture he became the spiritual father of much, if not most, of contemporary art—the piles of dirt, coils of rope, wads of paper, stacked bricks, leaning sheet metal, and framed slogans that so baffle and inflame today's art outsiders.

Andy Warhol was one of Duchamp's most visible offspring, merrily infusing value into soup cans and Brillo boxes merely by associating himself with them. He also mimicked Duchamp's prankish persona, relying on well-publicized silence, notorious elusiveness, and enigmatic yet outrageous gestures to pique the public's curiosity. Within the art world Duchamp continues to be the touchstone for the art history of the twentieth century, correctly so because he called attention to the decline of painting and sculpture as the quintessential art of our time. One would think that an artist who irreverently appended a scribbled "That's all, folks" to the glorious history of Western art since the Renaissance would find few friends in the arena where art is bought and sold or in a museum where rare and precious objects are exhibited. Yet in 1973 the Museum of Modern Art organized a comprehensive retrospective for Duchamp, complete with a weighty, profusely illustrated catalog. The snow shovel was solemnly displayed, identified in the catalog as the second version, which the artist had "obtained" for his patron, Katherine S. Dreier, in 1945. The original was lost, the catalog noted, but there existed also a third version, acquired by Ulf Linde of Stockholm in 1963, plus the "edition" of eight signed and numbered replicas produced through Arturo Schwartz. Of the *Bottle Dryer*, there were actually six versions scattered among friends and patrons of the artist beginning in 1921, after the original was lost, and ending (so far) with Schwartz's "edition." (Unknown at that time, and unpublicized until this moment, was a seventh "version," which the author located in the storeroom of a San Diego restaurant supply house. "Take it away," said the proprietor when asked

the price. It now reposes in the author's living room on a museum-quality pedestal that cost $50.)

In the face of such ironic facts, how does the trade in contemporary fine art maintain itself? How has the art market-place flowered so luxuriantly in this age of visual glut? The key insights began to emerge for me during research for a biography of Alfred H. Barr, Jr., the founding director and guiding spirit of the Museum of Modern Art for almost forty years. Barr believed that, in addition to painting and sculpture, "the art of our time," as he liked to describe it, included all its visual products—architecture, graphic art, photography, industrial design, costume, dance, and films. He envisioned a museum that would exhibit the latest and best in all these areas and continually update its collection to show its visitors the broadest samples of current work. The story of Barr's life details the erosion of that dream. Anchored, as it had to be during the museum's early days, in the latter nineteenth century, the museum was never able to remain contemporary because the older pieces had simply become too valuable. Today the MOMA's collection continues to feature art that verges on the antique. Indeed, in 1990 it sold seven more recent treasures in order to acquire another van Gogh—a masterpiece, but more than a hundred years old. Over the years the museum's lively expositions of the kinds of art that have little monetary value— advertising, household gadgets, theatrical design, clothing, book illustration, furniture—have shrunk or disappeared, displaced by the expensive status symbols that the trustees collect. Photography survives only because, thanks in large part to the museum's earlier efforts, photos now are traded and have value in their own growing market.

Barr's experience also illustrates the insidious intrusion of trustees into the exhibitions and acquisitions of museums. Fired from the director's job because he was insufficiently zealous in raising money, Barr ended up intimately involved in shaping trustees' collections. The reader of his correspondence finds his shameless flattery of potential donors embarrassing. This style persists at the museums of contemporary art now established in many American cities. Few of them feature any-

thing but the blue-chip art that the trustees collect. Dependent on gifts, these museums find it impossible to remain truly contemporary or to move away from a narrow focus on the rare, the famous, the costly. These are the exhibits that pander to collectors and donors, forming a decorative backdrop for the social activities that draw the all-important financial support. Although aware that they feature a narrow corner of aesthetic experience, directors of these museums feel helpless even to point out publicly their shortcomings.

Never in human history has the visual world been richer. Never has the individual had access to—been assaulted by—so many images. Film, television, print, packaging, all are vying for consideration by the human eye. To the consternation of the narrow-minded, all of it is art, and the only question is whether it is interesting art, provocative art, innovative art, meaningful art, lasting art, satisfying art, honest art, timely art, touching art, multilayered art, etc., etc., etc.

The Art Biz today casts a long, dark shadow across the swarming visual panorama that surrounds us during every waking moment and penetrates even into the inner spectacle of our fantasies and dreams. The Art Biz distorts what we see by drawing an arbitrary line around the valuable and calling it the sum total of art while ignoring all else. The Art Biz powerfully imposes its own values, which find their highest expression in high prices. Manipulated by a few, in deepest secrecy, it influences many, most obviously the large audience for art. Drilled in college art history classes, schooled in art publications, impressed by the millions a few collectors wager on the drop of a hammer, overawed by museums, intimidated by critics and scholars, the art audience dutifully "appreciates" what it gets. Ill equipped to form independent judgment, lacking the arcane vocabulary for discussing art, and intimidated by the wealth of its collectors, the art public meekly admires what it is given.

To the vast majority of Americans who never visit art museums, art is a plaything of the rich. The mass public sees no compelling reason to get involved with art at all: high art,

expensive art, awesome art, baffling art. It happily consumes its kitsch and is unaware that such fare as movies, television commercials, and MTV have aesthetic content too.

Then it learns that one artist dumps a crucifix into a jar of urine and another artist smears her naked body with chocolate and still another artist photographs naked children. And taxpayers' dollars are funding them. The outcry swells, and the art community declares an emergency. Censorship is at hand; art is besieged; barbarians imperil civilization itself!

In the quarter century since the National Endowment for the Arts was founded, hardly a year has passed without substantially increased funding. And hardly a year has passed without litanies of alarm that the arts were endangered. From a budget of $2.6 million in 1966, the endowment's spending escalated to $170 million by 1989. The money is there, say critics, but coherent policy is not. When the first National Council on the Arts was hastily convened in September 1965, the trigger was the Metropolitan Opera's distress at facing new, higher wage scales. In a weekend, the council determined to scatter some $2 million among the arts: $350,000 to send the American Ballet Theater on tour; $100,000 to house artists; $250,000 for new plays; $500,000 for experimental theater; $100,000 for ten choreographers; $80,000 to educate artists; $350,000 to give artists sabbaticals; $100,000 for fifty composers. Michael Straight, who later would be an NEA administrator, recalled that he "listened in disbelief. I could see no pattern in the grants." Nor did Karl E. Meyer, who studied museums during the 1970s, discern any government policy relating to the arts. By 1975 at least 250 federal or quasi-federal programs were assisting the arts. They were spending more than $180 million, yet, he wrote, "it was all too clear that a program of public assistance to the arts, prodigious in its amplitude, existed in a vacuum and that government, abhorring a vacuum, had filled it with a bureaucracy."

The reader may well wonder why a book about the art market includes these brief remarks about government support for art. Does not government support provide artists with an alternative to pandering to a crass and wicked market? Cannot the National Endowment for the Arts coax a multitude of

creative acorns to sturdy oakdom? Of course it could . . . but it does not. The reason is that the machinery for awarding the grants has become corroded by self-dealing and by political, not aesthetic, considerations. While public debate focuses on spurious issues of obscenity, government grants to artists and museums create and reinforce the activities of the art market. The artist whose résumé includes NEA grants finds it easier to be shown in a gallery or museum. A grant can trigger escalations of price and purchases by prestigious collectors. Nor do grants necessarily go to the needy. Well-established artists no less than tenured professors receive them, often on the basis of a well-written proposal or friends among the peer review panels. One full professor of art at the University of California at San Diego receives annual infusions of $10,000. His project? A long poem for which he writes four lines every year. Why $10,000? To pay for a team of sky-writing airplanes to puff his words across the sky on a particular day.

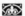

The flowering of the American marketplace for contemporary art may be roughly and arbitrarily divided into three phases. While traveling through the chapters that follow, the reader might want to bear these admittedly porous divisions in mind. They form a sort of horizontal trellis, a time frame, upon which the people and institutions described in the five central chapters of the book form a vertical grid. However, as the artist Paul Brach described it, "It isn't as though a whistle blew and everything changed. Rather, what changes is the air we breathe, so we experience everything around us in a new atmosphere." This is the spirit in which the reader should consider the following periodization: 1945 to 1960, the Era of Surprise; 1960 to 1970, the Era of Expansion; and 1970 to the present, the Era of Excess.

A wide-eyed air of wonderment surrounds the testimony of those who participated in the American art scene during the

Era of Surprise. The first shock came when the Second World War ended and Europe, especially France, was unable to recapture its prestige as the center of avant-garde art. People like Alfred Barr, whose training and experience had prepared him to look for vanguard art in Europe and expect little from Americans, dejectedly returned from their first forays into postwar Europe. Of course, Picasso, Matisse, Braque, and the other heroes of Modernism were still productive, but there was no sign of a new avant-garde wave. By contrast, Jackson Pollock, Willem de Kooning, Mark Rothko, and a close-knit band of other WPA veterans in New York were exploding with inventive vigor. By 1953 Alfred Barr could write that he had "never known a period in American art when I felt so much confidence in our own prowess." At the Whitney Museum, the abstract artists who during the thirties had been relegated to a few dark corners had by 1952 taken over and pushed their representational adversaries into the back rooms.

After the mid-1950s the first generation of Abstract Expressionists was stunned to find itself in need of accountants and tax lawyers to help manage hitherto unheard-of incomes. By then it was the next generation's turn to be astonished. In 1955, when Larry Rivers sold *Washington Crossing the Delaware* for all of $2,500, he literally fell to the floor in stupefaction. Five years later he received a $15,000 commission for a painting in the Seagram Building—and wondered if he could have gotten $20,000. A cohort of Rivers's, Michael Goldberg, worked as a moving man to make ends meet until the collector Walter Chrysler visited his cold-water loft on East Tenth Street one day in 1956. Chrysler plunked down $10,000 for sixteen paintings. That elicited a $10,000-per-year contract from the dealer Martha Jackson, and Goldberg was launched into full-time art.

The ranks of collectors for this new art also swelled with dizzy rapidity. During the early 1940s an opening at one of the few galleries featuring advanced art attracted virtually the entire art world. "Everyone seemed to know everyone else," recalled the dealer John Bernard Myers. At the Museum of Modern Art exhibitions of Americans had been lackluster gestures toward the home team until the first major show of

Abstract Expressionists in 1952. So excited were museum insiders then that the trustees bought sixteen paintings before the exhibition opened to the public. Prices were still minuscule, but the existence of any market at all for contemporary art encouraged the opening of numerous galleries. Alongside commercial dealers, the younger artists organized a profusion of cooperative exhibition spaces; on many a Friday night, the entire block of East Tenth Street between Third and Fourth avenues would be awash with an exuberant crowd of new art lovers making an entertaining evening out of cruising the simultaneous openings at galleries such as the Tanager, James, Fleischmann, Camino, March, Brata, Nonagon, Phoenix, Great Jones, Area, and Reuben. Sometimes they bought. Prices were still "reprehensibly cheap," said the dealer Samuel Kootz; a de Kooning he sold for $700 would bring $30,000 ten years later. The price rise really steepened in 1955, recalled the dealer Eleanor Ward, whose Stable Gallery thereafter enjoyed "golden years."

It was then that *Fortune* took note of the spreading interest in art. "Calculating dealers, sure-eyed experts, believing buyers combine with the majestic benedictions of great museums to set values on the world's most precious art," wrote Eric Hodgins and Parker Lesley in a two-part series. They were describing "the great international art market," where Old Masters and Impressionists were achieving new records. At the Gabriel Cognacq sale in Paris in 1952, Renoir's *Jeune Fille* had brought almost $65,000. Still, experts believed that no picture could sell at auction for more than about $85,000. Then, on October 15, 1958, the art market was stunned by the Goldschmidt sale: seven pictures by Cézanne, van Gogh, Manet, and Renoir racked up almost $2 million. This was a turning point, not only because of the extravagant prices but also because of the sale's setting. For the first time in auction history, Sotheby's scheduled an evening sale and the invitations to the select crowd requested black tie. Buying and selling of art had stepped from the shadows of aristocratic diversion into the spotlight of high-class entertainment. When the decade ended, an investment counselor who had hastened to write a book about the pros-

pects for art speculation called the 1950s "a boom in art such as has possibly never appeared before in history."

The crowd gathering around the contemporary American artists was not yet of the social or financial caliber to be invited to a black-tie evening at Sotheby's. Youthful and striving, it included many whom the postwar prosperity had lifted to comfortable middle-class status for the first time. Quite a few represented a new generation of Jewish collectors, people whose immigrant parents had struggled through the Depression. For the first time, too, Jews were prominent among the vanguard artists. Buying their work was an act of ethnic solidarity, but it also extended a long tradition of Jewish support for advanced art established by such earlier patrons as Leo and Gertrude Stein, Claribel and Etta Cone, Walter and Louise Arensberg, Solomon Guggenheim, and his niece, Peggy. Art patronage, too, provided an entry point into a level of society from which Jews had often been excluded. As the 1950s ended, however, the band of pioneer Abstract Expressionists, artists who had been welded by hunger and scorn into a tight social circle, was disintegrating. The lively gatherings in a scruffy clubhouse where they debated art and drank grapefruit juice laced with raw alcohol had shattered in a crossfire of petty feuds and obscure rivalries. They were rich, they were respected, they were deep into middle age. Their final party took place in a luxurious loft with parquet floors and a gracious colonnade. The old guard was well represented, but eight hundred others were also present—dealers, collectors, museum people, and the many hangers-on composing the new art crowd. All had received written invitations, which were checked at the door by armed Pinkerton guards.

The Era of Expansion had already dawned: of numbers of artists and styles of art, dealers, collectors, exhibitions, books, articles, university art departments, art history courses, color reproductions of paintings, specialized magazines, museum attendance and membership, media attention, interest in art investments, and, of course, prices. The social revolution of the 1960s, with its movements to liberate women and blacks and its warm welcome for diverse lifestyles, sexual adventures, and

drug experiments, was mirrored in the art world. The new freedom resembled the kind of life previously sanctioned only for artists, at least according to the bohemian myth. "The avant-garde is in the public domain," wrote the sociologist Daniel Bell. So many people who earlier were oblivious to the arts were insisting "on the right to participate in the artistic enterprise," he wrote, "not in order to cultivate their minds or sensibilities, but to 'fulfill' their personalities." The public had become so culturally voracious that it trampled past the critics and other certified tastemakers manning the gates. Art took its place beside foreign travel and gourmet food as a common adjunct to the good life. As John Gross put it, the critic had to "resign himself to being the doorman at the discotheque."

For successful artists this crowding meant the end of out-cast status: for this avid audience no artistic manifestation was too bizarre, too revolutionary, too repulsive, too contemptible, or too simplistic. The paint-daubed bedding tacked to the stretcher frame, the encaustic flag, the solid-blue canvas ex-panse, the single stripe on an unrelieved red background, the bronze beer can, the acrylic hamburger, the billboard, the drip, the rip, the fling of paint, and the plaster cast all found their enthusiasts. For more American artists than ever before, the eager customers meant fancy lofts in the city and fashionable weekend retreats, trips to Europe, private schools for the kids, antiques, sports cars, designer clothes: in short, they were now professionals. "Instead of being . . . an act of rebellion, despair, or self-indulgence," wrote Harold Rosenberg in 1966, "art is being normalized as a professional activity within society." Had James Joyce *really* described the artist's fate in this century as "silence, cunning, exile"? Not now. Not when each day's mail brought invitations to uptown dinner parties and museum and gallery openings, to write for magazines, to be interviewed on television. Not when universities were vying for lectures by the major figures and offering well-paid artist-in-residence status or tenured teaching positions to the lesser ones.

By the mid-1960s, some enthusiasts were alarmed. The collector Ben Heller deplored the "merchandising, promotion, and publicity" that were supporting "planned obsolescence"

and "increasing emphasis on fashion and money." In a letter to the editor of *Art News*, with a copy to the chief art critic of the *New York Times*, Heller worried that "the size, structure, and mechanics of the marketplace have so grown in scope, while deteriorating in quality and intent, that they all but overwhelm the artist and those who care about his work." American artists who had struggled so long to find recognition were now facing "problems of success, with a suffocating, brittle, fickle, feelingless acceptance that may well be as hostile as yesterday's rejection, and certainly as difficult to survive."

By the end of the 1960s, a chorus of disapproving voices deplored what was happening in art. Few exhibitions of a new artist or a new group were opening without sophisticated promotion to assure instant success, wrote John Russell Taylor and Brian Brooke in a 1969 book about art dealers. An article in the serious *Art Journal* identified the Museum of Modern Art as "the summit of all tastemaking" and concluded that "all taste-makers have one thing in common . . . the merchandising of commodities." Sherman E. Lee, the longtime director of the Cleveland Museum of Art, noticed that the term *avant-garde* had developed "a virtue of its own . . . thus new products assumed esthetic and hence monetary value." Mordantly, he wrote that "if 'less is more,' then 'more less is even more' and, contrariwise, 'more is less,' or to push the thought to its limits, 'more is nothing,' and, better still, 'nothing is more than something.' " *New York Times* art critic John Canaday also detected manipulation of the new public for art. "Art values (aesthetic and financial) do not exist in a state of nature," he wrote in 1969. "They are affected by a system of dams, pumps, irrigation, artificial evaporation, and cloud-seeding that makes the Tennessee Valley Authority project look like a wading pool in the backyard."

There is little evidence that these Cassandras had any effect whatsoever in persuading the Art Industrial Complex (for this is what the art world had become) to mend its ways. Indeed, the Era of Excess has spiraled into a baroque elaboration of the art market, a vertiginous succession of art stars packaged under a flaccid, nondescriptive label: Postmodernism.

Briefly during the early 1970s, some artists recoiled from art that could be traded as a commodity. A few, like Robert Smithson, retreated to remote places to fashion soil and rocks into Earth Art, while others, like Christo, developed flamboyant wrappings, fences, and curtains around buildings, over canyons, and across the countryside. To their ever-tolerant galleries and their hungry collectors they offered photographic and topographic descriptions of their work, and these, too, became commodities. Those who pursued Minimalism surely must have been amazed when arrangements of fluorescent tubes, blank sheets of steel, rectangles of gray Formica, gobs of lard, and tanks full of living lobsters (and sometimes just the sketches for these conceits) also were swallowed by the commercial system.

For the art historian Barbara Rose, the art world collapsed in 1973, when a frenzied auction audience cheered record prices for works by artists such as Jasper Johns and Robert Rauschenberg. On "that great come-and-get-it-day," she wrote, the art world in which she had matured died, "not with a whimper, but with a bid." The critic Harold Rosenberg was similarly pessimistic. Art had lost all reason for being, he wrote, "except as a medium of exchange." Even some passionate supporters of the spirited art scene of the sixties were troubled by the art emerging from the Pandora's box they themselves had helped to build. Calvin Tomkins noted widespread nostalgia among art writers while dismissing much of it as simply "the writer's wish that he or she were younger, fresher, less jaded by an art scene that offers mostly gossip, decadence, and galloping boredom." That the market increasingly was driving this scene seemed obvious: in 1974, more than $1 billion worth of art changed hands in New York, and an increasing percentage of it was contemporary. George L. K. Morris, who had pioneered abstract painting since the 1920s, believed that the market's extraordinary tolerance for novelty grew out of previous rejections of new art. Because what few tastemakers survived were determined never again to be "laughingstocks," he wrote, "they have proceeded to enshrine every absurdity that comes along."

In 1975 Tom Wolfe commandeered an entire issue of

Harper's magazine to fulminate against modern art and the crazed offspring it had been hatching in New York. He perversely blamed critics for spinning the convoluted theories that supported artists' most ridiculous excesses. In book form *The Painted Word* elicited universal condemnation in the art world for the shallowness of its argument and the shrillness of its tone. That Wolfe dared to illustrate his simple-minded slurs with his own feeble drawings added an aftertaste of sour grapes: was Wolfe a failed artist? Naively, he was blaming the critics and their baroque theories just when dealers and collectors were driving the market.

In reality, theorizing about contemporary art was retreating from the popular press; no longer did critics care to tell their readers how they felt about a particular artist or exhibition. The jargon of the academic journals, replete with obscure allusions, minute dissections, and spongy concepts infected the art press. Meanwhile, a new kind of article about art began to appear—the camouflaged shopping list. In this genre the author would deplore the extreme commercialization of art while simultaneously dropping tips on which artists might provide the most lucrative investment. In "Art Stars for the 80s," published in the *Saturday Review* in 1981, Carter Ratcliff bemoaned how artists "have begun to promote themselves in a manner reminiscent of chorus-line hopefuls in a Busby Berkeley movie." He then named three whose prices were booming. In a 1987 article in *Vanity Fair*, Anthony Haden-Guest condemned the art market as resembling "the hog-pit of the futures-trading floor in Chicago." Then he swung into a chatty report about how the brightest art stars were abandoning the dealers who had created their reputations for more lucrative arrangements elsewhere. The illustrations showed no new art, just three stylish dealers and one modish artist in his white-hat-white-suit-white-shirt-crumpled-tie artist costume.

Bitterness over the flagrant commercialization of art mounted in concert with escalating auction prices. After yet another series of record-breaking sales in May 1989, an editorial in the *New York Times* suggested that "only the finest trash" could rest in an Art Deco wastebasket that had just fetched

$33,000. Christie's president had proposed that younger art lovers who could not afford the $47.9 million paid for a Picasso might get started by spending $20,000 or $50,000 for a print. But "in a world that seems to be starving for blue-chip art," the *Times* caustically submitted, "that's like stopping with the hors d'oeuvres." When prices reached yet another crescendo the following November, Robert Hughes blustered in *Time* magazine that art "loses its inherent value when it is treated only" as a commodity. He found the spectacle of greed in the auction rooms intolerable: "What strip mining is to nature, the art market has become to culture." After the Guggenheim Museum waded gleefully into the fray in May 1990, auctioning three mint examples of Modernism, the veteran auction correspondent Souren Melikian sardonically suggested that since the $47 million proceeds were to go for buying an extensive Minimalist collection, the museum's trustees would have no trouble "brilliantly" disposing of the museum's entire collection. That would yield enough cash to purchase the world's reserve of Minimalist art ten times over "and even leave a little something for black-tie events to celebrate . . . if a riot has not started among New Yorkers who love art."

It was late in the day to start worrying about what commercialism was doing to fine art. For more than four decades, the marketplace for art had been building, often with the aid of the very same people who were now aghast. Barbara Rose noted in 1969 that "one of the fundamental assumptions of modernism is that art can replace religion as the repository of the spiritual and bearer of modern conviction." However, she saw "many indications that art . . . is . . . about to follow religion as an illusion without a future." Geraldine Keen, a journalist who published a study of money and art in 1971, observed that American tax laws facilitated a symbiotic relationship between the religion of art and its financial benefits—speculation. Displayed in galleries decked out in synthetic religiosity, art had become so mystifying, wrote Waldemar Januszczak in 1987,

that it promised its viewers "a spiritual frisson of a kind that used to be supplied by religious experience."

The outcry over speculators' excesses resulted, perhaps, from exaggerated expectations of what painting and sculpture could offer in these last years of the twentieth century. After all, the fine art pursued so zealously by grasping speculators was only a tiny fraction of all the fine art being created by an army of artists, more artists than had ever been active before. In California alone, some fifty thousand art students were preparing each year to squeeze into an already overcrowded market, and only one-half of 1 percent of all their painting and sculpture was expected to have any value whatsoever in thirty years. Moreover, university art history courses, art publications, and museums had enshrined the artists now achieving the highest prices. In settings more reverential than critical, they had laid down the canon and studiously counseled their audiences against the evils of kitsch. This canon assigned the greatest aesthetic value to those works that also embodied the greatest monetary value. Was it any wonder that the moneyed had rushed in to acquire and make a market in what was so widely revered?

If they were speculating in real estate or pork bellies—or gold—all the stratagems of salesmanship, manipulation, promotion, and maximization of profits would be considered an admirable example of the free market. True, the stock markets, and even the less regulated commodities markets, do not now permit the sort of secret dealings and conflicts of interest rampant in the market for art; ominous experience and public disgust brought on regulation. Ironically, just because the Art Biz allows such a full scope of unbridled entrepreneurship, it fascinates financial high fliers. The people who take advantage of it are not by and large evil, nor do they consciously aim to diminish art or to interfere with its diversity or scope. In a sense they are victims of our society's overwhelming emphasis on profit. This accent on gain shows up even in the rules the IRS enforces on artists: no tax deduction beyond the cost of materials for any work donated to a museum; no tax deduction for expenses unless there is a balancing income from the art.

Under such rules, van Gogh himself would not be recognized as an artist because he did not turn a profit. Such a society presses artists into a commercial mold. It encourages the art investor to fresh excesses of manipulation because it does not recognize that any art could possibly exist outside the commercial system.

The problem is that the speculation of the few is seeping like toxic effluent into the aesthetic environment, polluting the very source of art—artists—and the revered public spaces—museums—where monetary value is increasingly driving exhibitions, acquisitions, and—a ghastly word—deacquisitions.

This is not a book for art insiders, the few who already know who paid how much for what and whether it was worthwhile. This is a book for art outsiders: the many who stroll through galleries on a Saturday afternoon; who attend museums; who hunger for pleasurable communion with the talent, insight, daring, and imagination of the artist; who may sometimes wonder why on earth anyone would pay immense sums for an object even if it were touched by genius.

Haunted by the ugly ignorance of philistines ready to pounce on all new art, this outsider hesitates to question any contemporary art, even though it sometimes appears baffling or repellent. The sad fate of van Gogh and other rejected vanguard artists of the past weighs heavily, stilling quick critical judgments. This art outsider confronts a black hole of silence at the heart of the art world, a silence that weighs heavily on what artists create, what writers and publishers print, what dealers show and collectors choose, and what museums select to display. This silence basically revolves around money. When art insiders get together, money is probably the most popular theme of conversation. But when outsiders appear, they are often treated to a woolly mash: "stubborn longings for equanimity," "neo-classicism manqué," "the distancing effect that suspends modernism's traditional immediacy or presentness." What manner of discourse is this? Does anybody read it, understand it, believe it? But it does have a message: keep out.

So the first objective of this book is to provide the art

outsider with a map and compass on the road to joining the art insiders. Past profundities and inanities, through hyperbole and hype, skirting the fog banks of jargon, over the treacherous glaciers of snobbery and arrogance, the reader will enter into the gathering of extraordinary personalities who inhabit the Art Biz. Each of the next five chapters focuses on one group of players or institutions comprising the art world: artists, critics and media, collectors, dealers, and museums. Each chapter describes one or two representatives in detail while discussing many others in general. Necessarily, this is not an all-inclusive work but rather a fair overview. The final chapter presents some speculations about the position of "fine art" in contemporary society and why its perhaps unrealistic role as a cultural fetish encourages worship and investment in it rather than appreciation. The concluding section also offers some strategies for navigating through—and savoring to the fullest—the immensely rich panorama called visual glut.

2
ARTISTS:
A HALL OF MIRRORS

"I was born in Cody, Wyoming." Paul Jackson Pollock invariably opened every interview with this announcement. Then he would fall silent, seldom volunteering that his family left this picturesque paradigm of the Old West in 1913, when he was ten months old, for a hardscrabble odyssey through dusty farm towns in Arizona and California. Though he never returned to Cody, his origin there was supposed to convey his identification with "the wildness and virility of the American frontier, even if it wasn't his real heritage," writes Deborah Solomon in the 1987 book *Jackson Pollock*, one of the best biographies to date. At the age of sixteen Pollock was expelled from Manual Arts High School in Los Angeles. A year later he was permitted to return, only to be expelled again in 1929 for distributing leaflets critical of the school administration. Turning briefly to another common stereotype of that time, Paul Jackson Pollock boasted to his brother that the school considered him "a rotten rebel from Russia."

In 1930, after crossing the country with his two older brothers in a $90 1924 Buick touring car, Pollock dropped Paul from his name. This emphasized the Jackson, with its frontier connotations of Jackson, Wyoming, not to mention the association with rough-hewn Andrew Jackson. He enrolled at the New York Art Students League, where he studied with Thomas Hart Benton, a Missouri-born muralist whose work romantically dwelled on the American Scene, particularly the rural world of the West, its cowhands, its campfires, the silences of

its people masked by the thin plaint of a harmonica. Jackson Pollock could not draw—would never learn to draw—and retreated often into glum silences, along with protracted drinking bouts. Still, his four older brothers, all aspiring artists, as well as the Bentons, protected him as though he were a disabled child.

Members of New York's tiny avant-garde art world during the 1930s and into the 1940s naively looked at paintings, heatedly discussed styles, and struggled to float, artistically and financially, in a philistine sea. The American art community thrived as never before, as artists, including Jackson Pollock, received small stipends through the WPA art projects for producing what eventually became mountains of paintings, murals, prints, and sculptures. However, no serious art critic or museum curator believed that the American artists so industriously churning out works were anywhere near the cutting edge of Modernism. That, for almost a century, had been in Paris.

But suddenly, shortly after the Second World War ended, a chorus of critics began to discern a new art movement, based in New York, which they found so original and dynamic as to replace Parisian supremacy. A French critic, Serge Guilbaut, described the phenomenon with understandable rage. *How New York Stole the Idea of Modern Art* is the title of his diatribe. He argues that American postwar painters vaulted to international dominance because their loose, abstract style demonstrated the freedom of American artists and was a weapon in the Cold War. Most art historians, however, see the Abstract Expressionists, among whom Jackson Pollock was the most prominent, as part of the long history of Modernism that began with the Impressionists and that embraces as well what today is called Postmodernism.

The triumph of American painting, as Irving Sandler, the group's leading chronicler, described it, was far more, however, than a new twist in the kinky skein of modern art. Nor was the shift of avant-garde art from Paris to New York a simple change of venue. Beyond a stylistic change, it meant a revolution in the ways art was marketed, in the kind of audience to

which it appealed, and in the meaning of art within the national culture. For the Abstract Expressionists presented not only their art but themselves as icons of creative imagination. Their paintings were said to be reports from an inner war zone, material traces of a desperate struggle to bring inchoate emotions to sublime reality. Their subject, they proclaimed, was the picture itself, clawed and lashed with the frenzy of creative passions. While each artist's confrontation with the canvas was a lonely one, the practitioners of this painting style were pleased to share their solitary agonies with the rest of the world. In fact, they invited the mass media to witness their travails with a zest that earlier American artists or Europeans would have shunned but more recent artists elaborated with even more inventive élan.

In May 1950, for example, the Metropolitan Museum of Art announced plans for a juried exhibition, *American Painting Today*. The very next morning, the *New York Times* received a letter from eighteen avant-garde painters and ten sculptors denouncing the museum's juries for being "notoriously hostile to advanced art." The letter, embedded in an article about its signers, appeared on the front page. The more conservative *New York Herald-Tribune* published an editorial chiding "the Irascible Eighteen" for distorting facts, but the names were all spelled right, and *Life* magazine soon scheduled a photographer to snap a group portrait of the Irascibles.

The magazine wanted the artists to pose on the steps of the Met, carrying their canvases. But Barnett Newman, who had organized the protest, decided this would be undignified and instead arranged for the Irascible Eighteen to be photographed in a rented studio, dressed "like bankers." The seventeen graying and balding middle-aged men in dark suits and ties who soberly posed in Nina Leen's photograph reassured the magazine's five million subscribers that these folks were no threat to established values. The lone woman in the picture, Hedda Sterne, wore a decent black cloth coat for the photo; the only reminder that they were artists is her black beret.

In the very middle of the group stood Jackson Pollock. "Gamely he turns his head over his shoulder and raises a

cigarette," writes biographer Solomon. "He is as handsome as Gary Cooper." When Newman had telephoned for Pollock's backing of the original protest, his wife, Lee Krasner, said he could not be disturbed; later he did send a telegram of support. Despite this marginal role, Pollock had no qualms about taking his place in the center of the group, for he was by far the most famous member of it.

A year earlier *Life* magazine had ushered Jackson Pollock from underground notoriety into the spotlight of national celebrity. When *Life's* photographer, Arnold Newman, arrived at Pollock's ramshackle studio in The Springs, Long Island, the artist tried to borrow $150. Though Newman refused to lend him the money, Pollock allowed him to photograph what he had previously forbidden anyone even to witness—his pirouettes of paint, his dribbles and slashes on a canvas-covered floor, the hallmark of his work.

As early as 1945 the critic Clement Greenberg had deemed Pollock "the strongest painter of his generation," rejoicing that "he is not afraid to look ugly. All profoundly original art looks ugly at first." But those comments went to the few thousand readers of *The Nation.* Other avant-garde critics had been equally admiring, beginning with Pollock's first exhibition in 1943 at Peggy Guggenheim's Art of This Century Gallery in New York. His talent was "volcanic, lavish, explosive," wrote James Johnson Sweeney in the catalog, reveling in the artist's "freedom to throw himself into the sea." The more traditional critics either ignored or mocked Pollock's work. "What it means or intends I've no idea," wrote one experienced critic. Another suggested that his pictures resembled baked macaroni.

The *Life* article, however, was not so much about the art of Jackson Pollock as it was about his personality. His wife, Lee Krasner, accompanied him to the magazine's offices, where an interviewer struggled to extract a text from this singularly taciturn man. He evasively twisted his hands and let Lee explain what he meant. "Is He the Greatest Living American Painter?" asked the magazine's headline. The text, even with Krasner's eager elucidations, revealed little. In a style that hovered nervously between awe and derision, the anonymous

author assembled two paragraphs that started out with "Jackson Pollock was born in Cody, Wyoming" and included another often-quoted ambiguity: "When I am *in* my painting, I'm not aware of what I'm doing."

The photographs presented an antiheroic figure reminiscent of James Dean or Marlon Brando. Jackson glowered before a great tangle of painted drips, his arms crossed, his brow furrowed, the stump of a cigarette dangling from his lips. The caption noted that the painting behind him was three feet high and eighteen feet long and added that "critics have wondered why [Pollock] stopped when he did. The answer: his studio is only twenty-two feet long." Other photos show him leaning athletically over the canvas, pouring paint with religious intensity, a noble savage engrossed in a ritual.

The photographs accomplished far more than simply conveying the content of Pollock's art. They hopelessly mingled the image of the artist with the images he created. And because the image of the artist was so familiar, so powerfully and patently American, the bizarre, crude, violent, insolently baffling art slipped into public acceptance. More than tolerance, the image of Jackson Pollock evoked affection through many of the same communal dreams and fantasies that underlie the stunning success of the Marlboro man, one of the most enduring icons in the pantheon of advertising.

The cowboy associated with Marlboro cigarettes was concocted to counter the effeminate image then attached to filter cigarettes. The campaign began in 1955 and, interestingly, was not developed on Madison Avenue but by Leo Burnett in Chicago, where, some say, the West begins. In a similar manner, the image purveyed by and for Jackson Pollock also countered a common perception of artists as sensitive, effete dabbers of paint.

An advertising image is, of course, a conscious, sophisticated manipulation of the public's fantasies and desires. The image Jackson Pollock presented was a product of his own personality, augmented and amplified by his wife and by the critics who discovered him. This image resonated in the wider public—not to mention the art market—because of its close fit

with the most enduring hero of the American imagination.

"The making of the illusions which flood our experience has become the business of America," Daniel J. Boorstin lamented in 1962 in a bitter tract deploring Americans' preference for image over substance. "We have willingly been misled into believing that fame—well-knownness—is still a hallmark of greatness," Boorstin went on. "The household names . . . who populate our consciousness are with few exceptions not heroes at all, but an artificial new product—a product of the Graphic Revolution in response to our exaggerated expectations."

The media image of Jackson Pollock was one of these artificial new products. The art lurked behind the presentation of the artist as a Marlboro man, a stereotype borne out only superficially by the man himself. The real Pollock's alcoholism was so severe that he was hospitalized many times, once for seven months. He was treated for years by psychiatrists who diagnosed underlying schizophrenia but were unable to break through his silent, self-pitying resistance. His personality alternated madly between violent aggression and meek indecisiveness. Thus he would lurk at the Cedar Bar, where the Abstract Expressionist artists gathered, and greet important arrivals with "Who the hell are you?" To women his favorite salutation was "You're a fucking whore." Yet when Peggy Guggenheim's chubby, truly effete factotum, Howard Putzel, created a mock interview to publicize Pollock's first one-man exhibition in 1944, the artist mildly allowed himself to be quoted: he was "very impressed with the plastic qualities of American Indian art."

Putzel ghostwrote quotes for Pollock that suggested his work contained "references to American Indian art and calligraphy" but modestly allowed this "wasn't intentional; probably just the result of early memories and enthusiasms." In 1947 the critic Clement Greenberg helped Pollock to apply for a Guggenheim Fellowship. "I believe the easel picture to be a dying form," the critic wrote in the artist's name. This was a notion Greenberg frequently expressed in his own name in the pages of *The Nation*. When his analyst was Jungian, Pollock agreed

that he found Jung helpful. At yet another interviewer's prompting, Jackson willingly agreed that "we were all Freudians."

These and other erudite statements that purportedly emanated from Pollock have been widely quoted as evidence of the profundity lurking beneath the artist's loutish, narcissistic, foul-mouthed veneer. Many observers have noted Lee Krasner's role in elaborating this myth of Pollock's sensitivity and cultivation, characterizing a diamond in the rough. She was the source for such statements attributed to him as "I choose to veil the image" and "I *am* nature." She also portrayed her husband as a connoisseur of classical music as well as of jazz and as an avid reader. "I just don't think that was the scene," said B. H. Friedman, a friend and early biographer of Pollock. "Jackson was not involved with serious music and he was not a literary man and he was not an intellectual." Barnett Newman, the acknowledged ideologist of the Abstract Expressionists, would often harangue Pollock with abstruse art theories. Jackson would gruffly interrupt, shouting "Barney, you know what I think? You're a horse's ass."

Clearly Pollock had little use for intellectual—or even aesthetic—rewards; rather, he worshiped at the altar of America's traditional god—mammon. Robert Motherwell remarked that Pollock was the first artist he had met "who mostly talked not about art but about money." After the *Life* article appeared, Pollock gave up his wheezing Model A Ford and spent $400 on a suitable symbol of his new status: a 1941 Cadillac. Tony Smith, an artist whom Pollock consulted about the purchase, commented that "Jackson was a straight American boy. He wanted what most people want." And his biographer adds, "He just wanted it more."

Many of his colleagues also remarked on his inordinate, childish passion for fame. He kept a stack of the *Life* articles in his kitchen and pressed them upon everyone he met. In the summer of 1950 a Pollock painting was the sensation of the Venice Biennale. On the day his family arrived for its first reunion in seventeen years, the artist received an Italian magazine containing a review. While his four brothers and his

mother entertained themselves in the living room, Jackson pored over the article at the kitchen table, grasping at the sleeve of anyone who came near to ask if they could translate it. *Time* magazine did so in its next issue: "Chaos. Absolute lack of technique, however rudimentary. Once again, chaos." To which Pollock angrily cabled: "Sir, no chaos, damn it. Damned busy painting as you can see by my show coming up Nov. 28."

The bright light of renown attracts its own buzzing satellites. A young freelance photographer, Hans Namuth, built his own reputation by gaining access to Pollock's studio. His poses of the artist ostensibly at work appeared in *Harper's Bazaar*, *Art News*, the *New York Times Magazine*, and *Life*. Soon Pollock agreed to make a film, and Namuth appeared at the artist's studio every weekend and crouched under a large glass pane recording the artist's drips and spatters of paint upon it. Something inside Pollock may have rebelled against this blatant self-exploitation, for this was when he broke more than two years of sobriety, his most productive period, by gulping down a tumblerful of whiskey.

Yet Namuth's photography also fostered Pollock's crude desires for center stage. He began to quiz visitors such as Harold Rosenberg and Clement Greenberg on the "persona" of the modern artist and he modified his behavior to conform with the image the public might expect of him. Those around him were treated to "long silences and enigmatic stares," wrote Steven Naifeh and Gregory White Smith in their revealing biography, *Jackson Pollock: An American Saga*. He also stressed his roots in the American West, "lacing his rare comments with references to sheep ranchers, cattle rustling, city slickers, and Indian lore; ridiculing the privileged Eastern backgrounds and refined sensibilities of fans." Within his alcohol fog Pollock blended the movie version of the Old West with his own crippled personality into a charade of the alienated, misunderstood artist.

Thus began the artist's final, tragic decline. His behavior became increasingly provocative and outrageous. At one Thanksgiving dinner he ferociously tilted the festive table—turkey, trimmings, and all—onto the floor. Invited to a dinner

party at the critic Harold Rosenberg's home, Pollock pugna-
ciously kept interrupting with shouts of "Ah, a lot of shit" and
was ignominiously sent upstairs to bed. One summer night in
1956 Jackson Pollock careened his convertible into a tree. His
body flew out into the Long Island forest; he died instantly. A
young woman who had met him only a few hours earlier was
also killed. She was a friend of another passenger, Ruth Klig-
man, who was hospitalized for months by grievous injuries.

The drunken crash that catapulted Jackson Pollock to his
death completed the transmutation of his story into myth, as
his jagged life paralleled the oft-told tale of the western hero.
In a penetrating study, Will Wright describes the repetitive
structure of the classic western film as it developed during the
years of Pollock's maturity, 1930 to 1955. In movie after suc-
cessful movie, Wright found the identical pattern. In abbre-
viated form, it is this: (1) The hero, a stranger, enters a social
group. (2) He is revealed to have an exceptional ability. (3) The
society recognizes his talent and gives him a special status,
while not completely accepting him. (4) Strong villains threaten
the society. (5) The hero stands aloof but eventually defeats the
villains and is accepted before riding off into the sunset.

This pattern strongly resembles Jackson Pollock's mercurial
transit across the firmament of the American art world. A
young artist among many, Pollock intuitively stressed his few
strengths: a raw cowboy demeanor underlined by long silences,
rough language, and drunken escapades; his birth in Cody,
Wyoming, his professed love of certain rocks, and his spurious
references to some special knowledge of Indian lore or western
spaces; his usual garb of blue jeans and white T-shirt stretched
over a barrel chest and, by contrast, the single decent suit into
which he squirmed for exhibition openings. Fellow artists no-
ticed, and were chagrined by, his posturing. Mark Rothko
described him already in 1947, as "a self-contained and sustain-
ing advertising concern."

The critics who early took up his cause were enchanted by
this noble savage, an exotic creature from the West, purveying
an art whose subject, as best as could be discerned, was his
inner struggle to express romantic notions of freedom and
primitive spirituality. By his stoic silence, he appeared to be

confronting the villains of the art world, the philistines. Because Pollock expressed no ideas of his own Clement Greenberg was free to make a virtue of Pollock's muddy colors and to call his drips and slashes assertions of the picture plane and a logical development of Cubism. On the blank sheet of Pollock's silence, Harold Rosenberg sketched a crisis in society that drove the artist into doing away with subject matter, drawing, composition, color, texture. "In a fervor of subtraction," he wrote, "art was taken apart, element by element, and the parts thrown away. As with diamond cutters, knowing where to make the split was the primary insight."

These and other early intellectual devotees of Jackson Pollock comprised the first cohort of serious American art critics who had never been to Europe. In Depression America, where nationalistic American Scene painting dominated, they hungered for native painting that could rival or surpass the European avant-garde. With Europe out of the picture during and immediately following the Second World War, they were free to spin theories of American innovation in art. The art of Jackson Pollock was innovative indeed and may well be of lasting value, but the artist's resemblance to America's favorite cowboy myth reinforced its primitive enchantment.

The image represented by the Marlboro man especially appealed to Jewish New York intellectuals such as Clement Greenberg and Harold Rosenberg. To an urban people whose ancestors were forbidden to own land, the limitless spaces of the West conveyed a promise of freedom. To the well-educated, trained in indoor intellectual hairsplitting, the cowboy represented a broadly iconic antithesis: he was a man of action, not reflection; silent, not voluble; mobile in his vast spaces, not chained to a desk; dealing with physical challenge, even danger, not mental convolutions. To the veterans of New York's radical wars of the 1930s, the cowpuncher's calloused hands and grizzled face summed up working-class virtues. The intellectual sons of Jewish immigrants scoffed at the Marlboro man and rudely dissected his synthetic innards, as constructed by advertising flacks, but they, too—perhaps especially—were beguiled by his quintessentially American stance.

Many years later Harold Rosenberg would deplore what

had been wrought by critics of the late 1940s and 1950s, including presumably his own too ready and enthusiastic embrace of the artist's persona instead of the artist's work. "Breathing or moving one's arms and legs is equivalent to executing a fresco," Rosenberg wrote sadly in 1975. "Art has enmeshed itself in public relations. . . . The artist today is primarily a maker not of objects, but of a public image of himself. . . . The irreducible reminder of the idea of art has become the figure of the artist." The life and death and myth of Jackson Pollock, I believe, are a key turning point in this baleful transformation.

The scramble for fame and fortune has destroyed many an American artist since Jackson Pollock, and it continues to corrode the lives of a multitude of talented individuals. While art consumption has increased dramatically since Pollock's day, the number of Americans who call themselves artists has grown even more. Arriving at numbers of artists is tricky because census figures draw no firm line between commercial and fine art, and artists often work in both areas. Nevertheless, statistics and insiders' impressions indicate that artists are not exactly a vanishing breed. In New York during the early 1960s, more visual artists made a living from their profession than poets, dramatists, novelists, and composers combined; nationwide, there were more painters than hunters.

In the late 1960s, as many as 50,000 artists were active in the United States; New York City alone harbored more painters than had worked in all of Italy during any decade of the Renaissance. The 1970 census listed 15,374 artists in the New York Standard Metropolitan Statistical Area. By the late 1970s ever more aspirants were in the pipeline: 25,000 students of art were enrolled in the California state colleges alone, many times more than the number of apprentices during the great age of Florentine painting. Each year during this time, more than 4,500 students graduated in California alone with a B.A. or M.A. in art, and many others obtained training at nondegree art schools. From 1970 to 1976 the number of professional

artists increased by 50 percent, more than double the rate of increase in any other profession. By the 1980 census 199,000 Americans were making their living by producing art; in New York alone, the Department of Cultural Affairs estimated 60,000 men and women were attempting to wrest a livelihood from making art.

Clearly, for every Pollock or Warhol, there are tens of thousands of artists struggling for recognition—and thousands more are arriving on the scene every year, slide portfolio, résumé, and M.F.A. degree in hand, dreaming of the artist's life. The gatekeepers of the art world—critics, dealers, museum curators—insist that true talent will not go unrecognized. But the "unprecedented glut," as *Time* art critic Robert Hughes terms it, provides "the art dealing system with a large proletariat from which trends can be condensed at will." Those who don't fit are not likely to be discovered: to succeed in the Darwinian struggles among art hopefuls luck counts more than talent, and the personality of the artist outweighs the quality of his or her work.

Behind battered doors, barred and locked, is the SoHo studio of Joe Maresca. Vandals long ago disabled the downstairs buzzers, and now a visitor must announce herself or himself from a pay phone two blocks away. From the dim landing up two rickety flights of stairs, Maresca beckons the visitor into a cluttered space. The high pressed-tin ceiling is lost in the cobwebs and grime of a hundred years of city life. Beyond a partition is Maresca's cavernous studio, where his paintings glow in the dim light filtering through brown paper over the windows. Beyond them is a renovated loft building, now gentrified into expensive abodes for lawyers and bankers. "They resent the artists still working around here," Maresca says.

During the late 1950s artists began to occupy the decrepit loft spaces where, since the mid-nineteenth century, marginal in-

dustries had operated. Dolls were made, rags were baled, clothing was manufactured, and waste paper was processed in four- and five-story structures, many with impressive classical facades. But behind the pilasters and entablatures, urban decay appeared to be inexorable as marginal industries gave up or fled. Artists moved in illegally, renovating rotted floors, antiquated wiring, and uncertain plumbing. For $60 per month an artist could rent a 2,500-square-foot space, ostensibly for a studio. At first overnighting on makeshift cots, then moving in permanently, artists for years played a canny cat-and-mouse game with building inspectors. By the middle 1960s groups of artists were refurbishing whole buildings as co-ops and energetically lobbying the city to legalize their status.

It was not the first time that artists pioneered urban rehabilitation only to attract the chic and trendy and the well-to-do. As in Greenwich Village and the adjoining tenements of Little Italy, upper-middle-class professionals flocked to the neighborhood because of the "bohemian" ambience created by artists. When the city legalized SoHo artists' lofts as living spaces in 1971, the costs of space in the forty-three-block neighborhood began to soar out of reach for all but the most successful artists. By 1980 raw studio space rented for at least $500 per month. Renovated space cost $700 per month, plus a "fixture fee" of $8,000 to $15,000 paid to the departing tenant. Co-ops cost as much as $60,000 for a raw space and $130,000 for a refurbished one. Monthly maintenance fees for co-ops had soared from $225 per month in 1972 to $450 or more in 1980 and nearly doubled again a decade later.

Paula Cooper in 1968 was the first dealer to move from Fifty-Seventh Street to SoHo. Since then, the neighborhood has attracted scores of galleries, clothing and furniture boutiques, restaurants, coffee houses, wine bars, bookstores: an amusing ramble for weekend strollers from the suburbs and a shopping mall with an arty atmosphere for sophisticates from Santa Monica or Grosse Pointe in town for a culture fix. With the aid of gallery listings, maps, and even Grey Line guides, tourists trip across gritty sidewalks in search of real art by real artists. Remnants of the area's historic manufacturing lend a

veneer of authenticity, like battered lobster boats in a sleek New England marina.

In his hopelessly unrenovated loft, just a few blocks from Paula Cooper's expensive gallery, Joe Maresca represents another authentic remnant of times past. "From my window, all I can see are plush places with Le Corbusier chairs," he grumbles. The city allowed nonartists to buy SoHo lofts in 1979, and now "they even resent our moving paintings through the halls. But they want to live in an art neighborhood; they like the aura." Rent for the space costs him $850 per month, $200 more than he pays for the cramped apartment he shares with another artist.

From a hopelessly sprung thrift shop sofa, he surveys his most recent works, a series of picture-postcard landscapes framed with lovingly painted fruits. "Some call these Postmodern," he says. For more than twenty years, since graduating from Pratt Institute, he has devoted himself to painting, deliberately working at "any job that didn't involve using my abilities, so I could save energy for my painting." For the past twelve years he has worked part-time as a "sitter" in the Marilyn Pearls Gallery nearby, while also acquiring an M.F.A. at NYU and starting on a Ph.D. in studio arts. Currently he ekes out the $1,200 to $1,600 per month he needs to survive by also teaching an occasional course at NYU: "I'm an adjunct professor," he says wryly, "add in the spring and junked in the fall."

He has passed up a chance to be an industrial designer and regularly refuses commercial art work because he is afraid to corrupt his talent. "Painting is fucking hard work," says Maresca, "but I love every minute." During the late 1970s he showed steadily, and success appeared to be at hand. Then he lost his dealer, and "now I'm out there again, hustling," making the rounds of galleries, slides in hand. Wistfully, he wishes he had become "a famous art star. But the reality is that none of my friends in art school expected to make a lot of money. I

always assumed I'd live like this. Remember, I have no alterna-
tive." Now forty-one years old, Maresca admits that he is
"terribly disappointed and terribly jealous that people with no
training are making it."

The paintings on display sell for $3,000 to $6,000, and he
is hoping for a gradual rise to $9,000. Even though he could
probably sell more pictures at lower prices, previous buyers
expect a steady price rise. Although financial success—or even
recognition by the art world—appears to be out of reach, Ma-
resca keeps submitting his slides to potential dealers and hopes
that "with time and luck, my things won't be in a garage sale
either."

An urban myth: A dealer famous for creating art superstars
moved out of the modest apartment she had long occupied into
more spacious, luxurious quarters. The windows of the old
apartment overlooked a mean concrete courtyard fenced in
with sagging slats. After she left, the courtyard was knee-deep
in discarded slides of art works submitted by artists hoping for
an exhibition in her gallery.

Sadness Because the Video Rental Store Was Closed & Other Stories is
the title of Mark Kostabi's first retrospective book. Between
silver endpapers, its 176 pages show color reproductions of 186
paintings, almost all of them produced in 1986 and 1987. In a
brief self-interview printed at the back of the book, Kostabi
pertly mingles high-minded parody with disarming crassness:

> "Who writes your material?" asks M.K.
> And m.k. replies, "I am the mouthpiece of my
> generation."
> "What will be the first thing you say when you
> finally meet God?"
> "Any messages?"

"How can I get a spontaneous answer out of you?"
"Just start my spontaneity tape."
"Who are your influences?"
"Andrew Carnegie, John D. Rockefeller, Donald Trump, Andrew Mellon and King Midas."

Kostabi's irreverent manner, vaulting ambition, and sensational publicity have attracted biting scorn from the established art world. "No comment," snaps one dealer when asked about him. "A fraud," says another. But the Kostabi phenomenon demands more than curt disdain, especially from a world fraught with gossip about who is in and who is not, and who sold what to whom for how much. His paintings, he insists, are only a small portion of his art; they are "mere artifacts of a conceptual performance." The totality of his aesthetic statement includes more than 1,500 press clippings garnered in less than two years and dozens of radio and TV appearances. His purpose is not mere self-aggrandizement, Kostabi says, but to counter the image of the artist represented by van Gogh and Pollock, "the tear-jerker of the isolated artist." To that end, he audaciously presents a counterimage, fictionalizing what the media get to see. When the crew for "Lifestyles of the Rich and Famous" came by, for example, he had only eight employees. "So I got some friends to come over and we had twenty-five people all acting like they work here." Fiction soon turned into fact, however; Kostabi now has twenty-eight people on the payroll. His frequent job advertisements in the *New York Times* and *Village Voice* bring in hundreds of applicants, he says; more than half of them have M.F.A.s and are willing to work for minimum wage. Though he likes to tell interviewers about "mindless minions working for minimum wage," Kostabi admits that he pays more—up to $15 per hour.

On the far west end of Thirty-Eighth Street, inside a three-story building which Kostabi rents for $10,000 per month, they are industriously turning out paintings, prints, sculptures, and even T-shirts, all featuring Kostabi's faceless, almost sexless, figures floating in an electronic void. Many of the images convey suffering: the physical pain of lying on sharp

tacks, the psychic pain of loneliness and alienation. Many also include his favorite symbols: the ubiquitous video screen; the witch's hat, which he calls "the cone of wisdom"; the plumber's plunger symbolically unclogging the human mind; the cash register representing the bottom line. Kostabi finds inspiration during frequent travels and often draws sketches while in a foreign hotel room. These he faxes to the workshop, and by the time he arrives home "the paintings are done and ready to hang."

The block where the Kostabi factory hums is dominated by smashed taxis under repair and is redolent of horses. Hansom cabs stable their steeds in some of the buildings, and it is not unusual, as one approaches Kostabi World's yellow porte cochere, to see an unhitched horse munching the coarse grass in a vacant lot. In a bright ground-floor gallery, Kostabi displays a handsome array of his latest works, priced at $10,000 to $15,000. He also sells through the funky Ronald Feldman Gallery in SoHo, through a nationwide network of print and framing shops, and through galleries all over the world. In fact, he says, Europeans and Japanese appreciate his works even more than Americans. "Over there, they have much more respect for artists. In France, they have a portrait of Eugène Delacroix on the money. And in Japan there's no such thing as a negative review, only 'good, great, and greater.'"

Last year Mark Kostabi grossed more than $1 million. Yet he lives frugally in a thirty-six-hundred-square-foot loft on Thirty-Sixth Street and insists that every cent of his income goes into "creativity . . . to prove that my bottom line is to create and strengthen life through art. Here there is no Trump style." Indeed, Kostabi dresses like an eager young executive, his hair trimmed into a neat 1940s-style crewcut and his open face creased in a winning smile. And he works hard, supervising the assembly line of paintings and the gallery as well as handling the publicity and writing his own reviews. "I make it easy for the reporters," he says. "I write my own myth, act as my own curator, and I finance myself."

The goal of his media performances, says Kostabi, is "to call attention to the yuppie obsession with goods." In addition,

he wants his work to be a critique of the current system for marketing art. Dealers denigrate his art, he says, because they want to control artists. Many dealers insist that their artists create no more than twenty works each year, so that scarcity inflates the prices of their work. "It's an unwritten rule. Collectors believe that an artist is serious only if he creates few works." Kostabi's factory grinds out hundreds of paintings and sculptures every year as he merrily urges artists to be "less obedient. They should take control of the media."

Such control, however, occasionally has escaped even Kostabi. For an interview with Morton Downey, Jr., he appeared in a red suit, accompanied by seven of his artists, who were to be making paintings in the background. To convey his artistic creativeness, Kostabi opened the interview by sprinkling a handful of ashes on Downey's head. This so incensed the outspoken television host that he wrestled the artist to the floor, where in desperation, while being choked, Kostabi grabbed for a small pot of chartreuse paint and flung it at the camera. That stopped the show. Kostabi and his artists were tossed out of the studio, and the program never aired. Yet, to Kostabi's great glee, a description of the fracas appeared in two major articles, including one headlined "TV Talk Show Host Attacked by Mad Artist" in the *National Enquirer.*

Kostabi grew up in Whittier, California, a sedate Los Angeles suburb, which still enjoys renown as the birthplace of Richard Nixon. His parents had fled Estonia after the Second World War and lovingly supported their son's ambitions, first to be a fireman and then, at age five, to be an artist. During the early 1980s, while still a junior college art student, Kostabi brought some drawings into the Molly Barnes Gallery on La Cienega Boulevard in Los Angeles. Barnes was instantly smitten with the work. "It was sensational," she says. "He had no censor on his mouth or on his art." By chance, some movie people came into her gallery that same day and snapped up most of the drawings. After that, Barnes did what she could to publicize Kostabi's work, but, she says, "he knew he had to go to New York to become an art star."

The day he arrived, Kostabi had a drawing published on

the *New York Times* op-ed page as well as an interview with dealer Leo Castelli. His cool reception there may well have inspired the subsequent series of paintings, which exude alienation. "I feel the loneliness," he says of American cities, "but it's not necessarily depressing. There's real satisfaction in loneliness."

At the age of twenty-eight Kostabi is ebullient about his future. He has just published *Kostabi: The Early Years*, a colorful coffee-table tome, "something like those blockbusters on Raphael or Leonardo that Abrams published in the 1960s." He also expects to collaborate with other artists on a series of large-format books to be published monthly. "I produce enough work myself to fill it," he says, while granting that it might be more interesting to include the works of others. "It would be a sort of monthly annual report." Artists, he argues, should be "the new CEOs. They should have as much influence as sports figures or politicians." To that end, he has already met with accountants and lawyers to consider going public. "But they say 'Why share?' "

In the near term Kostabi's ambition is to be on the cover of *Time*, whose art critic, Robert Hughes, has refused to visit Kostabi World while privately denouncing the artist as a charlatan. Kostabi calls the self-selected art world "very provincial," claiming that it is dominated by four publications, all with small circulations. Even the biggest, *Art News*, he says, has only seventy-five thousand subscribers. "They're all just trade papers," he says. "The larger art audience is yet to be reached by artists. So I say yes to *People* magazine."

Poverty and obscurity have been the lot of most American artists throughout the twentieth century. Joseph Stella, for example, whose Cubist paeans to the Brooklyn Bridge and other American landmarks hang in major museums, was forced to adopt a more figural style during the 1920s in order to subsist. So was Max Weber obliged by an unenlightened public to abandon his explorations of Fauvism, Cubism, and

Futurism. During the 1930s Weber lacked the money for paint and canvas and was unable to pay for shipping works he had left in Paris to the United States. The *Magazine of Art* in 1946 surveyed five hundred artists about their incomes. Of the two hundred who replied, fifty-eight had sold nothing during the previous year and only four earned more than $8,500 from their art. One commented that "art and artists have no place in American life, as of today."

In 1949 Mark Rothko reported an income of only $3,935, most of it earned from his teaching job. After deducting the cost of painting materials, his net income, at the age of forty-six, was $1,285.65. "The unfriendliness of society . . . is difficult for the artist to accept," he wrote. "Yet this very hostility can act as a leaven for true liberation. Freed from a false sense of security and community, the artist can abandon his plastic bankbook, just as he has abandoned other forms of security . . . Free of them, transcendental experiences become possible."

Like most of the other first-generation Abstract Expressionists, pioneers of the first American art movement to capture worldwide acclaim, Rothko had grand ambitions for his art. But after more than twenty years as an artist, financial success seemed as elusive as ever. Indeed, most of the Abstract Expressionists considered themselves economic outcasts, condemned by their innovative talents to a life of alienation, poverty, and scorn. "That their paintings might be exhibited and purchased for huge sums of money," wrote sociologist Diana Crane, "seemed to them utterly unlikely." For this reason, they banded together socially to "convince themselves that the artist's role as such was a viable one."

For a few golden years beginning in 1949, it seemed as though a true artists' community could develop around The Club, a dusty loft at 36 East Eighth Street. Romanticized reminiscences today tell of an evening when the hat was passed to help a member pay his rent; of a party at which the critic Clement Greenberg jitterbugged the night away; of a concert by the youthful Juilliard String Quartet at which Willem de Kooning leaped forward to give the group a black-and-white wash drawing; of lectures by philosopher Hannah Arendt,

sociologist Paul Goodman, composers Edgard Varèse and John Cage, and mythologist Joseph Campbell. Dylan Thomas read his poetry at The Club, and artists as varied as Hans Arp, Richard Hülsenbeck, Fritz Glarner, Adolph Gottlieb, and Harry Holtzman talked about their ideas.

Jack Tworkov was amazed that such an array of talents came to The Club. "Here we learn not only about all the possible ideas in art," he wrote, with some exaggeration, "but learn what we need to know about philosophy, physics, mathematics, mythology, religion, sociology, magic." For a few years into the early 1950s, The Club represented the solidarity of vanguard artists banded together in defiance of an uncaring mass society. No sooner did some of that mass begin to care, crowding into The Club of a Friday evening for an artists' panel or lecture, than the core began to decay. The most successful artists, Pollock and de Kooning, attended less often, and newcomers joined with career benefits in mind. In the end "no one could make a critical remark," gallery manager John Myers recalled, "without self-promoting shouts of 'Name names!' "

The origins of the artists who formed The Club strikingly resemble those of subsequent schools of successful artists. Only three of the twenty-one first-generation Abstract Expressionists were born in New York, while the rest had gravitated to the city from elsewhere in the United States or from Europe. Unlike more recent groups of artists, however, not a single member of this pioneering group had studied art at a university. While a few had college degrees, their art training had been marginal: a few courses at the Art Students League, a stint or two as assistant to a WPA muralist. The fifty-three artists named by art historian Irving Sandler as second-generation New York School had origins similar to those of the first generation: only fifteen were born in New York, and seven were born abroad. However, twenty had studied art at universities, and sixteen had attended classes with Hans Hofmann, himself a member of the first generation.

Since then, colleges and universities have played an increasingly significant part in educating American artists. The backgrounds of artists shown in the 1981 Whitney Biennial

offer provocative comparisons and contrasts. Of the one hundred fourteen participants, only fourteen were born in New York and thirteen were born abroad. Only nine had attended no college, while fifty held an advanced degree: M.A., M.F.A., or Ph.D. Sixty-eight (60 percent) lived in New York, while seventeen resided in California; the rest had homes scattered across the nation. An analysis of seventy-four participants in the 1989 biennial shows a few changes: only ten were born in New York and nine were born abroad. Of the fifty who were college-educated, thirty-two had gone on to advanced degrees, mostly M.F.A.s; twenty of the college-educated came from two institutions: twelve from California Institute of the Arts and eight from Yale University. Forty-seven (64 percent) live in New York.

University education of artists presents a mixed blessing: while offering a broader schooling in humanities, the academic emphasis on the history of art pushes students into creating works that fit into the tradition. Today this tradition includes the hundred-year-old legacy of the avant-garde: shock the bourgeoisie. Instead of communicating feelings or insights into the human condition, academic art courses tend to identify works as a further refinement of a style or a technique that already has a scholarly niche. The built-in support and audience for academicized art diverts both student and teacher from the serious, perhaps fatal, central problem of art in the twentieth century: what is the subject? So both stick to the subject that already has received the sanction of those who count—art itself. Like movies about movies and literature about literature, art about art chews its own tail. Because science plays such a potent role in the university setting, artists on campus cannot simply be mooning about, playing with materials, and exploring ways to express their individuality. Instead, they feel compelled to be pondering a problem, conducting experiments, developing theories. Now that the number of university-based artists has reached a critical mass, it forms a closed system for appreciating, disseminating, and writing about those who work within its system.

The wealth of formal education enjoyed by contemporary

artists would have been unthinkable in the New York art community of the 1930s and 1940s. Nor would the earlier artists ever have dreamed of living away from the city. During the Great Depression, New York was the world for American artists. Held together by the promise of small WPA stipends and protests against the bureaucratic hurdles that had to be cleared to obtain them, the city's artists—abstract and representational, liberal and revolutionary (none was vocally conservative)— were united for perhaps the last time in this century. More than four hundred attended the First American Artists' Congress in 1936, demanding more public aid while also denouncing fascism.

During a decade strident with ideologies, the men who would become America's vanguard artists were moving toward styles of abstract art that were individual and yet contained a common thread. Caught between two dominant movements, the one pressing for provincial Regionalism, the other thrusting toward politically motivated Social Realism, the artists who would triumph increasingly looked inward for inspiration. For ten or more years, as warring ideologies escalated to the outbreak of the Second World War, they debated the future of art among themselves and, in response to a "crisis" they perceived, attempted increasingly bold visual experiments.

Herds of art historians have since delved through the record, attempting to sort out the origins of Abstract Expressionism in New York during the 1940s and in particular assessing the influence of Surrealism. The Americans had read and heard about the French Surrealists during the 1920s and 1930s and also had some contacts with the large contingent of French Surrealist artists and writers who spent the war years in New York. But Harold Rosenberg termed the attempt to trace the American avant-garde to European roots nonsense; the Americans found the Europeans' rigid ideologies unacceptable. "Finally, the only solution for them," Rosenberg decided, "was for each one to begin to develop a spontaneous personal relation to what he was doing and to feel it was hopeless to look for any guidance anywhere." This is why Abstract Expressionism was the beginning of American art, Rosenberg insisted, "because it

was the first time American art didn't look for guidance any-
where."

In addition to sweeping such impressive European art stars
as Fernand Léger, Piet Mondrian, and Max Ernst into New
York, the Second World War vitalized New York's avant-garde
artists. On the most basic level, the war brought an end to a
decade of depression; also, as younger men were drafted, the
artists who were shaping the American avant-garde managed
to stay behind and to establish themselves, at least within the
tiny public then interested in advanced art. A surprising num-
ber of Abstract Expressionists avoided the draft altogether.
Jackson Pollock was deferred when his psychiatrist wrote a
letter testifying to his fragile mental health and in June 1941
was classified 4F because of chronic alcoholism. Pollock's
brother Jay told his roommate James Brooks that "if you want
to become an artist, it's a good idea to stay out of the army."
Rothko, de Kooning, Motherwell, and Kline also stayed home.
Barnett Newman, with typical contentiousness, refused induc-
tion because he was an anarchist. He was ready to kill Nazis, he
argued, but being in the military would make such killing
subject to the orders of a superior officer and thus deprive him
of his personal right to kill. He was finally deferred for physical
as well as political reasons.

So the new artists could benefit from fresh interest in their
work. Cut off by war from the European art they admired,
museum people like Alfred H. Barr, Jr., director of the Mu-
seum of Modern Art, began an earnest search for the new at
home. In 1941 Barr accepted a gift of Arshile Gorky's *Argula*
from Benjamin Davis, and the following year the museum
acquired Gorky's large *Garden in Sochi*. From a 1943 exhibition
at Peggy Guggenheim's Art of this Century Gallery, Barr
selected Jackson Pollock's primitive *She-wolf*. In 1944 he bought
Robert Motherwell's *Pancho Villa Dead or Alive* as well as Mark
Tobey's *Threading Light*. In 1946 the Museum of Modern Art
received Adolph Gottlieb's *Voyager's Return*, and in 1947 it
acquired William Baziotes's *Dwarf*. Barr would often cite these
early acquisitions in refuting charges that he was late in recog-
nizing the new developments in American art.

But if Barr was hesitant, the small band of wealthy collectors and connoisseurs who were at all interested in new art were even less persuaded that a true avant-garde would sprout on native soil. For nearly a century new art movements— Impressionism, Fauvism, Cubism, Expressionism—had risen in Europe, taking decades to reach the New World. Even among the most adventuresome of art insiders, there was little doubt that Europe, especially Paris, would continue to dominate world art after the war ended. Until then these Americans reveled in their close brush with avant-garde art provided by the French Surrealists exiled in New York by the war.

Whatever stylistic cues they took from the Surrealists, the artists later to be called Abstract Expressionists learned a great deal about the Europeans' methods for gaining attention where it counted. One time-honored European tradition was the manifesto. In this subspecialty the Futurists had set the high-water mark with a declaration published in *Le Figaro* in 1909: "Let's break out of the horrible shell of wisdom and throw ourselves like pride-ripened fruit into the wide, contorted mouth of the wind!" F. T. Marinetti had proclaimed. "Daily visits to museums, libraries, and academies (cemeteries of empty exertion, Calvaries of crucified dreams, registries of aborted beginnings!) are, for artists, as damaging as the prolonged supervision by parents of certain young people drunk with their talents and their ambitious wills. . . . So let them come, the gay incendiaries with charred fingers! . . . Set fire to the library shelves! Turn aside the canals to flood the museums! . . . Oh, the joy of seeing the glorious old canvases bobbing adrift on those waters, discolored and shredded! . . . Take up your pickaxes . . . and wreck, wreck the venerable cities, pitilessly!"

Ever since, the writers of manifestos have been much given to apocalyptic shrillness and, alas, to authoritarianism. Typically the organizers of avant-garde movements call for the overthrow of tired and oppressive traditions and then promptly enforce upon their followers their own draconian program. Stalin himself was hardly more staunch in compelling orthodoxy than André Breton, the inventor and ruthless enforcer of

Surrealism. Loosely basing their notions on some ideas of Sigmund Freud (whom Breton visited in 1922, on his honeymoon), the Surrealists believed in teasing out the creativity of the unconscious by suspending the censors of the conscious mind. Automatic writing and automatic painting, dreams and fantasies, accidents, coincidences, and magical congruences fascinated them, along with the avant-garde's by now typical spirit of revolt. Surrealism meant "complete insubordination," wrote Breton in 1930, in his second manifesto. He urged "sabotage according to rule" and expected "nothing save from violence. The simplest Surrealist act consists of dashing down into the street, pistol in hand, and firing blindly, as fast as you can pull the trigger, into the crowd."

During the 1930s the Surrealists were plagued by dissension, much of it brought on by Breton's efforts to enforce political orthodoxy. Their last creative gasp came in 1938 in a sensational Paris exposition. Under a ceiling swathed by Marcel Duchamp with perhaps twelve thousand coal sacks, it featured a perpetual rainstorm in the lobby. There Salvador Dali had created *Rainy Taxi*, a Paris cab in which a slatternly female dummy grinned while live snakes slithered around her. On opening night spectators picked their way with flashlights among unlighted streets named after devils and blood. Periodically a dancer improvised a choreographic spectacle titled "The Unconsummated Act"; elsewhere a loudspeaker hooked to an echo chamber blared German military music. If artists are, indeed, prophets, the exhibition's dead leaves and rank moss on the floor, its decadent exhibitionism, and its desperate clutch at the elbows of a distracted public foreshadowed the end of European civilization.

By the time the Surrealists straggled into New York in 1940 and 1941, their energies were sapped by bickering and the melancholy of exile. Few of them spoke English at all, and Breton, in a perverse fit of chauvinism, refused to learn. The American artists who were to become the Abstract Expressionists were awed by their nearness and began to use mythological titles that suggested their influence. Mark Rothko painted *The Syrian Bull* in 1943 and *Tiresias* in 1944. Adolph Gottlieb created

Eyes of Oedipus in 1941 and *Rape of Persephone* in 1943. Barnett
Newman titled a work *The Song of Orpheus* in 1945. But, unlike
the classical artists who used mythical themes to lend poetic or
philosophical prestige to their works, the Americans were
calling attention to man's primitive, atavistic nature.

Robert Motherwell and William Baziotes contributed to
First Papers of Surrealism, an illustrated anthology of writings
published by the emigrés in 1942. Guided by Roberto Matta,
they tried to form a Surrealist group to rival Breton's and even
hoped to exhibit their work at Peggy Guggenheim's Art of This
Century Gallery. For a brief time Pollock, Lee Krasner, and
Arshile Gorky joined a circle earnestly experimenting with
automatic drawing based on fire, water, or earth. Matta also
tried to get the group to throw dice every hour to see if their
psyches were communicating and to log their thoughts to check
the existence of a collective unconscious. However, Willem de
Kooning refused to join in, Pollock found this discipline too
confining and dropped out, and Matta retreated from efforts to
challenge Breton.

While there is ample evidence of personal contact between
Surrealists and Abstract-Expressionists-to-be, the artistic styles
developed by the Americans show diminishing traces of Sur-
realist influence as their careers developed. But the Surrealists
profoundly influenced how the American artists presented
themselves, their social organization, and the philosophy they
articulated.

That they presented a philosophy at all was new. Manifes-
tos aside, European artists such as Wassily Kandinsky and Piet
Mondrian frequently published philosophical treatises. Amer-
ican artists, by contrast, reflected American pragmatism and
indifference to ideology; in interviews and articles they
eschewed philosophizing and instead dwelled on their work
and lives. All that changed in 1943 when Mark Rothko and
Adolph Gottlieb proclaimed their artistic creed in a letter to the
New York Times: "Art," they declared, "is an adventure into an
unknown world" involving "risks," a world "violently opposed
to common sense." Their role was "to make the spectator see
the world our way—not his way." They favored "the large

shape because it has the impact of the unequivocal" and flat forms because "they destroy illusion and reveal truth." Finally, they attacked as "the essence of academicism" the notion then common among painters that "it does not matter what one paints, so long as it is well-painted." Rather, they argued, "the subject is crucial and only that subject is valid which is tragic and timeless. That is why we profess spiritual kinship with primitive and archaic art."

Spurred by the example of the Surrealists, the Americans thus issued their first manifesto in the grand old European tradition: they proclaimed the revolutionary nature and the exclusiveness of their vision, they challenged the public to accept it, and they denounced other artists who might disagree. Like the Futurists, who had published their manifesto in a leading French newspaper, the Abstract-Expressionists-to-be announced themselves in the leading American newspaper.

Thus began American artists' obsession with media attention. When Mark Rothko had a show in 1945 at the Mortimer Brandt Gallery, he wrote to Emily Genauer to complain about not being reviewed. This is particularly strange since Genauer's reviews in the *New York Herald-Tribune* were notoriously critical of advanced art. Yet even vicious attacks were welcomed. Artists took uncommon delight when Huntington Hartford in 1951 denounced Willem de Kooning's witchlike women with large advertisements in seven major newspapers, headlined "The Public Be Damned."

Other New York artists marveled at the Abstract Expressionists' concerted publicity campaign. "Overnight," remarked Raphael Soyer, "all these people . . . became geniuses and the other artists were neglected. You heard only about these Abstract Expressionists all the time." By postcard, Soyer rallied more traditional artists—Edward Hopper, Ben Shahn, Yasuo Kuniyoshi, Benjamin Rattner, Isabel Bishop, Jack Levine—and they eventually published their own manifesto attacking the Abstract Expressionist group. But, Soyer lamented, the editor of *Art News* accused them of being Communists. After the Museum of Modern Art also threatened to withdraw its support for them, Shahn and Rattner fell away, afraid that their

careers would be damaged. Hopper stayed on, "very honest and very staunch."

The Surrealists had clamored for decades about a crisis of European civilization, and the rampaging Nazis in Europe seemed to validate this dread. To many American intellectuals, the Depression followed by the outbreak of war reinforced Marxist predictions of a crisis within capitalism. While vanguard artists were suddenly made aware of crisis by the war, avant-garde painting and sculpture had been reacting to crisis for more than a hundred years. The waning of aristocratic patronage in the early nineteenth century had thrown the artist into the marketplace to be exploited by dealer and client alike. The rapid development of photography after the 1830s gradually eroded the artist's social role: the camera provided portraits and landscapes galore and the work of the artist became a luxurious frill. Each new wave of technology diminished society's need for the artist's work: the depiction of a face, a place, an event.

Artists responded inventively. The Impressionists used the brilliant new pigments made from aniline dyes to create luscious, misty paintings of bourgeois life. The Fauves and then the Cubists responded to the advent of movies by training their own creative lenses on many viewpoints of the same subject. The Futurists confronted the movies head-on with their imaginative depictions of motion. Moves into total abstraction, such as the Russian Constructivists', asserted that the painting or sculpture itself was the subject. Still, all artists in the twentieth century have faced two critical questions: What is my subject? How can I present it in an original way?

Barnett Newman, chief theorist for the Abstract Expressionists, recognized the search for a subject as the central crisis for midcentury painters. "I had to start from scratch," he said, "as if painting didn't exist." In his quest for originality he needed to move beyond the Surrealist preoccupation with magic, dreams, sexuality, and mythology. "The problem of the

subject became very clear to me as the crucial thing in painting. Not the technique, not the plasticity, not the look, not the surface: none of these things meant that much. For himself and "for all the fellows, for Pollock, for Gottlieb—the problem was what are we going to paint? The old stuff was out. It was no longer meaningful."

Perhaps because he had witnessed Stalin and Hitler plumbing the depths of evil, Newman called this discomfort a moral crisis. The Abstract Expressionists dealt with this predicament by declaring that their subject was the painting itself. Newman asserted that this theme "has more relevance . . . in relation to the real issues involved in human life than all the little things that for hundreds of years everybody was involved in trying to make beautiful. People were painting a beautiful world and at that time we realized that the world wasn't beautiful. . . . We couldn't build on anything. The world was going to pot," he said, with typical apocalyptic gravity. "It was worse than that. It was worse than that."

The matter of subject continues to preoccupy artists, as it must, but by asserting that the work itself is the subject, the Abstract Expressionists opened the door to Postmodernism. Robert Rauschenberg explained that he daubed paint on an old quilt to create *Bed* in 1955 because the quilt "was what to paint on mostly. . . . After you recognize that the canvas . . . is simply another rag, then it doesn't matter whether you use stuffed chickens or electric light bulbs or pure forms." Joseph Kosuth, who began in the mid-1960s to present panels of enlarged photostatic dictionary definitions of words, says his goal is to "question the nature of art." He warns that "unless artists reconceptualize their activity to include responsibility for rethinking art itself, then all that is of value in art will be subsumed by the market." But despite such brave words, Kosuth also relies on the market; he is represented by New York's most prestigious dealer, Leo Castelli.

A 1982 work by the German artist Joseph Beuys presents even more rarefied notions of the artist's subject—and of its value. Titled *Fettecke*, it consisted of eleven pounds of extra-quality butter molded into a corner of Beuys's studio. After the

artist died in 1986, a housekeeper tossed the graying, odoriferous work into the garbage. When an outraged former pupil of Beuys, Johannes Stüttgen, sued the West German state of Nordrhein-Westfalen for damages he won a judgment, in 1989, for $24,000.

"Money should flow through the society like blood through the body," Beuys had told the *New Yorker's* Janet Malcolm during his first New York show in the early 1970s. Actually the show, at the Ronald Feldman Gallery, had nothing in it. When visitors noticed the absence of art, Beuys would ask, "Don't you feel it?" Feldman was moved to explain that "we were the art" and was hurt that some considered Beuys a charlatan instead of, as the artist insisted, a shaman. When a Wall Street newsletter touted the artist as "blue chip, the Picasso of our time," people called the gallery from all over the country, but when Feldman told them that Beuys did not paint, they hung up. Feldman attributed the artist's subsequent success to his acute awareness of the media and public relations "as a means to further his ideas and art. He can handle a cigarette in the course of a conversation so that it becomes like a dance. He knows exactly when the cameras are clicking. He has a hundred different poses," Feldman marveled, "which are absolutely beautiful to watch."

At about the same time, Yoko Ono placed advertisements in several New York art publications for an "exhibition" of her work at the Museum of Modern Art. When people came to view the show, they found only a film crew and interviewer at the museum's front entrance. "How did you like the Yoko Ono show?" the interviewer would demand, while the replies were immortalized on film. So sophisticated is the New York art audience (or so sophisticated the editing of the final film) that most respondents went along with the fiction. "I thought her show was wonderful," said one. "I wished she had shown more things," said another. And a few maintained that they hated the "show," describing in great detail their (mythical) objections to the (mythical) exhibition. But Yoko Ono did eventually get her New York museum show, in May 1989 at the Whitney. The works on display were made in the early 1970s and in-

cluded such Duchampian toys as a (blank) painting to be stepped on, conveniently laid out on the floor, and a painting to be nailed, with the hammer neatly hanging from it on a chain. But the hammer and nails were not quite "ready-made"; they had been cast in bronze. In a theater upstairs, visitors were treated to the film about Yoko Ono's mythical exhibition at the Museum of Modern Art.

Because there are no objective standards of quality in art, originality has become the Holy Grail for artists. In our time it is the only road to success; achieving it, sustaining it, replenishing it challenges—and destroys—many. "An artist may have one surging important mental configuration in him," the dealer Ivan Karp observed, "and he explores it and it depletes. We see artists who push this kind of image over decades." While he feels compassionate and sympathetic, Karp finds the constant demand for innovation damaging to certain artists who are quite fragile. Henry Geldzahler recalled being shocked in the late 1950s when many insiders who admired de Kooning's blazing paintings were "wondering aloud whether next year's show would repeat his success, whether he could consolidate his lead not by painting a beautiful show but by changing in an unexpected and unpredictable way."

Ironically, once an artist arrives at an original style, medium, or point of view, he or she is often chained to that oar for life. It is perilous, not only financially but psychologically as well, to change, to rethink, to explore other ideas. The artist's gallery calls for more works like those that sold so well last time; critics compare perhaps baffling current work with familiar older images; collectors want a target or flag or numbers that say "Jasper Johns," an electric chair or a Marilyn that says "Warhol," even a blankly black square that proclaims "Ad Reinhardt." Frank Stella insisted in 1960, after completing twenty-three almost identical black "pinstripe" paintings in sixteen months, that he aimed for unoriginality and would welcome a machine to paint his pictures. His career, however, demanded

"originality," not only to attract clients to his dealer's shows but also to form the basis for a museum exhibition.

In recent years new art movements have cascaded through the art world with kaleidoscopic speed. The Neoexpressionism of Julian Schnabel, Anselm Kiefer, Robert Longo, David Salle, Cindy Sherman, Georg Baselitz, and others burst upon the scene in 1980; barely five years later *New York Times* critic Michael Brenson, perhaps hard up for a Sunday piece, was asking "Is Neo-Expressionism an Idea Whose Time Has Passed?" While the artists still sold for high prices and attracted crowds to their shows, Brenson discerned "far less sense of expectation and excitement." The movement was "down to a glow," unlikely to hold center stage again. The reason for the movement's speedy burnout, Brenson speculated, might be its meteoric success: massive sales to collectors, exhibitions for these youthful painters at prestigious museums in the United States and Europe, publication of books devoted to individuals and the movement as a whole, extensive media coverage. Capitalizing on success, artists were employing assistants to help turn out more pictures for clamoring collectors and for overly frequent gallery exhibitions. To many of the artists, Brenson noted, "not having gallery walls to fill up every few months is tantamount to suicide."

"Originality is widely taken to be a synonym with creativity," wrote two sociologists who in 1965 interviewed a large group of vanguard artists. They found that aspiring artists were constantly trying to separate themselves from, or even deny the existence of, predecessors or influences. The quest for originality overrides individual styles and has exhausted many competent painters, writes Charles R. Simpson, a sociologist who lived in SoHo as a participant-observer during the late 1970s. Artists worry about their ideas being stolen and "prefer to link themselves only with the deceased." Said one artist: "I paint for art history; anything less is masturbation."

It is difficult not to smile on reading such grandiose state-

ments by artists. However, beset as they are by critics, curators, journalists, and the public to explain the meaning of their work, most artists are sincere though vague about their intentions. If their talents were verbal, after all, they would be writers. Frequently, too, their themes simply elude words. A few artists, however, have spoken so eloquently on their work as to overshadow its content. In recent history the master of memorable prose—the interviewer's dream—has been Barnett Newman. Asked by one journalist about his role as a revolutionary, Newman pointed to one of his gigantic monochrome canvases and replied: "If this painting were understood completely, it would mean the end of all State Capitalism." It was Newman who had rallied the Abstract Expressionists against the Metropolitan Museum's conservative policies in 1950 and had not rested until *Life* magazine took notice of the Irascible Eighteen. Even earlier, as the anonymous author of a manifesto accompanying a 1943 exhibition organized by American modern artists, Newman issued a ringing indictment of "isolationist art." American art, he charged, "is the plaything of politicians"; it was "high time we cleared the cultural atmosphere . . . for the crisis that is here hangs on our very walls!"

There is some evidence that Newman at one point considered devoting himself to art writing. In 1945 Mark Rothko wrote to Newman about possible openings for an art critic at the *New York Times*: Edward Alden Jewell had retired after a long career, and Howard Devree had apparently suffered a second heart attack. Rothko suggested that these developments emphasized "the importance of our conversations about your possible function in the picture." Though the *Times* did without his services, Newman wrote catalog essays for many exhibitions, some of which he also organized, always provocatively arguing for new art. In a catalog essay for a 1946 exhibition of Northwest Coast Indian art, he wrote that "abstract art was the normal, well-understood, dominant tradition" among these tribes. "Shall we say that modern man has lost the ability to think on so high a level?" No sooner did Newman gain status as the Abstract Expressionists' philosopher, however, than he was forced to abdicate and even resented being lumped with the

group. "I do *not* come with a body of beliefs for others," he told
an interviewer in 1954. "I take full and single responsibility for
my work, thoughts, and acts."

In explaining his own work, Newman consistently monop-
olized the high ground. "The present painter is concerned not
with his own feelings . . . but with the penetration into the
world mystery," he wrote early in his career. "His imagination
is . . . attempting to dig into metaphysical secrets. . . . His art
is concerned with the sublime. It is a religious art which
through symbols will catch the basic truth of life which is its
sense of tragedy." Newman's titles—*Onement, Euclidian Abyss,
Profile of Light, Cathedra, Voice of Fire*—also imply the profound-
est subject matter. Despite the objections even of friends like
Harold Rosenberg, Newman insisted on naming the fourteen
huge black-and-white paintings he completed between 1958 and
1966 *Stations of the Cross.*

From his prolific writings and statements, flurries of con-
tentious letters to the editor, and the critical publications of his
friends, Newman emerges as an engaging yet rabbinically re-
lentless propagandist for controversial art, especially his own.
Habitually dressed in sober three-piece suits, he also sported a
walrus mustache, a monocle, and frequently a tweed deer-
stalker cap. At a dinner party he once bragged that he patron-
ized one of the best tailors in America, a man who at one time
had also made suits for Al Capone. Newman had "an authentic
flair for conversation, argument, polemic," wrote gallery man-
ager John Myers. He refused to allow any photos to be taken
while he was painting because "the hard work shouldn't show.
. . . To emphasize the dignity of the human being, art has to go
beyond the manual." Perhaps to lend consistency to his oeuvre,
he also destroyed all the paintings he had done before 1945, an
act applauded by his admiring critic Thomas B. Hess. "History
has been deprived of, or perhaps has been spared, hundreds of
Barnett Newman's paintings of the 1930s, of beaches or straw-
berries, workers or odalisques," Hess remarked calmly, even
though such destruction leaves future scholars without evi-
dence to trace the artist's early development.

Born in 1905 in New York of Jewish immigrant parents,

Newman studied at the Art Students' League while attending
high school and college. After graduating from CCNY in 1927
with a philosophy major, Barnett (who was then named Ber-
nard) reluctantly joined his father's clothing manufacturing
business. The father suggested that within two years Barnett
could earn $100,000, an amount that would then allow him to
do whatever he wanted. Just as the two years were up, the
1929 crash buried Newman's dreams for financial indepen-
dence. With the business failing, the son devoted himself to
helping his father repay his creditors. In 1937 the father suf-
fered a heart attack, and Barnett liquidated the business. Even
while trapped in the garment trade, he discerned philosophic
and aesthetic profundities. "I learned about the nature of plas-
ticity in the cutting room," he would later say, "the meaning of
form, the visual and tactile nature of things: how to take a rag
and make it come to life. I learned the difference between a
form and a shape. . . . I learned that women's clothes are
painting and that men's clothes are sculpture . . . soft sculp-
ture."

Like so many offspring of Jewish immigrants, Newman
cultivated a passion for political radicalism and philosophical
disputation even as he fell away from his religion. At CCNY he
had studied with Morris Cohen, a professor whose philosophy
classes stimulated a generation of New York intellectuals,
among them Philip Rahv and other founders of *Partisan Review*.
In 1933, while unraveling his father's business problems and
also teaching high school art as a substitute, the twenty-eight-
year-old Newman ran for mayor of New York as an anarchist.
To kick off his campaign, he issued a manifesto: "On the Need
for Political Action by Men of Culture." His platform called for
creation of a municipal opera, orchestra, radio station, theater,
and art gallery; streets closed to traffic for cafés; free art and
music instruction; and parks with open forums for speakers.
Almost as an afterthought, he also advocated city ownership of
banks, businesses, and housing. Newman did not expect to be
elected, he modestly admitted to A. J. Liebling in a *New York
World-Telegram* interview; his campaign would serve "merely as
a focal point for a demonstration of the strength of intellectuals

in New York." A society run by artists, he declared, was the only one worth living in, and he denounced the other candidates, including Fiorello La Guardia, then running for his first mayoral term, as "sullen-minded materialists or maniacs who express the psychopathology of the mob-minded."

Throughout Barnett Newman's career as an artist, it was difficult to draw the line between his puzzlingly simplistic works and the bombastic statements he made about them. Unlike Jackson Pollock, whose silence induced others to define his work, Newman challenged critics to dispute his assertions of profundity. This they zestfully did. When he showed in 1949 as part of a group at the Betty Parsons Gallery, Helen Carlson expressed her bafflement in the *New York Sun*. His "mural sized canvas painted an unrelieved tomato red with a perfectly straight band of a deeper red cleaving the canvas neatly in two," she complained, "is as pointless as a yard rule, which at least has the advantage of being functional. Is Newman trying to write finis to the art of abstraction?"

It was not a stripe but a "zip," Newman would huffily point out, and critics obediently accepted his definition, enthusiastically piling up verbiage to elucidate the sublimity of the zip. "The rectangle of the canvas is under continual attack," wrote Thomas B. Hess, "and is continually defended. Its defense is a traditional tactic. Its attack is a radical move. To keep both forces in a vital suspension was Newman's inspired originality." Clement Greenberg, who, like Hess, had been skeptical of Newman's early zip paintings, later suggested that viewers were "color-deaf" if they focused on the stripes. The enlightened whose ear for color was intact, who "look *at* and not into pictures," he wrote, "will be aware of emanations of color and light." At the Cedar Tavern, however, Newman's friends subjected the zip to good-natured mockery. A popular game there was to interpret all paintings as self-portraits of the artist. Newman's single-zip paintings, said one wit, depicted "Barney walking into an elevator and just a split second before the doors close, he turns around and looks at you."

His first one-man exhibition at Betty Parsons in 1950 followed on the heels of the *Life* magazine photo and other

publicity about the Irascibles, but it puzzled his friends as well as most critics. On one wall Newman posted a statement that could only add to the mystery: "There is a tendency to look at large pictures from a distance. The large pictures in this exhibition are intended to be seen from a short distance." Thomas Hess, who would later publish a book about Newman, was unimpressed. He described the artist as "one of Greenwich Village's best-known homespun aestheticians" and the works as "some of the products of his meditations."

After the 1951 show also drew jeers, even from most artists, Newman did not show again for seven years (the number itself drawing a biblical interpretation of seven lean years from Harold Rosenberg). But all through the drought Newman continued to expound volubly on art and life, tossing off enigmatic, witty, and above all irresistibly quotable one-liners. For an article about an exhibition of Abstract Expressionists he organized in 1947, the epigraph had been: "For it is only the pure idea that has meaning. Everything else has everything else." In *Tiger's Eye*, an ephemeral publication that appeared and died after a few issues in the same year, Newman had written that "an artist paints so that he will have something to look at: sometimes he must write so that he will also have something to read." Aesthetics, Newman told a forum in Woodstock, New York, "is for the artist as ornithology is for the birds."

Despite his personal charm and verbal brilliance, Newman's art remained baffling even to insiders. But what he said about it sounded so deep, and the way he said it was so forceful that he gradually won over the most influential writers on contemporary art. Hastening to redress his earlier skepticism, Clement Greenberg wrote the catalog introduction for a one-man show at Bennington College in 1958. The following year Greenberg began his tenure as director of contemporary art for French & Co. with another one-person show for Newman. By then the artist was affecting his trademark monocle dangling over a comfortable paunch and always appeared in public wearing a polka-dot tie or bow tie. Belatedly Thomas Hess confessed a "lapse of taste" in not recognizing Newman's genius and made up for it by writing the text for a picture book about

him. Harold Rosenberg continued to marvel at Newman's "ideological persistence" and found it endearing that the artist's "highly developed skill in disputation" could also "fan out into lawsuits against landlords and 'slanderers.' " Only the "abominable No man" of the New York art scene, Hilton Kramer, dissented; to him, the twenty-nine works shown were "a bore," offering "too little engagement for adult sensibility." Most cutting was Kramer's verdict that the artist showed "a meager level of feeling."

Such bleak judgments of the art hardly dented the flamboyant public image Newman painted with his colorful language. What, one might wonder, could a critic seriously say about massive monochrome canvases featuring a single narrow stripe? Yet Meyer Schapiro, the academic guru of the Abstract Expressionists, was impressed with "how beautifully each painting was made, how the line was straight just where it should be and quivered at exactly the right point and with the correct frequency; how perfectly the colors were chosen and applied; the precision with which the artist executed the corners." Newman himself made much of the craftsmanship involved in his works: the striving to get unsized canvas to accept the paint, the spreading of colors to avoid brushmarks, the layering of many thin coats to achieve "the big radiant effect." Was it the talk or the art that captivated even a skeptical collector like Ben Heller? A hard-bitten businessman then just beginning to collect contemporary art, Heller, too, gradually succumbed to the enigmatic power of these huge expanses of a single color slashed by a single "zip." He had been invited during the early 1950s to view six or eight such paintings brooding over two rooms in Newman's studio on Front Street. "It was a little bit like the emperor's clothes," he recalled. "I looked and the paintings were clearly nothing." When Heller and his wife returned to look again, he found himself "very affected by the works." By the third visit, Heller decided that Newman was a great painter. More than two decades after making that decision, Heller, a man who has no trouble at all verbalizing his views on art, still found himself "beyond the words that we have gotten familiar with to talk about painting."

Newman himself had no such problems. He persisted in substantially the same style of painting for more than twenty years until his death on July 4, 1970. Interviewed on film by Emile De Antonio a few weeks earlier, he still claimed that his work embodied a revolutionary blow against the bourgeoisie. Furthermore, the huge scale of his pictures eliminated "the sense of a painting over a fireplace," he said. Yet scale itself was not just a matter of size, he added with typical perverseness; "it's human scale that counts, and the only way to achieve human scale is content." As so often before, Newman's personality overshadowed his views on painting. "The [film] crew loved Barney Newman, with his monocle and mustache," the directors reported. "Even the camera loved him. He was more American than Miles Standish. . . . We loved his camera presence, his sharp sense of himself, the flash awareness of what he was saying and giving, his pride, his quick anger, his glass of what Annalee [his wife] assured us was water, and one cigarette after the other with his emphysemic wheeze."

The coauthor of this account, Emile De Antonio, had played an important role in launching Andy Warhol's career, first as an agent for his commercial art and then as mentor and chief critic of Warhol's earliest ventures into fine art. As a filmmaker De Antonio was keenly aware of the power of image; of its tendency, in our age of visual glut and complexity, to overshadow substance. "De was the first person I know of to see commercial art as real art and real art as commercial art," Warhol said later, "and he made the whole New York art world see it that way too." As an agent, De Antonio had obtained commercial commissions for Jasper Johns and Robert Rauschenberg, window decorations for Tiffany's executed under the pseudonym Matson Jones. He also introduced the pair to Leo Castelli, who gave them their first exhibition.

Inarticulate and painfully shy, the young Andy Warhol developed an almost pathological attachment to people who were "good with words." De Antonio had written five novels, had taught philosophy at William and Mary and literature at

CCNY, and spoke, Warhol said, "in a deep, easy voice with every comma and period falling into place." So Warhol listened intently when De suggested he become a painter, especially since the agent, just like the art directors Warhol had been working with for years, gave him ideas for subject matter. "You've got more ideas than anybody around," Andy gratefully told him. Rejected at first by Castelli, Warhol was even more grateful when De Antonio arranged for his first show at the Stable Gallery.

In refreshing contrast to the Abstract Expressionists, who so volubly declared the sublimity of their subject matter while covering great expanses with various colored patterns, Warhol made no bones about his lack of inspirational themes. Where Barnett Newman declared that "the self, terrible and constant, is for me the subject of painting," Warhol dealt with the problem of subject by passively allowing the world to suggest themes. He constantly badgered others for ideas about what to paint and on one notorious occasion paid a friend $100 for her suggestion: "Paint money." Nor was Warhol alone in being bereft of subject matter. Jasper Johns was one of many other artists who professed relief at not having to search for a subject; his flags, targets, and other ready-made images, he said, liberated him to work on "other levels." However, Andy Warhol went a step further, a step familiar to anyone who has ever done commercial art. He traced photographs, painted over images projected onto the canvas, and finally printed photos directly onto the canvas and simply colored them in.

Neither Warhol's mundane subjects nor his commercial techniques form the core of his contribution to contemporary art. Rather his innovation lay in his brilliant use of the media to focus on everything about him—*except* his art. Like everything else about Warhol, what he did was not exactly original. But he put a spin on what others had done in a way that propelled him to stardom; his art achieved renown almost as a by-product.

Picasso, who was perhaps the first art superstar, had a fine eye for the telling gesture. There is a story widely circulated in the art world of a visitor who asked him what it is to be Picasso. The artist asked for a dollar bill and signed it, saying, "Now your $1 bill is worth $500. That's what it means to be Picasso." When the center of the art world moved from Paris to New York after the Second World War, American-style salesmanship and self-promotion infused the way artists sold themselves to the public. No sooner did the Abstract Expressionists taste success than their solidarity was shattered by the enthusiastic media courting of Pollock and Newman. In the next generation, Larry Rivers attracted "so much publicity that his existence now seems apocryphal," wrote dealer John Bernard Myers. "This was no accident, since Rivers firmly believes that even notoriety is better than being ignored." By the mid-1960s even a popular writer on art was grumbling about "the self-advertising, self-promoting, self-sensationalizing methods of the artists of the New York School."

Despite such complaints, artists' self-promotion had necessarily been directed at the small, sophisticated, snobbish art world. For Pollock the pinnacle of mass interest had amounted to little more than a picture spread in *Life* magazine and a few paragraphs about the artist, including, of course, "I was born in Cody, Wyoming." Thundering publicity for Barnett Newman meant the likes of an interview in *Art News*, an occasional letter in the *New York Times*, and, at last, an article in *Vogue*. To say that Warhol changed all that is to credit him with excessive foresight and cunning. What had really changed was that the audience for art had vastly grown. It now included a preponderance of poorly educated spectators who found entertainment, social status, and sometimes considerable profits in supporting new art. Influenced by the acute people-orientation of television, many of them approached the work of art through the personality of the artist.

It was the height of irony that the most famous artist of our media-talk-obsessed time was also the most silent and elusive. Who has not seen a film or television interview in

which Warhol teases an increasingly desperate interviewer with
his blinking stare and mumbled monosyllables? Consider this
exchange with the British documentary maker David Bailey:

"What hobbies do you have?"

"I like to make tapes."

"Is that a hobby or an art?"

"Well, I don't think about it that much."

"What do you think about?"

"You mean during the day when I'm working? Did I say
working or waking?"

"Which painters influenced you the most?"

"Dick Tracy, followed by Little Lulu, Sluggo, Dagwood,
and Blondie."

After a good deal more sparring, Bailey mutters, "Oh, this
is a very difficult interview. . . . Who would you like to be if you
weren't you?"

"Jackie Kennedy."

At length, the interviewer is reduced to floundering: "Let's
think, what else, what else, what else, what else?" And Warhol
sweetly observes: "Here I am conducting an interview and
you're asking me why I don't say anything."

As a youngster, Warhol once confided to a friend, he had
learned that when he tried to tell someone what to do, nothing
happened. "I learned that you actually have more power when
you shut up." Patrick S. Smith, who wrote one of the most
perceptive books about the artist, was convinced that Warhol's
silence was a pose and presented some examples of the artist's
witty repartee. But confronting his media persona as well as
his art, every viewer was compelled to project his or her own
vision onto the blank screen Warhol presented. Extremely banal
works such as the multiple *Marilyns*, *Elvises*, or *Maos*, for
example, force each of us to delve for a unique meaning within
our private reservoirs of recollections, fantasies, and feelings
about these subjects. The visual image is just a whispered cue
for triggering a whole spate of personal associations.

The legions who battered their notebooks and tape re-
corders against the flinty plinth of Warhol's aggressive silence
were thrown back onto their own resources. In the face of

Warhol's maddeningly slippery evasions and muteness, those who interviewed him or wrote about his work were forced to project their own views of his intentions onto him. No hunter is more assiduous in attempting to tease out a fresh angle than a journalist sent to interview a famous personality by a TV station or publication. Indeed, Smith wrote, "a survey of art and film criticism concerning Warhol would demonstrate the almost obsessive desire by critics to explicate what the artist signified in his works by means of *their* response to them."

As he appropriated images from the popular media to create his art, so did Warhol appropriate his public persona from elswhere. An important source was Marcel Duchamp, an artist who signed his name to turn everyday objects into art and made aesthetic statements by donning bizarre garb while uttering a few enigmatic words (and sometimes none) in explanation of his work. During the early 1950s, Warhol claimed that he was acquainted with Duchamp, who was then living in New York, and had even played chess with him. Later Warhol bought an exemplar of Duchamp's multiple minature museum, *Box in a Valise*. Warhol then created *Glass—Handle with Care*, which may have been inspired by Duchamp's masterpiece, *The Large Glass*. In 1963 Warhol attended the opening night banquet of Duchamp's exhibition at the Pasadena Art Museum. The show included *Wanted/$2,000 Reward*, a printed poster featuring a photo of himself, of which Duchamp sold many copies during the 1920s. The following year, when Warhol was commissioned to create a work for the 1964 New York World's Fair, the Duchamp poster was a likely inspiration for a notorious series, *Thirteen Most Wanted Men*.

Like Duchamp's enigmatic, provocative silence, Warhol's puzzling muteness evoked an unquenchable passion in his audience to discover what he was *really* like. Unfortunately, Duchamp lived during a time when his posturing attracted interest only in a small corner of the art world, a time before the mass media discovered that artists were entertaining grist for their readers, listeners, and watchers, decades before there were art stars. Publicity about those who seem to shun it—Greta Garbo, for example—appears to whet the public's interest far more

than information about those who court the limelight. The public overvalues fame; to many people, creative work is not really worth doing unless it results in fame. Therefore, Warhol's toying so coolly with fame made him all the more bewitching.

The public also believes that the rich and famous lead endlessly fascinating lives and is always eager to learn the details of their glamorous existence. Since, however, even the rich and famous spend probably 90 percent of their existence on the same humdrum activities as everyone else, journalists are hard-pressed to provide their readers with details of the stimulating remaining 10 percent. To do this, journalists tend to scatter a few croutons of sensational news into a soup of recapitulations, repetitions, and repackaged tidbits from previous (or other people's) reports. Thus the researcher's hunt for fresh news or insights in the measureless dump of media Warholiana can become exceedingly tiresome. It is striking—and one of Warhol's greatest achievements—that his interminable, insufferably boring films convey this texture of real life among celebrities. By including the 90 percent of everyday life that is totally ignored by the media, he comments profoundly on human existence.

At a glance, no two artists could be more different than Barnett Newman and Andy Warhol. While Newman dressed like a banker in three-piece suit and monocle, Warhol favored a street kid's black leather. While Newman endlessly spouted rhetoric on the deep metaphysical meaning of his work, Warhol was monosyllabic, if not mute. Newman was politically involved, while Warhol was not. Newman was a solitary figure, while Warhol cultivated an exotic entourage. Newman painted huge, monochrome abstractions; Warhol churned out masses of silkscreen prints. Newman was aggressively disputatious; Warhol was passive. Newman was cerebral and philosophical; Warhol was instinctual. Newman sought to express himself with originality; Warhol preferred repetitions, even clichés. Newman titled his works grandiosely; Warhol emphasized banality.

Newman favored good taste, while Warhol adored kitsch. Newman said he scorned money; Warhol proclaimed he loved it.

But closer examination reveals some interesting similarities. Both artists had an acute instinct for the temper of their times. Newman was pugnacious and outspoken in an era that prized conformity. Warhol was uncommunicative in an era of florid rhetoric. Countering the dominant sensibility of their time, both artists challenged the art "system." In Newman's day art was serious, and, above all, Newman wanted his art to be taken seriously. In Warhol's time art was just a game, an investment, a toy, no more serious than, say, a Hollywood movie, a Broadway musical, or a rock concert. Warhol seldom commented about other artists, but he felt moved to discuss Newman. "I think Barney went to more parties than I did," Warhol said, "I just don't know how he got around. . . . Maybe he didn't have to work a lot if he painted just one line, so he had time for parties." Warhol also waxed sardonic about Newman's many studios. "Every time I'd go by a building, they'd say, well, Barney has a studio there. . . . Didn't Barney have a studio for every painting he ever painted?" Asked about Newman's spindly "zip" sculptures, the artist who outraged art traditionalists remarked, "Frankly, I never understood how he got away with it."

To Ad Reinhardt, a self-proclaimed radical and lifelong Communist, "the ugliest spectacle is that of artists selling themselves." He had broken with the Abstract Expressionists over what he considered their pandering to success. "Art as a commodity is an ugly idea," he had written. "Art as an entertainment is an ugly activity. . . . Economic relations in art are primitive and ugly. . . . Artists once led less ugly lives than other men. Today artists lead the same kinds of lives as other men. The artist as businessman is uglier than the businessman as artist." Underlining his despair, Reinhardt had obsessively painted virtually solid black canvases for some fifteen years before he died in 1967. Did Reinhardt truly crave obscurity and

the simple life? Or were his caustic ravings simply another device to differentiate himself from the herd? The answers hardly matter. Bitterly as he might excoriate the art scene, his works were bought by major collectors and proudly hung in museums. Alfred Barr called Reinhardt "the conscience of the art world," while the art world affectionately nicknamed him "the Black Monk." To Willi Bongard, a German journalist studying the American art scene, Reinhardt fumed that "the whole situation is whorish." When Bongard asked why he continued to show and sell his somber squares at a gallery, the artist insisted that he did not wish to sell his works but simply made them available. Still, his works have appreciated handsomely over the years, selling for as much as $130,000. Meanwhile, Reinhardt's bitter fulminations about decadence and corruption in the art world have been drained of all meaning by repetition, his vitriol no more than a curious specimen from the past.

The extreme contrast between a Reinhardt and a Warhol illustrates far more than a simple change in art styles. Reinhardt spoke for a sensibility, now antique, that clearly separated high and low culture, the cultivated from the vulgar, the few who had taste from the many who did not. To him fine art was a diamond, while commercial art was coal. Warhol flamboyantly proclaimed their common carbon—and the return to dust that is the fate of all man's creations. In 1966 he was sponsoring the Velvet Underground's garish rock blaring in a rented Polish hall in the East Village. And his campy movie *My Hustler* had a run at the Filmmakers' Co-op. And his helium-filled silvery mylar pillows were floating in rooms decked with cow wallpaper at suave and chic Leo Castelli's gallery. "So now . . . we were reaching people in all parts of town, all different types of people," Warhol gleefully observed. "The groups were getting all mixed up with each other—dance, music, art, fashion, movies. It was fun to see the Museum of Modern Art people next to the teeny-boppers next to the amphetamine queens next to the fashion editors."

Warhol was sure that something extraordinary was happening, and he reveled in it. A few months later he and his funky entourage traveled to Philip Johnson's glass house in New Canaan, Connecticut, to attend a benefit the Menil Foundation of Houston was giving for Merce Cunningham's avant-garde dance group. For Fred Hughes, who then worked for the Menil Foundation and now heads the Warhol Foundation, it was the first close encounter with the bizarre denizens of Warhol's Factory. Hughes had arranged for "a dose of the Velvet Underground" to augment Cunningham's avant-garde dance to a John Cage score for viola, gong, radio, and the door slams, windshield wipes, and engine turnovers of three cars. This was the year that the American pavilion at the Montreal Expo showed a promiscuous mingling of high art and low, which struck Warhol as "an official acknowledgement that people would rather see media celebrities than anything else." Then, too, Warhol found it meaningful that Met director Thomas Hoving, talking about an exhibition of three busts of ancient Egyptian princesses, had called them "the Supremes." So, Warhol exulted, "everyone was part of the same culture now. Pop references let people know that *they* were what was happening, that they didn't have to *read* a book to be part of culture—all they had to do was *buy* it (or a record, or a TV set, or a movie ticket)."

"Whenever I've found that what I'm doing has become pleasing to even one person I have redoubled my efforts to find the next step."

—John Cage
composer

"Any work of art has a phase where it's alive and then it almost has to pass into a museum phase, which is when people have exhausted its function. . . . Then they put it into the back room of a museum. . . . The thing loses its sting."

—Claes Oldenburg
artist

"A good artist has to keep his distance from the art machine, but in the eighties, many were standing right next to the fat in the pan."

—Robert Miller
art dealer

The death of the avant-garde has been announced—with glee or grief—almost since its birth around the middle of the nineteenth century. Indeed, the bohemian artist, the free spirit who flouted middle-class values and lived in poverty because of his need to express himself in innovative ways, may never have existed at all. *La vie Bohème* acquired a name in the last words of George Sand's 1838 novel, *The Last Aldini*. It achieved its most sentimental flowering in Henri Murger's fictional *Scenes of Bohemian Life*, collected in a book in 1851, after appearing in Parisian newspapers sporadically from 1845 to 1849. When Giacomo Puccini's opera *La Bohème* had its premiere in 1896, the drama of struggling artists had been a cliché for almost half a century. After its nineteenth-century heyday, writes one scholar, "the myth of the bohemian artist" enjoyed "an illustrious afterlife of radical chic."

And yet, more than half a century later, the American art critic Thomas B. Hess was crying that "no society (except perhaps the Parisian nineteenth century horrors celebrated by Balzac) has been as cruel and as viciously indifferent to its best artists as ours." Vanguard artists, he suggested as late as 1960, were "under attack by virtually the entire Establishment— mass-circulation newspapers and magazines, museums, collectors, critics, official culture-rollers." After fifteen years of such neglect and, indeed, malediction, the typical painter or sculptor, if not driven mad or "back to his successful cousin's rug business," would be lucky to obtain even a modest livelihood. Only twenty-five Abstract Expressionists were earning the kind of living that a forty-year-old college graduate might expect, and that was merely "a miracle of the individual's perseverance, courage, ingeniousness, wit, and faith, a miracle which daily is greeted by abuse from practically every spokesman of the 'Powers that Be.' "

A few years later, two sociologists who interviewed

twenty-nine successful artists were pleased to report that their subjects were "fully alienated" from the dominant society. The artists repudiated "those values which exalt money, fiercely denying that beyond a necessary minimum of creature comforts it can be used to buy good things." To avoid being alienated from their work, artists *had* to be scornful of their civilization's commercial values, they wrote (and seriously, too). The trouble is that the commercial civilization that artists claim to scorn is ever more rapidly accepting and enthusiastic about avant-garde art. While artists cultivate "an air of intransigent iconoclasm," wrote sociologist Judith Adler, their audience avidly seeks out more and more revolutionary works. "The only tradition to be honored and preserved is the tradition of breaking with tradition."

There seems little doubt that beginning about 1945 American artists have won increasing popular recognition as well as financial rewards. Yet many critics, and less successful artists as well, remained dissatisfied. Artists were pandering to the public and creating work that was merely decorative, said some. Others blamed the gatekeepers—dealers, curators, and critics— for ignoring standards of artistic quality in favor of prestige and financial gain. Slick commercial enterprise, they charged, had replaced a thriving avant-garde, and the result was watered-down, uncommitted art. In 1970 Harold Rosenberg looked back through the rosy glasses of nostalgia to a time when only artists knew who was doing interesting work and who was "phony," before "people began to appear that nobody ever heard of, who were pushed by critics and promoters." Somehow the critic who had been one of the Abstract Expressionists' chief advocates, who had accepted gifts of paintings from them, and who had entertained them in his home on many occasions was dismayed that the newer artists were "inviting to their homes people who would be useful to them in their careers." Indignantly he demanded, "Who the hell had a career in those days?"

Older, successful artists also voiced their disenchantment with the new generation. Barnett Newman deplored four unpainted canvases shown by Robert Rauschenberg during the late 1950s. Although the works closely resembled Newman's

experiments with empty canvas, Newman sniffed that "empt-iness is not that easy. The point is to produce it with paint." Newman's contemporary, Adolph Gottlieb, told an interviewer he grieved that there was no sign of younger colleagues feeling "that they were in the vanguard and in the front line" as the artists of the 1940s did. "It seems to me that most of the artists are young Republicans, although I don't think they would admit it."

Many others were disappointed that the lifestyles of artists during the 1970s reflected their friendly embrace of the com-fortable life. When it came to flamboyant bohemianism, SoHo during the late 1970s compared poorly with yesteryear's Paris or Greenwich Village, wrote one resident sociologist, who was apparently seduced by the bohemia of nostalgic myths. The least successful artists, Charles R. Simpson found, were most likely to "mythologize their alienation." The more successful artists merely nodded toward the bohemian myth by occasion-ally expressing "dry irony" toward the dominant society. "Suc-cessful SoHo artists tend to view flagrant bohemianism as evidence of a superficial artistic talent and commitment," Simp-son found. Indeed, many of them declared their disdain for such posturing by moving to rural areas, especially New En-gland. And so "parts of Vermont," Simpson noted, "remain socially closer to SoHo than does Brooklyn."

By the early 1980s a chorus of critics wondered whether artists' emancipation from poverty and public disdain had been a good thing. William D. Barrett as an editor of *Partisan Review* had watched the Abstract Expressionist avant-garde storm up from obscurity into the establishment and claim powerful sup-porters at museums and universities. But later he was skeptical of such success: acceptance was clearly good for the artists, but, he wondered, was it ultimately good for art? Marxist art historian Suzi Gablik was alarmed that "the vital, fractious spirit and critical intransigence of the avant-garde is evaporat-ing in front of our eyes." The complicated bureaucratic machin-ery of museums, universities, and government grant agencies "preconditions the drive and ambitions of the artists whose well-being it ostensibly exists to promote," she warned readers of *Art in America*. Such a bureaucracy "encourages accommoda-

tion and surrender to our society's predominant values and in so doing it has undermined the very basis of artistic alienation."

If any individual can be blamed for killing off the avant-garde—or, perhaps more accurately, for exposing the hollowness of the concept—it would have to be Andy Warhol, the pale, inarticulate artist in his white wig and, even more importantly, the vast media cocoon in which he shrouded himself. At first blush, Warhol displayed all the trappings of the mythical avant-garde: antisocial behavior; excessive indulgence in mind-altering drugs; bizarre clothing; provocative statements, whether verbal, musical, or visual; associating with social outcasts; attractiveness to youth and to wealthy idlers. Warhol was obviously creating a new aesthetic canon as well, but to the dismay of those devoted to high culture, his innovation mingled in heaps of low trash. They saw him taking over a rare old vintage and willfully blending it with Kool-Aid. As did his private collection, where fine Georgian silver gleamed next to Porky Pig cookie jars, so his art exalted kitsch. The patrician dealer Leo Castelli, who prized his own image as a suave continental connoisseur, tried at first to avoid showing Warhol because his work stank so patently of the back pages of cheap magazines. Castelli rightly feared that Warhol's indiscreet truss ads and dance-step diagrams would drag the gallery's other Pop artists into disrepute. But when a crowd came to the Green Gallery to view—and a few even to pay $250 each for—Brillo boxes, Castelli was persuaded to capitulate. That opened the door to an avant-garde so madly inclusive that sober academics write monographs on the iconography of Minnie Mouse, and, conversely, a half-clad Cher on television shares her insights into the mystery of van Gogh.

The brief, tragic career of Jean-Michel Basquiat illustrated how success based on bizarre behavior could shade quickly into

madness. The artist first came to public attention in 1978 at the age of eighteen via graffiti painted on Manhattan walls. "Pay for Soup, Build a Fort, Set It on Fire," said one. "SAMO for the Art Pimps," said another. *SAMO*, it turned out, stood for "Same Old Shit," a slogan that somehow intrigued art insiders. Within a year Basquiat was a regular at a sleazy East Village bar, the Mudd Club, where he sporadically played with a band called Gray, sold little drawings on the club's matchbooks for a dollar, and peddled "baseball cards" created from color-photocopied photographs. A friend called them "limited-edition type things." One evening Basquiat sold one of the cards to Warhol, who was having dinner with Henry Geldzahler. Not long before, Basquiat had burst into a fashionable boutique and deliberately smeared oil paint onto the carpet and couch before being thrown out. Now, invited to Warhol's Factory, Basquiat slopped paint onto clothing, and the resulting art garb was sold at a boutique on East Eighth Street.

Less than six months later, a perceptive art consultant, Jeffrey Deitch, then working for Citibank, appeared at the dilapidated apartment Basquiat shared with Suzanne Mallouk. She worked as a waitress to pay the rent while the artist covered every surface with little drawings on typewriter paper. The wealthy collectors advised by Deitch began to hear about the wild-looking young man whose hair style veered between a bleached blond mohawk and tangled dreadlocks and whose moods seemed to swing equally wildly. To hear him tell it, Basquiat had escaped from an abusive home in Brooklyn where his father, a Haitian accountant, bullied and beat him. To Deitch and others who stepped in to promote him, Basquiat looked trendy; his graffiti reflected the tropical efflorescence of spray-painted goo affronting the riders of every subway train. To those who bought his early works, people who never rode the subways, his unpredictable daubings seemed worth a gamble, especially now that they were admired by Deitch, Geldzahler, and *Village Voice* critic Peter Schjeldahl. Shown in 1982 in a group called "Public Address" at the Annina Nosei Gallery in SoHo, all of Basquiat's squiggles sold at $2,500 each. Nosei immediately planned a one-person show for the artist and gave

him not just a stipend but a space in the basement of her gallery to do his work. She worried that his considerable consumption of cocaine and heroin might adversely affect his work, but she profited from his feverish output. Nosei would bring collectors downstairs to watch as he simultaneously attacked three or more canvases. Sometimes the artist would turn threateningly toward the visitors, brandishing a wet brush. Despite a downpour, the opening in March 1982 was packed; Jean-Michel refused to come out of hiding in the back room.

Big money showered on Basquiat after a Swiss dealer paid $300,000 for paintings on which Warhol had collaborated. When these works were shown at the Tony Shafrazi Gallery they received lukewarm reviews, and one collector complained that they were part of the history not of art but of public relations. Nevertheless, the values of Basquiat's works soared, and in February 1985 the *New York Times Magazine* showed the artist shoeless on its cover to illustrate the article "New Art, New Money: Marketing of an American Artist." The artist posed defiantly in a business suit, white shirt, and tie, one bare foot thrust aggressively toward the camera. The painting propped behind him shows a ratlike silhouetted head, grinning sharkishly, attached to a vestigial body. A single eye, blankly white, conveys the impression of a vicious newborn.

The article related how, at the age of fifteen, Basquiat was roaming New York city streets, virtually homeless, dropping acid in Washington Square Park. By the time he was eighteen, he was dropping the right names: rasping a file over his guitar strings at the Mudd Club was inspired by John Cage, he said, adding, "We were trying to be incomplete, abrasive, oddly beautiful." By the time Basquiat was twenty-four, his paintings were selling for up to $25,000; Richard Gere, Paul Simon, and S. I. Newhouse owned his works, and so did the Whitney Museum.

Within three years Basquiat's paintings were selling for as much as $32,000. And then, in the spring of 1988, at the age of twenty-eight, Jean-Michel Basquiat was dead, victim of a heroin overdose. Those around him, including the dealers who

profited so handsomely from the artist's work, must have been aware of how disturbed Jean-Michel really was. For six months he had lived in dealer Larry Gagosian's beach house in Venice, California, working hard but also suffering a perforated septum from snorting massive doses of cocaine. He spent lavishly to fly friends in from New York. Once he left six new Giorgio Armani suits in a friend's car and never bothered to retrieve them. In New York he wore designer suits while painting and ruined them, tossed hundred-dollar bills at panhandlers, and insisted on drinking only 1961 Lafite. But many of his other deeds went far beyond what one would expect of a spoiled youngster or a bohemian artist. Jean-Michel often could not distinguish between fantasy and reality and suffered violent mood swings. Once he slashed a roomful of his own canvases. At an uptown gallery opening, he dropped his pants. At a downtown opening, he threw a stink bomb. Yet those who benefited so handsomely from his work and proved so astute in managing his career seemed strangely unconcerned about his obvious addictions and illness.

Even when Basquiat threw food in restaurants, doodled on a wall at the Whitney Museum, left the French pastries stuffed into his refrigerator to decay, and impulsively carted home $10,000 stereo systems, no one closed the money faucet or used Basquiat's earnings to provide him with medical help. He was not even recognized as a dope addict, said his high-school friend Zoe Leonard, after he was dead. Everything he did "was OK because he was an artist," she said. In typical pop-lugubrious style, she blamed "society" for turning artists into stars.

It took almost three months to organize an appropriate memorial service for Jean-Michel. On November 6, 1988, some 220 art insiders in black and leather, in high-top sneakers and colorful hats, gathered at St. Peter's Lutheran Church on East Fifty-Fourth Street to pay sentimental tribute to this troubled young man. On the altar was a large photo of Basquiat and behind it a large painting of two blocky figures with the legend "Nothing to be gained here." Was it for sale? Basquiat's family was absent because, said spokesman Jeffrey Deitch, they were "not comfortable with this whole world." In the crowd were

many who benefited handsomely from their investment in Basquiat's works: collector Ethel Scull; art journalist Ingrid Sischy; Deitch, who had early on promoted Basquiat among his clients; and his dealer, Tony Shafrazi, who had arranged for the opening the following week of a London exhibition of the Basquiat-Warhol collaborations. They were priced at $300,000 each. In eight years the artist had produced perhaps 600 works worth tens of millions of dollars. Shafrazi gushed that the paintings resembled "the dark side of van Gogh." By the spring of 1989 another of his dealers, Vrej Baghoomian, was offering medium-size Basquiats for $150,000 and large ones for $200,000. By the fall of 1989 Basquiat drawings were selling in Paris for as much as $50,000, and paintings brought as much as $500,000.

The lightning bolt of fame and fortune that illuminated Jean-Michel Basquiat's lonely—and in many ways lamentable—success contrasted glaringly with the experience of artists a generation earlier. The Abstract Expressionists finally achieved financial success in the late 1950s, relatively late in their careers. By then, ironically, the Pop artists were already capturing the aesthetic high ground, attracting exhibitions, collectors, and the sanction of museum shows and purchases. The new art stars—Johns, Rauschenberg, Lichtenstein, Oldenburg, Rosenquist—felt no moral qualms about cashing in on fame. "Money is very important to the new scene," wrote Alan Solomon, the organizer of a number of innovative exhibitions at the Jewish Museum. Poverty for art's sake and bohemian ways may have suited artists when their works were selling for $500, he wrote in 1967, but now that the price was more like $5,000, there were "analysts' bills, sports cars, Barcelona chairs, summer houses, travel abroad, custom clothes." By appearances and lifestyle, it was hard to tell the artists from the collectors, a transformation Solomon considered "a blessing . . . [thanks to] cash in the pocket, which got there in the traditional American way, in an open, competitive economy."

The new styles blatantly reflected this bountiful economy. These new artists boldly appropriated images from commercial art and television, and while some observers professed to discern Dadaist spoofs of America's materialism in the likes of Oldenburg's *Soft Toilet* or Lichtenstein's gigantic Ben Day–dotted comics, it soon became apparent that any satirical edge of such works was purely in the eye of the beholder. Before their paintings caught on, many of these artists had supported themselves with commercial art—window displays, billboards, advertising. Now the dam between crass work for peddling products and supposedly pure and spiritual fine art, which in America had never been altogether spillproof anyway, burst in a flood of frank commercialism. The avant-garde, one sociologist noted in 1975, had not just abandoned all serious revolt against the traditional culture; rather, its quest for experiment and innovation had led to a passionate embrace of the enemy.

It was not only the products of the artist that had radically changed, but also the artist's place in society. The art market was forcing the artist as well as the work to become a commodity. In politics and in the business world, the prestige of successful artists lent legitimacy to endeavors remote from the world of creative struggle. Robert Frost read from his poetry at President John F. Kennedy's inauguration, while vanguard artists such as Franz Kline, Seymour Lipton, Mark Rothko, and Mark Tobey for the first time were invited to witness the ceremony. Meanwhile, Picasso's daughter Paloma was trading on her illustrious name to sell jewelry at Tiffany's.

For fear of succumbing to commercialism, the Abstract Expressionists had resisted being named. When pressed, they argued over being called Intrasubjectives, action painters, or even, despite their mostly provincial origins, New York School. But the very success that shattered their solidarity demanded a convenient handle. "Groups self-label when they are ready to enter the art market," observed Barbara Rosenblum. "Economic necessity constrains different painters with individual

approaches to find commonalities in their work." Once given,
the name becomes a handy label, a shorthand for dealers and
collectors, almost a trademark to inspire brand loyalty. But the
name that is such a convenience to art consumers, critics, and
art historians can become an iron grid for the artists. Packed
into a labeled cubbyhole, artists may hesitate to move into a
different style because describing their work will be more
tricky. Too, all sorts of diverse talents get tossed into a catchall
category, such as New York School, while individualists who
can't possibly fit simply get passed by. "The moment you label
something, you take a step," Andy Warhol noted. "You can
never go back again to seeing it unlabeled." Driving across the
country to Los Angeles in 1963, Warhol saw Pop Art every-
where. "Once you 'got' Pop, you could never see a sign the
same way again. And once you thought Pop, you could never
see America the same way again."

By the 1980s, whole firms of prestigious lawyers and accoun-
tants were specializing in handling artists. "From a legal stand-
point, being an artist is like being part of an industry," ob-
served one such legal specialist, a man who had been one of the
lawyers representing the heirs of Mark Rothko in their sensa-
tional suit against Marlborough Gallery in the late 1970s.
Though almost all successful (and some not so successful)
artists were represented by dealers, a French sociologist of art
noted that some of the most famous painters were spending the
better part of their professional lives "traveling, making per-
sonal appearances in the appropriate circuits, and generally
promoting revolutions and counter-revolutions in order to in-
crease sales of their works." Such changes in the lives of
artists, he soberly concluded, "alter the meaning of the distinc-
tion between 'art for art's sake' and commercial art."

Eli Broad, a Los Angeles collector and founder of the Mu-
seum of Contemporary Art there, is among many who believe
that the current "overheated" market for art is detrimental to
artists. In the mid-1980s, he says, when Lichtensteins were

selling for $100,000, the artist had a handsome income and could do whatever he wanted. "But when his works sell for more than $1 million each," says Broad, "he has to spend a lot more time with lawyers and accountants." While he does not think that high prices lock an artist into a salable style at the cost of experiment, Broad suggests that expensive artists do produce fewer works. Jules Olitski also believes that art stardom is no blessing, especially when it strikes painters too early in their careers. Long years of obscurity "when nobody is looking" allow an artist to develop "the habit of fooling around and trying things. It's hard enough to take risks if you feel you have something to lose. And it's that much harder when success comes about the same time you've begun to shave."

Anthropologist Lewis Hyde poignantly describes the dilemma of the dedicated artist in the face of the cash-conscious structure of his calling. "The artist who sells his own creations must develop a more subjective feel for the two economies [creation of art and the marketplace] . . . and his own rituals for both keeping them apart and bringing them together." While creating works he must be true to his own gifts; while selling them he must assess their value in terms of fashions and demand and be able to part with them when someone pays the price. "He must create for himself that gift-sphere in which the work is made, and only when he knows the work to be the faithful realization of his gift should he turn to see if it has currency in that other economy."

Idelle Weber has been struggling to maintain her balance on this tightrope since 1956, ever since one of her drawings was selected for an exhibition at the Museum of Modern Art. Then twenty-four years old, she left Los Angeles for New York. Her career since then looks like an unbroken success—participation in sixty-one group exhibitions, fifteen solo exhibitions at important galleries, some eighty-two articles about her work or reviews of her shows. Weber's paintings are in many corporate collections, including those of Chemical Bank, Metropolitan Life, Becton Dickinson, Pacific Bell, and Merrill Lynch. They

also have been acquired by major museums: Yale University Art Gallery; Brooklyn Museum; National Museum of American Art, Washington, D.C.; Nelson-Atkins Museum of Art, Kansas City; Albright-Knox Art Gallery, Buffalo; Metropolitan Museum of Art.

"A very special artist," wrote Theodore F. Wolff in the *Christian Science Monitor* in 1985, "whose evolution has been consistent and fascinating to watch, and whose dedication, imagination, and talent make her more than worthy of inclusion in the small but exceptional band of painters and sculptors who are bringing dignity and respect to the art of the eighties." The glossy red folder Weber has assembled as a résumé holds many such glowing reviews and also a number of expensive catalogs from recent shows, with lavish full-color illustrations.

With all this recognition, with steady sales at steadily rising prices, Idelle Weber should be riding the crest of euphoria. She lives with her husband, a successful attorney, in a luxurious SoHo loft and spends three days a week at Harvard, where she is a professor of visual and environmental studies. Compared with most other artists, Weber has done inordinately well, so why is she troubled? "The market is so big," she says, "you must produce so many pictures, you have to work all the time. And show at least every two years."

To produce enough work for such a schedule, Weber must have an assistant and spend weekends in the studio. Although her work over the years has moved from Abstract Expressionism through Pop and Photorealism to her current large-scale flower and garden paintings, she finds it hard to pursue new inspiration because "once you have a successful style, dealers and collectors don't want you to change." Meanwhile, she feels driven to pursue every chance to publicize her work; she was eager to leave her snug studio on a beastly, rainy afternoon to be interviewed for this book. "Sometimes I wonder what I am doing," she said wistfully. "I don't have the stomach for it."

During the 1960s "life was fast and fun," Pop artist James Rosenquist recalled. His daily routine was to wake up with a

hangover at about 10:00 A.M., paint all day until about 5:00, then rent a tuxedo for a long night on the town: "Going up to 57th Street to an opening, going up to the Jewish Museum to Rauschenberg's opening, or somebody else's opening, or my own opening, then going out, staying out till one or two in the morning, waking up with a hangover, working the next day, renting another tuxedo . . . (or keeping the same one), going out again—every night of the week. Sometimes I was invited to three dinners at a time."

This was a way of life Rosenquist had never dared to dream about. He had arrived in New York from Minneapolis in the mid-1950s and supported himself by painting billboards and creating window displays for Bonwit Teller. "Young, unknown artists felt they didn't have a chance," he said, "when they saw someone like de Kooning walk down 57th Street in an old Levi jacket and bedroom slippers, looking very poor. If *he* wasn't doing well, how could a lesser-known artist expect to do well?" In 1958 Rosenquist was stunned when a de Kooning sold for $14,500, the highest price ever for a living American's work. He was even more astonished to learn that Metropolitan Museum curator Henry Geldzahler and art dealers Ivan Karp and Richard Bellamy were actually prowling through dilapidated loft neighborhoods in search of new artists. Though Rosenquist's résumé no longer mentions his first exhibition at Bellamy's Green Gallery, the artist whose works now sell for upwards of $300,000 recalled his delight at seeing collectors buy his works at $350 to $1,100.

That Rosenquist related his sentimental reminiscences of the glorious bad old days at a series of artists' workshops in 1981 called "The Business of Art" itself indicates how much the art world had changed. The all-day sessions in New York, Washington, and Chicago were jointly sponsored by the National Endowment for the Arts and the Small Business Administration and attracted such crowds that a repeat workshop had to be scheduled in New York. Successful artists shared their experiences while dealers, attorneys, and accountants gave insider tips on how to seize success by the tail. The dealer Ivan Karp archly described the artists' dream: "Fame and fortune, preferably as soon as possible and hopefully before they are

forty." On the way to this goal, the artist wants to be shown "in a clean, elegant space . . . populated by rich, intelligent collectors, enlightened art critics and museum officials, and presided over by a brilliant and generous art dealer." Karp's ironic tone made it clear how few in his audience could expect to realize such fantasies.

Then dealer after dealer from various parts of the country worked out the grim mathematics that would deprive most of those in the audience of even a single one-person exhibition. Most galleries, it turned out, sponsored ten or twelve exhibitions each year, which were almost always dedicated to artists already in the stable. They devoted even occasional group exhibitions to artists they already knew or who were recommended by artists they knew. Most galleries, in fact, don't even look at new artists' work, since they have no time in the exhibition schedule to show them. Nevertheless, dealers in city after city reported that artists came by or telephoned almost daily in an effort to show their work.

Advice in the tradition of Fuller Brush foot-in-the-door salesmanship came from John Dowell, a professor of printmaking at the Tyler School of Fine Arts at Temple University, who also teaches a course on the business of art. He advised artists to "make it easy for the dealer to like you and do business with you." To prepare for interviews, an artist should practice confidence-building exercises such as looking in the mirror daily while saying, "Why of course, there lies genius." The artist also should practice his or her verbal presentation at home and deliver it in a "continuous flow," Dowell advised. "Eye level and eye contact are crucial."

Artists who have difficulty confronting their genius in the mirror can turn to a new breed of professional, a career adviser, such as Walter Wickiser. He is a serious young man in a sober navy-blue suit, white shirt, and narrow tie. He arrived at his present career in 1977, when he started marketing the works of his father, Ralph Wickiser, a longtime teacher at Pratt Institute and author of several popular textbooks in art educa-

tion. The son, a graduate in business administration from Indiana University, turned to the Yellow Pages and began to take slides of his father's work around to galleries he found listed there. He also visited dealers in other cities. "After a while, I realized that I knew a lot more than most people about how to market artists." That was when he started placing small classified ads for his services in *Art News* and *American Artist.* "It's not just for the money," Wickiser says of his consulting. "I like to help artists." His biggest obstacle, he says, is the sheer number of aspiring artists. He estimates that there are seventy thousand in New York alone, "so the averages are very much against success." Yet his small advertisements in art magazines attract a steady flow of hopefuls. In the initial two-hour session (at $35 per hour) Wickiser typically spends the first half hour to "find out where they are" and the rest of the time giving them a year's program to further their careers. "I tell them they have to spend at least two hours every two weeks working to become part of the art world. And they have to do that for the rest of their lives." He smiles indulgently. "Some do it and succeed. Others do it for a while and quit. There are all degrees of success." To him, success means selling enough work to paint full-time.

While Wickiser does not advise clients on their artistic style, he feels constrained to mention that representational work is easier to sell than abstract work. "There are more outlets," he explains. He is also realistic about how far talent alone can go. "Knowing people is as important as anything," he says. "Dealers are afraid to stick their necks out, so good artists get turned down." Dealers also favor artists with a following, friends or collectors willing to buy from a show. Some artists are so anxious to show that they share the costs of an exhibition with a dealer, which could come to $5,000. "Money comes first," he says. "An artist has to realize that art is a business. There are rents to pay and many other expenses—and that's when art goes out the window."

Probably most artists today dwell more or less happily in the unpublicized no-man's-land between abject failure and glitter-

ing success. One of them is Robert Kaupelis, who retired in 1988 after a thirty-two-year career teaching art at New York University. Now he relishes painting full-time. He is shown regularly at Circle Galleries, a nationwide chain of commercial galleries, and sells regularly at prices beginning around $1,000, but good sales cannot possibly keep up with his prodigious output. "I have no plans for the next show," he says, "no particular assortment I expect to do. I don't do series. I just get up every day and make a painting." Although he loved teaching and has written several successful books on how to draw, retirement has enabled him to indulge what can only be described as a blazing passion to paint. While his teaching colleagues complained that they were exhausted by the classroom, Kaupelis would finish a night class at 10:00 P.M., commute home for two hours, paint for two hours and be back at NYU the next day for a 9:00 A.M. class. "I *must* paint every day. I never go to bed without doing at least a drawing or two. I feel *guilt*," he grimaces at the thought, "if I don't do it."

Kaupelis knew in kindergarten that he would be an artist, he says. "I was always the class artist and achieved my mature style in fourth grade, maybe fifth." In the upstate New York town of Amsterdam, where he was raised, the teachers' concept of art was Christmas cards and magazine covers. "I never saw a painting before I went to college," he says. "There I heard about something called modern art. I didn't know what it meant." After graduating, he married and lived in a trailer while teaching art in a K–12 district in Allegheny, New York. "I painted in the living room after school and put the finished things behind a couch," he recalled recently. "Pretty soon the couch was pushed out into the middle of the room, with all those pictures behind it." Since those days, Kaupelis has persisted in his daily painting stint and now works in two studios: a cluttered loft above a barbershop near Penn Station in New York and a new studio attached to his home in Yorktown Heights in northern Westchester County.

At both places he follows a similar routine, usually working on three paintings at one time. The lean times taught him thrift, and he still carefully husbands materials. He spreads a couple of sheets of top quality paper at the foot of his two

easels in the New York studio and starts new paintings on them with pigments left on his brush after applying what he wants to the canvas. "Here, I already have this great cadmium red on the brush—it costs $20 for a jar—so I use the rest on the paper; I destroy the virgin paper. Then I already have something there, so I can work on it some more later." He works on all three paintings at the same time, moving them all along. "But then after a while I'm finally concentrating on just one, and I finish it." Then he dates it on the back, gives it a name, and enters it in a log. The current log began on August 18, 1970; as of March 1989 he had listed 3,366 works in it. "Not much," he comments dryly, "compared to Picasso or Matisse."

Kaupelis builds his own stretchers and uses every scrap of wood, "so the size of the wood determines the sizes of my pictures." He also uses up all paper, creating small paintings, sometimes only two- or three-inch squares on the trimmings. These, he says, sometimes take as long as five-by-six-foot paintings. Forced to classify his work, Kaupelis would describe it as Abstract Expressionist, but such labels mean little in his scheme of things. Expressing his compulsion to paint is what counts. "The work of an artist," he says, "is to make art. If he's lucky, someone will show it. If he's really lucky, someone will even give him money for it."

Pia Stern has been working for thirteen years as a waitress, the last seven at Berkeley's fashionable Chez Panisse restaurant, to support her love of painting. Now thirty-eight years old, she has regular shows at one of San Francisco's best galleries, and prices for her work are rising above the $10,000 level. She can look back with some detachment on the horrendous climb to moderate success.

In the fall of 1973, when Stern was in her senior year at UC Berkeley and headed for law school, she took a class in painting, the only course that would fit into her schedule. She put one bold blue stroke on her first canvas, a three-by-four-foot expanse, "really too big for a first one," she says. "It

sounds corny, but I started to cry. I felt I'd gotten my tongue."
Law school forgotten, she became totally obsessed with paint-
ing and went on to get an M.A. and M.F.A. at Berkeley in two
years. Then she was out on her own, holed up in a dingy
apartment in a violent red-light neighborhood in Oakland. "It
was horribly depressing being deprived of daily feedback and
guidance," she recalls. At school she had won grants and fel-
lowships; now she was alone, working as a waitress and won-
dering why she felt driven to push on.

A year out of graduate school, she was asked to join a local
cooperative gallery. When a local critic or two mentioned her
name, she was buoyed up for months, even though dealer after
dealer riffled through her expensive slides, held a few up to the
light, and muttered, "Not for us." There are thousands of
artists in the Bay Area, says Stern, and only thirty or so real
galleries. Her first break came in 1984, when Anna Gardner
agreed to give her a one-woman show at an obscure gallery in
Stinson Beach. Transporting her work to the remote beach
town was "an odyssey," says Stern, as she and a boyfriend
wrapped up the paintings in plastic and duct tape before load-
ing them aboard a rented horse trailer. It broke down on the
way during a terrific rainstorm, but the exhibition attracted a
few more friendly reviews.

A year later Stern was showing at the Jeremy Stone
Gallery, one of the best in San Francisco. Prices ranged from
$1,200 to $1,800, and only two pieces sold. At her next show,
in 1987, the pieces were larger, prices had doubled, and almost
everything sold. Locally there was one favorable review, then
Art News mentioned Stern as one of only two California artists
that critics were watching. At her 1989 show the paintings
were still larger and prices doubled again, ranging from $5,500
to $10,000. Stern now is also showing at the Esther Sachs
Gallery in Chicago and is considering representation in New
York.

Stern has no plans to leave the Bay Area, however, and
happily spends more time in her studio, painting. She works
steadily, always on one canvas at a time. "My soul is connected
to it," she says. Describing herself as "a drone . . . constantly

wrestling with it," Stern also admits that 1989 was the first year she saw her gift "as a blessing, not as a curse or an addiction." She still wonders whether she is tenacious or stupid. And the struggle continues; to make ends meet, she still has to work in the restaurant two days a week.

While the vast majority of artists resemble Robert Kaupelis and Pia Stern, steadily building up an oeuvre in relative anonymity, the public continues to focus on the small minority of art stars. These are crassly described by a former takeover lawyer, Martin S. Ackerman, in a handbook for art investors, *Smart Money and Art*. He cites Frank Stella and "curtain raiser" Christo as being particularly knowledgeable about "the game and the players. They are not afraid to spend their own money on their careers," he writes. "They understand that art is a business and to be in the art business you have to be a businessman as well as an artist." Unlike artists of an earlier generation, who sold their work at low prices in order to survive and become known, artists like these never sold their works cheaply and instead supported themselves with grants or commissions. Their reward has been rich: "cooperative apartments, studios both in New York and in the country, money for travel and funds to participate in the art world networking games—all essential for keeping their names and their art before both the collecting and institutional public."

The artist's drive for material success has become inextricably intertwined with the creative process of making art. And the art often shrinks in the giant shadow of the artist's personality. "Even the smart new breed of artist who has gone to the right schools, has made the right friends, who knows the ropes to climb and the strings to pull, focuses his art to the salable and intriguing," wrote Stuart Greenspan in the most market oriented of art publications, *Art & Auction*. Artists want to do work that is challenging, "but not so much as to turn off . . . collectors, the growing hordes who line up to buy the latest art as if they were waiting to purchase a ticket to a Madonna

concert." Despite all the excitement, Greenspan discerned "a very conservative time."

It seems paradoxical that vast media attention and unparalleled financial support for artists could lead to conservative work. But this should be no surprise when the public spotlight falls on the artist, not the art. In the late 1960s two art historians declared that "for long-term results, there is nothing like the artist as a public personality." Unwilling, indeed unable, to assimilate an artist's work, the public demands someone who looks and acts like an artist. "The element of outrage attracts publicity and publicity attracts buyers." Peter Selz, art history professor and museum curator, recently told of an artist whose accountant advised him "to dress more like an artist and to develop a form of eccentricity that would [however] not be threatening to the contractual relationship between himself and the gallery director."

Pursued by the media, adored by the public, their works bought by collectors for unheard-of sums, art stars can develop self-destructive levels of arrogance. When Robert Rauschenberg, for example, recently threw a party to celebrate publication of a book by his friend Billy Klüver, he wore blue flip-flops to greet guests. Those who expected to see some of Rauschenberg's formidable hoard of Jasper Johnses and Cy Twomblys were met at almost every door in the apartment by hand-lettered signs reading "Do not enter. Alarm is on." Rauschenberg was the artist who in 1973 physically attacked a collector after he had made a tidy profit by auctioning off some of Rauschenberg's works.

"Business is the step that comes after Art," was one of Andy Warhol's most memorable observations. "Being good in business is the most fascinating kind of art."

3

ARBITERS:
KITSCH FOR BEGINNERS

For some twenty years beginning in the early 1940s, Clement
Greenberg was the most influential art critic in America. He
taught a generation not only how to look at art but also how to
talk about it knowingly and, above all, judgmentally. His re-
lentless and often solitary drumbeat accompanied the Abstract
Expressionists on their triumphal march to prominence. He
articulated their achievements while developing a vocabulary
that firmly tied their work to the grand progression of Mod-
ernist experiments in art stretching back to the nineteenth
century.

A master of persuasive prose, Greenberg dispensed ver-
dicts on the work of a vast array of artists with the majesty of
a Renaissance pope. To compare him with a rabbi, however,
would be more apt, for the explanation of his success lies as
much in the ethnic, political, and cultural composition of his
audience as in the cogency of his arguments.

Clement Greenberg was born in 1909 and grew up mostly
in the Bronx, the eldest of three sons of Jewish immigrants
from Lithuania. Like many of these newcomers, Greenberg's
parents substituted socialism for their religion but remained
culturally attached to Judaism and spoke Yiddish at home.
Clement Greenberg himself remarked that "a quality of Jew-
ishness is present in every word I write." The Talmud, he
wrote, was "something a Jew got into his bones without ever
having read . . . [it]."

Like many art critics (Thomas B. Hess, Dore Ashton, and

Elaine de Kooning come to mind), Clement Greenberg had some pretensions as an artist, attending the Art Students League after obtaining a B.A. from Syracuse University in 1930. His father had meanwhile found modest success manufacturing metal goods and tried to interest Clement in a wholesale dry-goods business, which failed soon after the 1929 crash. Clement then spent at least a year reading at home and also taught himself enough German to apply for work as a translator. He then won a federal civil service job, a great prize during those bleak Depression times, and in 1937 began writing for magazines during long idle stretches at his office in the Customs Service of the Port of New York.

Greenberg's essay "Avant-Garde and Kitsch" brought him instant recognition as a perceptive observer of American culture. It was published in *Partisan Review* in 1939 and widely reprinted thereafter and was responsible for showing a whole generation of (mostly) New York intellectuals how to distance themselves from that complex of profitable, popular, ubiquitous, and contemptible cultural artifacts called kitsch.

In muscular, often strident, prose Greenberg condemned kitsch as an insidious succubus. It feeds on "a fully matured cultural tradition whose discoveries, acquisitions and perfected self-consciousness . . . [it] can take advantage of for its own ends," he wrote. "It borrows from . . . [this tradition] devices, tricks, stratagems, rules of thumb, themes, converts them into a system and discards the rest. It draws its life blood, so to speak, from the reservoir of accumulated experience . . . which [is] then watered down and served up as *kitsch*."

Like Beelzebub himself, kitsch "is deceptive," Greenberg admonished. "It has many different levels and some of them are high enough to be dangerous to the naive seeker of true light." He then cited *The New Yorker* as a particularly satanic example of "high-class *kitsch* for the luxury trade," converting and diluting avant-garde material for its own diabolical uses.

Greenberg probably learned his contempt for kitsch in the Jewish immigrant home and neighborhood of his parents in the Bronx. Alienated from their cultural roots and their religion, bereft of formal education, these immigrants harbored little

more than idealism in their intellectual baggage. But for their
children they wanted only the best, and they scorned popular
culture, kitsch, as contributing nothing to the intellectual life.
Clinging to arduous and often marginal jobs or small busi-
nesses, they poured their own ambitions into their children. As
a community, influenced by folk memories and the age-old
reverence of Jews for the Word, they highly esteemed the world
of ideas and literature. In fact, these particular immigrants
sired a robust generation of writers and thinkers, among them
Saul Bellow, Irving Howe, Alfred Kazin, Lionel Trilling, Del-
more Schwartz, Daniel Bell, and Irving Kristol. But while
Jewish writers trace their articulateness back to biblical times,
the taste of Jews in the visual arts was stunted at best. Jewish
artists, perhaps because of religious strictures against graven
images, have flourished only in the twentieth century.

In his essay on kitsch and in other early writings, Clement
Greenberg himself dealt mostly with literature. It was only
after his return from a stint in the Air Force, during which he
read through the works of that quintessential patrician Henry
James, that Greenberg began to write frequently on art. Per-
haps to differentiate himself from the pack of first-generation
Jewish literati then teeming around such New York–based pub-
lications as *Partisan Review*, he contributed regular art reviews
to *The Nation*.

Still, the tone of Greenberg's criticism resembled the pre-
scriptive, even doctrinaire, style popular among his cohorts in
literature—strong opinions with a moralizing edge that often
verged on pontificating. The five-thousand-year-old tradition
of disputation on the Talmud was transmuted by them into its
secular shadow. They replaced the religious cosmos questioned
or even abandoned by their parents with a Marxist system in
which the mills of history, rather than those of the Almighty,
ground majestically to their scrupulous ends.

The search for an overarching system pervades all of
Clement Greenberg's writing, whatever the subject, and Marx-
ism at first seemed apt. Industrial capitalism rampant is the
cause of kitsch, he tells us, displacing the handicrafts, seducing
the "native of China, no less than the South American Indian,
the Hindu, no less than the Polynesian . . . to prefer to the

products of their native art, magazine covers, rotogravure sections, and calendar girls."

Having sided with the anti-Stalinist, leftist intellectuals who founded *Partisan Review*, yet soon despairing of finding aesthetic enlightenment in Marxist doctrine, Greenberg gradually filled the ideological vacuum with a home-brewed system of beliefs. His comments on specific artists and exhibitions float in a rich soup of positivism, formalism, and historicism, seasoned with just a dash of timely xenophobia.

"Modernism," he would write, "is not an option for art in our time, but an ineluctable imperative." And when the Abstract Expressionists burst upon the New York art scene in the late 1940s, Greenberg hastened to incorporate what looked like a sharp break with tradition into the logical development of painting. Having championed Jackson Pollock from his first exhibition in 1944 as the best painter of his generation, Greenberg in 1946 noted that Pollock "submits to a habit of discipline derived from cubism." Barely six months later, in a review of School of Paris paintings at the Whitney, Greenberg was already proclaiming that "the main premises of Western art have at last migrated to the United States." And he gave reasons based in history: "The alienation of Bohemia was only an anticipation in nineteenth-century Paris; it is in New York that it has been completely fulfilled." He was referring to the ordeals of cold-water flats and Depression poverty endured by most of the Americans now tasting their first success.

So anxious was Greenberg to fit this new American art into an inclusive system that he often ignored the artists' own intentions. Thus, although Franz Kline denied that he used color for expressive reasons, Greenberg asserted that the calligraphic black and white slashes in his first one-man show of abstract work, in 1950, were an "extreme statement" of the color values present in all painting since the Renaissance. He deplored the concern of many Abstract Expressionists with the spiritual side of their art. By 1955, despite their denials, Greenberg was rejoicing that painters like Rothko and Gottlieb had finally rid themselves of such sentiments and significantly advanced toward "pure painting."

As he waded enthusiastically among freshly graven images,

so Greenberg seldom hesitated to batter the more established
gods. In 1946 he compared Gauguin with socialism in Russia,
both cases "of premature and uneven development." Often,
Greenberg found Gauguin's pictures "noisy; the brilliant hues
and the spectacular contours strike us . . . without coherence or
dramatic unity. And, frankly, Gauguin does not draw well
enough." Because artists such as Stuart Davis and Alexander
Calder failed to realize his historical inevitabilities, Greenberg
suggested that society assign them "fixed, exactly defined tasks
that require them to fit their cheerfulness and discretion into
the general decor of modern life." As for Edward Hopper, his
"second-hand, shabby and impersonal" approach made him a
bad painter.

Like a fastidious rabbi guiding his congregation, Green-
berg often honed his reviews to a moralistic edge. After flaying
Georgia O'Keeffe's work as "pseudo-modern . . . little more
than tinted photography," for example, the critic then lam-
basted the exhibition's organizer. "That an institution as in-
fluential as the Museum of Modern Art should dignify this
arty manifestation with a large-scale exhibition," he wrote, "is
a bad sign."

Greenberg began writing on art just when the intellectu-
ally oriented sons and daughters of the Jewish immigrant mi-
lieu hungered for guidance through the confusing, baffling,
newly revealed world of avant-garde art. Their tradition had
always valued literature, and therefore, like Clement Greenberg
himself, they had little trouble in assimilating the classics and
assessing the avant-garde. In cases of doubt, critics such as
Lionel Trilling and Alfred Kazin stood as reliable guides.

But to these aspiring culturati, the world of art was a
foreign planet, a realm where old money presided over hushed
museum galleries and faultlessly tailored aesthetes handled
precious objects with slender, manicured fingertips. Moreover,
Jewish sages had for millennia interpreted the Second Com-
mandment ("Thou shalt not make thee any graven image . . .")
as a total taboo on painting or sculpture. Only in the nine-
teenth century did a few assimilated Jews begin to take an
interest in the world of art as collectors or scholars, and only
with the turn into the twentieth century did a scattering of

Jewish artists (Modigliani, Chagall) emerge. Then, suddenly, near the middle of the twentieth century, art joined literature and philosophy in the curriculum of cultivated Jews. In the pages of *The Nation* and *Partisan Review*, many now sought authoritative guidance on visual aesthetics. And Clement Greenberg, like a secular rabbi, supplied it.

A great tide of interest in art washed across the entire United States at this time, sweeping non-Jews as well into galleries and museums to look and to wonder. In reading art critics such as Greenberg (and his cohort and arch-enemy Harold Rosenberg), this new art audience enrolled in an informal cram course not only on contemporary art but also on Rembrandt and Renoir, Michelangelo and Miró. Furthermore, such critics provided a vocabulary for expressing sophisticated aesthetic opinions. But New York, with the Museum of Modern Art, the Guggenheim, and the Whitney, not to mention a growing number of adventuresome galleries, was clearly at the epicenter of the wave.

Far from welcoming Americans' newfound interest in art, Clement Greenberg saw cause for alarm. "The middle class in this country is now surging toward culture under the pressure of anxiety, high taxes and a shrinking industrial frontier," he warned readers of *The Nation* early in 1946. Greenberg considered it positively dangerous that art was becoming newsworthy in popular magazines such as *Time* and *Life*. "This state of affairs constitutes a much greater threat to high art than *kitsch* itself. . . . Given the temptations of attention and money, even the best of artists find it difficult amid the present confusion of standards not to surrender to Mr. Luce."

For artists facing this crisis, Greenberg stood ready, like the quintessential Jewish mother, with sound advice. William Baziotes "will become an emphatically good painter," Greenberg wrote about the artist's first one-person show in 1944, "when he forces himself to let his pictures 'cook' untouched for months, before finishing them." For Robert Motherwell, Greenberg prescribed: "Only let him stop watching himself, let him stop thinking. . . . Let him find his personal 'subject matter' and forget about the order of the day."

Having chosen Jackson Pollock as the art star of his day,

Greenberg invested many hours and days in critiquing his work, suggesting improvements, and promoting sales. The critic "seemed a combination of patron, mentor and career mover" for the artist, said one observer. Elaine de Kooning told an interviewer that "Clem acted as an unpaid p.r. man," furthering the artist's career more than any dealer. Pollock responded with an obsequiousness that some found cloying, but his wife, Lee Krasner, detested Greenberg, partly because of the critic's low opinion of her work but also because of his influence on her husband. Greenberg often spent weekends with the Pollocks and delighted in rummaging through the paintings in the studio to pronounce them good or bad. Willem de Kooning, among other artists, resented Greenberg's hectoring and finally ordered the critic out of his house.

In the early 1950s, having successfully linked the Abstract Expressionists into the great chain of Modernism, Greenberg pondered what sort of new style history now demanded. It would be abstract, of course, its subject simply the painting itself, and it would rigidly preserve the integrity of the picture plane. An obscure Washington, D.C., painter named Morris Louis sought Greenberg's counsel in 1953 and was told to study the stained canvases of Helen Frankenthaler, then Greenberg's intimate friend. The following year Greenberg included Louis in an "Emerging Talent" exhibition he organized at the Kootz Gallery, and from then until the artist's death in 1962 Greenberg and Louis corresponded steadily. Several times a year Greenberg would visit Louis's studio, suggesting how the artist's poured curtains of pigment could "extend the modern tradition of making art about the formal properties of art." One close observer found it hard to imagine Louis's art and career without Greenberg. "It seemed clear that Louis, along with Kenneth Noland and Jules Olitski, who were also Greenberg's protégés, were 'filling [Greenberg's] orders.' "

In the Greenberg papers thus far microfilmed by the Archives of American Art, there are only inklings of the critic's Stalinesque browbeatings. For some years during the early 1960s, Greenberg combed Canada for likely artists he could "discover." Early in 1963, he swept through Toronto to choose

paintings for an exhibition there as well as for shows in Los Angeles and New York. For Toronto he picked ten of eighteen canvases by Jack Bush, but, to the artist's chagrin, "he did not choose anything for L.A.," Bush wrote to Greenberg's wife, Jennie. "I am going to paint six more. Doesn't that sound like Clem? Then I am to send three to L.A. And if the others are better . . . I will replace some for New York." Greenberg sanitized not just paintings but artists' writings. "I had written a foreword for my catalog in Regina and crazily showed it to Clem," Bush confided. "It was so nice, Jennie, something I've wanted to say in print for a long time. But he didn't like it, so I wired a cancellation. I don't know if it was in time." Four days later Bush reported that the Regina publisher "accepted the cancellation of my foreword, but also canceled the catalog on the grounds that it was senseless to do without the foreword. . . . Kind of too bad."

The following November, Greenberg was back in Toronto, and Bush excitedly anticipated his visit. "I have all the paintings," he wrote, "the twenty of them, ready for you to see." The resulting Toronto show was roundly panned locally, but Bush stoically hoped for better results in Los Angeles. "You are right," he wrote to Greenberg about the framing for those paintings. "The floating moldings work better. Now I see what you mean by the 'pinched' look of the strips flush against the sides of the picture." He enclosed slides to illustrate the improvement. Greenberg apparently did not care for some of the paintings anyway, so Bush "cut up and destroyed the two canvases you didn't like. Have painted two new larger ones which look good." After another royal Greenbergian sweep to Toronto, Bush conceded that "one thing stands out. Your suggestion of leaving the canvas and going on to the next has proven itself again and again." Two weeks later Bush wrote that he, too, was "continually nonplussed regarding my inability to distinguish between one of two canvases where one turns out to be much better than the other." He also agreed that "the whole group of small paintings I did has proved disasterous [sic], with the possible exception of the one you chose for yourself."

Six weeks later Bush shipped a bundle of eight new paintings by express truck to Greenberg's home at 275 Central Park West. "On the one called *Joseph's Coat*," he asked, "what do you think of cutting the green down to about fifty-inch width?" He urged the critic to "use them in any way you see fit. . . . If you want some of them stretched up and framed, do so. If nothing happens, Fine Art Services can pick them up whenever it is convenient." Unfortunately, Greenberg's replies to these groveling letters are unavailable. One can only imagine their stentorian nature from the artist's continuing obsequiousness: "Once again, thanks for the privilege of being a part of your world."

Not just Greenberg's writings but his direct involvements in the art market promoted such obeisances. In 1959 Greenberg had agreed to set up a department of contemporary art for French & Co., New York's oldest dealer in traditional art. After persuading Barnett Newman out of retirement for an initial—and disappointing—exhibition, Greenberg showed Louis and Noland to mixed reviews. While still employed at French & Co., Greenberg saw no conflict the following year in promoting his artists, whom he grouped under the rubric Postpainterly Abstraction, in an *Art International* article. "From a cynical standpoint," wrote one critic much later, "Greenberg's curatorial presentation and later critical promotion of Louis' work formed a brilliantly engineered bit of self-promotion."

Indeed, so impressed was *Art International* with the critic's judgment that every one of its covers between 1959 and 1966 featured the work of an artist holding Greenberg's imprimatur. These were the years when *Art International*, published in Switzerland, had a worldwide following even as its publisher, James Fitzsimmons, was sinking into a quagmire of alcoholism, drug use, and family disarray. By 1965 he was desperate to get $12,000 for a Morris Louis painting he had been given. By then Fitzsimmons was staying up all night at least twice a week, keeping himself going, he confided to Greenberg, "by drinking a quart of scotch, several martinis, and a liter or two of wine a day, plus 150 milligrams of Librium (which is supposed to keep me calm—but 150 milligrams a day is about three times too

much), plus up to fifty milligrams of Dexedrine a day." A doctor had told Fitzsimmons that on such a regimen he had a year to live. In addition, he had gotten romantically involved with a woman who worked in his office. As a result, his wife Vera had left him "after a couple of years of hell," he wrote, because "I'm a drunken, lecherous bum."

In 1964 Greenberg boosted his favorite artists further by organizing an exhibition of Postpainterly Abstraction at the Los Angeles County Museum of Art. In his catalog essay he studiously avoided mentioning the vibrant Pop Art then shaking the art world and stressed instead that his chosen artists were the direct descendants of the Abstract Expressionists because their work was "the only authentically new episode in the evolution of contemporary art."

By then Greenberg had clearly fulfilled the classic complex of ambitions that Jewish immigrant parents (and many other immigrant groups since then) have harbored for their children—scholarly renown, influence, respect, and material success to boot. His achievement had come, however, at the price of affection. Few people liked Clement Greenberg, and many detested him. From Jackson Pollock, whose record as an ingrate is well documented, to Rosalind Krauss, whose career as a critic Greenberg helped launch, disparaging gossip abounds. Much of it deals with Greenberg's aggressive pursuit of money. Pollock told the artist Fritz Bultman that to succeed he should "cotton up to Greenberg." To Steven Naifeh, who was writing a book about the art business, Krauss retailed a rumor that Greenberg received $100,000 per year from the dealer André Emmerich for writing articles lauding artists in the gallery's stable.

There were many years, however, when Greenberg eked out painfully small amounts for his freelance chores. In 1963, he was offered $50 by the editor of a college text anthology for reprinting "The Case for Abstract Art," originally published in the *Saturday Evening Post*. Greenberg demanded $75, which the editors called "frankly out of line." "How would $60 be?" the critic scrawled on the bottom of the editor's letter. "That's the lowest I'd go with all due recognition of your difficulties." In 1965 Greenberg received $750 plus tourist air fare and ground

accommodations for four days of judging paintings at the Walker Art Gallery in Liverpool. For giving a gallery talk as well, he demanded—and got—an extra $75. Later that year he received $300 plus all expenses for a half-hour lecture at the University of Illinois.

Meanwhile, Greenberg was taking every opportunity to promote the artists he liked and to augment his own collection of their works. In 1957 Robert Motherwell offered him a painting in the Stable [Gallery] Annual, suggesting the critic go by there to "see if you want it." The Stable Gallery's director, Eleanor Ward, recalled that Greenberg was advising collectors long before taking up duties at French & Co. Without announcing to anyone that he was a dealer, Greenberg took over the collector J. Patrick Lannan, whom Ward had been counseling. As early as 1955 Greenberg was considering an offer from a Los Angeles gallery to arrange a show of Clyfford Still, Newman, and Rothko, give a lecture about these artists, and attend opening functions for three days. Not all the paintings Greenberg accumulated stayed on his walls as reminders of past affections. In 1964 he gave Adolph Gottlieb's *Side Pull 1956* to Marlborough Gallery to sell for $9,000.

By the mid-1960s a new generation of intellectuals was attacking not only Clement Greenberg's pronunciamentos but the very idea of arts criticism itself. In an influential essay, *Against Interpretation*, Susan Sontag compared critics' effusions to "the fumes of the automobile and of heavy industry, which befoul the urban atmosphere." She called interpretation "the revenge of the intellect upon art. Even more. It is the revenge of the intellect upon the world." In 1989 the art dealer Jeffrey Deitch dismissed Greenberg's ultimate influence. "He was too worried about low culture's influence on high culture," Deitch said. "His problem was that he didn't appreciate how Modernism develops." The unkindest cut was that Greenberg's artists had become difficult to sell: "You can buy a Morris Louis painting for less than $60,000."

Nor did Greenberg hold the affections of his erstwhile comrades at *Partisan Review*. Greenberg's old colleague Harold Rosenberg contemptuously told a collector to "go and see

Clement Greenberg. He gives advice to collectors. I just write about art." Philip Rahv, the magazine's coeditor, had long deemed Greenberg's art reviews "too dogmatic and one-sided." Rahv suspected that the critic raved over the Abstract Expressionists because "he expected to ride in on the wave of their success." And indeed he did, acquiring the authority to impose new artists on the public and an art collection, anchored by the paintings, drawings, and sculptures given him by grateful artists, worth many millions of dollars and appreciating rapidly.

During the early 1980s two filmmakers arrived at Greenberg's apartment on New York's Central Park West to interview him. Then well into his seventies, he "spoke very quietly, magisterially, ex-cathedra," they reported. During the tedious minutes while lights were set up and the camera positioned, "Greenberg made us feel that each of those moments was lost to history," they wrote. "The crew did not like him, which made no difference to them or to him. . . . All that mattered: Greenberg on camera was very good; prickly, contentious and good." He was also the only one among dozens of interviewees who asked to be paid—$100.

Clement Greenberg has not written on art for many years and now lives in seclusion. Characteristically one of his last aesthetic pronouncements, in 1981, dealt not with art but with art critics. Contemporary critics explain, analyze, and interpret art; they situate art historically, sociologically, or politically; they treat art as a document, as a symptom, or as a sheer phenomenon. But, he complained, they withhold value judgments, omitting "the responses that bring art into experience as art, and not as something else."

Understandably Greenberg was offended by the anemic discourse that floods art writing today. The elegant Anglo-Saxon prose of a John Russell, for example, stands in direct opposition to Greenberg's contentious, opinionated, and abrasive views. "The historical impact of [Clement Greenberg's] rise is only half the story," wrote Kay Larson recently in *Artforum*. "The other half is the personal irritability that he brought to his mission." One painter told Larson that "Clem uses truth like a blunt instrument"; another refused to be quoted because

"Clem holds grudges for twenty years." How did he come to have so much influence over so many? Larson points to "the perverse magnetism of the authoritarian personality. . . . His contempt was one of his most powerful weapons. . . . Moral righteousness and intellectual arrogance were the signs by which the Chosen separated themselves from the Philistines."

For a Jewish boy from the Bronx, there was no other way to be.

For better or worse, there are no critics today with the magisterial influence wielded by Clement Greenberg during the 1950s and into the 1960s. The intolerant prose that battered and shamed, the arbitrary assumptions, the passionate assertions—all the infuriating Greenbergian devices have faded into history. But the conflicts of interest pioneered by Greenberg have continued and blossomed in luxuriant fashion.

John Coplans, whose exhibitionist photos of his own body were featured in a 1989 show at the Museum of Modern Art, taught art history at the University of California at Irvine, then became director of the university art gallery. He went on to become a curator at the Pasadena Museum of Art and became director of the Akron Art Institute in 1978. These responsibilities did not interfere with his simultaneous association with *Artforum*, at first as editor at large, then as associate editor, and eventually as editor. Meanwhile, he also obtained two Guggenheim Fellowships and was twice funded as an arts fellow by the National Endowment for the Arts. In 1972 he produced two books, one on Roy Lichtenstein for Praeger and one on Ellsworth Kelly for Abrams.

Robert Pincus-Witten is a professor of art history at Queens College and also teaches at the City University Graduate School in New York. Simultaneously, he contributed to *Artforum* during Coplans's editorship and after 1976 wrote a diary-like column for *Arts*; he continues as an associate editor of this magazine. A collection of his critical writings on contemporary art, *Eye Contact*, was published in 1984. Concurrently,

the busy professor has also been advising collectors. From 1982 to 1986 Pincus-Witten accompanied Jerry Spiegel, a Long Island developer, and his wife, Emily, on their rounds of galleries, private dealers, and artists' studios, helping them to accumulate a valuable collection of contemporary art including works by Gerhard Richter, Anselm Kiefer, Sigmar Polke, and Andy Warhol. The Spiegels paid Pincus-Witten a commission, but he refuses to reveal the amount and instead fastidiously points out that "you cannot be disinterested if you're being paid by the gallery." Meanwhile, he professes loyalty only to "the aristocracy of the intellect, the aristocracy of sensibility."

A professor of art history at New York State University at Stonybrook, Donald Kuspit is also the editor of an ongoing series of scholarly art monographs at UMI Press, where he can accept books about the artists and art movements he favors. He accepted the Pincus-Witten anthology of 1984. In addition, he writes frequently and, according to Janet Malcolm in *The New Yorker*, with "dense prolixity" for *Art in America, Arts, Artforum*, and *Art Criticism*. The National Endowment for the Arts awarded him a Younger Humanist Fellowship in 1973–74, and the Guggenheim came through in 1977–78. Kuspit also edits *Art Criticism*. In 1989 he organized the first exhibition of contemporary American art in the Soviet Union, obscurely titled "Painting Beyond the Death of Painting." He included sixty-eight paintings by such well-known artists as Julian Schnabel, Alex Katz, and Lucas Samarras and, inexplicably, Nina Maric, who happened to be the wife of the lawyer who arranged for the show. Kuspit insisted that the exhibition was a fair sampling of what contemporary American artists were producing and had "no point of view, stylistically or ideologically." Despite his multifarious and presumably profitable involvements, he calls the art world "a dreadful place" and deplores "the megalomania that is rampant among artists." He now suffers "bouts of wondering whether art isn't just a matter of fashion and glamour."

During the late 1960s and early 1970s, a flurry of exposés in the media pointed out the blatant conflicts of interest in the art world. Willi Bongard, a financial writer for the *Frankfurter*

Allgemeine Zeitung, noted that Alfred Frankfurter, the publisher of *Art News* until his death in 1965, made a considerable income on the side from commissions paid by those he advised: collectors such as David and Adele Levy, Albert and Mary Lasker, and Paul Mellon; and dealers such as Pierre Matisse, George Wildenstein, and Paul Rosenberg. Bongard was stunned to learn that no one considered this conflict improper and wondered what people would have thought if he had given private clients investment advice while holding his newspaper position.

In *The Art Crowd,* published in 1973, Sophy Burnham revealed the gift relationship among artists, museum curators such as Henry Geldzahler, and critics such as Clement Greenberg. Sam Hunter, who had been an art history professor at Princeton, director of the Jewish Museum, and a consulting editor for the art publisher Harry N. Abrams, donned his hat as a book reviewer to disparage her work in the *New York Times Book Review.* Burnham's moral qualms represented "misguided muckraking," he wrote, ignoring "a long-standing tradition of reciprocal appreciation dating back at least to the Impressionists." Worse, he said that her allegation of conflicts of interest "mechanizes and degrades the relationship between serious artists and their critics."

John L. Hess, a veteran *New York Times* correspondent in Paris, agreed that the tradition of "reciprocal appreciation" had a long history among the French. French publications had never paid their critics a living wage. The art public there was well aware that artists or dealers were helping writers financially with gifts of art or commissions for catalog essays. Unlike American readers, who assume a decent professionalism among their journalists, the French public *"expects* critics to take," he wrote in his 1974 exposé of the Metropolitan Museum's secret, questionable sales of paintings left to it by Adelaide de Groot. American art writers were indulging in French-style shenanigans, according to Hess; he knew of not a single American art critic who had never accepted a token of appreciation from an artist. He cited Harold Rosenberg, a longtime critic at *The New Yorker,* who mounted an entire *show* of art given him by grateful artists, and also described Clement Greenberg's activities as

executor of the estate of David Smith, adviser to the widow of Morris Louis, guest curator at museums, and director of a gallery.

Since those heady investigative days, the incestuous relationships among critics, museums, scholars, and dealers have proliferated, but only an occasional, oblique blip has broken the deep media silence. In 1976 the code of ethics for art historians was revised to require that a scholar appraising art receive a fixed fee rather than a percentage of the work's value. "The need to establish a monetary value for the work of art," said the new wording, "must have no influence on the objective, scholarly judgement of it." The change suggests that some art historians had been skewing their appraisals upward in order to enhance their fees. This would have been in the venerable tradition of Bernard Berenson, who received 25 percent of net profits from every Italian Renaissance painting he authenticated for art dealer Lord Duveen. As art prices rose to astronomical levels, the stakes in all appraisals of art also became greater, with consequent pressure on the ethics of art specialists. Critics and art historians were frequently asked to serve as consultants to corporations or to government agencies, including the IRS, with millions of dollars sometimes riding on their judgments.

A sociologist who spent years studying the SoHo art community found it notable that the professionals—curators, critics, scholars—were tightly linked to "the formal associations of the art world which make the artist's sales, grants, and celebrity possible. . . . They set the price, judge 'museum-worthiness,' and predict the potential for distinction which makes an artist's career 'a good investment' for artists and audience alike." Concurrently, he added in dry scholarly prose, the same individuals, "Janus-faced[,] . . . are at once powerful critics and spokespersons, publicists and legitimators, of the artistic enterprise."

The egregious conflicts that once inflamed investigative journalists have become so ubiquitous and entrenched that they have vanished into the art world's landscape: no one writes about a universal phenomenon. Nor do respected scholarly

journals feel obligated to explore every side of important art
world issues. In 1984 the *Annals of the American Academy of
Political and Social Science* devoted an entire issue to "Paying for
Culture." Among the fifteen authors were Francis S. M. Hod-
soll, chairman of the National Endowment for the Arts; Senator
Claiborn deB. Pell, sponsor of the legislation that created the
national endowments for arts and humanities; Kitty Carlisle
Hart, director of the New York Council for the Arts; Sheldon
Hackney, president of the University of Pennsylvania; David
Finn, whose firm specializes in public relations for the arts; and
various trustees of museums and spokespeople for foundations
and corporations that finance art. Not a single article was
written by a disinterested critic, nor did a single voice examine
the underlying assumption that government or corporate fund-
ing for the arts is an unalloyed good and more would be even
better.

In 1976 a leading European art magazine, *Connaissance des Arts*,
published a listing of contemporary artists currently considered
"important" (read "best investment"). The French critic Pierre
Faveton reported that Jasper Johns was mentioned twenty-three
times by his respondents, one hundred people considered "espe-
cially knowledgeable in the evolution of art." The rest of Pop
Art was holding up too, Faveton's poll indicated, especially
Oldenburg, Warhol, Rauschenberg, and Arman, while Op Art
was fading. The American Abstract Expressionists also con-
tinued strong, but not their European reflections such as Pierre
Soulages and Alfred Manessier. The article was typical of many
in the art trade press, a series of "buy" recommendations veiled
in a spurious aura of research. Not revealed in the article or
anywhere else in the magazine was the information that the
publisher of *Connaissance des Arts*, Dimitry Jodidio, was also
chief agent of a Lausanne-based art investment group called
Cristallina. When this group of speculators decided to sell eight
paintings at auction in 1981, Christie's chief of public relations
was delighted that Jodidio conveniently arranged to print in the

magazine a "eulogistic article" commissioned by the auction house. Jodidio continues to be publisher there. Readers of the magazine's many handsomely illustrated articles about artists continue to be unaware of his role in the art investment syndicate.

American art magazines have not generally operated with such flagrant disregard for journalistic ethics, but they do suffer from the excesses of secrecy prevalent in the art business. Until the mid-1960s, for example, *Art News* routinely published the prices for the art in gallery exhibitions it reviewed. Curiously, the practice died out just when art prices began to soar from a few hundreds of dollars to many thousands. Since then, no magazine regularly publishes prices of works in exhibitions, not even *Art & Antiques* or *Art & Auction*, an upstart publication begun in 1979 on the premise that the public wanted to know everything about "the pleasures of collecting for aesthetic as well as investment reasons." On its tenth anniversary, *Art & Auction* published a history of its success in overcoming early criticism of its investment orientation. "It is no longer offensive to mention art and money," wrote its publisher in a self-congratulatory article. "Indeed, what discerning collector would not." Yet even in this business-oriented journal, mention of gallery prices remains taboo.

In an article about art magazines published in *New York* in January 1990, Dinita Smith dismissed all of them as trade magazines "not meant to be read; they are meant to be seen[,] . . . and many are not held to ordinary standards of editing." *Arts*, for example, often publishes daunting pages of dense, double-column text, unbroken by illustrations or so much as a subhead. The art magazines' circulations are also meager and probably widely overlapping. The largest of them, *Art News*, sells only seventy-seven-thousand-odd copies each month. Next is *Art in America* with under seventy thousand, trailed by *Art & Auction*, with forty thousand and *Arts* with twenty-seven thousand or so. *Artforum*, which deals exclusively with contemporary art, has no audited circulation at all; its publisher claims it has recently grown by about one-third, to about twenty-seven thousand.

The numbers are small, but other available statistics about art magazines are considerable. *Art News* subscribers, for example, have a median household income of $88,100 and a median net worth of $854,000; more than half of them have at least a college degree and work as professionals or managers. A 1988 survey showed that they had spent a total of more than $265 million on art and owned or controlled art worth almost $4 billion; the average value of their collections was $81,000. Those among them who were museum or corporate curators or corporate art consultants had spent almost $1 million during the previous year on art. A two-page list of notable *Art News* subscribers includes such artists as Red Grooms, Chuck Close, Cindy Sherman, Robert Motherwell, Jasper Johns, and Robert Rauschenberg; dealers such as Leo Castelli; collectors such as Philip Johnson, S. I. Newhouse, Norton Simon, Eli Broad, and Frederick Weisman; and entertainment celebrities such as Frank Sinatra, Woody Allen, Steve Martin, Liza Minnelli, and Dustin Hoffman.

Art & Auction promises advertisers a similarly select audience. A 1988 survey showed that its subscribers live in homes worth an average of $434,500; 68 percent of them decorated one or more rooms during the previous year (at an average cost of $26,200); and 39 percent of them own a second home. Their average household income was $210,100, and their average net worth was more than $1.5 million. They are avid art lovers indeed: more than half of them visited museums, galleries, or antique dealers during foreign travels, and 47 percent made purchases averaging $17,700. More than half also paid five or more visits to auctions, and 36 percent made purchases; the average purchase was $64,093.

It takes but a quick flip through these magazines' abundant pages to learn that advertisers are anxious to reach such free-spending readers. Even *Artforum*, with its awkward square format, scanty circulation, obscure subject matter, and lumbering prose, runs to two hundred or so pages in the average month, close to two-thirds of them advertising. Full-color pages in all the art magazines cost in the $3,000 to $4,000 range, with production charges adding another $1,000 or so.

While the art magazines' detailed inquiries into their readers' spending habits bespeak strenuous efforts to attract advertising for liquor, automobiles, travel, jewelry, and other luxury goods, dealers still provide most of their advertising. Typical ads show merchandise for sale or announce specific exhibitions; indeed, aside from direct mailings, the only way to notify collectors of current exhibitions is through advertising, since reviews generally appear long after the exhibitions have closed and omit the dates the show was held. *Arts* magazine does make an effort to publish reviews while the exhibition is still on, but deadlines for editorial copy are such that the reviewer must view the works before the opening, in the artist's studio or in a warehouse. By contrast, the magazines accept advertising up to two or three weeks before publication.

Artists, especially the young and hungry ones, hang on every word in these reviews, however late, bland, brief, or indifferently written they might be. Clippings of them gain immortality in scrapbooks, choice phrases eke out a portfolio, and the citation is added to the multipage, lovingly assembled résumés artists present to possible dealers or collectors. Yet there is little evidence that anyone outside a particular artist's narrow orbit ever reads them. "There are lots of words written . . . but they have few readers," says J. Patrick Cooney, a former Frick Collection curator who now works for the Citibank Art Advisory Service. His colleague Jennifer Josselson Vorbach says that "in SoHo they can tell you who got a review, but they don't read it." Emily Tremaine, one of the heroic collectors of the 1960s, doubted that art magazine reviews were "motivated by . . . really honest criticism. I think they have other axes they're grinding." A leading dealer of the same period, Ivan Karp, believed that "critics write for each other. They write for their wives. And they write for the artists they're writing about."

John Coplans, who edited *Artforum* during its liveliest years (in the 1970s, when circulation was less than nineteen thousand), experienced steady pressure from dealers and artists for editorial coverage. The dealer André Emmerich "complained bitterly about the amount of coverage of his artists," Coplans

recalled, and dealers generally believed that favorable editorial coverage in exchange for advertising "was clearly a tit-for-tat idea." Sometimes artists were so anxious to be somehow represented in *Artforum* that they would pay for the advertising themselves. Over time "the galleries felt that they were buying the [editorial] space." The result was that "if a magazine adopted in any way a skeptical or adversarial role, they thought they had cause to complain." Leo Castelli was "extremely dissatisfied" when Coplans assigned the artist Bud Hopkins to review a Lichtenstein show and also printed a "somewhat critical" review by Nancy Foote of a Claes Oldenburg exhibition. Although Castelli never canceled his advertising because "there would have been a lot of questions asked about [his] openness to the art world," Coplans is convinced that the dealer was responsible for his being fired as editor in 1977.

Certainly, Castelli adroitly courted the magazine's publisher, Charles Cowles, as soon as he acquired *Artforum* in 1965. In the transit lounge of Heathrow Airport on the way to the Venice Biennale, Cowles encountered the dealer and the artist Roy Lichtenstein. "For the next two weeks we traveled together," recalled Cowles. "It was magnificent the way Leo took me under his wing, making sure I met everyone and saw everything—in short, that I was properly introduced to the art world. Leo wanted everyone to be aware of the future potential of *Artforum*."

The link between editorial coverage and advertising in recent years is more subtle but pervasive. Barbara Rose charged in 1981 that a number of art magazines "assure their advertisers of reviews. Even if editorial space is not literally bought, editorial and advertising content merge to such a degree that the two become inseparable." An artist who works in a prominent SoHo gallery says that his employer "is barraged every month with ad agents [from various publications]. The more you spend and the more consistent your advertising, the more likely your shows will be reviewed. . . . The publications pander to the biggest spenders." Peter Goulds, who owns the L. A. Louver galleries in Venice, California, and SoHo, says that "theoretically they don't sell editorial support for advertising."

However, if a particular magazine is planning an article about one of his artists or exhibitions, "there's no question I'll get a call from their advertising people." He is also convinced that if a gallery advertises regularly in a magazine, the editorial department's attention to that gallery's exhibitions increases.

There was a time when a number of strong critics challenged Clement Greenberg's autocratic decrees about art. One of them was Thomas B. Hess, who joined the sickly *Art News* in 1945, becoming managing editor in 1950 and executive editor after 1965. He had bought his first Jackson Pollock in 1944 for what he considered a lot of money—$150. Hess soon became such a fervent advocate for the new American painting that some called the movement Abstract Hesspressionism. Under his influence *Art News* became "the family journal of the New York School in general," wrote Irving Sandler. Hess particularly favored Willem de Kooning and his "downtown" circle as opposed to "uptown" artists such as Mark Rothko. In 1951 Hess wrote the first book about this group of artists, *Abstract Painting: Background and American Phase.* Not content with merely printed propaganda for his favorite artists, four years later Hess organized an exhibition of twenty-one younger New York School artists at the Stable Gallery, "U.S. Painting: Some Recent Directions." He then reinforced his choices, such as Elaine de Kooning, Joan Mitchell, and Larry Rivers, with a lavishly illustrated extended essay with the same title in *Art News Annual.*

Hess was another of the host of art world auxiliaries who had abandoned earlier ambitions to be artists. At Yale he was intrigued with exploring the techniques of oil painting, fresco, and watercolor but foundered over subject matter. Perhaps this is why he most admired the New York School artists who explored some kind of subject, however abstractly, painters such as de Kooning, Rivers, Milton Resnick, and Robert Goodnough. At college he also discovered Baudelaire and the early friends of Modernism in America such as Meyer Schapiro and

Alfred Barr, as well as early English devotees of Modernism such as Quentin Bell and Roger Frye. In his office at *Art News* there was not a single picture or even a poster, but in the grand Beekman Place house he shared with his wife, the daughter of a New Orleans mogul, Edgar Stern, the walls were decked with major New York School paintings. Outside the two-story windows, traffic streamed by on FDR Drive.

John Bernard Myers, the director of the Tibor de Nagy Gallery, believed Hess was "the ideal editor to pump life into a moribund publication such as *Art News*." Myers admired Hess's choice of writers for the magazine: poets such as Frank O'Hara and John Ashberry and artists such as Elaine de Kooning, Ad Reinhardt, and Fairfield Porter. Myers considered Hess's judgments adventuresome and knowing, no doubt influenced by the editor's friendly support of so many artists who showed at the de Nagy Gallery. Largely because of Hess, *Art News* became the most influential art trade publication of the 1950s and early 1960s. Nevertheless, its financial foundation continued to be shaky. As late as 1963 the magazine demanded $400 from artists who wished to have reviews of their shows accompanied by a color reproduction. One artist who refused to pay was told that her review "would be unimpressive."

The clannishness among the New York School artists fostered by Hess was abruptly challenged in 1959, when John Canaday arrived at the *New York Times*. He was brought in to revive the newspaper's musty art coverage, then consisting of a midweek article and a single Sunday page. "The artists regard the page as a kind of trade sheet," Canaday wrote to the artist Aaron Bohrod in 1961. "We regard it as a page to be read by a wide public interested in art." Unlike Greenberg and Hess, Canaday scrupulously avoided organizing exhibitions, writing catalog essays, or receiving gifts from artists. No propagandist for any particular kind of art, he insisted on playing his primary role as a journalist, an unbiased, educated observer of the scene. Unlike so many other critics, he also retained a sophisticated sense of humor about the foibles of the art scene and of himself. One

correspondent who hated the work of an artist Canaday had praised concluded his letter with "My wife tells me that she went to the Yale Art School with you. She now plays the piano. May I suggest the same to you." Canaday replied that he did play the piano, "but if you heard me you would know that I play it even worse than I write."

He, too, had started out as an artist, studying painting at the École du Louvre in Paris for several years after graduating from Yale in 1933 and going on to an advanced degree in art history. As an artist he was technically proficient, but "one day I looked at what I was painting and wondered who cared, including myself, whether I finished it," he wrote to a friend. "The answer, no [one] in both cases, concluded my efforts to paint." After teaching art history for some years at the University of North Carolina, Canaday became director of education at the Philadelphia Museum of Art. While there he developed the Metropolitan Seminars on Art, a popular slide-illustrated series of home study courses widely distributed by the Book-of-the-Month Club. Just as he was taking up his duties at the *New York Times*, his lucidly written *Mainstreams of Modern Art*, which would be widely adopted as a textbook, was published to admiring reviews.

"Well, you certainly earned your first week's pay," wrote one of the readers who responded gleefully to Canaday's inaugural column on September 6, 1959. "The best abstract expressionists," the critic had written, "are as good as ever they were. . . . But as for the freaks, the charlatans, and the misled who surround this handful of serious and talented artists, let us admit at least that the nature of abstract expressionism allows exceptional tolerance for incompetence and deception." He went on to pinpoint the roots of current uncritical acceptance of new art in the nineteenth-century academy's blind rejection of such vanguard painters as Delacroix, Courbet, Manet, van Gogh, and Cézanne: "Because of all this, we have tried to atone to a current generation of pretenders to martyrdom [on] the premise that wild unintelligibility places a contemporary artist in line with great men who were misunderstood by their contemporaries."

Canaday's comparatively mild call for careful evaluation of

all those who were then clinging to the paint-bespattered coat-
tails of Pollock, de Kooning, Rothko, and other first-generation
Abstract Expressionists elicited hundreds of supportive letters
from the public and other artists. It also provoked screams of
rage from those who had battled for years to establish Ameri-
ca's first native art movement. As he would throughout his
seventeen-year tenure at the *New York Times*, Canaday an-
swered every letter. "I have not come into the easiest situation
in the world here," he replied to one dealer's letter, "and it may
take some time for me to get the Art Page into the shape I want
it."

Canaday's immediate predecessors at the *Times*, Edward
Alden Jewell and Howard Devree, had spread their benign
presence over the page like marmalade. While spiritually im-
pervious to the new art, they had also tried hard not to antag-
onize its supporters. When letters came in attacking even the
now-mild Modernism espoused by the Museum of Modern
Art, Devree would defensively answer them and then supply a
copy to Alfred H. Barr, Jr., the museum's director of painting
and sculpture. Such cozy favoritism ended abruptly with Cana-
day's arrival at the newspaper. Just a few weeks after taking
over, Canaday wrote to the artist Philip Evergood that "there
has not been exactly a coolness [at the MOMA] since after all
the *Times* is a medium of communication dear to them, but they
have been eager to point out that they have presented other
work than abstract expressionism." Canaday objected to the
museum's "lopsided emphasis" on "experiments that are valid
but not as earth-shaking as the Museum's presentations and
publications imply that they are." Canaday detested critical
cant, and soon he was ridiculing the pretentious, meaningless
verbiage in some museum catalogs. When the MOMA's curator
of painting and sculpture exhibitions, Peter Selz, wrote that
Rothko's paintings "disturb and satisfy partly by the magnitude
of his renunciation," Canaday called it "high-flown nonsense."

Canaday continued to mock the loose verbiage rampant in
the art world and the self-importance of those promoting
Abstract Expressionist art. In October 1960 he wrote a hilar-
ious send-up of the overblown art discourse he so detested.

Analyzing a spattered blue blot by a mythical artist, Ninguno Denada, he broadly satirized the writings of Hess: "The huge central element, generally globular in shape, is the very apotheosis of the inertness of matter, while the small, stem-like trail that runs beneath it is abruptly terminated, as if an attempted escape from the limitations of material things had been thwarted. This, of course, makes Denada philosophically a pessimist." He then quoted the "artist" about his work: "Even in blots, what I call the 'laws of inaction' determine the nature of the action. The action of a bit of paint that drips from the brush without your intention forms an 'accidental' shape, yet this shape is determined by the weight, texture, and velocity of the drip." His satire, Canaday explained, was "not much different from the brainwashing that goes on in universities and museums, except that it includes a minimum of jargon."

Judging by the enthusiastic letters pouring in, Canaday had touched an exceedingly sympathetic audience. Many notes came from a relatively ignorant public resentful of most abstract art, but many thoughtful letters came from the well-informed. J. B. Neumann, a dealer who introduced German Expressionist art in America, said he now agreed with Goethe, who had Faust say: "I summoned the spirits and now cannot get rid of them." Carl Zigrosser, then acting director of the Philadelphia Museum, admired Canaday's "deliciously witty turns" and agreed with his point of view. Lewis Mumford wrote that while he might "enlarge on your criticism . . . I shall not improve it." Arnold Nicholson, associate editor of the *Saturday Evening Post*, congratulated Canaday on "one of the most refreshing campaigns to hit the big city in a long time." Lee Eastman, an attorney specializing in art law, offered to buy Canaday a martini, and Victor D. Spark, a private art dealer, wrote, "No wonder there is such a shortage of good house painters. They have, for the most part, become professional abstract painters and exhibit in one-man shows."

Enthusiastic support also came from representational and abstract painters pushed aside by the Abstract Expressionist stampede, among them Philip Evergood, George Biddle, Balcomb Greene, Karl Knaths, and Jack Levine. Even Clement

Greenberg sounded a conciliatory note: "I find the best art of
our time to be preponderantly abstract," he wrote, "but I wish
it were not. All other things being equal, I, too, prefer illusion-
ist art." Greenberg phoned a few days later, and Canaday
explained in a one-and-a-half-page, single-spaced letter that his
reservations about the Abstract Expressionists were an attempt
to make room for other artists. If the Abstract Expressionists
"were a small group fighting for recognition instead of an army
imitating and profiting from the innovations of a few big and
honest men, I would probably be fighting their war with every-
thing I have." Nevertheless, Canaday's effort to counter the
Abstract Expressionist tide was misunderstood by many medi-
ocre artists. "Every poor broken-down realistic hack who
thinks his failure is the result of the abstract vogue has been
on my neck," he wrote to the artist Jack Levine. "Doddering old
ladies have been bringing me their picturesque watercolors. . . .
A messiah's lot is not a happy one."

At the *Times*, support for Canaday was absolute. Arthur
Hays Sulzberger read an advance proof of the critic's first
column and sent him an admiring personal memo. When
wounded letters from some of his critics arrived in the publish-
er's office, president Orville Dryfoos wrote Canaday, "Don't
give the matter a thought. You are in a particularly sensitive
field and all of us thought you would do an excellent and
responsible job as the *New York Times* art critic. We still feel that
way. So do continue the good work." Canaday replied that he
was receiving thirty favorable letters for every critical one. He
was trying to provide readers with the widest possible coverage
of the art scene, he wrote, to "function . . . as a kind of balance
wheel in the curiously weighted and eccentric mechanism of
New York exhibitions and reviews." Not that every member of
the newspaper's ruling clan uncritically approved of every Can-
aday judgment. In July 1965 he received a note crisply typed on
fine vellum: the writer had taken his advice and seen an Alex-
ander Calder exhibition at the Guggenheim. "There was only
one remark in your review with which I agreed," wrote the
Times' majestic matriarch, Iphigene Ochs Sulzberger. "You said
you didn't know why you liked it!"

By then Canaday had weathered the most concerted as-

sault not only on his views but on his job as well. In October 1960 Howard Conant, chairman of the New York University art department, gathered sixteen signatures on a letter to *Times* publisher Sulzberger begging him to "do something" about this obstreperous critic. Sulzberger affected surprise that Conant would ask the newspaper to "withdraw our support from Mr. Canaday—that is, to fire him." He wondered "what the reaction would be if Mr. Canaday and sixteen of his colleagues got together and petitioned NYU to fire one of you."

Conant raged on. In January 1961 Canaday published on his Sunday art page a letter Conant had circulated accusing him of persistently imputing "dishonorable motives" to the bulk of Abstract Expressionists and their supporters. It was signed by forty-nine pillars of the vanguard art establishment: artists such as James Brooks, Adolph Gottlieb, Stuart Davis, Willem de Kooning, Barnett Newman, and David Smith; art historians and critics such as Hess, Irving Sandler, Harold Rosenberg, and Meyer Schapiro; and many collectors such as Walter Bareiss, Ben Heller, and Boris Leavitt. (Notably absent from the list were Clement Greenberg and Alfred Barr, who, however, was kept abreast of the protest by personal letters from its organizers.)

The protest was couched in the language of aesthetic principle, although most of the participants had clear financial or career interests in the success of the artistic movements they were supporting. Much later, even the New York School's friendly chronicler Irving Sandler described the ingrown relationships among the Abstract Expressionist artists and their supporters. Having signed the protest letter, Sandler had gone on to publish, in 1978, the definitive history of the New York School. Few within the "in group" produced genuine criticism, he wrote; instead, they responded to friendship, social pressure, manipulation, or "a sense of mission." Now that a native American art had triumphed, mediocrity and even plagiarism were condoned in order to preserve a united front against a hostile public. Few seemed to realize that the scorned avantgarde had by 1960 become a powerful establishment; it was only reasonable for a critic such as Canaday to scrutinize its motives and values. In this assessment Sandler seemed to ar-

rive, after years of reflection, at a point of view strikingly similar to Canaday's. In a letter Canaday defined an academy as "an entrenched group in which a kind of incestuous imitation rather than invention is typical. The virtue of the old academy was that it demanded at least the mastery of certain technical bases for creation."

The Conant attack elicited an unprecedented avalanche of mail supporting Canaday. Some 550 of the more than 600 letters were friendly, although, as the beleaguered critic himself hastened to point out, not always "for the right reasons." The cartoonist Al Hirschfeld signed his note with an elegant self-caricature. The literary critic Dwight Macdonald called Canaday "the only art critic with cultural background and a decent prose style." An assistant professor of art at SUNY Buffalo assured Sulzberger that Conant's views did not represent all academics: "This kind of 'political action' is not typical of the way ideas evolve, mature, and survive in an academic and artistic environment." Ralph Colin, a MOMA trustee and founder of the Art Dealers Association of America, praised Canaday for "the courage to take an unfashionably moderate position in a time when the avant-garde has become more academic than any academy and when it has become treason to do anything less than accept all of its products as master work." The artist Edward Hopper flatly called Canaday "the best and most outspoken art critic the *Times* ever had." A reader from Middleburgh, New York, concluded that "anyone who can make so many distinguished people so angry must be doing a good job."

Canaday's freewheeling critiques did indeed anger art insiders all across the aesthetic spectrum. When he deplored the low standards of American war memorial architecture and sculpture, he evoked the wrath of the National Sculpture Society, a conservative group with a lock on government sculpture commissions. Again attempting to vault over the critic's head, a defender of the saccharine, sentimental sculpture purveyed by the society's members concluded that "obviously Mr. Canaday, with his predilection for the so-called 'modern' has no qualifications as an art critic." He begged the *Times'* editor to "take appropriate action if [the newspaper's] prestige is to be

maintained." Canaday calmly replied, "Your letter to The Editor has been turned over to me for answering. I suppose it is only natural that your opinion of me as a critic should correspond to mine of you as a sculptor; this always happens, whether my opinion of an artist is good or bad." While he admired such traditional monumental sculptors as Daniel Chester French and Augustus St. Gaudens, Canaday wrote, "it is their desiccated imitators I object to."

Stylistic wars aside, Canaday brought a first-rate reporter's perpetual curiosity into his art pages, along with a sensitive regard for what might interest his readers. Often he patrolled the fringes of "fine art," advising readers on how to find good, cheap art reproductions, critiquing the quality of art book illustrations, discussing children's art, and dissecting that curious magpie of a creature—the collector. Like all inhabitants of the art world, Canaday was intensely curious about prices, but unlike most art writers, he often included information about them in his columns. After describing a print show that had toured sixteen American museums, he reported on which works had sold and for how much.

Then, as now, a review in the *New York Times*, whether glowing or scathing, was just about the only media coverage that could draw attendance at an exhibition. Perhaps he could fill a gallery on a Saturday afternoon, Canaday admitted, but he was sure that the effect on the long history of art was minimal. The dealer Martha Jackson even thanked him for lambasting one of her exhibitions, "New Media—New Forms: Version II." John I. H. Baur, director of the Whitney Museum during the 1960s, acknowledged that a *Times* review was crucial to museum attendance, while television, even Baur's appearance on the "Today" show, had little effect. Art magazine reviews, he noted, usually came out too late to make any difference. A 1975 survey indicated that the public at large does not take critics in any medium seriously. Only 20 percent of respondents had "a great deal of respect" for critics, while 26 percent had "not much respect." These replies did not vary regionally, education-

ally, or ethnically and were substantially the same whether the respondent attended cultural events frequently or never.

By contrast, those with a direct financial interest in art—artists, dealers, and collectors—prize even a few cryptic lines in a relatively obscure publication. Ironically, the value they attach to reviews has escalated as the quality of art criticism in general has declined. From the rabbinical pronouncements of a Clement Greenberg during the forties and fifties and the skeptical judgments of a John Canaday during the sixties and early seventies, the profession descended into a morass of academic jargon and abstruse commentary, which illustrates the erudition of the writer as it confuses the reader. Overspecialized and underpaid, few critics can write "with full conviction," said the dealer Ivan Karp. More concerned with their status in the art world than with rendering any thoughtful opinion, critics shrink from hurting an artist's chance for success, he says. "It's very hard to go into a first show of an artist and say this show should not have happened," said Karp. "Or that so-and-so, whose works are now between $20,000 and $40,000 per painting, should not have achieved such prices." Karp's former colleague, Leo Castelli, agrees that magisterial critics like Greenberg or Harold Rosenberg, whose friendship with the Abstract Expressionist artists gave a propaganda edge to their writing, no longer exist.

With the loss of overt, outspoken criticism, covert, subliminal nuances have taken on importance. Most critical of all is whether an artist or exhibition gets any media coverage whatsoever. Most exhibitors would much prefer the most vicious denunciations of their work to that mortal cut—silence. To be condemned in print draws the mantle of bygone avant-garde artists around the victim. It enrolls him or her in the venerable club of rejected artists of the past, such figures as Gauguin, van Gogh, and Toulouse-Lautrec, such whole movements as the Impressionists, whose *salon des réfusées* garnered scathing reviews. But to be ignored sentences an artist to extinction. It means expulsion from the historical record, reduction to utter insignificance, oblivion. So even though few ever read what is printed in the art magazines, their words continue to be indispensable to artists, their dealers, and their collectors.

Photographs published in art magazines form an even more important record for an artist than text. The increasing use of photographs in art magazines contributed considerably to the success of the Abstract Expressionists. Magazines frequently placed enlarged details from Old Master paintings next to photos of contemporary abstract works, and the text pointed out similarities and derivations. It was photos, not originals, that carried the news of Modernism and contemporary art to its wider audience, while slides continue to be the chief educational and research aid for art historians. The way paintings reproduce in photographs actually has influenced how and what artists paint, argues Wilhelmina Van Ness, prompting creation of works that are "more graphic, colorful, blatant, and stark." When publications print photographs of artists at work, a tight link forms in the reader's mind between the appearance of the artist and the work. For Jackson Pollock the photographs showing him at work enhanced his *oeuvre* and forever affected how it was viewed. The photos became a part of his mystique. His ritual dance around the canvas merged with his subject matter to form a composite image: the mysterious shaman indissolubly linked with the magical world he bestrode.

Looking back on his career as an art critic, most prominently with *The New Yorker*, Harold Rosenberg mourned the loss of commitment by artists to their vision as success and high incomes replaced poverty and derision. "The minute they get hit by money it starts coming out of their ears, they lose their minds," he told an interviewer in 1972. "They found themselves with that big bank book . . . [and] began getting into fights with their wives . . . just like the shmucks in Hollywood." With the acceptance during the 1960s of artists like Ad Reinhardt, Kenneth Noland, and Frank Stella, he wrote in *The New Yorker*, "nothing remained of the meaning in art except what could be derived from the fact of the artist's own existence. Art history became the sole legitimating concern of painting and sculpture."

Rosenberg's background was strikingly similar to Clement

Greenberg's: Jewish immigrant parents who worshiped scholar-
ship and culture while substituting the religion of progressive
politics for the faith of their fathers; a short-lived attempt to
become an artist; the heated radical debates at New York's City
College during the 1920s; the Depression foreclosing career
possibilities, in Rosenberg's case as a lawyer; the move from the
crowded field of literary criticism into the more spacious realm
of art criticism. Rosenberg briefly worked as a mural painter
for the WPA Art Project before settling in, in 1938, for a four-
year stint as editor of the WPA-sponsored *American Guide* se-
ries. Inevitably, considering that time and place, Rosenberg was
attracted to the Communist party. Suffused with enthusiasm
for a revolution that he naively believed would sweep poets to
preeminence in a just society, he served briefly as editor of the
Communist party–sponsored propaganda sheet *Art Front* dur-
ing the late 1930s. Inevitably, too, given his will for indepen-
dent thought, he soon fled the Party and lent his powerful
talent for invective to the strident ideological wars that splin-
tered New York's intellectuals during those years. It was among
the non-Communist leftists holding forth on life and literature
at *Partisan Review* that Rosenberg and Clement Greenberg first
grappled, two blustering polemicists destined for lifelong en-
mity.

"Harold looked and shone like the Lion of Judah," a friend
described him. Well over six feet tall, he towered over his
bookish colleagues, "added to which he had a congenital game
leg that had to be propped up like a bayonet while he was
sitting. It gave him a Byronic wound, which increased his
romantic air—the ladies were not immune—and made a num-
ber of his thick-lensed intellectual peers defensive as hell."
Greenberg, no mean brawler among the erudite himself,
termed Rosenberg "a slick mystifier" suffering from "a special
weakness for the profound."

The dealer John Bernard Myers observed, with some un-
derstatement, that although Rosenberg was not at all religious,
"there is a strong rabbinical streak running through Harold."
Soon after his death in 1978, a memorial article in *Commentary*
reviewed the epic feuds that punctuated Rosenberg's confron-

tational career. Not just Greenberg but also the literary critic Dwight Macdonald was his mortal foe, even though Macdonald and Rosenberg had for years worked side by side at *Partisan Review* while also living in the same whitestone building on West Tenth Street. "He was one of the most skeptical iconoclasts I've ever run into, for all his expert Marxmanship," Seymour Krim wrote of Rosenberg.

Although writing about the same group of artists, Rosenberg refused to adopt the name Abstract Expressionist, which was used by Greenberg and many other critics to describe the artists' common style. Instead, he insisted on calling them "action painters," heatedly maintaining that this was a more accurate description of their work. Later Rosenberg would studiously avoid mentioning Greenberg's name at all in his published writings, privately showering him with bile. "He [Greenberg] was always terrified of intellectuals," Rosenberg told Paul Cummings in 1972 during an interview for the Archives of American Art. Greenberg practiced "a very cagey kind of belligerence," avoiding arguments with intellectuals while "browbeating artists," Rosenberg said. As for Greenberg's formalist ideas about the logical development of modern art, Rosenberg found them "totally worthless. I see nothing in his ideas, his choices, his enthusiasm or anything else. . . . He talks about taste as if he were a person of the nineteenth century. I don't think he knows what the hell is going on in the world at all. But he has his group of academicians. . . . He is such a little careerist."

Of the "stripe artists," as he scoffingly described Greenberg's protégés Kenneth Noland and Morris Louis, Rosenberg said they "are like the death of art. You just think of them and you get bored to death." As for Morris Louis, Rosenberg found it psychologically inconceivable that "a guy who has never sold a painting would stand around and knock out six hundred unsalable paintings of that size in four years. I demand to be shown the inside of this mind." He harshly dismissed David Smith, whose estate Greenberg managed: "Welding away, welding away. And lived up there [Bolton Landing, New York] in that boring place and he'd come rushing down every once in a

while and meet somebody. . . . There might be a girl. . . . He looked like a savage." His hackles aquiver, Rosenberg recalled Smith's duties among WPA artists in the 1930s. "For the first Christmas party . . . since he was in charge of materials, they gave him a five-gallon drum of alcohol and a lot of grapefruit juice and they said, mix."

Rosenberg's reservoir of righteous rage swamped many of the artists as well as the critical colleagues who rose to prominence during the 1960s and 1970s. Warhol was "insignificant," he thought, yet was "ten times as interesting as [the Earth artist Robert] Smithson or [the Minimalist sculptor] Robert Morris," whom he judged "completely boring."

Rosenberg's spleen was even more inflamed, if that was possible, by the writings of others on art. It irritated him that in 1972 Frank Stella was featured on the cover of several art magazines, while there was no publication in which he could ask "What kind of insignificant piece of nonsense is this?" He deemed Thomas Hess altogether too permissive in editing *Art News*, accepting "whatever happens to be successful in this miserable art world which is getting more and more to be . . . a situation of pressures of collectors, curators, and groups." In *The New Yorker* he suggested that the time had perhaps come "to abandon not art but art criticism which has anyway become little more than a shopping guide." Indeed, the entire avant-garde, if any remnant yet survived, had been "reduced to ritual" and had sunk "into a professional little thing." Instead of the artist being "somebody who projects . . . the notion of a creative richness in society," Rosenberg lamented, "he's just another guy who runs around making products." The problem, he decided in 1975, was that artists were no longer alienated from society; instead, "the habitats of artists became infested with dealers, agents, reviewers, collectors, public relations people, feature writers, media celebrities . . . [a] sudden efflorescence [which] pried apart the cell structure of the artists' community, like roots tearing up a sidewalk."

While he lived, Harold Rosenberg inevitably drew as much

hostile fire as he dished out. The lively critical debate over art and artists was a measure of the ardent commitment by thoughtful intellectuals to public discourse on cultural matters. By 1975, however, many of the next generation of critics were disillusioned with the kind of impassioned fiats on art purveyed by the likes of Rosenberg. Barbara Rose, for one, complained that his writing was mere sociology: "It had nothing to do with aesthetics, it had no background in art history." Rose and most of her contemporaries boasted elaborate academic training. Like the artists of that generation (Princetonian Frank Stella, for example, to whom Rose was married for some years), this younger cadre of critics did not speak from a broad, general grasp of cultural issues but rather from a more rigorous, specialized context. Rose had studied abroad as a Fulbright scholar, held a Ph.D. from Columbia University, and had taught art history at Sarah Lawrence and at Yale. In 1967 she had published an immensely successful textbook, *American Art Since 1900*, and her articles regularly appeared in *Art in America*, *Artforum*, and such general magazines as *Vogue*. Even as she recoiled from the passionate amateurism of a Harold Rosenberg, by 1975 she too was bemoaning the decline of art criticism as a viable profession. Miserably underpaid and often fledgling art historians desperate for publication, she wrote, the new art writers were part of a swelling tide of commercialism swamping serious discourse about art. She also blamed the transformation of art magazines from modest labors of love into glossy money-making enterprises stuffed with advertising for the unmistakable decline of art criticism. The profit motive prevailed in the art world, she charged, calling forth "all the techniques of marketing, opinion manipulating, and artificial 'events' that are the staples of the public relations mentality."

Until the early 1960s such vituperation against American art magazines would have been unthinkable. Rather, these publications suffered from bland writing and careless illustrations, which were usually black-and-white photos obtained from dealers and sometimes from artists. As late as 1962 Lloyd Goodrich, director of the Whitney Museum, believed that only one or two art magazines were sporadically profitable. But with the growth of an eager audience for art—and the development

of cheap color printing—readership blossomed along with advertising. New art movements began chasing each other across the art horizon accompanied by an immense mass of art writing, a mass that, according to a European observer, swelled "in direct proportion to the decrease in discernible content." The growth in the number of pages of advertising demanded a balancing expansion of editorial text. The pressure was on the art magazines to guide their growing body of readers to those few artists in each new movement destined for wealth and fame. The result was "intellectual porridge," wrote Robert Wraight. Writers afraid to overlook a future genius and publishers afraid to offend the dealer-advertisers substituted flat description for vigorous criticism. Almost anyone who could string one word after another, Wraight wrote, "need only learn the current jargon . . . and he will have little difficulty in persuading the editor of some sham-intellectual publication to grant him a space in which to practice the art of writing about art without saying anything comprehensible."

Ivan Karp noted irreverently that art magazine advertising was "the best part . . . really fine . . . better than the editions themselves." Henry Geldzahler, by contrast, lauded the art magazines of the late 1960s as "forums in the presentation and interpretation of the new art" for a far wider audience than those who could visit galleries, studios, and clubs. He admired Thomas Hess at *Art News* for covering Pop Art fully, even though he detested it, and *Arts* magazine under Hilton Kramer for persuading the artist Donald Judd to become a regular contributor.

Art in America pioneered in another direction by publishing many articles dealing with the personalities and lifestyles of artists: their preferences in food, their habitats, their favorite travel destinations, and their family arrangements. In pursuing such trivia, *Art in America* demonstrated a sympathetic awareness of what would capture its audience's interests. A 1972 survey, taken to attract nonart advertising, indicated that this magazine's typical reader was a forty-one-year-old married college graduate with a family income close to $100,000 (all amounts roughly translated into 1990 dollars) and a $225,000

life insurance policy. This mythical art maven lived in a $200,000 house, drank brand-name liquor and/or good wine from glasses costing an average of $24, and ate copiously from place settings costing an average of almost $100. The family had two or more cars and was also likely to own a boat and wear couturier clothes, a $1,000 watch, and a selection from $30,000 worth of jewelry. The magazine's survey also reported that its typical reader had some sort of art collection.

The *enfant terrible* of art publications in the 1960s was *Artforum*. Founded in 1962, it established its offices as far as possible from New York's art vortex—in San Francisco. It also sported a 10½-inch square format, daring because it required costly revision of advertisements created for the other magazines' traditional 8½-by-11-inch page size. Nevertheless, the magazine evolved into such an overpowering critical source that by the early 1970s its staff was called the *Artforum* Mafia. That a publication with minuscule circulation, never more than twenty thousand, could move and shake its readers so strenuously is one more sign of how small the art world really is. Mostly academics, its writers pursued innovative art to its obscure lairs and vied with each other in the abstruseness of their prose. One of them, Annette Michelson, boasted that the articles were so dense that they read as though translated from the German. Illustrations often consisted of black paintings, vast slabs of merciless steel sculpture, and acres of earth arabesques constructed in remote deserts by artists protesting the treatment of art as a commodity. Despite lagging readership, bitter staff schisms, and huffy defections, the magazine prospered financially. In 1979 it was bought by a wealthy Englishman, Antony Korner, and Amy Baker Sandback, who immediately changed the staff.

The new editor, Ingrid Sischy, was a twenty-seven-year-old "little waif of a thing," as art critic Arthur Danto described her. She prided herself on never reading anything. "I *look* for pleasure," she explained, an attitude lauded by Danto, a Columbia University philosophy professor, as "the embodiment of *imagination au pouvoir*" (Let imagination reign!). "Willful obscurantism" was one description of the magazine's text under its

new editor. One prospective writer was advised to place the best part of his article at the end because Sischy would invariably pounce on the last paragraph, exclaiming, "This would make a brilliant beginning." Another veteran suggested that no one would notice if the whole magazine were scissored into paragraphs and reassembled at random. Even Sischy's mother, a sophisticated professional woman interested in art, found the magazine indecipherable.

Although it was patently unreadable and its circulation limped badly behind *Art News* and *Art in America, Artforum* nevertheless prospered because dealers scattered their advertising evenhandedly among all the art magazines. If they advertised, their shows had a better chance of being reviewed, they reasoned, and their artists were more likely to be mentioned in articles. A serious investor/collector could rely only on reviews in the *New York Times* for impartiality, counseled Martin S. Ackerman in his crude how-to guide, *Smart Money and Art.* Reviews in art magazines are "by people in the business for the people in the business," he wrote. "These reviews are generally expected to be good or at least neutral or the magazines will lose their advertising. Some of the reviews are so obviously paid advertising that it is an embarrassment even to read them."

The affectionate alliance between art journals and dealers has a venerable history in France; as late as the mid-1960s, magazines there would publish photographs of artists' works in their editorial pages for cash payments by dealers or the artists themselves. During its heyday in the 1970s, *Art International,* notoriously linked advertising with editorial space. When Marlborough Gallery held its sales-oriented retrospective for Mark Rothko in 1970, a back-cover advertisement for the show was accompanied inside by two long articles about Rothko, both written by respected critics. Five years later Marlborough owner Frank Lloyd testified in court that "only through our contribution was it possible to write" these articles. The setting was the sensational lawsuit by Rothko's heirs against Marlborough's self-dealing manipulation of their father's estate. It was then, on January 20, 1975, that *Art International* published as a

"white paper" an article in which Marlborough defended its
dealings with Rothko. The byline identified Augusta Dike as
the author, a person who had never published on art before and
never has since. In a footnote the editor added: "After many
garbled and incomplete accounts based for the most part on
sheer hearsay, we think our readers will welcome an objective
and comprehensive presentation of the facts, set down by ven-
erable authority."

The population explosion in the art universe and the potential,
however illusory for most inhabitants, for making money there
have changed the whole social fabric of this world. By 1986
Barbara Rose was wistfully harking back to the 1960s, when
the avant-garde ethos forbade intercourse between the bour-
geois and the art worlds; socially, artists did not mingle with
patrons. A few artists then were even intellectuals, she wrote.
Contemporary artists, however, are "like cloak and suiters—
they make this product." Far from shunning the materialistic
world, she said, artists wanted only to be invited to expensive
restaurants and discothèques. Even worse was the rush of
oafish suburbanites into the sacred precincts of art. "They're
out in New Jersey and Long Island collecting Major Works," she
railed. "Now they're talking art, when twenty years ago they
were talking new cars." That her own articles in fashion mag-
azines such as *Vogue* might have contributed to this dire devel-
opment Rose did not discuss. When the Los Angeles Museum
of Contemporary Art opened in 1983, one of its organizers,
Robert Rowan, took it as a sign of the arrival of culture in Los
Angeles that "you can pick up a copy of *Vogue* magazine and see
a Barbara Rose article about the latest talent." Nor did she
recollect that, with all their fulminations about the ruin of
artists by money, Greenberg and Rosenberg and Hess poured
out rivers of adulatory ink about artists whose work they
owned in profusion.

Harold Rosenberg had spent $98 for two Pollocks at one of
Peggy Guggenheim's early exhibitions at her Art of This Cen-

tury gallery, as well as $120 on a Miró gouache. Such small
purchases alone would hardly have affected what he wrote.
However, he also regularly accepted gifts of paintings from
ambitious artists to the extent that his collection was worth a
small fortune at the time of his death. Accepting such gifts
contradicts standards of ethics for journalists and left Rosen-
berg vulnerable to accusations of self-dealing. Greenberg om-
nivorously grazed among the artists he admired. David Smith,
whom he described later as "the best sculptor of his genera-
tion," had paid tribute to Greenberg as early as 1947 by giving
him a ten-year-old piece, *Construction*. Smith's sales that year
were all of $150, he wrote to Greenberg, "despite the beautiful
position you've given me." In 1950 Jean Dubuffet wrote that
Greenberg's articles "testify to a superb understanding of my
intentions"; the letter accompanied a drawing, a gift for the
critic's birthday.

By the mid-1960s, it seemed to be understood by artists
that the gift of a substantial work or two was the price of
favorable mention in articles or inclusion in the shows Green-
berg was organizing. Preparing for a show in 1965, Jules
Olitski alerted Greenberg that he had asked his framer to
stretch the two paintings earmarked for Greenberg first and
deliver them to the critic's home. "Hope you and Jennie [Green-
berg's wife] like them." The sculptor Ann Truitt, about whom
he wrote in *Art International* and in *Vogue*, gave Greenberg one
work, *Bonne*, and urged him to pick out a second when he saw
one he would like. "In appreciation of your help over the past
several years," the painter Howard Mehring offered Greenberg
the pick of his next exhibition, in which, appropriately enough,
the subject matter was money. So extensive was Greenberg's
collection that in 1963 *Vogue* paid him $250 for writing an
article about it; the accompanying illustrations in such a presti-
gious publication added to the collection's market value. In the
following year a company specializing in art slides asked to
photograph his holdings for a series on significant private art
collections.

Gifts from artists usually generate an obligation of reci-
procity. To keep the gift and kick the giver requires more

churlishness than most people can manage. Yet despite the artists' abject toadying, Greenberg held most of them in utter contempt. "To be an artist is to be pompous," he pronounced. "Painters are less cultivated than writers and therefore pretentious in ways writers know how to avoid." He often complained that painters were also bores; asked why he spent so much time in their company, he replied, "Before analysis, I had a faculty for hanging around people I didn't like." Perhaps it was indeed masochism that prompted Greenberg to devote ample time and effort to nurturing Morris Louis and to promoting his works. In 1959 he organized an exhibition for the artist at French & Co., and in 1963 the artist received a one-person show at the Guggenheim Museum. In 1971 Michael Fried, a Greenberg protégé, wrote a monograph on Louis. Illustrated in it was an immense wash of pale rose and greens titled *Spreading*, painted in 1954 and "acquired" directly from the artist by Greenberg. Subsequently this work entered the Vincent and Sheila D. Melzac collection, from which it was sold at Christie's in May 1989 for $350,000.

Professionals in no other cultural endeavor would tolerate the kinds of conflicts in which Greenberg blithely pioneered and which since then have entangled so many other art writers. No respectable publication would permit a theater or film critic to write about productions in which he or she has a financial interest. For an author to press an honorarium on a book reviewer would be unthinkable. No self-respecting Washington correspondent would accept a substantial gift from a politician or lobbyist. And on Wall Street these kinds of rewards to financial writers—or even analysts for brokerage houses—constitute an indictable offense. Yet in the art world, this self-dealing behavior hardly earns a raised eyebrow and is quickly forgotten; the perpetrator's reputation remains intact, even enhanced by his success in obtaining such tainted commissions. Although a dozen schools of art history theory (or antitheory) contend today, Greenberg's influence remains "ubiquitous," in the words of Kay Larson. "Artists, consciously or otherwise, are still positioning themselves around Greenberg's ideas," she wrote in 1987. "The echoes of Greenbergian doctrine rebound

from the painting and sculpture department at the Museum of Modern Art to the tenured faculty of many universities and beyond."

Within the academic world where today's art writers are shaped and honed, the concept of journalistic independence hardly ever surfaces. The discourse among scholars is as devoid of the monetary, investment value of what they study as it is of critical evaluation. "Art criticism . . . serves now not to judge, analyze or interpret," lamented Barbara Rose in 1981, "but to validate the commodity function of the artwork." Paul Brach, an artist who was the founding chairman of the art department at the University of California at San Diego, describes this validating process as a "mysterious" decision as to "what kind of cultural air sticks to objects." Some are judged superior objects by criteria unstated; others "for endless reasons attract 'air.' " People buy "airy" art objects because "having them gives one a credit card for the cultural elite. . . . When enough 'air' sticks," he says, "the work becomes a real commodity."

Frequently the "air" building up around a particular artist or movement is pumped in by a surprisingly minute cluster of enthusiasts. A professor in a prestigious department of art may write both scholarly and popular articles, then produce an exhibition catalog and perhaps act as curator of the show at a private gallery or even in a museum. He or she lectures on the same subject and eventually writes the definitive monograph, often subsidized by the artist's dealer. Meanwhile, the same scholar, now established as an expert on this artist or style, advises collectors, receiving a commission from the dealer, an outright retainer from the collector, or both. Finally, with the artist safely dead, this scholar will produce the summation of the artist's oeuvre, a *catalogue raisonnée*, usually financed by the heirs, executors, or dealer handling the estate.

When Jackson Pollock's widow, Lee Krasner, moved the management of her husband's estate from Marlborough to the dealer Eugene V. Thaw, part of the arrangement was that he

would produce a *catalogue raisonnée*. Thaw in turn brought in Francis O'Connor, an art historian who had written on Pollock and also organized the artist's 1968 retrospective exhibition at the Museum of Modern Art. With Thaw's financial help, the two produced a mammoth work: 1,160 11-inch-square pages, containing 1,450 reproductions and descriptions of 1,100 works. It was published by Yale University Press in 1978 and sold for $250. Reviewing the book in *Art News*, Sam Hunter wondered why the work avoided "the kind of critical excerpts" that had been such an intriguing feature of O'Connor's catalog for the MOMA show. "The lyrical domestic photographs of Pollock with Lee Krasner," he wrote, "have a certain valentine unreality, if only because they exclude a wider circle of friends—and artistic rivals—of the 40s and 50s." There were, for example, no photos of such pivotal figures in the artist's career as Peggy Guggenheim, Betty Parsons, Barnett Newman, Tony Smith, Clement Greenberg, and Alfonso Ossorio. Hunter noted that whereas Franz Kline had described Pollock as "a lone shepherd dog running outside of the world," the Thaw-O'Connor book's photos depicted him "leashed and tethered." Despite the valuable information it contained, Hunter concluded, the work came off as "a naive effort . . . to control Pollock's public image."

When the most comprehensive and revealing biography of Pollock ever attempted was published in 1989, the polishers of Pollock's image hastened to trash the work. Steven Naifeh and Gregory White Smith had spent seven years researching the artist's life, interviewing hundreds of people who knew him, and locating great quantities of archival material, especially about Pollock's early life. Their 934-page biography for the first time documented Pollock's parents, their families and travels, their unrewarding relationship, and their fruitless trek around the West in search of a decent livelihood. Without a word of praise for the immense quantity of new information presented by the book, Elizabeth Frank dismissed it in the *New York Times Book Review* as a "glib, reckless, off-the-rack psychobiography that is dazzling in its lack of speculative humility and intellectual caution." Frank, who in 1983 had written on Pollock her-

self, did not find it important that, as the authors revealed,
Pollock could not draw, and mocked their attempt to relate the
artist's work to his life as vulgar "dime-store psychoanalysis."
By contrast, she preferred a scholar's monograph on Pollock,
even though it offered "little in the way of new biographical
information" and reinforced admiring academic interpretations
of the work. Unlike literary historians, who welcome fresh
information about a writer's life, art historians frequently react
defensively to such research. Having worked hard to date and
authenticate works, and to untangle questions of iconography,
materials, artistic influences, and subject, many art profession-
als find the details of an artist's personality or life irrelevant,
even distracting. They do not want to know whether the artist
was drunk, drugged, or mentally disturbed when he or she
produced important works. They often fear that such revela-
tions somehow reflect on the quality or sincerity of the work.
Moreover, the scholar or critic often develops such sympathy
for the artist that any negative information—that the artist
could not draw, for example—seems like an attack on the
validity of the work and evokes intense protective reactions.

Perhaps the endemic conflicts of interest within the art world
attract no attention because they have existed for such a long
time. Only a brief ripple, not altogether disapproving, greeted
revelations of the profitable partnership between the master
dealer Lord Duveen and the magisterial scholar of Italian Re-
naissance painting Bernard Berenson. Behind many a valuable
art collection stands a scholar, who not only authenticates and
evaluates a potential purchase, but whose writings form a
backdrop of advocacy, validating his own choices and ultimately
enhancing their value. John Hay Whitney, for example, had the
good judgment to select John Rewald to advise him in the
formation of his magnificent collection of Impressionist and
Postimpressionist paintings. While advising Whitney, Rewald
published widely on this period, including *The History of Impres-
sionism*, first published in 1946 and now in its fourth revised

edition. Whitney's first Impressionist purchase, in 1929, well before Rewald began to advise him, was *Dancing at the Moulin de la Galette Montmartre*. The picture was Renoir's second version of this scene; the first was bequeathed to the Louvre by the artist's friend and patron Gustave Caillebotte. Yet it is the second version, belonging to Whitney, smaller and far more sketchy than the work in the Louvre, that occupies a full color page in Rewald's book. In May 1990 this painting, now titled simply *Au Moulin de la Galette,* made worldwide headlines when it was auctioned at Christie's, straight out of the Whitney collection, for $78.1 million.

There is little doubt that John Rewald's eminently scholarly writings on the Impressionists, with their romantic descriptions of these artists' early difficulties in finding a wide audience, contributed to the stunning price achieved by this particular picture. Likewise, the tragic course of van Gogh's life, outlined in his touching letters to his brother Theo and dramatized again and again in print and film and major exhibitions, contributed to the extraordinary prices recently paid for his work. The *Portrait of Dr. Gachet,* auctioned for a record $82.5 million in May of 1990, is "one of van Gogh's most famous images," wrote Peter Watson in the *New York Times* soon after the sale. It was famous, however, not only because its owners had for years lent it for display at the Metropolitan Museum of Art but because another almost identical version had been hanging for decades in the Louvre, donated by the son of Dr. Gachet. The "air," then, that Paul Brach finds so mysteriously sticking to cultural objects is not a neutral atmosphere but a fiercely directional draft, sweeping the public in predetermined, specific directions.

Gerald Reitlinger, who devoted many years to a comprehensive study of art prices over several centuries, located a sea change in the manipulation of taste in the 1960s. This was, of course, the era when John Canaday was attacked so vehemently for his skeptical views on new American art. When Reitlinger's first volume was published in 1961, he recalled later, many critics "implied that it was presumptuous to dare to compare prices across the ages, as if these odd movements of money

could have anything to do with matters so pure as currents of taste which just grow like daffodils." By 1970, when he extended his studies through more recent years, Reitlinger lamented the extent to which "the identification of art with money" had taken root in the decade since his first volume was published. He deplored "the deliberate and indoctrinated confusion of artistic appreciation with self-interest" as signifying "something far worse than [mere promotion] . . . namely the corrosion of what is left of civilized life."

Such pessimistic notes have continued to provide a somber, but relatively feeble, counterpoint to the major theme of art's role in contemporary life. University art scholarship, which has grown immensely, interfaces with the public through museum exhibitions, where the art validated by the scholars is presented, often by the same individuals, with the added approval of a prestigious institution. Tirelessly searching for new art and artists to "discover," scholars, who also do the bulk of writing about art, tend to push young artists forward without giving their talents time to ripen. The widespread teaching of art history combined with high-profile museum publicity had lifted art "from the status of something half-suspect to the status of something accepted blindly as worthwhile," one avant-garde artist observed when he was interviewed by two sociologists in 1965. Most of the public interested in art consists of college graduates who learned about art from books or courses by art historians. Such an education, Edward C. Banfield notes, trains people to see art as "part of the history of culture, rather than as something to be responded to aesthetically."

With such training, it is no surprise that a preponderance of museum visitors views art as an exercise in identification as opposed to appreciation. To recognize the style of the artist, particularly the mature, "typical" style most frequently shown in art history slides and reproduced in art books, becomes synonymous with appreciating the artist's work. Yet to associate information about the artist's life, especially a colorful or tormented life, with the artist's signature style does not promote understanding. Indeed, it tends to interfere with the

emotional response that is the essence of aesthetic pleasure. The critic Leo Steinberg bridled at the suggestion of many Jackson Pollock supporters that knowing the artist personally was essential to appreciating his art. It was a bizarre symbol, he wrote in 1955, of "a radical change in the social role of art" toward "a sanctificationist cult, where the initiate can get himself into a private state of grace through the appropriate sacrament, to wit, the handshake of the artist."

In the effort to overcome the intrinsic barrier between the visual and verbal, and to make the book more appealing to readers, many writers of monographs about artists frequently conflate the work with the life. Thomas Hess, for example, opens his book about Barnett Newman with a sympathetic account of Newman's eviction from a downtown loft to make way for a skyscraper. From the "poor, persecuted artist" cliché, he moves to a "bohemian individualist" motif, detailing the artist's affectations: the British brigadier moustache, the reading glass dangling from a black ribbon around his neck, his silver watch fobs. As for Newman's work, Hess's subsequent description is not so much a critical appraisal as it is a propagandist's paean. Describing Newman's most recent opus, he gushes over its "eighteen-foot span of glowing red with a narrow zone of yellow at one edge, blue at the other." Hess compares it to "a mirror of both the past and the future. . . . The red extends like an athlete stretching his arms; it does not relate to the blue or the yellow as part of a balancing whole; it does not adhere to its rectangular format. . . . The red has been made real, palpable, as you, walking in front of the picture, are real. Something transcendental, something for the future, has taken place."

This sort of panegyric is smeared across the pages of many books about artists. While Hess's book about Newman was a labor of love, dealers and occasionally artists subsidize many such books. The subsidy is seldom revealed; as with other kinds of vanity publications, the public is unaware that the book has not passed the stiff scrutiny typical of unsubsidized publishing. Galleries hire the same writers who produce commercial books (but generally pay them better), then negotiate

with a publisher to help defray the costs of printing, distribution, and promotion. Harry N. Abrams, who founded the leading art book publishing house in the United States, and who was far from averse to quiet subsidies from outside, said such a book greatly enhances an artist's reputation: "People think about him quite differently. . . . People think if a publisher has brought out a book on an artist he must be important."

Many other respected publishers participate in such cooperative arrangements with dealers. During the Mark Rothko trial, Marlborough Gallery director Frank Lloyd testified that it was "not unusual for dealers to underwrite art books." He had contributed to publication of books about his artists published by Abrams, Viking, and Praeger. Testimony at the same trial revealed that when Abrams published a book by Ralph Pomeroy about the sculptor Theodoros Stamos, the artist himself bought $17,000 worth of books. The art historian Sam Hunter agreed that such subsidy arrangements were common. Sometimes collectors also provide financial help for books about artists in whom they have invested by paying for color separations of photos of works they own.

When it comes to publishing art books, museums have considerable advantages over traditional publishers. They can use their own curatorial staffs to write and produce them and grants from the government or corporations to pay for printing. They can give away such catalogs as membership inducements or sell them to members at a reduced price. Such arrangements can add as many as twenty thousand to the initial print run, reducing the price per copy. Selling the work in its own bookstore, the museum avoids middlemen and increases the profit as much as 50 percent. Special mailing rates for nonprofit organizations and exemption from local sales taxes give the museum publisher a further competitive advantage. Such benefits make museum bookstores major profit centers within the institution, especially when the same book maintains its market over many years. One of the all-time bestsellers at the Museum of Modern Art, for example, is the photography classic *Family of Man*, which has been continuously in print since 1955, selling some four million copies. The MOMA book about Pi-

casso, written by William Rubin to accompany the museum's massive 1980 retrospective, had an initial press run of three hundred thousand in English as well as editions in Italian, Spanish, Swedish, Japanese, and German.

Photographs in art books by critics can also serve as visual name-dropping to convey the author's status as an art insider. Frank O'Hara, a poet who spent some years as a curator at the Museum of Modern Art, is often cited as having been a particularly perceptive critic (before his untimely death in 1966, after being hit by a beach buggy at Fire Island, New York). His writing style as a critic was distinctively flat and assertive, including little support for his views. The frontispiece of his collected essays, published in 1975, shows him emerging from the revolving door at the Museum of Modern Art. On page 3 he is eating with Robert Motherwell and chatting with Franz Kline; on page 4 he is gazing into space with David Smith; on page 7 he is strolling with Larry Rivers; on page 8 he is standing with his back to some pictures and chatting with Reuben Nakian and Elaine de Kooning; and on a double spread of pages 10 and 11, he is sharing conviviality with Motherwell, MOMA director René d'Harnoncourt, and Nelson Rockefeller, all of them resolutely presenting their backs to the Motherwell paintings in the background.

Many believe that the growth of university art departments, where the training of artists and the teaching of art history is now concentrated, has had a dampening effect on public discourse about art. Harold Rosenberg decried such training of artists because, he said, the academic setting demands "measurable forms of progress" rather than providing unfettered opportunities for the artist to explore media and themes—and to make mistakes. Furthermore, the intimate combination of studio training and studies in art history tends to impose "art historical logic" on the artist's work—"the logical extension of certain formal principles"—rather than encouraging creative leaps. Paul Brach, himself a veteran of many years' university

teaching, notes that the principal function of university art departments, and of leading art schools as well, has become to "support mature artists teaching other artists."

William D. Barrett, who wrote for *Partisan Review* and then went on to *Commentary*, observed that over the years a self-styled avant-garde had come to dominate academic departments of art. He found a piercing irony "when a critic, safely ensconced in one of our leading universities, affects to speak in the language of the outcast." He wondered in 1982 "whether what has happened in politics may not be happening here: when a revolution takes over, it becomes fat, intolerant, and bureaucratic." More troubling is the evidence that the revolution has institutionalized itself not only in the academy but also in the other branches of the art tastemaking world. By the mid-1980s, the art historian Piri Halasz wrote, academics and other critics, museums, and successful artists had formed "a never-ending circle" of advocates for substantially the same point of view.

With academics manning most of the oars at most art publications, the ship of art criticism has wallowed into a turgid pool of jargon-laden muck. Often the writer relies on what the artist says about his or her work, even though artists are notoriously inarticulate. Frank O'Hara remarked on the "modest quality" of Franz Kline's utterances, although "in his art he was on stage at last with all his juggler's paraphernalia and the opportunity for great risks and great achievements was fully apparent to him in the harsh light." Robert Wraight deplored the adulteration of art criticism during the 1960s and believed that the decline coincided with the growing importance of American art on the world scene. Abstract Expressionist paintings, when they first toured Europe, were accompanied by "a torrent of irrational gibberish," he wrote, "that made the already confusing elements of modern art doubly confusing." Critics were often discerning esoteric ideas in the works far beyond the artist's intentions, he found, to the point where the artist began to "believe him and even learn to talk about his work in the quasi-scientific terms invented by the critic." The paradox was that "the simpler and emptier the work to be

described, the more involved the language became." At least one of these artists seemed to agree with such an assessment. Max Kozloff, a particularly ponderous purveyor of murky prose, approached Mark Rothko for a book about his work. Kozloff asked about the artist's development. "What development?" growled Rothko, showing him to the door. "I did not develop. You talk like a critic."

It would be rare indeed to read today the sort of personal reaction described by Leo Steinberg upon first encountering the works of Jasper Johns: "I don't know whether [these pictures] are great or good, or likely to go up in price. . . . I am challenged to estimate the aesthetic value of, say, a drawer stuck into a canvas. But nothing I've ever seen can teach me how this is to be done. . . . The value which I shall put on this painting tests my personal courage. . . . I am left in a state of anxious uncertainty by the painting, about painting, about myself." Instead of being personal reactions to the work, reviews of current art are speckled with the names of other artists, past and present, to whom the work under review is somehow indebted or related. The lead review in *Art in America* for May 1989 describes a particular artist's achievement as developing "a concrete, non-representational serial language form in which the human presence is invoked as the fundamental referent." Another artist is "able to let a cosmetic rationality take shape before our eyes, complete with a faked historic pedigree, and then, unsentimentally, indeed almost imperceptibly, indict itself."

The reader of such art criticism longs for the return of Clement Greenberg, with all his pomposities and autocratic dicta. Early in his career, in 1942, before he was carried away by his brilliance in print and the adulation of his acolytes, Greenberg wrote that "it is possible to get away with murder in writing about art." Three years later he conceded that "art writing has a bad name and rightly so. In no other field—except politics and perhaps music—can one get away with such hokum in print."

Faced with the opacity of so much current art writing, at least one artist has developed a sprightly defense. Donald

Holden's "Chinese Menu for Art Lovers" provides three columns of words culled from the writing of leading contemporary critics. From this menu the would-be art connoisseur can construct an impressive blend of appropriate phrases about art. "Begin with some simple combination like 'innovative creative statement,' " Holden suggests, before moving on to "a weighty combination like 'archetypal luminist isocephalism.' " More experienced users of the menu may enrich it by adding such phrases as "tends toward," or "moves away from," as in, "Her new work tends toward a minimal painterly simultaneity." Holden also recommends his menu for artists pressed for significant statements about their own work: "During that phase, I was involved with quasi-formalistic protoclassical constructivism, but then my work entered a period of highly personal monochromatic neo-environmentalism."

Where the art trade press frequently asphyxiates the reader with gassy clouds of quasi-analytic jargon, the popular press envelops the reader with fluffy, overblown effusions on the personalities and lifestyles of the artists. In such manuals for stylish living as *Vanity Fair*, the affluent learn about contemporary art while perusing glossy pages replete with advertisements for costly cars and clothing. Here, for example, Anthony Haden-Guest described "the brilliant intense life of a most remarkable artist," Jean-Michel Basquiat, who died of a ghastly self-destructive drug overdose at the age of twenty-eight. The life he then outlined consisted of hanging around in discos, picking up wild and pretty girls, drinking Gatorade, mumbling about giving up painting to be a writer or running a tequila business in Hawaii, traveling to the Ivory Coast for a tribal drug cure (unsuccessful). In breezy quasi-pop fashion, Haden-Guest concluded that Basquiat was "America's first truly important black painter," even though many scholars would name Jean Toomer or Romare Bearden for such distinction. The article gives no reason for ranking Basquiat so highly other than his bizarre behavior, his untimely death, and the meteoric rise of prices for his paintings.

The 480-page catalog that accompanied the Museum of Modern Art's immense retrospective of Andy Warhol in 1989 illustrates how inseparable Warhol's lifestyle had become from his art and how oppressively art history weighs in the assessment of his works. The authors of the four catalog essays vied with one another in connecting Warhol's concepts, themes, and techniques to every imaginable art movement of recent years and even as far back as the Italian Renaissance. Connections with Marcel Duchamp, Jasper Johns, and Robert Rauschenberg seem logical. But the effort to legitimize Warhol as worthy of such a massive museum exhibition includes references to such diverse talents as Barnett Newman, Willem de Kooning, Max Beckmann, Raphael, Eduard Manet, Walter Sickert, and Jackson Pollock, as though the artist's prolific talent required the weight of such names to counterbalance his embarrassing origins in the realm of commercial art and the orgiastic drug-drenched scene at the Factory.

The many references to Warhol's respectable antecedents also appear to be an effort to counter the many critics who recoiled in disgust at the advent of Pop Art during the 1960s. Greenberg simply ignored it as too kitschy for comment. Harold Rosenberg called Warhol "a veritable Leonardo of boredom." Barbara Rose reacted with judicious alarm. She disliked the low level of discourse about it, "but worst of all is the ghastly . . . irony that the public really *does* love it: they look at it, talk about it, enjoy it as they never have abstract painting."

One reason these critics decried the new art was that it was so patently easy to understand. Where the misty nuances of a Rothko or the rain-forest drips of a Pollock cried out for an authoritarian voice to tell the viewer what and why they were and what sort of vocabulary to use in discussing them, the Warhol soup cans locked into each viewer's familiar experience. So Pop Art required no critics at all (not that this fact discouraged millions of learned words from being written about it anyway). That Pop Art became established despite so many critics' fulminations marks a crucial turning point in the development of contemporary art. For one thing, its content was quintessentially American, and so was its audience—brash entrepreneurs quite different in character and temperament from

the quasi-aristocratic connoisseurs who had taken up the avant-garde movements of the past. They had it, and they were determined to flaunt it. No Greenbergian sermons against kitsch, no Rosenbergian rages could stem this tide; not in the United States, where the surf of the mass media beats ceaselessly against the fragile sandbags erected by defenders of high culture. Furthermore, if avant-garde art is the authentic expression of its time, no art movement expressed the exuberant mass media culture of America more authentically than Pop Art.

High culture believes that "the creator's intentions are crucial and the values of the audience almost irrelevant," writes Herbert J. Gans, while popular culture appeals frankly (some would say it panders) to the tastes of its mass audience. This is why, he writes, "high culture needs to attack popular culture, and especially its borrowing of high culture content. Moreover, high culture needs to think of popular culture as of low quality, of its creators as hacks, and its audience as culturally oppressed people without aesthetic standards." Here were art galleries, bastions of high culture, attracting large audiences to view paintings of comic strips and sculptures of Brillo boxes. The usual pattern was reversed as the high culture of galleries was invaded by low culture's despicable icons. Small wonder that art critics reacted with consternation. Art was deep; art was dense; art was a sacred shrine. They had not guided their readers through the aesthetic mine fields of difficult abstract art in order to watch them guzzle Coke and gobble hot dogs.

Even worse was the attention that this Pop Art attracted in the popular media. The avant-garde had always considered the mass media a mortal enemy. Even Jackson Pollock, who basked in media attention, worried about the effect on his artistic reputation of the spread *Life* gave him in 1949. "What's so fine about *Life*?" he grumbled. "For me, it's more like death. . . . That shit isn't for a *man*. People don't look at you the same." He was right. In de Kooning, for one, the magazine's photos of Pollock evoked a derogatory, low culture image: "Look at that, him standing there: looks like some service station guy ready to pump gas." Nor did the feature on this baffling avant-garde artist please many of *Life*'s readers; only 20 of the 532 letters the magazine received about the article were positive.

When Pop Art arrived, however, the popular media found that there was an eager audience for articles about such work. It may be that the mass public took pride in learning that its aesthetic icons—billboards, comics, supermarket goods—were appreciated in more elevated circles. Certainly it was amusing that such a blue-collar emblem as a Ballantine beer can had been selected by a fine artist like Jasper Johns for casting in bronze. The public may have wondered whether his flags were an ironic comment about simple-minded patriotism, but never mind; were not the best society people (or at least rich people who knew how to attract media attention) viewing such paintings with respect?

Coverage of Pop Art in the popular media avoided any dry critical evaluations and focused instead on the antics of the artists, the dress and demeanor of the celebrities who attended exhibitions, and speculation on who was buying this art and how much they would pay. Jasper Johns, a reclusive, taciturn artist, rejected the notion of restricting media coverage (even if that were possible) because, he said, "an art movement should be publicized just as quickly as someone wants to publicize it." Yet he complained that such publicity constantly pushed artists into social situations, with their work "used in ways we didn't ask for it to be used. . . . Work is being misused in *most* situations." The widespread coverage of Pop Art had triggered a total turnabout in the way new art movements progressed, thought Barbara Rose. In the past, the media covered art selected by museums, she wrote, but "now the situation seems to be reversed and museums feel compelled to feature the 'stars' created by the media."

Pop Art, most of all Andy Warhol, crashed through the thin red-pencil line drawn by American critics around high culture and appealed directly to the mass audience. More than the art, the personalities of the artists intrigued popular publications. There, Warhol's shameless pursuit of notoriety fit like one of his outrageous wigs onto the bald accounts of his behavior. At a Museum of Modern Art symposium in 1962, the literary critic Stanley Kunitz wondered how to explain "the overnight apotheosis not of a single lonely artist, but of a whole regiment wearing the colors of Pop Art." He compared it to an

advertising blitz and blamed "the real artists . . . the promot-
ers."

Such an explanation seems altogether too simplistic. In
American society, promoters indeed beat their drums loudly
and long, but the public appears to be exceedingly finicky about
the drumbeats it finds enticing. The history of advertising is
strewn with the skeletons of failed campaigns; there is not a
manufacturer of any line of consumer products who rolls out
new products, whether cars or toothpaste, with any confidence
in its success. Despite so-called research, the mechanism of
how the public allots its affections continues to be elusive. Each
year brings fresh evidence that no amount of cunning promo-
tion can guarantee the success of any product, including art.

What had happened was that a new art audience was gath-
ering. By the late 1960s many observers noticed how writing
about art had seeped out of specialized art publications into the
general media. Taylor and Brooke wrote that many dealers
"would give an arm for a spread in a color magazine section
accompanied by some assurance of how trendy this or that is
and how everybody who is anybody has already bought it, or a
lengthy report in the news columns of the year's spectacular
ups and downs in the sale price of art in general and their
specialty in particular." With rising public interest, art maga-
zines were more dependent than ever on dealers, not only for
most of their advertising but also for ideas about articles and
for photographs of new art. By the late 1970s Harold Rosen-
berg saw "a profound crisis" in the way dealers had shouldered
aside art critics as tastemakers.

Within the community of artists, as well, critics no longer
received the respect an earlier generation had given them.
Where in the late 1960s vanguard artists saw themselves in a
"hip and thigh struggle" with critics over who was the ultimate
arbiter of taste, a decade later the growing market for art had
called forth so many different styles that any overarching
theory of art, such as Greenberg's formalism, became irrele-
vant. The most simple-minded works seemed able to shout
forth their own message, said one artist, but for those that
were more subtle or profound, the artist or dealer must gener-

ate "the conceptual wrapping which makes the hole in the Nevada desert, the plywood box, the stacked railroad ties, or the pile of felt waste 'art.' " A number of artists, including Donald Judd and Robert Morris, were themselves moonlighting as art writers. As in the case of dealers writing about their own artists, hardly an eyebrow was raised in the art world about this conflict of interest.

Near the end of the 1980s, with more people than ever active in the art market, Barbara Rose acknowledged that critics had been totally emasculated by "dealers who have developed a sharp pseudo-historical rap that convinces their new-rich clients with the authority of sales charts of rising prices." Art, she wrote, "is indistinguishable from any other commodity, impervious to the authority of reasoned or knowledgeable judgment." Peter Schjeldahl, who wrote on art for 7 Days, cynically compared art critics to "Park Avenue maids. We have a full view of an indecent amount of wealth. We have intimacy with money and then we get our $300 per week and go home."

4

COLLECTORS:
THE ULTIMATE SHOPPING SPREE

Mark Rothko's funeral took place before the last rites for artists—even famous, successful, and rich artists—turned into tribal rituals televised for the evening news. Nevertheless, the powerful and varied group of patrons who gathered on February 28, 1970, at the fashionable Frank E. Campbell Funeral Chapel on Madison Avenue and Eighty-First Street indicated how lofty was the position of artists, even American artists, in the hierarchy of the art world. The crowd at the funeral also indicated that Old Money, the hereditary rich, had been joined in the rarefied realm of art by upwardly mobile newcomers, people who had been busy making fortunes or attaining advanced degrees during the previous quarter century. Some twenty-five years earlier, by contrast, only a tiny band of insiders had assembled to mourn Piet Mondrian. The Museum of Modern Art's Alfred H. Barr, Jr., had stepped in to give the funeral oration after the Dutch consul general in New York confessed he had never heard of the artist.

For Mark Rothko the mourners included many who had barged into the patrician art world by becoming patrons of contemporary American art. Over the previous twenty years they had lifted Rothko from anonymous poverty to the pinnacle of fame and wealth. For the artist their purchases had meant a move from downtown's flaking plaster and splintery floors to uptown chic on the East Side. Born in Russian Lithuania in 1903 and named Marcus Rothkovich, he was brought by his family to Portland, Oregon, in 1913. So poverty-stricken

was his childhood, he complained many years later, that he had never learned to play. Winning a Yale scholarship in 1921, he bitterly dropped out two years later and pursued radical politics along with an abjectly unsuccessful career as an artist. In 1929, he obtained a part-time job teaching art, work he said he detested yet continued for thirty years, even after he became famous. The turning point came in 1952, when the Museum of Modern Art included him in a major exhibition. In 1958 financial success followed, when his exhibition at the Sidney Janis Gallery attracted rapturous reviews—and collectors willing to pay into five figures for the right to own a Rothko. His behavior had always been erratic, but the money rolling in seemed to push him over the brink into bizarre deeds. One afternoon in the 1960s he punched his fist through a glass door at the Whitney Museum; while the doctor sewed up the cuts, Rothko refused anesthesia. He also began to drink to excess.

Still, the mourners at Rothko's funeral were shocked by the artist's gruesome suicide two days earlier. They collected in small knots outside the funeral home on that chilly afternoon, sharing recollections of the artist and speculations about the future of his work. Among them were William Rubin, the Museum of Modern Art curator who for some years had advised Rothko professionally, and Henry Geldzahler, who only months earlier had included Rothko in a controversial exhibition at the Metropolitan Museum of Art. Also present was a covey of art critics whose writings had elucidated and endorsed Rothko's brooding, ethereal abstractions: Dore Ashton, Thomas B. Hess, Max Kozloff, Irving Sandler, Brian O'Doherty, Katharine Kuh, and Elaine de Kooning.

The number of collectors who were there to pay their last respects, and who claimed profound influence on the artist's career, indicated yet another way that the art world had changed over the previous quarter century. Beyond patronage, they also desired, perhaps even boasted of, Rothko's friendship. Dominique and John de Menil had flown in from Texas; they had commissioned a series of somber paintings for a chapel they were building in Houston. Ben Heller, a textile manufacturer, collector, and private dealer, had befriended Rothko and

many of the other Abstract Expressionist artists during the early 1950s, when most American art collectors were still looking (vainly, it turned out) for a new European avant-garde. Also present was Robert Scull, the gruff New York taxi mogul who had infuriated Rothko five years earlier by including one of his works among twelve Abstract Expressionist paintings he disposed of at Sotheby's. The city's most visible patron of Pop, Scull had netted $165,000 from that auction. To counter critics who objected to his auctioning the work of living artists, Scull said the proceeds would finance a foundation to aid young artists.

To Rothko, the Scull sale in 1965 had been just one bitter signal that the heyday of Abstract Expressionism had passed. To a man who had toiled to make ends meet until he was well into middle age, the pleasure of his acceptance in the early 1950s and the financial success that followed quite a few years later were mingled with chagrin. William Rubin called Rothko's death "an incalculable loss to modern art," but the artist had long been consumed with anger and grief that Pop Art, facile, easy to understand, and even easier to buy—it was still cheap—was attracting more collectors than had ever before dreamed of entering the august realm of art patronage. During the last few years before he savagely slashed the veins and arteries of his wrists, Rothko had been increasingly agitated by what he saw as the calculating way people looked at his work. He had refused to exhibit it since 1961, worried that his pictures would be "permanently impaired by the eyes of the unfeeling." In the spring of 1969 he told a visitor to his studio that he wanted those who viewed his shadowy paintings to cry, "the way I do when I hear Beethoven's Fifth Symphony."

By then Rothko was willing to sell only two paintings a year because his immense income created too many tax problems. He had come a long way since his first exhibition in 1946, when the most expensive work cost $150. Two years later the top price was $600 and the following year he dared to charge $1,000 for a large work. In his 1950 exhibition six paintings sold for $650 to $1,300. From then on, prices had gone consistently skyward, especially after his 1961 retrospective at the

Museum of Modern Art. While it honored Rothko's achievements, this exhibition, like all museum retrospectives, proclaimed that the artist had reached his mature style and was no longer a rebellious innovator. The parade of collectors who beat a path to Rothko's New York studio at 157 East Sixty-Ninth Street was met by a former radical who was alternately triumphant and ashamed at how much they were willing to pay. The director of the Basel Museum got a $10,000 discount on a $45,000 painting. To a doctor Rothko offered a small work for $7,000—half price, he said, "but don't tell anyone." The writer Bernard Malamud walked out with two paintings for $6,000, although Rothko told him to insure them for $24,000. As though contemptuous of even such bargain sales, Rothko often threw wads of money into drawers or stuffed them among rolled-up canvases; sometimes he would rush to the bank to stash packets of bills in a safe-deposit box. During ten months in the late 1960s, he sold $525,770 worth of paintings.

For the chapel commissioned by the de Menils, Rothko was paid $250,000. He toiled in the midst of an increasingly complex apparatus for four years to create the paintings that would eventually hang in a building designed by Philip Johnson. Assistants mixed his paints and prepared the canvases while the artist teetered on a ladder high above, dripping paint and spewing abuse at them. Visitors paraded through and watched the work as Rothko nervously demanded, "Do you see it? What do you see?" No answer could satisfy the artist. "Visitors were given to understand that they were in the presence of a supreme master," recalled Max Kozloff. "He could not tolerate praise." Facing the page in *Artforum* on which this tribute appeared was a color reproduction of an untitled 1962 painting of misty mauve and orange horizontal bands, provided by the Marlborough Gallery.

A year before his death, Rothko had concluded a massive sale of his works to the international chain of Marlborough Gallery: twenty-six oils on canvas and sixty-one smaller paintings for $1,050,000. However, the dealer would pay out this amount over fourteen years, with no interest and only $100,000 down. Moreover, Rothko was committed to restoring

paintings that had been rolled up for more than a decade and also to mounting all works on paper onto canvas. Even less advantageous to him was Marlborough's appointment as exclusive agent for Rothko, with the right to buy four pictures per year at 90 percent of an agreed price while allowing Rothko to borrow $75,000 against sales each year. The artist killed himself the night before he was to meet again with Marlborough to choose twenty to thirty more paintings to sell.

None of these arrangements was in the artist's interest. Dumping so many painting on the market threatened the long-term value of Rothko's art. Yet just before he signed with Marlborough, Rothko had turned down a more lucrative arrangement whereby a partnership of Ernst Beyeler and Arnold Glimcher would pay $500,000 cash for only eighteen to twenty pictures. But Rothko was beguiled by Marlborough's worldwide art-selling network and by the gallery's plans to publish lavish catalogs and sponsor one-person exhibitions at major European and American museums. While the public bought the scholarly catalogs and flocked to the exhibitions, Marlborough alerted collectors that all these works were for sale.

Ben Heller, for one, was gratified by such a lively demand for Rothko's paintings. He recalled his misgivings about buying art by any American during the early 1950s: "I knew, boy, this is really spent money. . . . this is out the window," he told an interviewer. A yellow-green painting had caught his eye in Rothko's studio, but "I knew that the limit I could ever spend on a contemporary American painting would be $1,000, because this is out the window." After six months of picturing the work in his mind's eye, Heller asked Rothko's dealer, Sidney Janis, to show him the picture again. Then he took it home. It was still beautiful, Heller found, but Rothko still wanted $1,500. Heller, who had learned strenuous bargaining in the garment trade, finally extracted a 10 percent "museum discount" from the artist. "Look, it's my misery," said Rothko, "that I have to do this kind of painting. It's your misery that you have to love it, and the price of the misery is $1,350." Heller paid.

Rothko's emergence from such paltry deal-making into high-flying multipicture contracts did not bring him happiness.

Though a millionaire, he lived like a pauper. His studio was furnished with junk; when he installed an illegal shower there, he worried about buying a $1.99 Woolworth shower curtain for it. Near the end, he had bought expensive tailor-made suits, but he dropped them on the dirty studio floor in a heap. He talked about providing for poor elderly artists but became enraged by the thought of people getting something for nothing. He could not trust anyone, he said, "who did not have one foot in the Depression."

When dealing with the wealthy collectors who pursued him, Rothko often behaved with arrogant caprice. In his youthful decades as a radical, Rothko had developed bitter contempt for the moneyed. Now he treated rich patrons with temperamental scorn. In the late 1950s Phyllis Bronfman commissioned him to create a 550-square-foot series of paintings, for $35,000, for the luxurious Four Seasons restaurant in New York's Seagram Building. After working on them for eight months and receiving a $14,000 advance, Rothko said he was doing the restaurant a favor by refusing to deliver the pictures: "My paintings might have been bad for the digestion of their patrons." In 1960 Rothko raised the money to buy out the Bronfman contract, and ten years later the Tate Gallery, perhaps financed by Marlborough, gathered the pictures into a special room. When Ethel Scull said she was pleased to meet him at an East Hampton party, he snapped: "That's no big deal. . . . A lot of people are glad to meet me." She asked to visit his studio, and he curtly replied, "I don't let just anybody up to my loft." She demurred, "Well, I'm not just anybody. I'm collecting art and I love your work and I would love to see it." Rothko haughtily refused.

The almost desperate quest for the company of artists by wealthy collectors formed a poignant backdrop to the tragedy of Mark Rothko. To sojourn in the presence of talent, to bask in the glow reflected from a creative vision, to bandy about the sacred first name of Jasper or Andy—this was a privilege for which many were willing to pay dearly, not just in money but in abject humiliation. Visiting an artist's loft was like entering into the shrine of a contemporary god. Hanging an original

work on the wall—or even just stashing it in a warehouse—
provided a palpable thrill surpassing most other things that
money can buy.

By an ironic coincidence, Mark Rothko's front-page obitu-
ary in the *New York Times* was flanked by two articles that
conveyed complementary evidence of art's overblown signifi-
cance and the flagrant intertwining of art and money already
evident in 1970. At the very time that Rothko was drinking
himself into a stupor, the *Times'* British correspondent was
attending the unveiling of a new portrait of Queen Elizabeth II.
In the columns to the left of the Rothko obituary, he reported
that the new portrait, the result of eighteen sittings over ten
months, evoked strong criticism because it showed the queen
unsmiling and with blemishes under her mouth and on her left
ear. Some frankly called it atrocious, and the art critic Edward
Lucie-Smith predicted it would be relegated to the basement in
twenty years. But the artist, Pietro Annigoni, who had done
five previous portraits of the queen, insisted he did not paint
for the public or even the client: "I try to satisfy myself." A
London art dealer, Hugh Leggatt, had paid the artist $4,800
and then donated the picture to Britain's National Portrait
Gallery. The artist, who lived in Florence, announced he had
agreed to such a low fee because he loved England.

To the right of Rothko's obituary, the *Times* printed a report
of a landmark auction held just a few blocks from where the
artist was staggering bleeding among his own works, still
cruelly slashing into his forearms and wrists. At the Sotheby
Parke-Bernet Gallery on Madison Avenue and Seventy-Ninth
Street, fifteen hundred "elegantly dressed women and ob-
viously prosperous men" were packed into two salesrooms as
they watched a van Gogh painting, *Cypress and Trees in Bloom*,
sell for $1.3 million. The audience clapped sedately as the
hammer banged down on a price more than three times the
previous record for a van Gogh, $420,000, set in 1966. The
buyer refused to identify himself or even allow his nationality
to be revealed. Another van Gogh, *The Laborer*, sold for
$875,000 to the Beyeler Gallery of Basel, Beyeler being one of
the partners who had made such a tempting offer for a group
of Rothkos two years earlier. At the same sale Matisse's *Fête des*

Fleurs à *Nice* fetched a record $230,000, all the more remarkable because the same painting had sold only a year earlier for $106,152.

Although paltry by today's standards, such prices merited the *Times'* front page in 1970; the immense percentage increases added fuel to the subsequent maniacal speculation in art. The news of escalating art prices, however, had perturbed or elated insiders for almost two decades. One of the earliest books devoted to collecting art for profit, Richard H. Rush's *Art as an Investment*, noted that affluence, inflation, increased education, and the great growth of museums (especially in the United States, largely fueled by tax deductions for donations) had contributed to a striking surge in art prices during the 1950s. At about the same time, Peggy Guggenheim rejoiced at "how terribly lucky I was to have been able to buy all my wonderful collection at a time [from the late 1930s to the early 1950s] when prices were still normal, before the whole picture world turned into an investment market."

A French observer in 1962 blamed the unprecedented importance of collectors in the marketplace for the "vertiginous leap" in prices for art. By then museums had gathered in the most significant works more than a hundred years old, and collectors' appetites for more recent art were sharpening. While lust for barely dry avant-garde paintings remained a rather exotic passion, the entry of outsiders—women, entrepreneurs, Jews—kept the art market at the boil. The venerable dealer Maurice Rheims observed in his relaxed memoirs, *The Strange Life of Objects*, "collector's mania is more widespread and diffuse today than ever before." Even lesser works by lesser artists became attractive during the 1960s, wrote John Walker, director of the National Gallery. "Gresham's Law [that bad money drives out good] applies equally to art," he wrote. Even "mediocre examples have become ridiculously expensive."

By the end of the 1960s some were already describing the art boom as an unprecedented hysteria: buyers were willing to gamble on almost anything as a likely investment, often paying considerable sums with little discrimination. Furthermore, insiders were alarmed that the new art public appeared to be vulgar and poorly schooled. By contrast, these critics crowned

the collectors of the past with sometimes undeserved laurels for refined taste and discrimination. According to one European dealer, the fashionable plungers on art were mostly "young, mobile, affluent, highly-trained technocrats." Because they lacked a liberal education, "their cultural level was fixated at the verbal; their eyes 'read' art, but could not see it," and therefore they depended all the more on "middlemen skilled with words to help them comprehend what they were all too eager to buy and display." These collectors were rushing to acquire all kinds of new art, observed a French sociologist: "Innovation is the principal criterion for their choice." Art collecting had become a substitute for religion, noted an American dealer. "The followers of art have become true believers, lay contemplatives. To watch a disciple staring transfixed at a Jackson Pollock . . . is like witnessing one of Zurbarán's saints receiving the stigmata."

A rash of books in the late 1960s purported to unmask the unseemly gyrations of the art market. The Venice Biennale, wrote Robert Wraight, was "a Babel-onian market at which . . . booze flows continuously for days, the expense accounts and the old pals' networks are worked overtime, deals are fixed, bribes are paid, reputations are invented, publicity stunts are thought up." Collectors were not the victims of the dealers who dominated this biannual saturnalia but were collaborators, wrote Wraight; they liked to pay high prices because "their admiration for any picture is almost invariably in direct proportion to the amount paid for it." Due largely to collectors' lack of discrimination, which barred them from developing even bad taste, he complained, "the art trade has lost the last bit of that dignity that once raised it above other forms of trade." Inevitably there were tales of extreme crassness: the collector who telephoned a New York gallery from the West Coast after reading a favorable review and simply ordered a half dozen pictures, sight unseen, from the current exhibition; the tycoon who spent months negotiating for a mass of nearly worthless nineteenth-century Pesaros for $80,000 and reneged when he realized he was not getting several dozen Pissarros; the banker who was asked whether he wanted to see the Cézanne water-

color he had purchased by phone and refused, saying no one would want to see a share certificate.

More recent observers, their memories stunted by a media-oriented culture, looked back on the period before 1970 as a kind of Golden Age when collectors of contemporary art were few and uncommonly selfless. Back then, so the mythology went, buyers were also connoisseurs, people who bought artworks for the sheer joy of living in the presence of beautiful things. These paragons involved themselves personally with artists and felt protective toward their work. They savored the dizzy notions of the avant-garde and willingly endured the scorn of philistines. Above all, they were people who would give or bequeath their collections decently to museums rather than dump them back on the market via private sale or auction. From 1945 to 1960 there were perhaps two dozen who qualified as such selfless Maecenases. But by the mid-1960s those who could afford to spend meaningful sums on vanguard art had already grown to several hundred and not all were unselfish. By 1970 the number of collectors who spent more than $10,000 per year on new art numbered about two hundred, including some Europeans such as the German chocolate king Peter Ludwig and the Italian Count Giuseppe Panza di Biumo. By 1973 some estimates put the number of contemporary art collectors as high as fifty thousand.

Looking back on the 1970s in May of 1989, one art journalist discerned "a minor league game, a diversion for the wealthy, but not at all the stuff of TV cameras, newspaper headlines, and Hollywood films; a place of traditional values of discretion. . . . Hype . . . was still spelled with a lower case 'h.' " Globalization and the growing dominance of auctions changed this idyllic scene, wrote Stuart Greenspan in *Art & Auction*. Unlike the chaste, decorous aesthetes of the past, most collectors in 1989, he concluded, were motivated by social, business, or investment reasons. A dispassionate look at the past, however, indicates that such inelegant motives have always been potent stimuli for collectors. Gerald Reitlinger, whose massive study of the art market looked back to earlier Golden Ages, was appalled by the coarse acquisitiveness of the 1950s: "taste on

the expense account . . . the market of the declining Roman Empire of Western man." Yet his three-volume *The Economics of Taste* documents a steady parade of fashionable art acquired by high fliers back to the eighteenth century at what were then considered exorbitant prices and for mostly nonaesthetic reasons.

Two striking differences separate the universe of collecting inhabited by those Reitlinger studied and that in which the collectors of today dwell. One is that far more people today than ever before have the money to engage in serious collecting. The other is that far more collectors than ever before are interested in the art of their own time, contemporary art. Of the one hundred leading American collectors surveyed by *Art & Antiques* magazine in 1989, seventy-six collected art of the twentieth century; thirty of those were interested only in contemporary art. By contrast, only nine mentioned Old Masters (and Malcolm Forbes said he collected "anything").

At the very apex of the American collecting pyramid for contemporary art cluster perhaps ten or twelve individuals who willingly plunk down many millions for a desirable work. Most of them remain adamantly anonymous, refusing to allow auction houses to reveal their names when they bid successfully. Among those who are not is Hans Thulin. A Swedish real estate magnate who owns the West Coast Hotels, based in Seattle, Thulin paid $7.04 million for Jasper Johns's *White Flag* at a November 1988 auction. He also collects antique automobiles and in 1987 paid $9.85 million for a 1931 Bugatti Royale sports coupe. More narrowly acquisitive is the publishing tycoon S. I. Newhouse, who is said to be worth more than $3 billion. Vowing to "get that picture," he paid $17 million for Johns's *False Start* in November 1988. (His wife meanwhile confided to a friend that she would have preferred a celadon plate.)

Below this stratospheric level is a group of some hundreds of individuals—and, increasingly, corporations—who may be as wealthy as Thulin or Newhouse but who do not make the headlines in May and November, when the big auctions take place. They avidly follow the gallery and museum scene and buy the bulk of new work by fashionable emerging artists.

Most of them have made fortunes in the business world, although highly paid entertainers and sports figures are also represented in this group. Almost all of them say they buy for the love of art, and few admit that profitable investment is a goal. Yet these triumphant veterans of a grand succession of lucrative business and investment decisions would consider themselves fools if their art purchases became dust. That art might also be a good investment, writes Richard H. Rush, provides "a splendid excuse for a person to buy what he loves." To Henry Block, the founder of H & R Block accounting firm, for example, finding the right picture is "a real challenge . . . almost like making an acquisition of a company."

When Hugh Hefner decided to dispose of a de Kooning and a Pollock at auction in May 1987, the executive vice president of Playboy Enterprises insisted the works had been bought years earlier because Hefner admired the artists. Yet "there has never been a better time to sell this kind of artwork than right now," Hefner's business manager, Richard S. Rosenzweig, told the *New York Times*. "We are a corporation and we have a responsibility to the corporation to capitalize on this investment. This is a primo time and those paintings are 10s." However, as with all investments, timing is crucial. The Playboy Corporation's stockholders may have exulted over obtaining $2.53 million for the de Kooning and $2.57 million for the Pollock, but only two years later a similar Pollock, *Number 8*, sold for $10.5 million.

Such bonanzas are but airy pipe dreams to the great mass of contemporary collectors. Numbering in the tens of thousands, they are generally well-paid executives and professionals who use art to import excitement and culture into relatively humdrum, routinized lives. On weekends they stream from safe, sedate, and boring suburbs to stroll on gritty city streets in places like SoHo where, among unusual restaurants, trendy boutiques, and avant-garde galleries, there are glimpses of a different sort of life: free, impulsive, creative, personal. Shopping for art implies also the possibility of acquiring a piece of the artist's enviably liberated lifestyle, if only in fantasy. Safely back at home, they display their trophy; it represents their risk of daring to be different, their assertion of individualized taste,

a safe yet tantalizing identification with something avant-garde. Though pronounced dead for decades by scholars, the ghost of the avant-garde still rattles its titillating chains, if only in the collector's fantasies. Still, among materialists living in a money-oriented society, the possibility of making a killing in the art lottery enters into their choices.

Hindsight shows that some collectors indeed profited handsomely on their purchases. A typical German Expressionist work purchased for $1,000 in 1950 was worth $3,900 five years later and by 1960 could have fetched $15,860. Other categories of art also multiplied riotously in value between 1951 and 1969. The most profitable investments were in Old Master prints, which multiplied thirty-seven times; modern pictures, twenty-nine times; Chinese ceramics, almost twenty-five times; and Old Master drawings, twenty-two times. Less profitable categories were Old Master paintings, which multiplied only seven times, and French furniture, which multiplied five times. More recently some of the best-known contemporary art has also shown considerable appreciation. In the decade 1979–1989 a "basket" of post–Second World War paintings sold at auction increased by 581 percent, according to the Sotheby Art Index.

The trouble with such optimistic analyses is that it is virtually impossible to anticipate which kinds of art, and which artists within those kinds, will appreciate in the future. The investor who in 1873 paid almost $100,000 for Sir Edwin Landseer's particularly sentimental Victorian dog picture *A Distinguished Member of the Humane Society* might have wept (if he were still alive) to see the same picture sell in 1967 for about $800. Similarly, Thomas Gainsborough's *Blue Boy*, which Henry Huntington bought in 1921 for the equivalent of almost $2 million would have been worth perhaps $500,000 a half century later.

Among contemporary works, choosing those likely to appreciate is a process about as scientific as placing chips at roulette. Furthermore, the works themselves may be ephemerals. The crockery Julian Schnabel glued onto many of his can-

vases pops off "with some regularity," noted one conservator, and the straw embedded in some of Anselm Kiefer's paintings is bound to turn to dust. Work by this artist, one specialist advised, should be stored horizontally under glass if the owner wants to enjoy it in twenty-five years. A Barnett Newman auctioned for $770,000 in November 1989 had succumbed to severe crackling and had already been obviously retouched during its forty-year existence. Even museums are finding chunks falling off Pollocks, stains spreading across de Koonings, and the acid in newsprint embedded in Jasper Johnses eating up the rest of the work. In 1988 Harvard had to remove five Rothko murals from a penthouse dining room after sunlight had irreparably transformed a fugitive pigment, Lithol red, into anemic, watery blues.

Despite all the headlines about $50 million artworks, most economists who in recent years have studied art as an investment agree that the chance of reaping a windfall profit remains slight. A Rand Corporation study of the Sotheby-Times Index over twenty years from 1950 to 1969 found that the overall return on paintings was 73 percent of a similar investment in equities, not counting the expense of shipping, storage, insurance, and conservation that paintings or sculptures entails. Another economist who pored over the price behavior of more than fifteen hundred paintings between 1780 and 1970 did find that art prices rose markedly between 1954 and 1974, but this was the only period in his study of almost two centuries when art prices appreciated enough to attract speculators. His complicated formulas revealed that over those 190 years the rate of return on older art was about half that for common stocks, while for recent works the return was about the same. In 1980 the Economist Intelligence Unit, a London research group, compared prices of 182 works in fourteen categories to the London Stock Exchange Index of industrials and also to the Dow Jones Index. Some 69 percent had outperformed the stock indexes, 3 percent did as well, and 28 percent did less well. Nor did higher prices always mean immense profits. The most ex-

pensive picture in the survey, Renoir's *Pêcheur à la Ligne*, sold
for $1.2 million in 1979, giving the owner a scant 26.3 percent
profit at the end of eight years.

Some investors might be encouraged because during the
years 1984 to 1989 the Sotheby Art Index for all paintings rose
20.9 percent annually, with Impressionist and modern works
rising 32 percent each year. The Sotheby Index, however, is not
to be considered an unbiased measure such as the Dow Jones or
Standard and Poor's 500. Unlike those indices of rise and fall in
a representative array of stocks, the Sotheby Art Index is based
on an inevitably varied array of artworks sold during the pre-
vious month or year. Furthermore, its components are chosen
by experts at the auction house, which has an interest in por-
traying a steady rise. In contrast to the Sotheby Art Index, the
experience of the British Rail Pension Fund, the most massive
and carefully planned purchase of investment art to date, indi-
cates that, barring lucky strikes, profits in art remain trifling.
Between 1974 and 1980 the fund sank some $80 million into
various kinds of art selected by Sotheby specialists. In June of
1987, when television cameras frequently scanned the action at
Sotheby salesrooms on both sides of the Atlantic, the funds
began to unload their treasure. Two years later the net profit
amounted to all of 3 percent per year.

Even the spectacular auction price for Renoir's *Au Moulin
de la Galette* did not bring its owner spectacular profits. Bought
by John Hay Whitney in 1929 for $165,000, it fetched $78
million in May of 1990; compounded, the annual rate of return
was just 10 percent. For the buyer of contemporary art, the
chance of making a killing is near zero. Of all works sold in a
given year, said Gilbert Edelson, counsel to the Art Dealers
Association of America, 99 percent decline in value.

The economist who recently waded into the art investment
morass, William D. Grampp, also asserts that art speculations
render meager returns, if any, compared with investments in
securities. "Art for art's sake has a firm grounding in neo-
classical economics," he notes, whereas art for profit's sake
remains a mirage. Without resorting to the complex formulas
spun by other economists, Grampp points a warning finger at
the extreme speculativeness of art. For one thing, unlike the

publicized auctions of famous works by famous artists, most art sales are private and involve far lesser artists; the would-be speculator commands less hard information about past performance than a rail-bird at the races. For another, as the value of an artwork increases, the cost of holding it also mounts, because the art could be sold to buy other profitable assets. Finally, argues Grampp, the dismal feature of art as an investment is that, unlike securities or real estate, its value frequently falls to zero, so frequently, in fact, that all but one-half of 1 percent of the art of the past is totally worthless. Most vulnerable to total collapse, he found, is the most recent art. Only those who love high-wire risk and also enjoy art will buy contemporary art with an eye for profit; if risk alone appeals, Grampp recommends a flier on commodities or a trip to Las Vegas, because gambling on art "offers fewer thrills and calls for more patience."

Edythe Broad (or Edye, as she prefers to be called) was twelve years old when she bought her first work of art. For many years after she married Eli Broad, she disposed of a small "acquisitions budget," which she spent mostly on modern works, a Cézanne print or Toulouse-Lautrec posters. Her husband, meanwhile, was busy building a one-man Detroit accounting practice into a vast Los Angeles–based multinational construction conglomerate, now ranked among the Fortune 500. Not until 1974 was she able to snag her husband from his far-flung business and philanthropic activities and convince him to become seriously interested in collecting art. A man who constantly dealt with the vertiginous ups and downs in the housing construction business, Broad saw art collecting as a peaceful retreat. But as he does with his work, Broad jumped into collecting with zest and finesse. Now the couple manages three separate collections encompassing hundreds of contemporary works. They have never sold anything, but they did trade some of the moderns Edye had bought for more recent works. Although their home in Brentwood, California, encompasses perhaps ten thousand square feet, they can display only

about one-quarter of their personal collection; another one-quarter is out on loan, and the rest is stored in the headquarters of their family foundation in nearby Santa Monica. The Broad corporate collection enlivens the headquarters of Broad's construction and financial services companies in West Los Angeles as well as the four floors occupied by Broad's construction subsidiaries in Paris.

About once a month the Broads spend a weekend in their Fifth Avenue pied-à-terre in New York. Saturdays they devote to the hard work of adding to their collections. A limousine picks them up at 9:30 A.M. for the circuit of several artists' studios, places previously recommended by their foundation's curator, Michele De Angelus. By lunchtime they are making rounds in SoHo, then they head for Fifty-Seventh Street and farther uptown to the galleries along Madison Avenue. "It's a campaign," says Broad, who spends his long workdays following a meticulous schedule drawn up by two assistants. Buying art by the most wanted artists involves more than sturdy feet, eager eyes, and a ready checkbook, he says, recalling a scene at the Mary Boone Gallery in May 1989, when he watched the Zürich dealer Ernst Beyeler abjectly begging for a chance to buy a picture by Boone's latest sensation, Philip Taaffe.

"Artists and dealers nowadays don't sell," says Broad, "they place." Most galleries sell works before an exhibition opens, so even well-known collectors like the Broads must scout the studios; sometimes all they get is a place on the waiting list for the next show. In recent years 95 percent of their acquisitions have come directly from artists' studios. Competing successfully against other eager collectors takes all of the potent persuasive powers that have made Broad such a business success. It helps, he says, that, unlike many other collectors, they don't resell their purchases and, by contrast with museums, they don't hide them out of sight in the basement.

The Broad Family Foundation started out in 1984 with a mission similar to that of many beginning collectors, to acquire works by emerging artists. As the canvases accumulated, however, curator De Angelus persuaded Broad to focus on certain artists and "to collect them in depth, to collect pivotal pieces."

Currently the refurbished five-story telephone switching station in Santa Monica exhibits a changing selection of works by such art stars as Cindy Sherman, Jean-Michel Basquiat, Anselm Kiefer, Robert Morris, Leon Golub, Barbara Kruger, and Jenny Holzer. The foundation now owns some 250 works, bought at prices from $20,000 to $40,000. Its building is open only by appointment and only to art professionals, although it lends its holdings for special exhibitions and sometimes long-term display to museums around the country.

While the foundation's loans are bound to publicize the artists it collects and thereby enhance their prices, Broad remains skeptical of art as an investment. He is pleased that many of his purchases have appreciated in value because "it validates your taste" but finds the market too inefficient to reward speculation. It costs less than 1 percent to buy or sell securities, he points out, while an art auction involves a 10 percent commission for buyers and another 10 percent for sellers. This price spread means that a speculator automatically loses 20 percent, far too much for Broad to consider such investment profitable. "It's like a house," says the man who runs the biggest home-building enterprise in California. "All you get when the value goes up is bigger insurance bills."

A French brain specialist examined a prominent patient and was about to reassure him that he was in perfect health, when the man said he admired the doctor's taste in art. "Are you a collector?" asked the physician. "Yes, but I specialize," the patient replied. "Since my childhood, I have been collecting croissants from all the pastry shops and bakers in the world. I keep my collection a secret and house it in a place that I have constructed for the purpose, where I can regulate the temperature. I shall bequeath my croissants to the Louvre after my death."

A group of fifteen scholars including psychologists, anthropol-

ogists, sociologists, and professors of marketing traveled across the United States during the summers of 1986 and 1987, conducting the most elaborate study ever of what makes people stuff their yards, garages, living rooms, closets, and attics with the useless objects that constitute a collection. They went to swap meets and antique and art shows, attended meetings of various specialized collecting groups; followed up on classified advertisements for various items, and interviewed a host of individuals. The scholars expected to confirm earlier findings that collecting is an obsession as well as a compulsion, but they were shocked by its addictiveness. Like those addicted to drugs or alcohol, collectors viewed adding an item to their collection as a "fix . . . the focus of release from other fears or feelings," they reported. "Insecurity prompts the addicted individual to seek reassurance through a repeated ritualized activity," they wrote, citing an Arizona man who rushed away from his mother's funeral in order to dicker for a choice addition to his hoard of Barbie dolls.

Far from admitting to the shame experienced by alcoholics or drug addicts, however, most collectors considered their addiction a sublime asset. They described "altered states of consciousness," mood swings that the scholars believed resembled "the euphoria and depression induced by chemicals. . . . The search process is clearly a thrill-seeking experience. . . . Collectors often report feeling both a craving and a loss of control with respect to their acquisition habits." Some of those interviewed wished that there were self-help groups to treat compulsive collecting, but many others seemed to be resisting completing their collections, perhaps because they feared withdrawal symptoms.

For about fifteen years, says Frances Gorman, "collecting was our life . . . twenty-four hours a day." She and her husband, Eugene, spent about $1 million on the thousand or so items massed in their corporate collection, including a black-and-white Yves Klein, a Louise Bourgeois, and a Christo. But when they had to sell the corporation because of financial reverses,

the art, then worth about $3 million, went too. After it was gone, Frances admits she was "wild. It was as though someone had kidnapped my children. . . . We thought collecting art would be wonderful, but it's downright dirty and rotten. We thought people were friends. . . . They wined and dined us at their homes. But then, when you have trouble, they don't know you." She also thought that the artists they patronized were friends. "But if you're not buying, they don't know you either."

A slender woman with frizzy red hair and sharply fashionable clothes, Frances prides herself on frankness and saying anything she pleases. Now she and Eugene are trying to acclimate themselves to reduced circumstances, a spacious new loft in Tri Be Ca. A few floors above the fumes of clogged traffic creeping toward the Holland Tunnel on Hudson Street, the Gorman loft is guarded with prisonlike security. The name is not on the bell at street level, so a visitor must know the apartment number. Buzzed inside, one enters an elevator and waits to be lifted to the appropriate floor. When the door opens, a husky black dog strains at the leash. It is a *shar-pei*, a rare Chinese breed on which the *fu* dog is modeled, and its name is Sotheby.

The Gormans' new loft is already stuffed with new art purchases. Some works are stacked behind furniture, still swathed in bubble wrap from their recent move. Eugene, a handsome, graying country-club type in tweed and corduroy, pulls out each item and, without unwrapping it, proudly recites the name of the artist. It was Frances who originally got him interested in collecting when they were living in Reading, Pennsylvania. She began to buy art and antiques for her mother and is still pleased at having spent $28 for a Hudson River painting now worth more than $10,000. But she also admits that "being a collector is a terrible illness. . . . You are possessed by possessions."

Collectors of fine art like the Gormans would be chagrined to be lumped together with those who accumulate Barbie dolls, baseball cards, Mickey Mouse mementos, rusty farm imple-

ments, or souvenir teaspoons, but the motivations uncovered by the scholars seem to be similar for all their subjects. Making a collection, they found, "legitimizes acquisitiveness as art or science." All collectors avow a noble purpose: generating knowledge, preserving fragile art, or providing those who see it with a richer sense of history. Their highest goal is to shepherd their collection safely into a museum or even create their own museum. By investing so much effort in the search and acquisition, the collector convinces himself or herself and others that the activity is not "mere stockpiling or warehousing, mean acquisition, or sheer accumulation."

Nelson Rockefeller began collecting art when he was still in his twenties. The son of an avid collector, Abby Aldrich Rockefeller, he was also a trustee of the newly established Museum of Modern Art during the 1930s and became president in 1939. At various times, he accumulated Chinese and Japanese art, a genre favored by his father, John D. Rockefeller, Jr., but settled on modern art because, he said, Oriental art had become too expensive. The museum connection, however, simplified his choice, since he was able to shop many of the exhibitions held at MOMA and also relied heavily on the advice—and direct purchases—of the museum's founding director, Alfred H. Barr, Jr.

When Rockefeller was elected governor of New York in 1959, he angered and baffled many politicians by installing portions of his by then enormous collection in and around the governor's mansion in Albany. In the provincial state capital, Rockefeller told one interviewer, collecting any kind of art was considered effete. Even worse, the governor's array of Matisses and Picassos, Dubuffets and de Koonings, seemed to taunt rural upstate politicos with the wicked sophistication of New York City. As Rockefeller would have it, his taste in art endangered his very political career. At first, the hardbitten legislators of Albany boggled at the governor's artistic taste and sneered in the stereotyped manner of philistines: "My kid could do better than this." But as Rockefeller told it, his persis-

tence in exposing them to baffling new art converted the brutish heathen of upper New York State to acceptance of, if not downright affection for, vanguard art. It was not a lust for power that motivated Rockefeller, another interviewer reported, nor was it "an epicurean need to reflect a standard of richness." Rather, the governor basked exclusively in "the spiritual delight and solace which he receives from looking at art."

Rockefeller also indulged the typical collector's fantasy to an extent only a Rockefeller could support. While still governor, he created a grandiose mall enshrining his favorite architectural styles in steel, glass, and concrete. He also used his personal collection to establish New York's Museum of Primitive Art, which later became the Michael Rockefeller wing of the Metropolitan. To the MOMA he not only gave significant masterpieces, such as Rousseau's *The Dream* and Matisse's *The Dance*, but also lent his choicest works for an exhibition in 1969, complete with lavish, coffee-table catalog.

The scholars found that the simple act of gathering "ordinary profane commodities" into a collection transforms them in the collector's eyes into "sacred icons." Furthermore, the room, apartment, or house containing the collection becomes a sacred space. Rules for handling the collection and schedules for interacting with it "provide the ritual grounding for maintaining its sacredness." Collectors especially prize works associated with a famous artist or school of artists, and this is why they abhor fakes and forgeries: "If the aesthetic qualities of the item were paramount," the scholars write, "the forgery would not matter." Since collections are an extension of the self, many collectors also worry about the fate of their belongings after they die, especially that the collection "might fall into the hands of someone who would profane it by failing to appreciate or care for it properly."

Richard Brown Baker began collecting American contemporary

art in 1952, when fewer than a half dozen galleries were showing the works of Abstract Expressionists. He was educated at Yale and Oxford and spent some years (until he came into his inheritance) as a State Department specialist in Spain and Portugal. Finding himself inexorably drawn to collecting after visiting just a few Washington, D.C., galleries, Baker decided that art made after 1945 was a logical starting point. "Unless one is extraordinarily rich or tasteful," he decided, "one must focus on an area or aspect. So, I would rather spend $1,200 or $2,000 on a major Franz Kline than on a lesser Picasso." On an income that he says was not much more than a New York City policeman's, Baker determined to devote his life to buying art. He moved to New York's East Fifties, within easy walking distance of the Fifty-Seventh Street Galleries: "I was like a tourist with a new camera, going snap, snap, snap."

Baker's perseverance and thrift are legendary among New York art insiders. He could frequently be seen wrestling a large wrapped painting onto a crosstown bus. An acquaintance asked him why he did not have the work delivered or at least take a taxi, to which Baker replied, "Too expensive." Soon after the end of each quarter, Baker would industriously make the rounds of galleries with a neat stack of envelopes in his pocket. Presumably his trust income had arrived and now he was walking from dealer to dealer paying off his debts. "Why not mail the checks?" he was asked, and he answered, "Do you know the price of stamps?" Lately his thrift has focused, understandably, on space. "I hate to give up wall space," he says. "It's not the money, it's the wall space."

Today Baker owns more than twelve hundred works of art and continues to buy the works of emerging artists. He has never sold anything, even though his current apartment on upper Park Avenue is stuffed to overflowing with art. A tall, lean, and aristocratically graying bachelor, Baker speaks of his latest acquisitions with the indulgent affection of a parent. "Being a collector is built into certain people," he says. "There's a kind of excitement and a joy of possession." He would like to have collected in still greater depth, he says, even though two rooms in his apartment are already given over to bulk storage

of art and art fills every level or vertical surface of the rest. However, like his Yankee forebears, one of whom was the founder of Rhode Island's Brown University, Baker brings a touch of stern puritanism to his pleasures. "It's not safe to invest one's hope and money if the goal is only to be admired for one's possessions," he says. Rather, Baker considers his collecting as a charitable act, "an essential element in a good artist's career. My purchases enable him to live and work." And after he is gone, a few pieces will go to the Rhode Island School of Design, the rest to Yale University Art Museum.

Because a collection is so intimately entwined with the collector's sense of self, the scholars found, many live in terror at the prospect of completing their collection. For "if there is nothing left to collect, who is one then?" Many of those interviewed described the exhilaration of smoking out new items and the bliss, not of possession, but of acquisition. Like an artist teetering forever on the brink of completing a masterpiece, so the typical collector avoids adding the final item to his or her collection. To avert the depression that would accompany completion of their collections, they redefine what they collect or expand its scope. When money runs short, collectors often trade up or sell some things in order to acquire something else.

Though they are intensely relevant, the sober findings of the scholars would have seemed dull as dishwater to Ethel and Robert Scull, the unlikely couple who streaked across the collecting galaxy on the cusp of Pop Art. For the decade between 1964 and 1974, the Sculls were watched and envied, photographed and interviewed, deplored, mocked, and admired. What Ethel Scull wore, other women wanted. What Robert Scull bought, other men craved. Scull was "a painting addict," said a friend. "He's taking art in the veins, a mainliner." Jasper Johns created a fountain pen for their son Jonathan's bar mitz-

vah. George Segal created a plaster Ethel Scull, complete with Courrèges mini-dress, and was annoyed that the ruin of her boots in the casting process occupied the gossip columns and even art magazines more than the artwork to which they were sacrificed. Museum directors courted the Sculls and ogled what they owned. Dealers gossiped about their most recent purchases and vied for invitations to the dinner parties held to display them. Andy Warhol himself took Ethel to Times Square for a lengthy session in an automatic photo booth. The resulting portrait, *Ethel Scull 36 Times*, is one of Warhol's masterpieces, a vivid likeness not only of her face but of her brash, greedy, narcissistic, flamboyant, playful, pouting, tactless personality. "How come you have so many Johnses?" she was asked. And she replied, "How come you don't?"

The many who denounced the Sculls as flagrant social climbers were correct: Bob and Spike, as he liked to call Ethel, made no bones about their vaulting social ambitions. Robert had been born Ruby Sokolnikoff on the lower East Side, the son of a Jewish immigrant dressmaker. Ethel's father, Ben Redner, had built a taxi business substantial enough to raise his three daughters in comfort on the upper West Side. Bob Scull liked to tell interviewers that he had spent many years as partner in a design firm, that he had worked on the 1939 New York World's Fair, that he had invented a new kind of garage with walls hanging from pillars. This, he said, propelled him into the taxi business, where he prospered. Ethel sat by quietly while her husband told these tales, or posed coquettishly on his lap, and only after the two parted revealed that it was her father who had started Bob in the taxi business. There was no doubt, however, that Bob's sharp commercial talents expanded the modest enterprise his father-in-law gave him into an empire that included 130 cabs with four hundred drivers; a thriving taxi insurance agency; an apartment house; garages, warehouses, and factories in the Bronx; major interests in several Broadway plays; and substantial stock in a jiffy movie company called Electronovision.

The scenario cooked up with the aid of press agents depicted Bob and Ethel meeting on a blind date, during which she

ordered champagne he could not afford. Five months later they were honeymooning in Miami. They returned to a one-and-a-half-room apartment where they slept on a murphy bed and ate in the cheap cafeteria in the Museum of Modern Art nearby. Bob was a struggling industrial designer attending City College at night, while Ethel studied art at Parsons School of Design. The next scene shows Bob diligently building the taxi business he named Scull's Angels. They are living in a Long Island subdivision where, Ethel says, people were "only interested in playing golf or playing cards," raising three boys. In 1952 Bob spent $245 on his first painting, a Utrillo fake, as it turns out, but even this inferior art investment eventually netted him a $55 profit.

Tom Wolfe called the Sculls "the folk heroes of every social climber who ever hit New York." Less charitably, the art historian Barbara Rose called them "shameless" in their unending display of "all that was considered lowbrow, déclassé, grasping, and publicity-seeking. They made a thing out of being vulgar, loud, and overdressed." Yet if their aggressive assault on the social summit in New York was undeservedly successful, they were boosted to the top by the city's most respected art figures. Henry Geldzahler, curator of American art at the Met, was pleased that his George Segal likeness in plaster occupied the foyer of the Sculls' Fifth Avenue apartment. Geldzahler said he had "learned a lot" from Bob and admired his "terrifically good taste." The Met's director, James Rorimer, enjoyed dinner at the Sculls', *Time* reported, and would watch as Bob felt Geldzahler's plaster pulse in the hallways, murmuring to the effigy, "How pale you look." The MOMA's Olympian tastemaker Alfred Barr confided to "Dear Bob" that the French hegemony of art had collapsed; he urged Bob and Ethel to be ready "when I next see you . . . with an answer to the question: Who hates Pop more, the French or the Americans?"

The apartment that the Sculls rented for $900 per month at 1010 Fifth Avenue, across the street from the Met, was for some years a crossroads for New York's social and artistic elite. Old Money like Carter and Amanda Burden, Jean Vanden Heuvel, and Kay Graham mingled there with Jasper Johns,

Robert Rauschenberg, Andy Warhol, and Alan Ginsberg. They mingled over cocktails in the living room, where two white sofas, two leather and chrome Mies chairs, and even a Steinway grand piano were dwarfed by the Warhol, the Rosenquist, the Stella, the Walter de la Maria, the John Chamberlain, the Lucas Samarras, and the Jasper Johns. They mingled over dinner around the Louis XVI table, where the centerpiece was a jangling Claes Oldenburg plaster concoction that Scull took for eight slices of jelly roll but which the artist himself identified as eight portions of cold salmon coated with homemade mayonnaise. Society columnists like Eugenia Sheppard and Suzy covered the Sculls' doings, and they were frequently pictured socializing with philanthropists Albert and Mary Lasker, Met director Thomas Hoving, the William Paleys, the model Twiggy, and former secretary of state Dean Acheson. "Everyone" wanted to meet them, Ethel recalled, and confessed surprise that "some turned out to be deadly bores."

By 1964 *Vogue* had come to call at the apartment and informed its readers that the Sculls' art was "an adventure for the eyes." The magazine's emissary declared that the collection's art-obsessed owners possessed knowing, educated eyes, senses that were alive, and emotions "as responsive as bull-whips. Art is the center of their lives. . . . They like the gossip of the gossipy art world, the quarrels, the prices paid, the switch of a painter from one gallery to another, the dancing, the hot-dog parties." To the author of this portrait, the Sculls' dining table was "a news ganglion of the art field with the important nerves connecting there." By 1966 a *New Yorker* profile reported that during the previous year only Warhol and his Velvet Underground had garnered more media coverage than Robert and Ethel Scull. Even Warhol deemed them "big— very big, the biggest—collectors of Pop," cattily reporting how at a party they gave for the opening of a new wing at the Met, Ethel presumptuously seated herself next to Mrs. Lyndon Johnson.

From the beginning, Robert Scull professed the noblest intentions as a collector. His emotions about financing an artist's "happening," he said, resembled those of "the guy who

commissioned Mozart's violin concertos." In fact, Scull brought to his art-collecting enterprise a streetfighter's style he had learned while speculating in New York city taxi permits when, in just a few years, their price soared from a few hundred dollars to $30,000. Some art dealers were aghast when Scull brought his tough bargaining style into their galleries. He asked John Bernard Myers to talk the artist Ralph Humphrey into taking $85 for a $125 painting. A few days later Myers told Scull he had talked to the artist, and before he could say anything more Scull snapped, "Good. I will pay you $25." In his memoirs Myers wrote that it was the only time in a long career of running galleries he asked a client to leave and never come back.

Leo Castelli maintained a gingerly, complex relationship with Scull: pleasure at Scull's wholesale buying habits, pain over his ruthless haggling, and anxiety over how long he took to pay for purchases. "He likes our artists," Castelli would tell his manager Ivan Karp, shrugging off the collector's crude behavior. When Scull wanted to buy everything in Jasper Johns's 1958 exhibition, even the diplomatic Castelli told him it was "very vulgar. We can't do that." Scull then settled for just eight works from the show before heading straight to Johns's studio to scarf up more.

Ivan Karp watched in wonderment as the Pop artists were drawn, one by one, into the Sculls' social orbit, at first travelling out to Great Neck for parties and later to the Fifth Avenue apartment. Around the dinner table, Scull would regale the likes of Johns, Rauschenberg, and Rosenquist with tales of the taxi business. Scull himself was amazed that some of the artists would regularly travel to the Bronx to visit him at his taxi garage. "It was crazy," he said. "I wanted to talk about beauty and all they ever wanted to talk about was gangsters and dough." But he also found it touching to be intimately involved with creative people: "You get these wild phone calls at one in the morning: 'I'm being dispossessed,' or someone needs an abortion, or someone's having a baby."

Scull traced his interest in art back to childhood afternoons at the Metropolitan, eyeing visitors there as they stood

before paintings and whispered presumably profound observa-
tions about what they saw. "There was a kind of magic," he
told one interviewer, "and I fell under the spell of this mys-
tery." But to him, he said, knowing the artists personally
brought the greatest satisfaction. To another interviewer he
described the joy of buying art even though he "couldn't sell it
for a nickel tomorrow. I love to have paintings that nobody
knows about yet. I don't want art history—I only want a reac-
tion." His purchase of Pop Art was "sort of my involvement
with freedom—freedom from anyone telling me what to buy."
Modestly he told *Time*, "I don't presume to know a great work
of art from a so-so effort. I simply buy what I feel I want to
own and I live with these things. I just love them." For a *New
Yorker* profile in 1966 he emphasized his delight in being "used.
. . . My artists use me and I've learned how to support them
without getting anything in return but that great feeling of
being involved."

Despite the spell of art, the love for unknown master-
pieces, the selfless patronage of artists, Scull also kept a keen
eye on the profit potential of what he owned. At the time he
gave these interviews, Scull had already sold off some Abstract
Expressionists, with mixed results. A sale of twenty American
contemporary works, including thirteen belonging to the
Sculls, at Parke-Bernet in October of 1965 brought less than
$300,000. Indeed, some were bought in because they did not
make the reserve. Still, the successful bids reflected significant
advances for most of the artists. Willem de Kooning's *Police
Gazette* brought $37,000, twenty times more than the $1,820
paid for a comparable de Kooning auctioned three years earlier.
One cynical observer attributed this amount, the highest paid
for any work in the auction, to the fact that this picture was
most frequently lent for exhibition at museums. A Clyfford
Still sold for $29,000, compared with $10,000 paid for a similar
work only three years earlier. Despite such advances, contem-
porary American art remained relatively cheap, wrote one
observer, because most of these works were too huge to inter-
est European collectors. To a continental critic, these vast can-
vases symbolized "the boastfulness and ostentatiousness of . . .

the typical American, a big man with a big cigar in his big mouth, riding in an absurdly big automobile."

While selling some older works, Scull also continued to buy prodigiously; by 1966 the Scull collection included 260 paintings, 135 sculptures, and 300 drawings. The Sculls shoe-horned the best of them into their Fifth Avenue apartment and stashed away the rest at Hahn's Warehouse on East 107th Street. To shrink the glut, Scull lent some 140 works for museum and gallery exhibitions all over the world. In 1970 Scull again tested an auction, sending off two first-generation Abstract Expressionist and four Pop canvases. He had too much art in the warehouse, he virtuously explained: "They should be in a place where they can be seen." The sales results were dull; nothing attained the auctioneers' estimates, and Jasper Johns's *Two Flags* (which would sell for $1.7 million in 1986) was bought in at $105,000.

By 1973, however, Scull's munificent loans to museums were beginning to pay off; a much larger public was interested in contemporary art, especially since the images the Pop artists purveyed were so accessible. Following museum exhibitions on the Continent, Europeans were suddenly pouncing on American art. Meanwhile, Sotheby's had crossed the Atlantic to swallow up the staid Parke-Bernet auctioneers and proceeded to promote art auctions as posh entertainment. With the sale of some of their treasures in mind, Robert and Ethel Scull banged the publicity drums with an energy that far surpassed their previous excesses. *Art in America* described the couple as "the most exhilarating of collectors . . . who . . . entered the artists' lives . . . and generally had to suffer the ridicule more pedigreed collectors, who collect from a distance, offer to the energetically committed." Scull spent $60,000 on a documentary film to record the circus about to unfold. In it he gruffly revealed his unvarnished views on art and money: "Art is supposed to be such a fine, tony, cultured thing, y'know, and suddenly people are bidding wildly like it was a commodity, just like any other. And I think at Parke-Bernet, that's art without the floss of culture. Over there, it's hard, cold money and business and, man, over there you've got to write a check out. There's no

fooling around and talking about the aesthetics of art. There, they just talk about the money of art."

Those who approached the floodlit entrance of the auction house on the evening of October 18, 1973, had to negotiate a psychedelic mob of demonstrators, all burning to make a statement about the event. Chanting cabdrivers accused Scull of exploitation and carried signs reading "Robbing Cabbies Is His Living; Buying Art Is His Game" and "Never Trust a Rich Hippie." Nearby the radical Art Workers' Coalition presented a raucous piece of street theater with actors dressed as beautiful people abusing other actors shabbily clad as artists. Elsewhere a small band of feminists clustered to shout in rage that the work of only one woman, Lee Bontecou, was among those to be sold. The rabble reached such a crescendo as the Sculls pulled up in a chauffeur-driven Checker limousine that the couple had to be bundled inside through a back entrance and up a freight elevator. Ethel was wearing a long black jersey Halston sheath emblazoned in sequins with the trademark of the Scull's Angels taxi fleet.

Inside the paneled mock-dignity of the auction chamber a pack of excited would-be bidders and celebrity-watchers in evening dress greeted with knowing nudges the arrival of Lee Radziwill on the arm of Philip Johnson. Months of careful planning had produced a precise seating arrangement so that those buyers competing for special pieces were literally facing off against each other. Artists received only standing room tickets, and most had to witness the proceedings on closed circuit television in a back room. Although the prices achieved seem paltry by today's standards, they brought gasps of disbelief that evening. Jasper Johns's pair of bronze Ballantine beer cans, which Scull had bought for $960, were knocked down for $90,000. Johns's *Double White Map*, for which Scull thought he was overpaying at $10,200, now sold to the canny collector and private dealer Ben Heller for $240,000. Heller was flush from selling Jackson Pollock's *Blue Poles* to the Canberra (Australia) Museum for an unheard-of $2 million. Ethel elbowed Bob and exclaimed, "That was *some* birthday present!" when the bidding for a Cy Twombly she had bought him for $750 reached $40,000.

As the documentary filmmaker's camera recorded it, Robert Rauschenberg's *Double Feature*, which Scull had bought from the artist in 1959 for $2,500, brought $90,000. Another Rauschenberg, the painting-assemblage *Thaw*, bought by Scull in 1958 for $900, now sold for $85,000. The film ground on to capture Rauschenberg, who had been a frequent dinner guest at the Sculls' apartment, rushing heatedly up to Bob and shoving him in the stomach. "I've been working my ass off just for you to make that profit," he shouted. Drunk, the artist lurched up to Scull and heatedly demanded that he buy his next piece at these exorbitant prices. "I've been working for you, too," replied Scull evenly. "We work for each other." Indeed, while Scull had paid only $1,000 to $2,000 for the Johns and Rauschenberg items he was selling, the 1973 auction for the first time established new and monumentally lofty prices for both artists. The triumph brought a new hauteur to Scull's demeanor as well. The film records someone else in the crowd questioning Scull about his profit, only to be rudely asked "Who the hell do you think you're talking to?"

While Barbara Rose fumed, writing that the auction marked the end of the art world's innocence and a warning to artists of the betrayal they might expect if they befriended patrons like the Sculls, Bob and Ethel had their own good reason for pride. The sale results showed that Bob's legendary eye for art had yielded unprecedented profits. Larry Poons's *Enforcer*, bought for $1,000, sold for $25,000; a Lucas Samarras sculpture bought for $450 brought $20,000; a Warhol *Flowers*, bought for $2,500, fetched $135,000. The sale was not merely a triumph for Scull's discerning purchases but also for his generous loans to museums. Altogether the fifty works at auction had netted $2,242,000. However, the seven works shown at the Metropolitan Museum of Art in 1969 had brought in $550,000, while ten works shown at the Museum of Modern Art fetched $487,500 and eight others exhibited at the Whitney sold for $269,500. Thus the 50 percent of all the works in the sale that had been shown under the roofs of prestigious museums accounted for 75 percent of the proceeds.

Leo Castelli's assistant, Ivan Karp, was only one among many who were astonished by the spectacular results of the

sale. It "turned the corner for contemporary art," he later told *Forbes* magazine, showing a host of new collectors that buying the works of emerging artists could be not only a trendy, enjoyable pastime but profitable as well. Moreover, the Sculls' meteoric rise to social prominence demonstrated that the world of art offered an easy entry into lofty social circles usually barred to the newly rich. With little other recommendation than their omnivorous collecting habit, the Sculls were being invited out six nights a week; Ethel's red leather scrapbook, gold-embossed with "the Sculls and the Press," was bulging with printed reports of their society doings. Not that elegant manners followed. Attending a party at Warhol's Factory, Bob Scull pressed a $50 bill into the hand of a rising young painter and barked, "We're about to run out of soda water—go get some." As he preferred, Warhol silently watched the scene and wondered, "Who could ever figure out how a man who behaved like that socially could have such a keen sense for art?" To such questions, Bob Scull shrugged: "I'd like the world to approve of us, but I don't care if they don't. I'm having a ball."

Acquiring culture is the ultimate luxury. Yet those who aspire to be its patrons soon find that although they might commission a poem or a symphony, they cannot purchase it outright nor display their treasure on a wall as concrete evidence of arrival in a higher realm. Of all the cultural circles to which the socially ambitious may aspire—the worlds of art, literature, dance, music, or theater—only the realm of art welcomes the rough-hewn dilettante. The art buyer may speak in banal accents, but his money talks with elegant finality. By being involved with art, says the private dealer Jeffrey Deitch, "people like you and me can meet the biggest names in business and, in Europe, the top people in government and politics. The art market is where it all converges."

Any buyer willing to spend Sundays, as Bob Scull said he did, "prowling studios, the upper stories of fish wholesale buildings, the back alleys of Brooklyn tenements" will find

hungry artists anxious to be friends. The wealthy patron can seldom purchase the company of writers, musicians, or performers. By contrast, many visual artists seem only too pleased to lend their presence to a patron's dinner table. As the Sculls' vault to the peak of social prestige showed, artists are not alone in their eagerness to pander to the rich. Museum curators and directors suavely troll for loans, gifts, and bequests lurking in collectors' living rooms or vaults. Writers on art and art historians feast on the tidbits of information passed around with the canapés at art parties, while dealers, and even other collectors cheerfully overlook the utmost vulgarity in the interest of doing business. After a 1964 foray to the West Coast, Henry Geldzahler shared with the readers of *Vogue* his gratification that Los Angeles, too, knew how to play the game. It was now America's second city of art because its collectors offered such warm hospitality to New York artists, critics, and museum people. Getting into the art swing enabled them to "enrich the local culture in a way that no trips to New York or reproductions in art magazines can ever equal."

Not many collectors would call their art "ritual adjuncts," but this is precisely how some anthropologists describe such goods. Contemporary paintings on the wall tell as much about their owner's status as ancestral portraits and heirloom furnishings. They are visible evidence of the owner's social position; they herald the owner as a person of advanced taste as well as wealth. Collectors of contemporary art can instantly derive enhanced status by means of what hangs on their walls. Consumption, say the anthropologists, is "a ritual process whose primary purpose is to make sense of the inchoate flux of events." By displaying expensive goods, art collectors are "drawing the lines of social relationships." Many collectors view their passion as "just a fashion," says the incurable collector Frances Gorman, with some bitterness, using business profits or even drug money to buy respect. "I wished I could stick a hatpin into all those people puffed up with their own importance." Ethel and Robert Scull, she said, "were the forerunners of what the art world became."

The publicity generated by the Scull auction attracted a

host of others eager for acceptance and social status, their refined consumption of art a token of final success. But the business world—and the tax authorities—measure success only by financial profit. To own some elegant work of art and profit from it as well strikes such collectors as the best of all worlds. However, the liberal tax deductions once afforded American collectors have gradually evaporated. Collectors today look back longingly to the 1950s, when a person could write a will giving a work to a museum, take a tax deduction of up to 30 percent of income—and still keep the art at home until he or she died. "With such a regulation in force," wrote two critics, "it would be merely wasteful for a millionaire not to make use of it to reduce his tax burden." Indeed, so beneficial was this law to donors that it promoted the founding of three hundred new art museums in the United States between 1925 and 1955.

From then on, Congress and the IRS began steadily nibbling away at the tax advantages of donating art. First to go was the right to keep the donated work until death. Next, the IRS established panels of expert appraisers to knock down the extravagant values museums previously ascribed to donated art. In a key decision in 1970, the IRS Court of Claims laid down stringent rules for art collectors who professed to be investors. The case involved Charles Wrightsman, a trustee of the Met, and his wife, who claimed that the $8.9 million they had spent on art was an investment. As such, they took large tax deductions for insurance, security devices, temperature and humidity controls, interest, art books and magazines, shopping trips to Europe, and storage expenses. The court ruled, however, that while spending all this money on art, the Wrightsmans were also enjoying it; they had not "segregated their collection in a manner that would have precluded personal pleasure." Since then, collectors who claim to be investors have had to prove that they are buying more art than they want to own and are definitely not having any fun doing so.

With thousands of collectors combing galleries for new kinds of art and with hundreds of thousands of artists nationwide

attempting to market their works, one might imagine that an almost infinite variety of art would find patrons. Not so. The surgeon or corporate lawyer, the entrepreneur or executive who strolls through SoHo or along Main Street in Santa Monica is seeking a certain kind of product. Such a collector wants something that conveys at a glance an image of cultivated taste, something immediately recognizable as superior to what the mass culture's consumers like. Still, the work should look faintly familiar, like a Jeff Koons take-off on cartoon figures or one of Anselm Kiefer's somber glances at German history. Chained to demanding professions or businesses, these new collectors often have picked up their art knowledge on the fly, while gallery-hopping or at arty dinner tables. They want art that people are talking about, art that is accessible in nonart terms: a decorative design or innovative technique, familiar images or an easily recognized style.

These products, says Charles R. Simpson, should not be so "embarrassingly obscure" that the purchaser cannot talk about the work. Meanwhile, it is up to the dealer to provide "interpretive context." He or she will supply the purchaser with a vocabulary for describing the work and its style, for example, "expressionist, but with somber colors" or "an updated comment on Pop Art." The association with familiar schools of art subtly implies that the work in question will yield both aesthetic and economic benefits. Despite the publicity about megamillion-dollar paintings, the vast preponderance of art collectors fall into this middling, relatively uninformed category. One prominent SoHo dealer told Simpson that he had only ten clients with prestige outside the art world, and these included several European aristocrats. The rest were painfully insecure about their taste.

One such collector had longed for a Lichtenstein for seven years, meanwhile buying works by lesser artists from the Leo Castelli Gallery. At last, the collector was invited to accompany Castelli to Lichtenstein's studio. As the dealer and artist watched, the collector anxiously studied several new works, sensing that he was being tested; only the right choice would admit him into the inner circle of serious connoisseurs. With trepidation, he chose . . . a pause . . . then artist and dealer

smiled approval. Picking the right painting had cost him almost
$100,000.

These were not the kinds of prices that interested Robert
Scull. Ivan Karp recalled that his first encounter with the taxi
king was at the Martha Jackson Gallery when Scull appeared
announcing that he was interested in "really aggressive new
art." Karp ushered Scull to the basement, where a John Cham-
berlain crushed steel sculpture had been stashed because Jack-
son deemed its junkyard bulk too indecorous for the main
gallery. Scull gleefully hauled it away for $275. Once he was
hooked into collecting in earnest, Scull began to avoid galleries
and instead scrambled for a way to obtain the product whole-
sale. He approached Karp to manage a gallery for him. How-
ever, Karp was already managing the Castelli Gallery and
therefore suggested "a strange and odd and peculiar and eccen-
tric and spiritual" individual named Richard Bellamy, who had
discussed opening a gallery with Karp as a possible partner.
The Green Gallery, a name which piqued Bellamy's fey imagi-
nation as redolent of both newness and slime, opened in 1961
and soon gave both James Rosenquist and Claes Oldenburg
their first one-man exhibitions.

In his imaginatively assembled thrift store clothes, Bel-
lamy most impressed Scull with his aristocratic indifference to
money, but the collector was also awed by his new partner's
eagerness to escort him to the obscure locations of the new
artists' studios. Through Bellamy's exertions Scull became the
first of what would become a trampling horde of collectors
beating paths to rat-infested tenements and barren industrial
lofts in search of inexpensive new talent. Among the artists to
whose studios Bellamy led Scull were Larry Poons, Robert
Morris, John Chamberlain, and Mark di Suvero, all of whose
work Scull boasted that he was the first to collect.

The most exciting of Bellamy's discoveries in behalf of his
partner was James Rosenquist. On Scull's first visit to the
artist's studio in 1961, Rosenquist asked $200 for a billboard-
style painting; the taxi king munificently, uncharacteristically,
peeled off $250 cash. By 1962 Scull had taken down three
Abstract Expressionist canvases in his dining room to make

way for Rosenquist's *Silver Skies*, sixteen feet wide and six feet tall, which he had bought for $1,400. Then, in the winter of 1964–1965, while Americans were demonstrating for civil rights in Alabama and against war in Vietnam, rumors buzzed around the art world that Rosenquist was working on an immense project. It would become a series of fifty-one contiguous paintings ten feet high stretching for eighty-six feet. Indeed, its length was thirteen feet greater than the object it was named for, *F-111*.

Scull dashed to see the artist at work on the swarm of popular images conveying American excesses of consumption, whether of cakes, leisure, or weapons. The picture's size, said the artist, was visually equivalent to the American "economy of surplus," while its images of weapons and mushroom clouds and military emblems ominously counterpointed smarmy scenes derived from the color pages of magazine advertising. Most disturbing was one depiction of a little girl in garish makeup glassily smiling while under a gleaming chrome hair dryer . . . or was it a polished missile nose cone?

When the finished work was exhibited at the Leo Castelli Gallery on East Seventy-Seventh Street in the spring of 1965, Scull was away on vacation. After returning, he rushed to the gallery only to see the paintings being maneuvered down the stairs; Castelli had sold forty-one of the panels to various buyers for about $54,000, always stipulating that if he found a purchaser for the whole lot, the sales would be rescinded. Scull felt a burning need, he later wrote, to keep this monumental work from being "scattered to the winds." Bargaining hard, he ended up giving the artist $25,000 and paid another $20,000 to Castelli. It was probably the most he had ever spent for any work of art, but then, Scull said, he considered *F-111* "the most important statement made in art in the last fifty years." The artist also was pleased to sell his imaginative *F-111* in one piece "to someone who had probably bought the real thing many times by paying income taxes."

As word spread of his purchase, Scull's pronouncements about the painting waxed considerably more eloquent. It was "tremendous," he told one interviewer, not because of its size

but in the traditional sense: "orderliness, integrity, and execution." He demonstrated his own command of art jargon by pointing to "its authority and its content." Furthermore, he regarded the painting as "a milestone in the visual literature of what is perhaps art's greatest theme: the struggle between life and death. It speaks to all mankind," he noted—and immediately dispatched the panels on a two-year tour of major museums in fourteen world capitals. In 1968 *F-111* was exhibited at the Metropolitan next to Jacques Louis David's *Death of Socrates* and Nicolas Poussin's *Rape of the Sabine Women*, while Scull himself expounded on his art views in the museum's glossy *Bulletin*. "It speaks to all mankind," he wrote (or had someone write) portentously, "employing the plain language of everyday men, not the secret signs of the specialist."

Scull was not alive to witness the ultimate reward for his prescient purchase of *F-111*; if he were, perhaps even this bargain hunter would have lamented how dominant money had become in the world of art. On November 11, 1986, the vast square footage of Rosenquist's masterpiece was sold for $2 million to an agent bidding at a Sotheby's auction for an anonymous purchaser. The agent was Jeffrey Deitch, then working for the Citibank Art Advisory Service. Deitch glibly attributed his successful bidding to his willingness to "pay tomorrow's price. For the person who pays tomorrow's price," he explained, "it does become tomorrow's price and a few year's later, it looks like they got a good deal." Although artists, critics, dealers, and museum people had for decades inveighed against the pressures of the market in art, Whitney Museum director Tom Armstrong suddenly discovered at this sale that he was bidding against investors. Sadly, he said, "It confirms . . . that art is a commodity."

This was hardly news to Ethel Scull and the lawyers, judges, and witnesses who for eleven years had been embroiled in her divorce case against Robert. The couple's relationship had been tense even at the time of the 1973 auction, and later Ethel crowed that although Rauschenberg had wrathfully pummeled her husband at the sale, "he [Rauschenberg] kissed me." The catalog had listed only Robert as the owner of the works at

auction, Ethel explained, because he told her there were tax advantages; besides, she was laid up with a broken back, suffered while gathering shells in Barbados. She had wanted to complain about the omission of her name, she said, "but I was too well-bred." When Sotheby's advanced him $2 million before the auction, Bob showed Ethel the checks, exulting, "Now we are set for the rest of our lives." Having sold only one-fifth of all they owned, Robert moved all the rest of their art into storage, ostensibly because they were redecorating their apartment. Then, early in 1975, after thirty-one years of marriage, he walked out. A bare light bulb dangled from the foyer ceiling and a walnut dresser from a maid's room was the only furniture left in the living room when Ethel, then fifty-two years old, received the reporter from *People* magazine. "The walls ache and ache," she said, while the $850 per week alimony granted in a temporary settlement was "not enough for a sea urchin to live on." Meanwhile, a maroon limousine transported her, reclining on a board in the back, to her physical therapist and her psychiatrist.

They should never have married, Ethel later said; she quoted her mother's wail, "How could you do this to me?" To protect Bob's fragile ego, she had agreed not to reveal that the cabs came from her father. "I felt it would make Robert more secure if I let him have his illusions about owning everything and having power," she said. She agreed to tell their new friends that Robert was a professional art collector even though he was color-blind and had never even heard of Mark Rothko. Later she revealed that her husband was also a drug addict and impotent, to boot. Toward the end she feared he would beat her: "Once he broke down the door to the bedroom," Ethel told a reporter in 1981. His manners were so deplorable, Ethel added, that a New York socialite sitting next to her under the dryer at Kenneth's confided that "if he didn't have you on his arm, he would not have been allowed in anybody's living room."

But after their split, Ethel, too, fell out of "the social swirl." No longer giving parties, she was also not invited and blamed it on her name no longer appearing in the society

columns. "You fade away from the scene," she told an interviewer. "They don't know you. . . . They have to be able to say that they just had dinner with so-and-so who just gave $10 million to something. All this social thing, it's all money," she observed bitterly. "Didn't you know? Life's a fake."

After their divorce in 1978 a New York judge heard testimony and arguments as to who in the Scull family had actually made the collection. William Lieberman, now curator of twentieth-century art at the Met, told the court that Robert and Ethel's sense of style, their self-promotion, and the skillful promotion of their collection were "dazzling." The patrician dealer Eugene V. Thaw told the court that in the Sculls' hands "art was not just art, it was also . . . upwardly, how shall I put it, upwardly mobile activity." When Leo Castelli also supported Ethel's contention that she had played a vital role in forming the collection, Bob was so enraged that he never spoke to the dealer again.

Despite such testimony, the judge ruled in April 1981 that the prime mover in the creation of the collection was Robert Scull. Robert's judgment of emerging art trends was piercingly acute, said the judge; he "possessed the critical eye of a Berenson mixed with Duveen—the sure sense of where the trends in modern art were moving and where the great potential for appreciation of value was" and a knack for finding "what would endure in the frontier of artistic endeavor as opposed to transitory fads." Ethel had provided a glamorous backdrop as a hostess and party giver, he ruled, but "her husband lectured about the collection at art museums and other gatherings, and the shrewd timing of his auctions (especially the last one at Sotheby's in 1973) generated vast publicity which promoted the value of the collection." Ethel received only six paintings, the proceeds from the sale of a seventh, and $1,300 per week in alimony.

As doggedly as she had clawed to the topmost rung of New York's society ladder, Ethel now struggled to reverse this judgment. She fired her lawyer, and, after the replacement had obtained an injunction to keep Scull from selling paintings, she energetically plowed through three thousand pages of testi-

mony in search of error. The new attorney was Raoul Felder, who wears slippers and pince-nez in his office and calls Abstract Expressionism "the *schmeer* school." In 1983 Felder obtained a reversal of the original decision, a ruling so momentous, says Ethel, that it was featured on the front page of the *New York Law Journal*. It took three more years—and the death of Robert early in 1986—for the court to parcel out the property. She was awarded more than $1 million tax-free cash, plus five years' interest on it, and 35 percent of the paintings on which her fame rested. But the long conflict had taken its toll. Even as she told a reporter "I won't have to worry the rest of my life" her manner was subdued, and he detected the somber shadow of "anxiety that no amount of money could ever erase."

During the great November auctions of 1986, 140 of the paintings awarded to Robert were sold, and in a separate sale Ethel sold ten of hers. Among them was Jasper Johns's *Out the Window*, a work the couple had bought from the artist's studio in 1959 for $2,250. That occasion was memorable because it was the first time the Sculls had been granted the right to select purchases from Johns's studio in advance of his exhibition at the Castelli Gallery. Voraciously they had demanded to buy three works, even though Castelli had told them that such mass purchases were vulgar. Ethel had insisted on acquiring at least two: "I was not going to be regulated to one picture." Now *Out the Window* sold for $3.6 million. Though Ethel said she still found it "sensuous and seductive," she said she also needed the money. Asked how she would spend the $4.8 million netted by the auction, she replied instantly: "Buy art."

Her first purchase was a cartoonlike sculpture of a fisherman manufactured for the signature of Jeff Koons. "It's so ugly I fell in love with it," she says. "I love Koons, he's so ahead of himself." The manager of the Sonnabend Gallery telephoned Ethel on the last day of this Koons show to tell her a new piece had just arrived—and at a bargain price. While prices for other works started at $100,000, this one was irresistible at only $50,000. "I felt like I was back in the sixties," Ethel said. So, almost two decades after the gaudy whirl at 1010 Fifth Avenue came to its grievous conclusion, after eleven years of legal

battles, Ethel Scull's apartment high above Sutton Place is again filling up with art. She already owns works by the darlings of the new collecting breed—Basquiat, David Salle, Meyer Vaisman—and is again making the thrilling trek to studios to smoke out bargains by new stars. The first time she visited Vaisman's atelier, she begged for a small painting: "You know, I went into my number," she explains, "and three days later, I had one. I bought before prices tripled."

A wispy woman in a negligee, Ethel Scull sits in her brand-new apartment, the light streaming through uncurtained windows facing a spectacular midtown skyline, the roar of traffic on the Queensboro Bridge muffled on this high floor to a faint hiss. A large painting leans face to the wall, *Rauschenberg* daubed on the back. With some satisfaction, she describes her husband's painful, lingering death and grimly brings out a framed photo of herself and Bob in happier days; his face is surgically razored out. But her face brightens when she describes the thrill of the chase. "It's the same now as when I started collecting. It's nonstop activity . . . artists going through all these periods." She relishes even the failures of her new acquisitions campaign. She had tried her "number" on Julian Schnabel, imploring him to make a small painting specifically for her. "Years went by. I could afford it when it was promised, for $6,000, but not later, when prices jumped to $100,000. Still, we had a nice relationship, although Julian hasn't the constitution to give me a break." When she later met Schnabel at a Whitney opening, he asked her why she did not buy a painting. His work was now too expensive, she said. "As long as I have your admiration," the artist smoothly replied, "that's good enough for me."

Among followers of the avant-garde, the problem of controlling or disseminating information is made more difficult by continual change in the stock of information itself. When the whole environment is one in which inventiveness is being encouraged and paid for,

there will be a great sense of the shortage of time. It is
not just a matter of rushing to catch and use a partic-
ular form of marking, while the season for it is on,
though that may matter, too. In the top consumption
class, the attempts of some to control the information
scene are being foiled by others who stand to gain by
changing it. But since this is the class that both uses
and fabricates the information, naturally they cannot
but outbid each other and speed up the game, turning
the society into a more and more individualistic and
competitive scene.

—Mary Douglas and Baron Isherwood
The World of Goods

The Sculls were not the only couples hastening to Jasper
Johns's studio before his second show in 1960 hoping to skim
the cream off the works to be exhibited. Emily and Burton
Tremaine picked a canvas called *Device Circle*. Then the Sculls
coveted the same work, causing what cool Leo Castelli called "a
terrible fuss." The question of who was first to buy an artist's
work preoccupies many collectors, so the Tremaines were grat-
ified that a year earlier they had invested $900 in Johns's *Three
Flags*. In 1980 they would sell it to the Whitney Museum for $1
million. A month after that, they gave $4 million worth of art
from their collection to Yale and $12 million in art to the
Metropolitan.

By then the Tremaine collection consisted of more than
four hundred works illuminating a dazzling path through the
vanguard art of the mid-twentieth century. When Emily Tre-
maine chose to buy a Braque in the late 1930s, she was afraid
to tell her mother about it. Pressed to explain the strange
picture when her mother spotted it on the wall, Emily refused
to reveal how much she had paid. Her mother commented,
"Thank heavens your father left you your money in trust."
Eventually the Braque went on loan to the mother's New York
apartment, and Emily gloated that "General Electric [shares]
couldn't have been as good a thing." In 1944 she snatched
Victory Boogie Woogie straight from Piet Mondrian's easel to join

the Picassos and Klees already in her collection. Later, she added Warhols, Rosenquists, Michael Heizers, Neil Jenneys, and Robert Irwins.

Born in Butte, Montana, to a socially prominent family, she was the widow of a European aristocrat and divorced from sugar heir Adolph B. Spreckels II, when she married Burton Tremaine in 1945. During the Second World War he had built a modest sheet metal and lighting company into a sizable enterprise with nationwide contracts to illuminate war plants and convert offices from incandescent to the new fluorescent fixtures. To help him get the attention of architects who would be his chief postwar customers, Emily joined architectural scholar Russell Hitchcock to create an exhibition at the Museum of Modern Art relating modern art to architecture. Alfred H. Barr, Jr., always eager to cultivate a collector who might benefit his museum, wrote the catalog's foreword. Many of the pictures came from Emily's collection, and the rest were bought for her by her husband's company when the exhibition completed its three-year tour around the United States. Crass cash is not something a collector like Emily Tremaine likes to discuss, but she was proud that for her husband's company the publicity was worth millions.

Like investors in other instruments, collectors of contemporary art often lament their missed opportunities. Emily Tremaine recalled an afternoon in 1955 when the dealer Sidney Janis had arranged for her to visit Jackson Pollock in The Springs, Long Island. "I wanted to have about three pictures that day but he showed us so many it was difficult to choose." The artist refused to allow the Tremaines to enter his studio, instead laboriously hauling works into the house. Emily and Burton took the numbers of several picture, they liked and told Pollock they would get back to him, but then she and her husband went to Europe and "by the time we said we simply *must* call him, he was dead." Her regret was not simply for the death of the artist but also for the chance to acquire bargains; Pollock's prices leaped after his demise.

When the Pop artists came along, Emily was ready to abandon acquisition of more Abstract Expressionists; she was

"tired of all this *angst*," she said. Like many others, she also believed that Pop was a sardonic comment on American society, even if the artists themselves had no such intent. Ivan Karp took her to Warhol's studio, where she bought several items, and then introduced her to James Rosenquist, who impressed her as a Surrealist. Although the Sculls disputed it, she claims to have bought the first painting Rosenquist sold. His price then was $100 per square foot, and she paid $800 for a painting. Then Karp led her to Roy Lichtenstein's studio, where she bought *I'm Looking into the Room and There's Nobody in It*. Karp told her that these new artists had developed a common style without even knowing each other, so she invited a group of them to her home for cocktails. But, she reported in disappointment, they "did not like each other when they did meet."

The Tremaines, like the Rockefellers, typify an older class of art collectors that has deep roots in Western society. In the United States, these collectors followed a distinguished tradition of supporting new kinds of art. Louisine and Henry Havemeyer, for example, set the tone for an earlier generation of collectors, with their generous purchases of freshly painted Impressionists. Not just money but old money supports their drive to accumulate cultural goods; frequently antique heirloom furniture mingles comfortably in their living rooms with the blankness of Minimalism, the banality of Pop, the nervous flicker of neon, and the huge and often slapdash products of the latest artistic sensations.

Dominique de Menil, the heiress to a fortune built on the Schlumberger oil-drilling equipment empire, has devoted most of her adult life to collecting. "An art nun," Henry Geldzahler called her. "She had the children and then went back to preaching the gospel." She owns ten thousand or more paintings, sculptures, prints, books, and photographs representing all major styles of twentieth-century art, as well as Greek Cycladic sculptures, Byzantine icons, and African tribal objects. In 1971 she commissioned Philip Johnson to design a chapel in a nine-

block area she and her husband owned in Houston and then commissioned Mark Rothko to fill it with paintings. She brought in Renzo Piano, one of the architects of Paris's Beaubourg Museum, to design an appropriate museum to house her collection, and personally supervised the installation of the artworks. William Lieberman of the Met said she was "the best curator the Menil Collection will ever have."

Another type of collector is the entrepreneur who discovers the consolations of art after the consolations of money have palled. For the self-made millionaire, socializing with artists provides an instant—though superficial—aesthetic education. It also brings a sprightly bohemianism to dinner tables otherwise dominated by financial talk or social chitchat. Sometimes art meshes seamlessly with enterprise. David Bermant, a Santa Barbara shopping center developer whom *Art & Antiques* in 1989 placed among the top one hundred American collectors, likes to purchase technical and kinetic works for both his home and his malls. His business partners were at first dubious of the shopping center decor, but a survey showed that 30 percent of visitors there came for the art. Bermant's chief criterion for buying art is that it "makes me go 'Wow.' " Donald Bren, who is reported to own about one-sixth of Orange County, California, was also among the top one hundred, even though he buys only two or three pictures each year. Curators at the Los Angeles County Museum of Art, where he is a trustee and multimillion-dollar donor, admire the "rigor and purity" of his taste.

The takeover billionaire Asher Edelman refuses to discuss what kind of art he likes, but, though he calls auctions "a hogpen environment," he overcame his distaste to become the first to pay more than $1 million for a Frank Stella. The Wall Street raider approaches art just as he does the stock market. Aware that classical sculptures and artifacts seemed to be underpriced in relation to other kinds of art, Edelman in 1989 bought into a leading New York gallery of ancient art and has encouraged a sturdy campaign of advertising. He also wants to get into sculpture, saying that after twenty years of study "I'm almost to where I understand three-dimensional." Edelman also has

joined a campaign by New York's Salander-O'Reilly Gallery to market Jules Olitski, asserting that this artist was "the best painter of his school." Though friends said they had never seen an Olitski in Edelman's home or office, the daring financier announced, "I've always had Olitskis." Leo Castelli, the dealer who helped Edelman form his personal collection, calls him a typical 1980s collector, "ardent but not adamant in his insistence on keeping the collection intact." The Olitski arrangement, said Castelli, "seems to be more in the nature of a financial operation than a labor of love."

Larry Aldrich, a successful New York dress manufacturer, began collecting Impressionists during the mid-1930s, distracting himself from the pressures of the Paris fashion openings by attending gallery openings. After 1946 he became interested in collecting contemporary art during frequent business trips to Paris. Beginning in 1959 Aldrich gave the Museum of Modern Art $10,000 a year to buy works by new American artists. The museum's director of painting and sculpture, Alfred H. Barr, Jr., and his assistant, Dorothy Miller, could pick whatever they wanted, but Aldrich asked to view the works in advance and often bought something for himself by the same artists. By then the museum's acquisition process had become so cumbersome that six months went by after a show closed before the museum could decide what it wanted. In the meantime, the better pictures had often been snapped up by others. Soon Aldrich, who was nearing retirement, was devoting every second Wednesday to visiting galleries; so active had the New York gallery scene become that he limited his visits to the first show by a new artist. He was seeing more new work than Barr and Miller, frequently picking two works by one artist and then giving the MOMA first choice between them.

Like many collectors before and since, Aldrich soon found himself running out of space: more than two hundred contemporary works were crammed into his New York apartment, his country house in Connecticut, and storage facilities. In October

1963 he auctioned the older, more valuable items at Parke-Bernet and concentrated only on new art, planning to build a gallery onto his Connecticut house. His wife, however, disapproved, and one Saturday, while running into town to buy a pack of cigarettes, Aldrich spotted a For Sale sign on a 1783 building on Ridgefield's main street. "The next day I was there," he recalled, envisioning the historic four-story-plus-attic structure as a storehouse where, perhaps on Sundays, he could share his art with his friends. The Aldrich Museum is now a prime tourist attraction in the heart of Ridgefield, Connecticut, open on Friday, Saturday, and Sunday afternoons.

"I don't write and I don't paint; collecting is how I express myself," says a Miami businessman who in the course of four decades has assembled fifty thousand items of furniture, posters, and propaganda pieces dating from 1875 to 1945. Mitchell Wolfson, Jr., had to buy a storage company's warehouse to shelter the accumulation and expects to open the Museum of Decorative and Propaganda Arts in 1992. The overflow will supply a second museum housed in his Castello Mackenzie-Wolfson in Genoa.

Standing in stark contrast to such an omnivorous collector is Leon Kraushar, a New York insurance broker, who fell in love with Pop and only Pop. "Here was a timely and aggressive image that spoke directly to me about things I understood," he explained. In short order, he collected more than a hundred works in his Long Island home, where his spare, gray-haired figure moved with unwonted exuberance among huge and garish images. "I don't want to see European landscapes," he asserted to a visitor. "They're worn out, dead, stale."

Willi Bongard, a European journalist who spent months in America during the 1960s observing the boiling art market, was puzzled by what motivated collectors. After Richard

Brown Baker told him he had bought Lichtenstein's *Washing Machine* for $500 because it was "fun," Bongard verbally shrugged in wonderment. Europeans would never understand, he wrote, but it seemed that Americans were buying art in "pursuit of happiness." Indeed, paying higher prices appears to make some people happier. "The people who won't give house-room to an artist at $10,000 or $15,000," said West Coast collector and dealer Betty M. Asher, "will begin to consider him seriously when he hits $20,000 or $30,000." The New York dealer Terry Dintenfass also has noticed the change. Most collectors, she says, are not like Joseph Hirschhorn, who bragged about how cheaply he could buy art. "Now they brag about how much they paid."

For Vera List a Christo sculpture in her Connecticut garden represented the bluebird of happiness. The artist suggested a wrapped tree, and in the fall of 1968 his dealer, John Gibson, found himself aboard a rented truck hauling an enormous dead oak at least fifty feet long with which Christo had fallen in love. The tree projected off the truck so far that oncoming cars were forced off the road, which left Christo and Gibson "crying with laughter." When they arrived, Mrs. List absently told them to dump the tree near the side of the garden. The next day she brought in a crane to move it elsewhere on the estate, to a site overlooking Long Island Sound, and ordered a concrete base for it. Then Christo spent weeks encasing the branches in plastic, the roots in burlap, and the trunk in polyurethane. Some years later Gibson noticed that the tree was gone. The object had attracted all the neighborhood dogs, Vera List explained, so her husband, Albert, had it cut up for firewood.

People whose professions require plodding, meticulous, often stressful labor, find that collecting art represents a joyous, rare leap into spontaneity. A wealthy gynecologist, Donald Rubell,

and his wife, Mira, fell in love with a painting lying on the ground to dry outside Francesco Clemente's studio in Italy. They snapped it up, along with eight others, because, Rubell explained, they could not wait for the paint to dry. (Perhaps some other eager collector was lurking nearby.) Horace Solomon impulsively decided to spend $1,000 on a Lichtenstein he spotted at the Castelli Gallery in 1962. "I just got carried away and kept going back and buying more," he said. "After that I quit the golf club where I had been spending my spare time." Now he runs the Brooklyn Museum Gallery.

Canny collectors have quickly learned, as Robert Scull did, that exhibiting what they own in museums and developing catalogs or other documentation lend not just prestige but extra value to their collections. Attorney Stuart Speiser asked a dealer to commission a whole group of Photorealist artists to create works on the theme of his specialty, aviation. Then his dealer, Louis Meisel, packaged the works for exhibition and sent them on tour to museum and university galleries, complete with interpretive literature. The Rubells, whose collection includes examples of every 1980s trend, also sent seventy works to campus galleries around the country because, they explained, they wanted students to see contemporary art.

For many collectors today, buying art is just a glorified form of shopping. Actor Steve Martin called it "the last luxury"; in 1988 he spent $330,000 for a David Hockney drawing of Andy Warhol. Sylvester Stallone was willing to spend such large sums on art that he consulted an art broker, Barbara Guggenheim, on what to buy. Among other works, she supplied an Anselm Kiefer for a reported $1 million. Soon Stallone was described as "fuming" because the picture was falling apart, and shortly thereafter he sued Guggenheim for $35 million. The total price was flagrantly inflated, he charged, especially

since it included $1.8 million for a nineteenth-century academic painting by Adolphe Bouguereau that had belonged to her friend Stuart Pivar. Stallone complained that Guggenheim told him it was a masterpiece, although 25 percent of its surface had been restored or retouched. Pivar retorted: "She made him $3 million in four years. . . . How can he complain?" Such frustration did not drive the brawny movie star out of the art bazaar entirely. At the 1989 Los Angeles Art Fair, he spent $14,000 for a pair of life-sized mechanical pigs by the West German artist Michael Schulze.

Back in the 1960s Elaine Dannheiser used a secret signal to bid on a Marisol sculpture, only to discover too late that her husband was using another secret signal to bid against her. Since then the couple has accumulated twelve hundred works in a Park Avenue apartment and a nine-thousand-square-foot SoHo loft. At both venues they enjoy throwing parties for artists while heaping scorn on more recent arrivals in the collecting game. Art is her life, says Elaine; she sometimes spends seven days a week on it.

Eugene and Barbara Schwartz, who made money publishing books such as *How to Double Your Child's Grades in School*, like to spend every Saturday combing thirty or so New York galleries for new acquisitions. They hire a car because, said Eugene, "you can't move fast enough with a cab." Like hard-pressed business people, they "zooze in and zooze out" of exhibitions, wolfing a quick sandwich in the car between purchases. At least once a year, art installers take over the Schwartzes' New York apartment for two days to move art around and repaint walls. Their Anselm Kiefer was so huge, it had to be hoisted by crane outside the building and onto their terrace. A Jules Olitski painting, *Disarmed*, was too tall for their walls, so the artist took it back, trimmed a strip off the top, and renamed it *Twice Disarmed*.

Paul Cummings, who has observed the art scene as museum curator, writer, and interviewer for many decades, is disgusted

by what he sees. He could not name a single distinguished new collector of the 1980s and grumbled, "Most of them are gross, rich, vulgar, sly, and greedy." Like many survivors of a gentler era in the art world, Cummings implies that things were different in the past. Then, he believes, wise connoisseurs bought art with discernment and for noble ends. Perhaps he had in mind Leo and Gertrude Stein, who cultivated Picasso and Matisse when they were all young together in Paris, or Duncan Phillips, the heir to a great industrial fortune, who created a charming personal museum in his Washington, D.C., mansion. Or was he thinking of Abby Aldrich Rockefeller, who served forbidden sherry to visitors who came to contemplate the modern art in her private gallery on the top floor of her town house on West Fifty-Fourth Street? Indeed, the history of adventuresome art collecting early in the twentieth century sparkles with the names of daring, often eccentric individuals who leaped into the roiling waters of avant-garde art: otherwise sober New York attorney John Quinn; the hosts of a nonstop salon, Louise and Walter Arensberg; the dizzy black sheep among the Guggenheims, Peggy; a man who found a career in architecture through his love of modern art, Philip Johnson; irascible Dr. Albert C. Barnes; shy maiden lady Lizzie P. Bliss; bluff Valkyrie for Modernism Katherine S. Dreier. A roll call of such vibrant individualists would evoke few replies in the art world today.

The big art buyers today, says dealer Ivan Karp, are twenty-five or thirty people, "new, uninformed money," who "buy by rote." They have made unexpectedly huge fortunes in real estate or another business and are now ready to buy some culture. Another dealer, who wants to remain anonymous, calls the ignorance of some of her clients "heartbreaking." She invited one such woman, who had been mindlessly acquiring works by "in" artists, to a reading from *Finnegan's Wake*—"you know," she prompted, "James Joyce." The collecting lady proudly retorted, "We have eight Joyces." It turned out that this couple owned eight first editions of Joyce's works, none of which had ever been opened. Toward the end of his life, the critic Harold Rosenberg frequently fumed about the "unsophisticated money" that was going into art. His one regret about the

art market, he told an interviewer, "is that you can't sell short."

One person who has attempted to do just that is Charles Saatchi, the advertising mogul who during a two-decade shopping spree amassed more than nine hundred works said to be worth more than $250 million. Sometimes buying everything in a gallery exhibition, he became "the Pied Piper to the lemming-minded, status-conscious contemporary buyers," grumbled one art writer. He installed his hoard in a former factory in Hampstead, London, and allowed the public occasional peeks at his treasures. By generously lending his possessions—a 1982 Schnabel show at the Tate consisted almost entirely of Saatchi properties—he established new, higher values for everything he had chosen. But in 1989, when he began also to sell, the market quaked.

Through a shadowy middleman, Larry Gagosian, Saatchi disposed of an estimated seventy to one hundred items, sending chills down the spines of other collectors and artists as well. The sale of all but one of his twelve Robert Mangolds was an act the artist called horrible. Another artist, Robert Ryman, sadly regretted having worked with Saatchi to assemble a compatible dozen paintings, only to find that they were all dumped on the market. Gagosian emphasized that Saatchi was disposing of only 10 percent of what he owned, but his comment that they were by "artists who don't weather as well" sent an ominous signal. That Saatchi had recently bought a Warhol from the MOMA's retrospective for perhaps a record price was small consolation to the artists whose works were sold and the collectors who may have invested in them strictly because Saatchi gave the buy signal. Among the rejects were twelve Sigmar Polkes, seven David Salles, fifteen Francesco Clementes, eight Neil Jenneys, and six Malcolm Morleys.

One refuge for the artist in such a capricious environment is corporate collections, where the art serves as a subtle advertisement and image builder and healthy balance sheets prevent precipitate sell-offs. The pioneers of corporate collecting were

Abbott Laboratories, IBM, Johnson Wax, De Beers, Lucky Strike, Chase Manhattan Bank, and Pepsico, all of which were already acquiring art in 1960. By 1987 more than a thousand American corporations were buying art; in addition, the world's largest builder and landlord, the U.S. government's General Services Administration, devotes one-half of 1 percent of all construction costs to art. Although stockholders and taxpayers have often balked at these benevolences and critics have complained of blandness, corporate and public buyers constitute a steady and growing market for artists and dealers. There are no reliable statistics on such organizational purchases of art, but they account for a substantial proportion of the art trade and are especially valued because organizations buy with regularity and seldom sell.

In the corporate world, writes sociologist Charles R. Simpson, "art has come to represent a system of humanistic prestige parallel to more obvious gradations in rank and income." Corporations like to buy art that is decorative and presents a forward-looking image, but they generally shun works with erotic, political, religious, or violent content. Like private collectors, art-loving executives enjoy boasting about their investment prowess. When some stockholders murmured about Chase Manhattan's more speculative acquisitions, David Rockefeller was quick to remind them that the sixteen hundred works bought for less than $500,000 during the 1960s were worth more than $3 million by 1972.

At Minneapolis's First Bank System, president Dennis E. Evans hired a curator in 1981 to sink $3 million into twenty-eight hundred works of contemporary art for a new headquarters. "Art is the most powerful visual symbol of this organization's commitment to change," said Evans. But he also took a banker's pride in his announcement that the collection's value had doubled in only six years. By February 1990, however, Evans, the bank, and its collection faced severe reverses. Evans left the bank in 1988, and losses on its bond portfolio totaled some $310 million. The collection, insured for $10 million, was being trimmed by 20 to 30 percent, some of the most controversial pieces now deemed by a bank spokesperson as "inconsistent with our new mission."

While profit remains paramount, corporations frequently have taken to art patronage for nonart reasons. Philip Morris uses its culture-friendly image to counter criticism for selling cigarettes. Pepsico turned to art collecting during the early 1970s when neighbors protested the construction of its massive new headquarters in semirural Purchase, New York. The $1 million the food conglomerate spent on ten massive sculptures to enhance the rolling grounds also yielded a handsome return. Pepsico president Donald M. Kendall was pleased to report in 1987 that the works had appreciated tenfold; an Alexander Calder stabile, *Hats Off*, which had been bought for $150,000, was alone worth more than $1 million.

Many conscientious art consultants cringe at the sorts of art some corporations favor. Hasbro, Inc., which makes toys, commissioned a sculpture by Tony Cragg for its New York showroom featuring plastic fragments, including Frisbees and toy water pistols. One adviser says that the worst acquisitions are "simple adjuncts to wall calendars." Visually they "perform the artless function of Muzak," says art consultant Mary Lanier, who began her career as adviser to Chase Manhattan and now advises such corporate patrons as Becton-Dickinson, Philip Morris, and Dow Jones. The behavior of the best of corporate collectors, for better or worse, closely mirrors that of private collectors. Just as the routine-ridden doctor, lawyer, or accountant who takes up art collecting enjoys a leap into spontaneity, so the corporate executive, Lanier has discovered, savors the delights of shopping for art, especially when a new building is under construction or just finished. She likes to take a company's CEO on treks to studios and encourages a dialogue with artists. "The artist's work is not so different from a top executive's," she notes. "Both are multi-dimensional and creative." Lanier believes in bringing the client "up to the work, not the work down to the client." While top executives may be tolerant of some new art, the employees who work in its shadow often resist it. To convert them, Lanier writes detailed wall labels to provide a vocabulary for discussing art and conducts brown-bag lunch sessions with the artist to acquaint workers with particularly startling new pieces the boss has dropped into their environment.

Throughout history, collectors have always enjoyed linking the work of art with the artist. But in the machine-made twentieth century, wrote one student of the art market, "the collector's chief interest in a painting is in its reflection of the artistic genius and vision of its creator." As a professor who teaches artists how to market their work put it, collectors "like to buy biography." At a seminar sponsored by the National Endowment for the Arts on the business side of art, professor John Dowell told a packed audience what collectors are really buying. They like to quote the artist on his own work, he said, and to "talk about everything but the artwork." Fascinated with the artist's liberated lifestyle and the mysteries of creativity, collectors "are buying more than just the artwork. . . . They are buying a part of you." To sell themselves, he urged artists to attend as many art functions as possible, mingle rather than stand shyly in a corner, and dress appropriately rather than appear "looking as though you just dropped your brushes and ran."

Artists have always been wary, if not scornful, of their patrons. One vanguard artist told two investigating sociologists that art buyers considered having the names of artists and styles at their fingertips "a social asset. I don't think it has anything to do with basic culture." Another complained that collectors sometimes push an artist to stay with a certain style because they want their purchases to remain recognizable. Still another was convinced that a famous signature underpinned his success. "A collector would be shocked," he said, "if suddenly he couldn't recognize the handwriting any more. He's invested thousands and thousands in that signature."

While Americans had long prized social intercourse with European artists, it was only during the mid-1950s that they became interested in socializing with American artists. A new kind of collector then appeared on the scene, the critic Thomas B. Hess noted, "as interested in sharing the artist's social life as in hanging his pictures on their walls." Many artists went along, "pleased and flattered by the attention—after all, a vul-

garian who buys your paintings can't be all vulgar." The taci-
turn Jackson Pollock himself tolerated lengthy visits and long-
winded pronouncements on his work from an early buyer,
Alfonso Ossorio, a wealthy dilettante who also painted. He had
bought a drip Pollock in 1949 for $1,500 and a dozen more at
escalating prices during the next few years. When Ossorio at
last dared to show the artist one of his own creations, Pollock
pointed to a shape like a melting ice cream cone in one corner.
"This painting of yours," he said, "it's about this." Even such a
sparse critique from the great man delighted Ossorio; he re-
peated it for years to all his friends.

So keen are some collectors to immerse themselves in the
racy company of artists that no amount of humiliation dampens
their ardor. One observer even attributed the oversized can-
vases perpetrated by the later Abstract Expressionists and those
who followed as a subtle put-down of collectors by artists.
They "defy the collector to buy these impossible objects,"
wrote David Sylvester. With collectors willingly paying high
prices, the artist "finds other currencies in which to make the
bourgeois suffer for his love." Another critic speculated that
artists were deliberately creating eccentric, shocking works to
fulfill their patrons' yearning to scandalize their own class and
reinforce their certainty of being among "the few elect depos-
itaries of real artistic intelligence."

As he did with so many of the art world's foibles, Andy
Warhol pushed collectors' fancy for artistic trappings to the
point of parody—and made a mint doing it. Beginning in 1967,
Warhol collected $25,000 each for hundreds of painted por-
traits based on Polaroid snapshots. In 1969 he developed his
commercialized technique in limning the aristocratic Domi-
nique de Menil, who had become one of the world's biggest
Warhol collectors. By 1974 the Warhol portrait business had
become routinized and was yielding some $1 million per year.
Potential clients were invited for lunch at Warhol's Union
Square "factory." While nibbling pasta salad from Balducci's in
a bizarrely decorated dining room that screamed "artist," the
client would be flattered by conversation with Warhol's busi-
ness manager, Frederick W. Hughes, factotum Robert Cola-

cello, and assistant Ronnie Cutrone. Warhol seldom said a word at these sales luncheons but looked on amiably while fussing nervously with his wig. Celebrities like Brigitte Bardot, Liberace, and Liza Minnelli, fashion designers like Yves St. Laurent and Halston, and a host of art dealers—Alexander Iolas, Irving Blum, Ivan Karp, Ileana Sonnabend, Leo Castelli—all went through the same mill. In two years, 1976 to 1978, Warhol laid claim to being the portraitist of the modern age, executing almost a thousand likenesses. He traveled to Germany to capture a covey of industrialists; King Carl of Sweden sat for him, and so did Princess Ashraf of Iran. For many, Warhol created a second portrait for $15,000, a third for $10,000, and even a fourth, a bargain at $5,000.

Being admitted to an artist's studio, in addition to giving a collector a chance to pick over the scrap heap for bargains, seems to validate his or her discernment. Behind all those stacked rejects there may lurk an unappreciated masterpiece. Sitting around amid the evidence of artistic invention, trading gossip about the art world, the collector feels a part of a world of creativity, a participant in the artist's quest, almost a collaborator. Long Island real estate developer Jerry Spiegel points out that "an artist can paint as much as he wants, but if nobody buys it . . ." The unfinished sentence implies an equal role for buyer and artist. Spiegel was enchanted that, after he bought a Jeff Koons, the artist personally assembled it: three basketballs floating in an aquarium. He also enjoys having David Salle and Brice Marden over for dinner and savors attending tennis matches with Eric Fischl.

While most purchasers of high-priced art rely on the advice of professionals, they strive for the ultimate accolade: that they have the collecting "eye." Difficult as this quality is to define precisely, the "eye"—acquiring it, sharpening it, nourishing it, exercising it, displaying it, dazzling others with it—nevertheless remains central to discussions about contemporary art and its aficionados. The legendary collectors of the past—the Steins,

John Quinn, Peggy Guggenheim—of course had it. Robert Scull, despite his vulgarity, had it, and Ethel Scull fought an eleven-year legal battle to prove that she had it too. Museum professionals are supposed to have it. Dealers have achieved fame and fortune by having it. Critics might have it, but they have to fill columns with verbiage regularly to prove it. The "eye" goes beyond education or breeding, beyond reason or intelligence, certainly beyond financial acumen; it belongs to the realm of the occult together with that other kind of "eye," the evil one.

The dealer Paula Cooper describes the "eye" as similar to an ear for music or the sense some have for poetry, "a recognition." The collector Roy Neuberger, who was a trustee of both the Whitney and the Metropolitan, said it was "something that's there," a reaction to a work of art more emotional than intellectual. The "eyes" of Herbie and Dorothy Vogel, a New York mailman and a Brooklyn assistant librarian, became celebrated during the 1970s after the Vogels began cramming their one-bedroom apartment with vanguard art. Along with six cats and assorted turtles, they housed more than five hundred pieces of art and were attracting European museum directors anxious to study what they were acquiring. A Kansas City couple who were early collectors of Pop, the Jack W. Glenns, were said to have "the 'collecting eye,' which can instinctively sort out the worthwhile from the rubbish and intuitively discover first what others will eventually value." The Los Angeles collector Frederick Weisman, who made a solid fortune in a chain of car dealerships, resorts to the ethereal when describing the "eye." To him it consists of "a lot of exposure and 'I like that,' or 'I don't like that.'" In an interview replete with boastful accounts of financial coups, the humbling even of English aristocrats, and the hard-boiled pecuniary wizardry that produced his fortune, Joseph Hirschhorn waxed positively lyrical in attempting to describe his aesthetic gift: "I can't tell you why. I buy if I get a gut feeling. It starts with the head, then the gut, and then the heart." In the next breath, the uneducated financier who accumulated more than seven thousand items over a forty-year career of compulsive acquisition gloated over

buying a $30,000 work for half price. "They were glad to sell it."

The private dealer and collector Ben Heller is another flinty businessman who turns soft and runny inside when discussing his most prized possession, his "eye." "When a painting or sculpture hits me, it hits me in the stomach or the back of my neck and if I sing in those places and get the proper resonance then I know that I'm in the presence of a great work, as it were, for me." Of all the players in the art game, artists seem to be least anxious over whether they have or lack the elusive "eye." During a luncheon at a private club with Metropolitan trustees, one artist was asked how he recognized a good picture when he saw it. "My method," he replied, "is to go into a gallery, look at the pictures and then say this one stinks and that one stinks. That's one way of doing it."

5

DEALERS, AUCTIONS, AND OTHER MIDDLEMEN: SELLING THE SUBLIME

Seven men and one woman strut their stuff for a double-page Irving Penn photo in *Vogue* magazine for February 1, 1970. If ever image is the message, this is it. They are costumed to look defiantly bohemian while also conveying underground elegance, utmost discernment. They possess—perhaps are even possessed by—so said their clothing and stance, the mysterious "eye." Wrapped in a dark trenchcoat topped with a colorful ascot, Ivan Karp lurks behind dark glasses, puffing industriously on a dead cigar. He has just started his O. K. Harris Gallery in SoHo. Peering from underneath a fur hat and swathed chin-deep in a fur coat is David Whitney, who has worked for the Museum of Modern Art and Leo Castelli Gallery. The youthful Paula Cooper has lank, long hair, wears a trade-bead necklace on a fuzzy dark sweater, and sensitively gestures with meticulously manicured fingers. Robert Scull's one-time partner, Richard Bellamy covers one eye and half the other with a mop of dark hair and broods knowingly in inky garb. Arnold Glimcher's mustache, dark polo coat, and ascot suggest a racetrack, while his partner in the Pace Gallery, Fred Mueller, wears a conservative Wall Street suit under a rich overcoat—the gambler and the investment banker. Klaus Kertess's sensitive, pale face framed by longish hair and a black turtleneck conveys the image of his Bykert Gallery; it specializes in "still-difficult art." Michael Findlay's battered white straw hat and carefully chosen thriftshop garments underline

the message that his clients at Richard Feigen Gallery can expect the latest avant-garde sensation.

"Eight Gamblers on Young Artists," the magazine called them, and indeed their carefully individualized appearances spoke of sensitive mentors of artists, intrepid explorers of obscure lofts and basements where the creative spirit lurked. They were free spirits but down to earth, the photo hinted; a client could rely on these dealers to ferret out the best of the new artists, to be friends with them, to bring them over for dinner on Park Avenue or Sutton Place. Dealing with Ivan or Paula, Arny or Dick, was more than a canny business transaction, it was the admission ticket to a new world of creative elegance and style, a world just acquiring its mythical name: the art world. The most successful dealers, said Hilton Kramer, functioned somewhat like psychoanalysts in the lives of their clients: "They fill a void. . . . The psychiatrist assists the patient in discovering his own personal history, and the dealer comes on as the man assisting the collector in discovering his personal taste."

The cascade of new art movements since the Second World War had produced not only some of the most astonishing art of the century but also astonishing prices for contemporary art. The critics who had been in the forefront, shaming and exhorting their readers to look and look again at the new art, to revel in it and perhaps to buy, had retreated into pettifogging scholarly disputes. Museums, too, were diluting their tastemaking function with obligations to powerful donors and trustees. After the Abstract Expressionists found success, even artists realized that dealers were shaping the taste of the time. They "play more than an amusing social role" in postwar art, wrote Henry Geldzahler in 1969; rather, the array of new galleries had "served as school, forum, and news transmitter" to the vanguard art community. "The dealer who is alert to quality, who has committed himself early and clearly to the new art, has risked ego, prestige, and money, and must finally be considered a minor cultural hero."

For the fast-growing audience attracted by contemporary art, the quickest way to get an education, to nourish and culti-

vate an "eye," was to make the rounds and partake of the talk in "the little curious places," as Ivan Karp called galleries, where the exciting new art was shown. Here, too, the new collectors like Ethel and Robert Scull, who built a sparkling social career on their patronage of new art, could get in touch with the artists themselves and draw them into their social life. By displaying a new style, an important dealer obliged critics to comment and occasionally managed to "transform a tendency among some artists into a named and defined movement." Their "eye" honed by seeing more works by new artists than either museum curators or critics, and their Rolodexes stuffed with the names of avid collectors, America's leading dealers held the power to transform their aesthetic judgments into the stuff of art history.

Beyond hanging an artist or style in their galleries, dealers were sharpening their tools for promoting their artists. Carefully hung and lit, art often looked more impressive in a gallery than in a museum. The excitement of an opening at a well-known gallery drew hundreds of prospective clients, all jabbering and gesticulating, sipping white wine, and usually keeping their backs to the art while scanning the room for celebrities, social leaders, and artists. Long after the show had closed, its content lived on in the catalog, an increasingly elaborate publication. Indeed, the catalog was becoming more important than the exhibition during the 1970s, says the veteran Fifty-Seventh-Street dealer André Emmerich, who represents such luminaries as Helen Frankenthaler, Jules Olitski, and Sam Francis. The essays written by respected scholars and often lavishly illustrated with expensive color plates "help people to see," says Emmerich, putting them in touch with an artist's work for more than the few minutes many collectors spend in the gallery. Nevertheless, Emmerich modestly minimizes the role of dealers in shaping taste. They are "like surfboard riders," he says. "You can't make a wave. . . . But the good surfboard rider can sense which of the waves coming in will be the good ones, the ones that will last." Furthermore, adds this consummate salesman, "Good art dealers don't sell art; they allow people to acquire it."

"In the case of certain artists—if the dealer is prosperous enough to advertise extensively, if the critic pronounces his or her work significant, that artist can gain a measure of fame that he or she doesn't deserve." Ivan Karp was describing the Marlborough Gallery's ruthless promotion of Mark Rothko just before and after his death in 1970. During the lawsuit by Rothko's heirs against Marlborough, Karp was courted as an expert witness by both sides, a measure of his shrewd judgment and his reputation for pungent comment on the art scene. "Rothko's prices were overstated," he said. "He was a fine painter at his best and [also] produced a lot of work of no consequence whatsoever."

Karp holds forth at his O. K. Harris Gallery on West Broadway in New York's SoHo, an expansive, outspoken, quintessential New Yorker whose thirty-five-year love affair with the art world remains intense. Amazingly, he is one of the few dealers in the city who views all the artists' slides that arrive in the mail and sees every artist who walks in. While frazzling a cigar in his teeth and barking into the insistent telephone, Karp trains astute eyes on the slides and portfolios that the parade of hopefuls, some 50 to 150 each week, present. A few have even brought their life's oeuvre to him in a U-Haul truck. Karp must almost always reject their work, but he tries to do it "so gracefully that they don't even know they were rejected until they're back in Oshkosh." Lecturing at universities, Karp usually gets a tour of the student and faculty studios and, although he is generally appalled by what he sees, tries to resist making his standard tactful yet devastating comment: "Seek another path."

Despite the overwhelming odds against finding a new talent, Karp remains passionate about the "very insular and beautiful community" called the art world, "for all its facets and for all its difficulties and for all its complications and complexions, for me the most beautiful community of its kind in the country or in the world. . . . I like their visual lusting after things." After all these years, it takes Karp less than a minute to decide whether an artist has promise, a sad sixty

seconds for someone who may have spent years preparing for this moment. But every once in a great while, Karp's piercing and skeptical eye is captured by a quality in the work so mysterious that he cannot describe it. In spring 1989, for example, a Korean student at Pratt Institute, Sook Jin Jo, shyly showed him slides of her work—constructions of abandoned plywood, the only material she could afford. "I saw instantly that she could be a major force," he says. He visited her studio the following Sunday, then he revised the gallery's entire schedule to accommodate her work. After a successful show at O. K. Harris, Karp arranged for an exhibition in Detroit and another on the West Coast.

Nurturing a new artist is tricky and expensive, even though Karp eschews advertising. Like most other dealers, he can count on perhaps twenty-five loyal collectors who buy only from him, plus several hundred who see his shows and sometimes buy. However, even the casual visitor to O. K. Harris will find something to take home—a twenty-five-cent postcard reproduction of one of his artist's works, posters ranging from $5 to $25, $10 T-shirts, lithographs for under $500, and paintings beginning at $3,500. For the more committed there are paintings costing up to $130,000, or perhaps a Duane Hanson figure for $200,000. Karp's average sale is $15,000 to $25,000, but somewhere in the resale racks lurks a Warhol tagged at $2.2 million.

Like Emmerich, Karp shrinks from naming dealers as today's tastemakers. Collectors are the most powerful players in the art world, he believes, more powerful than critics, art historians, or dealers. As for museum curators, Karp finds them hopelessly narrow, biased, and even ignorant. His harsh views are prompted, perhaps, by the fact that the Whitney Museum has never included a single one of his artists in its biannual show of new talent. He also puts little faith in newspaper reviews, claiming that "the New York Times critics cover the same galleries and artists season after season. It's considered a joke in serious art circles."

Unlike many galleries, which feature a particular style or movement, Karp's shows a wide variety of art: lovingly air-

brushed ladies' crotches and buttocks; yards of white untracked paint; colorful renditions of New York newsstands. There are horses in the Photorealist style—discovered by Karp—by a painter he unblushingly describes as "the greatest horse artist of all time, even greater than George Stubbs." Besides showing the right kind of art, a dealer's success depends on "a vivid personality," says Karp, leaning dangerously backward in his swivel chair and adjusting the bill of his Mets baseball cap; the gun he habitually carries in his waistband is not in sight. Rapidly he ticks off the five essentials for making a sale: the buyer must appear in the gallery, be responsive to the work, and have the money to purchase it, a place to put it, and a consenting spouse.

Karp's verve and imagination have been with him since childhood; growing up in Brooklyn, he knew he was destined for an unusual life. "I felt things differently," he says. "I worried that I was odd . . . and then I took pride in it." A child of the Depression, Karp worked after lackluster sessions at Erasmus High, earning twenty-five cents a trip for delivering hats and clothes for a dry cleaner and meat for a local butcher. Not a reader but a looker, Karp perused only the pictures in his schoolbooks and relished the movies. "I spent more time in the movies . . . than anybody I've ever known, five, six, or even seven days a week." He attributes his success in the Air Force mechanics' school during the Second World War to his grasp of the manuals' illustrations. Though he never aspired to be a painter, he says that he always knew that he would be "around the arts in some way." At age seventeen Karp discovered the works of Joseph Conrad, the first books he read with pleasure. In the late 1940s, when he stretched $500 over ten months in Europe, he wallowed in Kafka, "a beautiful period of romantic agony," and the letters of van Gogh, over which he wept. "I used to read them every day as if they were a biblical thing," he recalls. "I'd read three letters a day and I'd feel elevated and purged and profoundly moved; it was a real exorcism."

Back in New York, Karp began making the rounds of new galleries as an unpaid art writer on the *Village Voice*, glorying in the volatile art scene of the 1950s. Richard Bellamy, who was

managing the cooperative Hansa Gallery, invited him to share the job; they would each work three days a week for a salary of $10 plus commissions. Barbara Rose recalled Karp puffing cigars and arguing over old movies in the back room there. When no visitors came around, he would spend most of the day hunched over a typewriter, laboring over an epic novel about the Visigoths. Karp himself could not recall who "discovered that I was a very energetic young man and that I could speak very nicely about paintings." The forgotten visitor also told Karp that "Martha Jackson might need somebody," and he moved uptown.

Karp goggled at Martha Jackson's "ritzy" commercial Madison Avenue establishment, the salary plus commissions, the first time he saw a customer casually write a check for $6,800 (for a Sam Francis). He bought a Brooks Brothers suit. "Slowly," he recalled, "I got used to the idea that people would pay big for fine art. I had always felt that they should, but I had never seen it happen. I was very impressed and bought myself another suit." He wore the second suit in 1958 to a luncheon meeting at the Carlyle Hotel with Leo Castelli and his then wife, Ileana Sonnabend. "I had never had a lunch like that before," he said. "I even ordered some wine." Castelli offered Karp $100 per week.

Two more disparate backgrounds and personalities could hardly be imagined than those who embarked on this professional relationship in 1959. On the one side was the brash and bulky younger man, Ivan Karp, with his fast-talking, slangy, New York ways and perpetually smoldering cigar; on the other was Leo Castelli, a diminutive aesthete with manicured fingers, European-born, graying, and sleekly tailored. In the background was Castelli's wife, Ileana, the sheltered daughter of a Romanian industrialist, whom Castelli still admires, three decades after their amiable divorce, for her infallible "eye" for new art. That the art this elitist couple was preparing to promote that day was based on popular icons, comics, and advertising added an extra dose of incongruity.

Leo Castelli was born in 1907 in Trieste, then still an outpost of the Austro-Hungarian empire. At home he spoke

German but in the streets picked up Italian and, of course, spoke French—*de rigueur* in his cultivated Jewish family, as it was in the family of Ileana, who had been beguiled by modern art since her girlhood in Bucharest. The couple had briefly operated a gallery in Paris with a partner before being swept by the storms of the Second World War to New York. Castelli flitted around the edges of New York's art world while ostensibly working in his father-in-law's sweater factory, "a great bore for him," said Ileana. The war had no sooner ended than Castelli began receiving paintings from his former partner in Paris and selling them out of his apartment in an East Side town house owned by his father-in-law. A pilot friend would fly the rolled-up paintings to New York, and Leo would pick them up at the airport. "It was all done in a rather homespun manner," Castelli says. He sold Kandinskys to Hilla Rebay, the imperious curator of what would become the Guggenheim Museum, and spent $2,000 on two Klees and a Mondrian for himself. A few years later he was "reluctantly obliged to sell them at what seemed a decent profit, $11,000," he says, adding that in 1980 he could have gotten at least $2 million. Artist friends urged him to open a gallery, but Castelli then considered himself "too much of a gentleman, in the old European sense, to indulge in commerce."

Looking back on his early years of dealing in established European modern masters, Castelli protested to *Life* magazine that he was "not really a businessman. I am a born collector." The gallery at 4 East Seventy-Seventh Street existed only "because I have to have paintings. This was the only way I could have them." The original capital came from a distribution of his earlier share in the Paris gallery: a Léger still life, three excellent Dubuffets, a small Kandinsky, and a Pevsner metal sculpture. These, wrote Calvin Tomkins in a 1980 *New Yorker* profile, "became the basis for much of Castelli's future activity as an independent dealer." In the early days, however, the gallery exuded Castelli's ambivalence about commerce. An assistant who arrived in 1957 was convinced that Ileana and Leo were trying to lose money, that they were rich people indulging a hobby. They insisted, for example, that the floors

be waxed twice a week and the walls be repainted for every show, that the files be kept as though in a museum, and that anyone who asked be given photos of every work ever shown, along with reviews, biographies of the artists, and other background materials. Karp later revealed that he was constantly trimming expenses "to reduce the drain of Leo's reckless generosity and his European patrician attitude—if Leo wanted to move a bench in the gallery, he'd hire an architect."

The connection with vanguard art mitigated Castelli's professed disdain for commerce. His quick brown eyes, his nervous step, and his Central European suavity seemed to be ubiquitous during the late 1940s and early 1950s in the places where new art was not only being shown but actually finding buyers. In 1947 Clement Greenberg took him to Willem de Kooning's studio; the visit confirmed Castelli's view that Picasso and Braque were "dead ducks" and the wave of the future was emerging from New York. In 1950 he joined Sidney Janis in an exhibition that paired European and American contemporary painters who appeared to have styles in common, among them de Kooning and Jean Dubuffet, Franz Kline and Pierre Soulages, Mark Rothko and Nicholas de Stael. Janis, who had just taken on the Americans, was anxious to legitimize them by showing their European roots, but to Castelli "there was really no connection, except on a very superficial level." In 1955 Castelli sent Alfred Barr, the director of painting and sculpture at the Museum of Modern Art, a four-page proposal for a Paris gallery to feature American artists. Still dubious about the importance of American artists, Barr ignored the proposal for more than a month, then coolly offered support only if the project attracted foundation funding. At The Club, an informal Greenwich Village social and intellectual hangout founded by the Abstract Expressionists, Castelli sought to promote those artists he considered the best. In 1951 he helped to organize a huge exhibition in a vacant store on East Ninth Street, featuring such second-generation Abstract Expressionists as Helen Frankenthaler, Robert Goodnough, Grace Hartigan, Alfred Leslie, Joan Mitchell, Milton Resnick, and Fairfield Porter. Despite lively critical noise, no one bought.

Back in his own gallery, Castelli continued to feature the salable Europeans; even though he believed that leadership in art had passed to the Americans, he left the riskier Abstract Expressionists mostly to more established dealers such as Betty Parsons and Janis. In 1957 he dared to feature Jackson Pollock's *Scent* in a show called "Modern Masters." But far more exciting that year, "*un coup de foudre*," as he frequently described it later, the greatest aesthetic shock of his life, "as if I had seen the treasures of Tutankhamen," was his first encounter with Jasper Johns's flags, targets, and numbers. Castelli later described his reaction to confronting Johns's *Green Target* at the Jewish Museum in March 1957 as resembling "the sensation you feel when you see a very beautiful girl for the first time and after five minutes you want to ask her to marry you." In eight weeks he arranged to include a Johns flag in a survey show called simply "New Work"; in eight months, he gave the twenty-eight-year-old artist his first one-man exhibition. In one of the many bursts of luck that were to illuminate Castelli's career, Thomas B. Hess, the editor of *Art News*, happened to drop by just when the paintings were leaning against the walls preparatory to hanging. Without reflection, says Castelli, he allowed Hess to borrow his favorite overnight, a target with plaster casts of faces along the top. Castelli professed incredulity when a photo of it appeared on the cover of the next issue of *Art News*, just in time for the show's opening in January 1958. Already the Sculls were vying with the Tremaines over who would buy the most works from the show, and the taciturn Johns had to cope with instant fame.

The following month Castelli gave a show to Johns's friend Robert Rauschenberg, but the results were disheartening. The single buyer could not endure the sniggers her purchase evoked from visitors to her apartment, and she returned *Collage with Red* for a refund. Even the MOMA's tastemaker, Alfred H. Barr, Jr., who had raved about Johns, detested Rauschenberg's slashing spatters of pigment combined with real, everyday objects. To console the artist, Castelli did what many dealers do: he bought the largest piece in the show for himself. To Castelli, the paint-splattered pillow and quilt conveyed gruesome vio-

lence, perhaps a rape or murder, but the profound effect of time on shocking new art is such that in two decades the dealer found the same work "very mild, very beautiful." In time, the Museum of Modern Art also radically changed its views. While Barr's successor, William Rubin, consolidated the museum's core collection by adding more Picassos and Matisses, the man who followed him, Kirk Varnedoe, was "much more forward" in his attitudes, says Castelli. In 1989 he jubilantly accepted Rauschenberg's *Bed* as a gift from Castelli. "I would never have sold it," said Castelli, "so it's not as though I gave the museum $7 or $9 million."

The "accident" of discovering Johns and Rauschenberg was the dawn of a dazzling series of sensational exhibitions at the Castelli Gallery. But more than accident was involved. Although his gallery had been operating for just a few years, Castelli had long been familiar with the progress of new art movements in the twentieth century. The restless succession of new kinds of art presented a pattern, he believed, that could help an astute dealer anticipate changes in style and quickly recognize new art movements when they were just beginning to emerge. Steeped in Alfred Barr's methodology at the MOMA of presenting modern art in terms of the evolution of styles, Castelli tried to discern the future by studying the past. "I thought I would continue the work of the museum and try to find out where art was going from this point." He picked painters, he said, "not just because they were good, but because they seem[ed] to be part of a new movement." That was the supply side. But there had also been a transformation on the demand side: collecting became fashionable. "The aspirations of a new social class, their pockets bulging with money," observed Brendan Gill, "could be fulfilled by learning to distinguish between first-rate art, which was sure to outlast mere fashion, and the trashy art that would perish when the fashion perished. And there stood Mr. Castelli, urbane, incantatory and . . . profoundly concerned that the most gifted of each succeeding generation of artists should be given their just places in the sun."

Ivan Karp's ebullience perfectly balanced Castelli's patri-

cian image. Only necessity forced him to do business day in and day out, said Castelli, otherwise he would like to "forget about it completely. Museums are kept alive by grants, but I must sell art to keep my exhibition going." Karp, by contrast, stressed that the gallery walked an economic tightrope, sustaining its high overhead, lavish expenditures, and regular stipends even to unproductive artists it believed in by sales of the Castellis' collection of early modern masters. When the acerbic *New York Times* critic John Canaday castigated the gallery's high-powered promotion, Karp set him straight with a personal letter: "Our entire, ferocious 'promotion' consists of installing work about the gallery space"; artists succeed only on the basis of their work "and not through a conspiracy of diabolical businessmen out to make a killing. In this regard I must confess (most confidentially) and in great sadness that we have barely gotten through from season to season. We nevertheless experience joy."

While it was true that the Castelli Gallery in those heady days of the 1960s seldom advertised in art journals, it was uncommonly generous with photographs of works by its artists, even to hostile critics, and also subsidized articles about the artists and movements it supported. In 1962, when the critic Max Kozloff denounced Pop Art in *Art International*, the magazine illustrated his tirade with photographs obtained from Castelli: four Lichtensteins and many works by James Rosenquist, Claes Oldenburg, Peter Saul, and Jim Dine. For supporters Castelli went the extra mile, monetarily speaking. When the art historian Leo Steinberg wanted to write an article about Jasper Johns in the Italian art magazine *Metro*, the publisher offered him just $200 instead of the $1,000 Steinberg wanted. Castelli paid the difference. The spreading references to Castelli, his artists, his gallery, and his recommendations, especially in nonart magazines of much ampler circulation—*Vogue, Life, Time, Newsweek*—prompted questions about whether he employed a public relations agency. To which Castelli modestly shrugged, "I just furnish material."

Ivan Karp believed that the gallery's deliciously intellectual ambience attracted critics and art journalists to hang out there

and, inevitably, write about the merchandise. "We always got media coverage," he said, recalling his ten years as the gallery's grand factotum. Fondly he described the back room where art personalities would gather and where "you could borrow magazines. You could go through the photograph files. You could go through everything we had." The gallery's atmosphere was particularly electric on Saturdays, he recalled, when dozens of people would congregate there, "discovering each other," including "a lot of beautiful girls." Among them was Karp's future wife, who arrived one day to show slides of an artist she was acquainted with. "I guess I was more interested in her than in the painter," he said. Henry Geldzahler recalled spending many a pleasant hour in that back room, smoking cigars with Frank Stella until Castelli appeared, briskly clapping his hands, saying, "Okay, boys; okay, boys; this is not a smoking club. Out! Out!"

It was this clubby atmosphere, fostered more by the flamboyant Karp than by the reserved Castelli, that helped to sell the gallery's art, first to critics and then to collectors. The better galleries in Europe and New York had been elegant establishments, replete with velvet ropes and drapes to match. A novice purchaser of art had to overcome the intimidatingly discreet location, the "who are you?" scrutiny of the gallery assistant, the aroma of expensive deals and rarefied taste wafting in whispers from back rooms. The exhibition itself often presented baffling art with no explanation whatever, a rudimentary catalog, and certainly no prices. To confess ignorance about the art while inquiring about its price required more chutzpah than most new buyers could muster. By contrast, just about anybody could hang around in Castelli's back room, picking up the jargon, meeting artists (or pretty girls), and soon sounding like a terrific "eye."

Yet among some veterans of that earlier New York art scene, Castelli's arrival is recalled as a baleful turning point, making its change from a small gathering of insiders who passionately discussed the future of abstraction or the poetry of Ezra Pound to a hard-driving, money-oriented milieu with a rapid turnover of art styles and artists more reminiscent of the

quicksilver fashion business than of eternal art. The dealer
Tibor de Nagy, for one, bitterly blames the change on the rise
of Pop Art and on the heavy drumming of public relations
fostered by Castelli and Karp. Other observers note a sea
change in the methods of successful American dealers of the
1960s, with deep roots in the American character itself. Robert
Wraight described traditional dealers traumatized by a new
cohort who saw no reason why art "should not be marketed by
the same modern, high-pressure sales methods that were prov-
ing so successful in less hallowed fields of commerce." John
Russell Taylor and Brian Brooke believed that it was not artists
who had made New York the world's art center but the dealers
who grasped "how to use major publicity machines and . . .
flamboyant selling techniques." The cult of personality was
assiduously developed, they wrote, not only of artists, who
come and go, but of dealers, who "go on forever."

It is easy to perceive the Machiavellian element in Castelli's
success, especially since the man himself presents a princely
persona. He has been described as "the Metternich of the art
world," "the last aristocrat from some chivalrous kingdom," or
even more extravagantly "a seventeenth-century cardinal, pad-
ding in gold-encrusted slippers through the marbled vastness
of St. Peter's." Often overlooked by those who find slickness
and hype or even a sinister manipulativeness in Castelli's suc-
cess are his and Karp's dogged hard work and vertiginous risk-
taking during the early years. When Karp arrived on the scene,
moneyed buyers were going to Sidney Janis or Pierre Matisse
to shop, while the Castelli Gallery attracted perhaps two hun-
dred visitors each week, most of them just looking. Here Karp
developed his habit of examining the slides of every artist who
came in and arranging to visit the studios of the considerable
number who then looked interesting. Along with Castelli, he
spent every Saturday and Sunday tramping to obscure lofts and
dilapidated apartments—as many as forty in a weekend—in
search of the new art. "We enjoyed the adventure," Karp said
later, but, given the nation's fecundity in producing artists, for
every Stella or Lichtenstein there were hundreds of dullards,
daubers, and dilettantes.

What were Castelli and Karp looking for? "You have to have a good eye, but also a good ear," Castelli told Calvin Tomkins of *The New Yorker*. "You hear things, feel vibrations, gauge reactions. In the beginning, you're unconscious of what you're doing—you just pick artists. Then you come to the point where you pick trends. . . . You spot movements emerging and you try to pick the best practitioners." The personality of the artist weighed surprisingly heavily in Castelli's and Karp's calculations. "An artist who hasn't got a personality—strong personal style that is reflected in everything he does—can't be a good artist," Castelli told Barbara Rose.

Perhaps it was Andy Warhol's colorless look and zombielike personality that prompted Castelli to reject him at first. Karp, however, kept in touch and began to discern a marketable gleam in the artist's pallid persona, not to mention his early gropings for painterly style. Castelli said that he liked both the work and the artist but feared that the early paintings, of Coke bottles and other popular dross, were too similar to Roy Lichtenstein's comic-book creations. He referred Warhol to the Stable Gallery, where Eleanor Ward shouldered the frustrating task of nurturing new talents until they were successful enough to interest a more prestigious dealer. A growing group of seemingly unshockable new collectors and museum people gathered there, eager to appreciate even Warhol's excesses of kitsch. Still, "like a college kid wanting to get into a certain fraternity," Warhol later wrote, he was determined to be accepted by Castelli. "Dior never sold his originals from a counter in Woolworth's. It's a matter of marketing," he wrote, in the frankest assessment of the dollars and cents of art. "If a guy has, say, a few thousand dollars to spend on a painting . . . he wants to buy something that's going to go up and up in value, and the only way that can happen is with a good gallery, one that looks out for the artist, promotes him and sees to it that his work is shown in the right way to the right people. . . . You need a good gallery so the 'ruling class' will notice you and spread enough confidence in your future so collectors will buy you."

Warhol kept hammering at the gates of Castelli's gallery,

and Ivan Karp exuberantly supplied him with subject matter, always Warhol's nemesis. On one occasion Karp, with some exasperation, marched into the gallery's back room and reappeared with a Campbell's soup can. Setting it down with a bang, he ordered, "Paint this!" After Warhol's sensational 1964 exhibition of piled-up Brillo boxes, when throngs of aggressively tolerant new collectors milled through the Stable Gallery, Castelli finally relented. Karp continued to offer Warhol helpful advice on subject matter. Paint cows, Warhol recalled him suggesting one day, because "they're so wonderfully pastoral and such durable images in the history of art." Yet even Karp was at first put off by Warhol's cow wallpaper, amiable bossies as blank-looking as Warhol himself, silk-screened in garish pink on a yellow background. Then he caught on, and exploded with gusto at its total vulgarity. Karp also guided collectors to Warhol's studio while encouraging the artist to market himself: "People want to see *you*," Warhol recalled Karp saying. "Your looks are responsible for a certain part of your fame—they feed the imagination." But even Karp was shocked by the wild drug-fed scene that later developed at Warhol's Factory. He called it "gloomy" and confessed disinterest in "the bizarre and the peculiar and people at their most raw and uncovered . . . and essentially destructive" who surrounded the artist.

The Karp-Castelli partnership, which had nurtured the most successful artists of the sixties—Johns, Rauschenberg, Lichtenstein, Stella, Warhol—broke up in 1969, when Castelli decided, reportedly on the recommendation of Frank Stella's wife, Barbara Rose, that the next innovative wave consisted of Minimalists like Donald Judd and Robert Morris. "Certain artists should be affiliated with Castelli Gallery," the dealer explained, "whether we truly admired their work or not." When he also took on Dan Flavin, Karp disagreed and immediately found backing to open his O. K. Harris Gallery. Castelli went on to immense financial success, even though the flow of new artists dwindled and his heavy investment in the Minimalists and Conceptualists for many years brought returns that were mostly minimal and often purely conceptual. The decline was part of a natural cycle common to virtually all dealers,

DEALERS: SELLING THE SUBLIME 227

Castelli said. From 1957 to 1972 he found one great group of artists after another, but more recently, he said wistfully, the artists he discovered were "never as great as before . . . one can't go back to a great period. My fifteen years were exceptional."

After ten years of inhabiting the same work space and hundreds of joint visits to artists' studios, Karp still found Castelli's true personality elusive; even Castelli's age remained a mystery. "He's in the back room and I'm in the front room," Karp said just before he set up on his own. "We divide our relationships with the artists. . . . He deals with whatever aspects of finance we must understand. . . . Myself with half the collectors; he the other half. Me with certain museum curators whom I know very well, and he with the others." David Whitney, who worked closely with Castelli around 1970, also remarked on Castelli's frosty emotional distance: Whitney said he "sort of became Leo's friend, but there was nothing to be a friend with." Whitney concluded that Jasper Johns, Frank Stella, and Barbara Rose unduly influenced the gallery's direction. Castelli himself, he said, "has no eye whatsoever."

Given the occult, chimerical, possibly illusory nature of the "eye," such a criticism may be meaningless. More to the point is Henry Geldzahler's observation that "the magic of the Castelli Gallery is that he put this package together. . . . [The artists] were brought to him and he was cultivated enough to understand what he was looking at." Also significant was the tender care Castelli provided (and still provides) for the artists in his stable. Once accepted, artists receive a monthly stipend against future earnings that ranges from $500 to more than $5,000, and he has continued for years on end to carry such difficult artists as Minimalists and Conceptualists because he is so sure that "the work is of great historical importance." While many dealers split the sale price with artists 50-50, he gives the most desirable artists 60 percent. After expenses the gallery nets less than 20 percent. In 1979, when the gallery grossed $3.5 million, almost all the profits went right back into expenses, said Castelli; one artist alone had collected stipends of $200,000 more than what his work earned. Castelli says that

such largesse keeps artists in his stable: "Holding an artist is difficult. Not everyone is polite; there's friendship . . . but there's also competition."

In recent years many of the artists Castelli nurtured so tenderly have left. Cy Twombly and John Chamberlain are gone. Richard Serra, whom Castelli valiantly backed during the years of controversy over his *Tilted Arc* sculpture in New York's Federal Plaza, has jumped to Arnold Glimcher's Pace Gallery. Stella and Rauschenberg now show mostly at Knoedler & Co., while James Rosenquist sells mainly through Richard Feigen. Castelli blames high demand for the defections. The paint is hardly dry on new works by the big names before zealous collectors snap them up. "There are not paintings lying around that you can easily and cheerfully send off," Castelli observes.

Probably the most potent ingredient in Castelli's success is the intricate international web of dealers he has spun to market his artists. After Rauschenberg stunned the European art world by winning first prize at the Venice Biennale in 1964, many rumors suggested that Castelli had somehow rigged the award. Castelli called the allegation absurd. "It was just that . . . so much work had been done in Europe by Ileana and myself to make the public understand that Rauschenberg was a major painter." Castelli was omnipresent during those early years at every international exhibition, "holding court in front of his artists' work and answering questions about it in half a dozen languages." Henry Geldzahler recalled an angry scene in 1966 when he was commissioner at Venice. Castelli was "in a rage that I had dared to choose my four people without consulting him, that only one [Roy Lichtenstein] was from his gallery, and that there wasn't enough Pop Art. . . . Where was Warhol? Where was Rosenquist? He was going to set up a counter Biennale somewhere else in Venice."

The threat was not fulfilled, but Castelli labored to diminish the Venice Biennale's prestige. What had once been the most important of international art shows had by then deteriorated into a boozy international trade show. It was no longer a suitable setting for Castelli, and beginning in the mid-1960s he arranged for his artists to be shown instead by the most pres-

tigious galleries in Europe: Bischofsberger in Zürich, Sperone in Turin, Heiner Friedrich in Munich, and Ileana Sonnabend (by then a friendly ex-wife, remarried to Michael Sonnabend) in Paris. In the United States he had various arrangements with dealers in such places as Chicago, St. Louis, and Los Angeles. He permitted the upper tier to sell new works by certain artists on an exclusive basis while doling out other works to the secondary galleries according to their clients' prestige. In 1976 the art world buzzed briefly over his outright merger with a prominent gallery in Toronto, and there was a rumor that its owner, Jared Sable, was being groomed to take over the entire Castelli operation. Nor did Castelli scorn the sale of less-than-museum-quality items by his artists. In 1967 he was advertising a limited edition of black-and-white dinnerware designed by Roy Lichtenstein; each place setting cost $50, including a numbered certificate.

Meanwhile, Castelli was also spreading his operations around New York. From the single gallery at 4 East Seventy-Seventh Street, he expanded in 1971 into a spacious headquarters at 420 West Broadway, in the heart of SoHo. On opening day a mob of some thirteen thousand swarmed through, blocking traffic on the entire street. In 1980, he opened a second gallery nearby, at 142 Greene Street. When it and the Seventy-Seventh Street gallery closed in 1988, Castelli opened yet another space, in a renovated garage at 65 Thompson Street, this time in partnership with Larry Gagosian, melding Castelli's reputation as a perfect gentleman aesthete with Gagosian's suede-shoes hucksterism. Gagosian, who refused to be interviewed for this book, had risen in ten years from selling posters out of a Los Angeles storefront to "king of the resales in top-of-the line American art." His sharp dealings and abrasive personality have not endeared him to art writers; in *Time* magazine Robert Hughes called his fast-talking style "mud-wrestling." Gagosian has since also opened a spacious gallery on the top floor of the former Parke-Bernet Building on Madison Avenue. Not surprisingly, the opening show, in the winter of 1988, featured Jasper Johns's map paintings from the early 1960s, many of them lent by the Museum of Modern Art.

Castelli is proud not only of his artists but also of his clients. Early in his career he became the grey eminence advising voracious European collectors like Count Giuseppe Panza di Biumo and German chocolate czar Peter Ludwig. "Great collectors," Castelli told *People* magazine, "are as rare as great artists"; he often rewarded them with discounts of up to 20 percent. During 1978 he was selling quantities of works to the shah of Iran to stock the Teheran Museum of Contemporary Art. As the shah was falling just a year later, Castelli advised him on how to dispose of the collection. "People say that I was greedy," he said later, "but I was creating a great collection in that museum."

Since his earliest days in New York, when he haunted the Museum of Modern Art, Leo Castelli has had a congenial relationship with museums. He has an uncanny talent for appearing infinitely obliging while advancing the interests of his gallery and his artists. Always ready to accommodate budgets, consult with curators, and donate works by his artists, Castelli recognized that the museum connection helped sales, boosted the gallery's prestige, and lent his artists the invaluable stature conferred by having their works hanging on museum walls. When he first discovered Frank Stella in 1959, Castelli hastened to steer MOMA curator Dorothy Miller to the artist's studio. Reluctantly, as he tells it, he allowed her to include Stella in an exhibition she was organizing, "Sixteen Americans." Castelli worried that the twenty-three-year-old artist would be spoiled by being included in such an important exhibition, but she insisted, he says, and he gave in. At MOMA, Stella's work was "a bombshell"; certainly the exhibition bolstered Stella's sales from the one-man show Castelli had a few months later. Alfred Barr wanted to buy the largest painting in the show, *The Marriage of Squalor and Reason*, priced at $1,200, but when the trustees balked Castelli allowed him to buy it for $700, an amount Barr could spend at his own discretion.

In 1963, when CBS was building "Black Rock," its Eero Saarinen building in New York's Rockefeller Center, Barr called on Castelli to persuade Jasper Johns to create a mural map of the United States for the lobby. The president of CBS, William Paley, was an important collector and a powerful MOMA

trustee for whom Barr was always eager to do favors. Castelli enthusiastically offered to help, although, he confided to Barr, a discreetly unnamed someone else had already asked Johns to consider a similar project. Still, Castelli promised to try to dissuade Johns from going ahead with that commission, if CBS was seriously interested. In the end the CBS mural never materialized.

Museum people are notoriously inept in their negotiations with dealers. In a landmark study of museums Karl E. Meyer flatly stated that "there is no known instance of a dealer's being bested in a transaction with a museum." Museums also are notoriously naive about dealers' motivations, seldom questioning the reasons behind a particular favor or gift. In 1980 Castelli traveled to California in order to personally present a Warhol flower painting to the La Jolla Museum of Contemporary Art. These rather insipid paintings had excited neither critics nor collectors, but the gift and its donor received a royal welcome in La Jolla. No one at the museum hinted at the possibility that hanging such work would lend it prestige and perhaps encourage sales.

Castelli has continued to complain that museums in general were "very remiss" in picking up on new art all through the 1960s. "The few galleries that are involved in avant-garde art have done the whole job," he said.

As with numbers of artists and collectors, arriving at the number of galleries in the United States is a slippery task; galleries spring up like mushrooms in the forest and vanish with equal rapidity. Often a single lackluster season exhausts the small capital an optimistic owner has mustered. Silent partners, who are frequently wealthy collectors hoping to be first onto a good thing and yearning for closer communion with artists, get discouraged when they confront the plodding daily gallery routine, the quirky arrogance of artists, and the fickleness of their clients. If a gallery does take off, the landlord soon appears demanding exorbitant rent raises. However, there

is little doubt that the number of galleries has grown im-
mensely since 1945, especially in the field of contemporary art.
From seventy-three respectable galleries in New York when the
Second World War ended, the number had grown to almost
three hundred by 1970. Galleries also increasingly specialized
in certain genres or periods. During the decade of the 1960s
alone, vanguard art galleries multiplied from about twenty to
two hundred. The growth was even more dramatic outside
New York during the same decade. In Washington, D.C., for
example, the six galleries operating in 1964 had by 1972 be-
come twenty. In less than twenty years after 1945, the number
of galleries in the United States had multiplied fivefold, with
the number outside New York equaling the number within the
city. In 1967 there were almost as many galleries in Manhattan
as bakeries—and by the late 1970s there were more.

While the number of New York dealers had grown even
more by the late 1980s, they continued to cluster in just a few
neighborhoods. Of the 133 members of the Art Dealers Asso-
ciation of America, 97 are headquartered in New York, tightly
concentrated in four zip codes: 39 on and around Madison
Avenue, 31 on Fifty-Seventh Street, and 16 in SoHo. Almost all
of the ADAA members offer twentieth-century art, and fifty-
two sell it exclusively. With the development of NoHo, north
and east of SoHo, the New York art scene continues to thrive,
although not as hectically as in the 1980s. According to the art
appraiser and sometime dealer Aaron Berman, more galleries
are now clustered in two renovated buildings on lower Broad-
way (numbers 560 and 568-78) than there were in all of Man-
hattan in 1974.

And still more galleries keep opening—and closing—be-
cause the economics for independent galleries are grim; just to
get the door open costs about $500,000. A typical budget,
Berman says, would include $50,000 per year for a director
plus $50,000 more for two assistants. Rent would be $120,000
for four thousand square feet and utilities another $6,000. For
advertising at $1,200 for a block in the *New York Times* and
$5,000 for a full-color page in *Art News*, the new gallery would
have to budget at least $10,000 per month. Yet the market for

all kinds of art is growing, too, although estimates of its size vary wildly. Bonnie Burnham in 1987 suggested that American art sales, excluding auctions, amounted to $6 to $7 billion, with New York galleries accounting for one-third of the total. *Time* magazine's art editor Robert Hughes estimated 1989 world art sales, including auctions, as high as $50 billion per year.

The numbers are clearly there, but the profits are elusive. New York's East Village, for example, was the city's fastest-growing art district during the early 1980s. Dozens of new galleries opened each fall, as wealthy gambler-collectors arrived in limousines for openings at such storefronts as New Math, Civilian Warfare, and Piezo Electric. But by 1987 steeply rising rents had driven some to other locations and others out of business (including the Fun Gallery, which first exhibited Jean-Michel Basquiat and Keith Haring). By the end of 1989 the East Village was dead; and even in SoHo the upward rent spiral was collapsing, and vacancies there proliferated.

Despite the crush of new dealers, the list of truly successful dealers in contemporary art remains surprisingly short, and the names on it change relatively slowly. In the mid-1970s Steven Naifeh named only six who were consistently profitable. Knoedler's Contemporary Art opened with the critic Clement Greenberg as its adviser, then merged with a gallery owned by Lawrence Rubin, brother of the MOMA's director of painting and sculpture. At Pace Gallery, Arnold Glimcher adroitly established artists such as Jim Dine, Chuck Close, Joseph Cornell, and Louise Nevelson but also developed a profitable sideline in African art. The infamous Marlborough Gallery, which was sued over the Mark Rothko estate, also managed the estates of Jackson Pollock, John Marin, and Kurt Schwitters. Castelli profited by selling off some of the many Johnses and Rauschenbergs he had bought when prices were low; Sidney Janis was slowly doling out his vast stock of Mondrians and Légers, always jogging the prices upward; and André Emmerich made ends meet by selling pre-Columbian art.

Emmerich's finesse in handling the estate of Hans Hofmann illustrates how much more there is to success as a dealer than the discovery of new artists or the elusive good "eye."

When Hofmann's widow, Renate, first gave him the estate in 1966, Emmerich assembled an exhibition of those works that most resembled the currently popular hard-edge and color-field painters. Even so, nothing sold. Emmerich then raised the prices of the works he judged most attractive to $21,000 and lowered prices on more "difficult" canvases to $12,000; in between, some were tagged at $15,000. This price structure cued buyers on which were the "best." By 1970 he had sold an average of twenty-three paintings each year. Then he began to raise the middle and lower prices and also restored and re-framed Hofmann's paintings from the forties, fifties, and six-ties, charging up to $18,000 for these previously less desirable works. In the 1972–1973 season, he sold 137 Hofmanns. Meanwhile, Henry Geldzahler had acquired several Hofmanns "through trades," and they hung prominently in his office at the Met. He also included several Hofmanns in his influential 1969 exhibition, "New York Painting and Sculpture 1940–1970." As a follow-up, Hofmann's widow lent the Met the nine paintings in Hofmann's "Renate" series and then made the museum a gift of one of them. Within two years Emmerich had sold a Hofmann for $85,000, and in 1974, with Geldzahler as intermediary, he sold *Pre Dawn* to the National Gallery of Australia for $200,000.

Hans Hofmann always tried to maximize his prices, but he would have been flabbergasted by such amounts. In 1947 he left dealer Betty Parsons for a more promotion-minded gallery run by Samuel Kootz. Parsons called Kootz "that crocodile," but within two years he was showing other artists associated with Parsons: Willem de Kooning, Adolph Gottlieb, Ad Rein-hardt, and Mark Rothko, as well as Robert Motherwell who had previously shown elsewhere. In contrast to Parsons, whose business methods were casual, Kootz demanded that artists sign five-year contracts and that they produce a minimum of forty to seventy works each year. Not that he was selling much or achieving remarkable prices when he did sell something; de Kooning's *Black and White Snow* sold in 1949 for $700.

Long before he opened his gallery in 1945, Kootz had enthusiastically supported American artists. During the 1920s, he would take time out from law studies at the University of Virginia to visit Alfred Stieglitz's avant-garde gallery at 291 Fifth Avenue. There he became familiar with such pioneering Modernist Americans as Charles Demuth, Carl Holty, Preston Dickinson, Yasuo Kuniyoshi, Peter Blume, and Max Weber. In 1930, while working as an advertising executive, he published *Modern American Painters*, and in 1941 he caused a sensation among artists when he wrote to the *New York Times* to announce that Europe was probably finished as a center for world art. He urged the Americans to push into the void: "Isn't there a *new* way to reveal your ideas?" he asked them. In the following year he assembled 179 paintings representing the best responses to his challenge for an exhibition at Macy's department store. In such a setting, many looked, most sneered, and few bought. Nevertheless, Kootz published another book, *New Frontiers in American Painting*, in 1944 and opened his gallery "to sponsor exactly what I felt was the future of American painting" the following year.

His noble ideal would have drowned in red ink had he not arrived at Picasso's Paris studio during one of the disputes the artist delighted in pursuing with his dealer, then exclusively D.-H. Kahnweiler. If Picasso allowed him to sell works in the United States, Kootz suggested, the profit could subsidize younger artists "the same way Cézanne paid for his upbringing by Paris galleries." Savoring Kahnweiler's rage at losing his monopoly, Picasso allowed the brash New York dealer to pick certain pictures and to show them along with the unknown Americans. "We could not have existed unless I'd had Picasso shows," Kootz said later. A good share of the profits went to pay monthly stipends to Adolph Gottlieb and William Baziotes, to hire professionals (among them John-Paul Sartre) to write literate essays for exhibition catalogs, and eventually to send Picasso, the professed Communist, a brand-new Cadillac.

Kootz summoned all his skills as an attorney and publicist in promoting his gallery and artists, albeit with mixed results. In 1947 he dared to show his six best-known Modernists in Paris. The exhibition of William Baziotes, Romare Bearden,

Byron Browne, Adolph Gottlieb, Carl Holty, and Robert Motherwell excited the vicious Paris critics to fresh paroxysms of
chauvinistic bile. "Now American painters no longer have to
come to Paris to copy our masters," sneered *La France au Combat*
about the Americans at the prestigious Galerie Maeght. Their
"dryness of soul" particularly moved *Carrefour* to demand sarcastically: "Does the art of a young and powerful people have
to go through this ungraceful phase before acceding to a new
world?" While Kootz tried to insulate New Yorkers from these
devastating comments, *Time* magazine briefly summarized
them and concluded that the show had "closed in a hurt hush."
The artists had expected neither friendly reviews nor lively
sales. When the airline briefly misplaced their paintings in
Iceland on the return trip, they hoped the shipment would
never be found; at least then they could recover insurance.

Despite some success at marketing his painters through
Gimbel's department store and his sculptors through advertising to architects in trade journals, despite Clement Greenberg's
admiration for his business skills and his taste, Kootz never
considered himself a great success as a dealer. In late 1965 he
refused to answer questions about himself from German journalist Willi Bongard, saying, "I rely entirely on the walls of my
gallery." Several months later an advertisement in the *New York
Times* announced that he was closing his gallery immediately.
He had tried to adhere to his formula for success: "Show as
good pictures as can be provided and get rid of them as fast as
you can." He was closing, Kootz said in an interview, because
"the challenge is gone. . . . I am only a businessman."

The career of Allan Stone shows how much more promising—
and also frustrating—the New York art scene had become for
dealers in the fifteen years after Kootz had opened his gallery.
Stone had once wanted to be a painter but instead attended a
New England prep school, then Harvard. By that time he
wanted to be an architect, but "my father would only pay for
law school," so Stone dutifully went on to Harvard Law School.

While working at the Department of Justice in Washington, he spent every free moment in New York art galleries and by October 1960 was well enough known in art circles that Chase Manhattan Bank asked him to join a committee selecting works for the bank's collection. In December 1960 he opened his gallery, despite difficulties in raising the monthly rent of $300. His nocturnal prowls of promising young artists' studios had uncovered Warhol, James Rosenquist, and Robert Indiana, but it was typical of the artists' burgeoning self-esteem that when he offered them a three-man show, they refused, insulted. Meanwhile, he had also discovered Wayne Thiebaud, whose California version of Pop focused on lavishly painted ice cream sundaes, cakes, and pies, and who was grateful for exposure in New York.

To appeal to a more established clientele, Stone approached Barnett Newman and Willem de Kooning to share his inaugural exhibition. Newman, whom Stone calls "the Talmudic scholar of the art world," reluctantly agreed, while urging Stone to "get rid of the pie guy." Then he demanded that Stone assemble the entire group of Abstract Expressionist veterans. Then he demanded to write the catalog essay. Being also somewhat Talmudically inclined, Stone settled the problem by writing the catalog essay himself. Anticipating Newman's next demand of precedence over de Kooning, Stone arrived at a solution worthy of Solomon: he printed a two-sided catalog, which the reader could flip to display either Newman or de Kooning.

Stone went on to make a fortune on the sale—and resale—of art. In his early days, he was overjoyed to make $1,500 when a chance visitor coveted a Léger left by its owner at his gallery for framing. Today he bids into the millions at auctions, especially when the work of one of his artists, perhaps Wayne Thiebaud, is on the block. The phone in the office at his gallery, a bit off the beaten track at Eighty-Sixth Street and Madison Avenue, chirps incessantly with deals or, equally vital, news of others' deals. Stone is a man prodigious in every dimension: physically expansive, mentally omnivorous, and pathologically insatiable as a collector. At the entrance to the gallery, one is

enveloped in a sea of goods, and the closer one gets to his office, the denser the sea. Inside it, this large man is almost engulfed by things, "all the stuff," he explains, "that my wife won't let me bring home." Masses of objects have long ago filled every available flat surface, and now his massive desk offers only a tiny space, perhaps the size of a sheet of legal-size paper, where he can work. In the glut are hundreds of African and South Seas tribal figures, fetishes, beadwork, masks, and totems, mingled with folk and kitsch items of every description. Overseeing his minute work space is a bridal couple, straight off the wedding cake, surrounded by tiny dice. He thought it "a profound comment about marriage."

Stone clearly enjoys his position at the center of so many things and at the heart of the art world's insider network, where gossip circulates like a cyclone, taking on force and refinement with every revolution. Yet he is saddened by the art world's current direction. In the 1960s, he says, "the art world was art. Now it's money and it's a big bore. It's too much like business. . . . the promotional people have taken over."

Diana Crane, a sociologist who tried to analyze how various kinds of vanguard art achieve acceptance, discovered that the artists whose works subsequently brought the highest auction prices were associated with only eleven galleries (unfortunately unnamed). She speculated that "certain galleries had access to elite collectors who in turn were increasingly likely to treat paintings as investments to be bought and sold like stock." Collectors flock to galleries well known for promoting their artists and expect the dealer to support and enhance prices. "A lot of collectors will buy the work speculatively," says Irving Blum, who has owned galleries in New York and Los Angeles, "simply because a certain dealer has taken the work of a young artist into his gallery." Such steady clients often rely on the dealer to buy back works if another collector threatens to dump them onto the market at too low a price, which means that the dealer must watch the auctions for any pictures coming up for

sale. Allan Stone, whose artists include Richard Estes and Franz Kline, says that if a work by one of his artists seems to be flagging at auction, he buys it himself in order to support the prices of other works by the same artist. As a dealer, he says, "You can never have enough money."

Beyond purchasing a work from each show to encourage artists they believe in, dealers stand to make the greatest profits on the works they already own. Castelli, for example, continues to prosper by selling works by Johns and Rauschenberg that he bought outright many years ago when prices were low. After the November 1988 auctions, at which five of the ten most expensive paintings ever sold were Jasper Johnses, Castelli raised the prices of the Johns paintings in his stock by 20 percent. It was as a seller, not as a middleman, that he built his fortune.

In this respect he is no different from the legendary dealers of the past. The respected Paris dealer Paul Rosenberg began accumulating works by the early masters of Modernism during the 1920s and was dismayed when the Depression of the 1930s, followed by the Second World War, made it difficult to sell many paintings. "I made a fortune by mistake," he said in 1948, "because almost all my life I had to keep pictures I couldn't sell, by Picasso, Braque, and Juan Gris, which all of a sudden became priceless." Less fortunate was Paul Durand-Ruel, the dealer who first promoted the Impressionists during the 1870s. By providing them with stipends and advances against sales he accumulated a vast stock of their works. When he died in 1922 he had no money, but his estate owned fifteen hundred canvases by Impressionist and Postimpressionist painters. His heirs doled them out into the market over the next two decades, garnering what they thought were handsome prices but which were nowhere near what such works brought in more recent times.

Ambroise Vollard, who was the youthful Picasso's first dealer (and whose 1910 portrait was one of Picasso's early works in the Cubist style), is often cited as the model for Leo Castelli. William Rubin noted how both men were "devoted and committed to the artists they handled, to helping the art

find its rightful place." Both, wrote Barbara Rose, were "pa-
trons of art too advanced for its time" and preferred "the
company of artists to that of collectors."

But more appropriate a model for Castelli might be Daniel-
Henry Kahnweiler, who not only supported Braque, Picasso,
and Juan Gris but defined their art and then tirelessly pro-
moted it. An outsider and a Jew, Kahnweiler arrived in Paris in
1907 from Mannheim, Germany. He was determined to aban-
don the family's investment banking business in favor of the
risky trade in art as quickly as possible. He brought to it,
however, a canny head for business, all the cannier because,
like Castelli after him, he steadfastly denied putting business
first. While other dealers (Durand-Ruel, for one) subsidized
critics and even entire publications to support their artists,
Kahnweiler was the first to create his own definition of the art
he was selling, in terms that excluded other artists with similar
styles. Only Braque, Picasso, and Gris were "major Cubists,"
what he dubbed analytical Cubists, dismissing the swarm of
other painters—Gleizes, Metzinger, Villon among them—who
associated themselves with the new movement after 1910. Like
Castelli, Kahnweiler accumulated a vast store of unsold paint-
ings; when they failed to sell in France, he organized exhibi-
tions through dealers in other places that he later called "the
foundation of my activity." For many years he monopolized
Picasso's prodigious output and would allow other dealers to
show his work only if they also agreed to show some of his
lesser artists.

Kahnweiler also savored the company of artists and many
years later relished describing his youthful evenings with Pi-
casso at the Cirque Medrano, *Le Lapin Agile*, and a sordid
cabaret called *Le Rat Mort*. The most striking parallel between
Kahnweiler and Castelli, however, is their exquisiteness of
dress, manner, and language, implying that the art being sold is
equally exquisite. To the young Leo Castelli and his wife,
Ileana, who were attempting to open their first gallery in Paris
during the late 1930s, the imposing Kahnweiler establishment
at 29 rue d'Astorg must have seemed like Mecca itself. By the
same token, the young man or woman today considering a leap

into a modest gallery, perhaps a single room in NoHo, would first make a pilgrimage to Castelli's.

Mary Boone did just that soon after she opened her modest space on the ground floor at 420 West Broadway, just beneath the Castelli Gallery. When Boone discovered Julian Schnabel several years later, she asked Castelli for space in his gallery to accommodate some of the artist's large paintings. The veteran dealer refused but suggested that they hold a joint exhibition for Schnabel, which took place in April 1981. "Schnabel is a very ambitious young man," Castelli explained, "and he felt too confined in that small space." Castelli says he approached Boone about sharing the artist and she cheerfully agreed. Schnabel later deserted both Boone and Castelli for the Pace Gallery, which opened a SoHo branch in the spring of 1990 at 142 Greene Street, a space Castelli had abandoned two years earlier. Ironically, Pace's opening exhibition there was of sculptures by Schnabel. Castelli and Boone have continued to cooperate, with Castelli sharing two of his artists, Richard Artschwager and Roy Lichtenstein, with Boone while she shares one of her discoveries, David Salle, with Castelli. Since then other dealers have approached Castelli for the same sort of arrangement, but he always tells them "they can do very well without me."

Sidney Janis set the artistic agenda in New York during the 1940s and 1950s. Because of his dominance, few even in the puny art community of that day failed to have a strong opinion about his abilities. The eccentric collector Walter P. Chrysler no less than the artist Philip Guston asserted that he was totally ignorant about art. Willem de Kooning went so far as to declare that he was not even a dealer, just a shopkeeper. Clement Greenberg, on the other hand, called Janis a great teacher, while the artist George Segal found him "really involved with modern art." An anonymous colleague curtly described him as "a thief; a robber."

No one could easily dispute, however, that Sidney Janis had

the will, the talent, the reputation, and the resources to intro-
duce Americans to vanguard art. "He showed Americans along-
side Europeans as if they were equals," says Paul Cummings,
and thereby became the most important figure in making New
York the center of the art world and American artists the world
leaders. Furthermore, adds Cummings, "he understood money
and had access to the most important buyers. . . . It was Janis
who made the art business a business."

Raised in Buffalo, New York, as Sidney Janowitz, he was
making a fortune by the simple innovation of manufacturing
shirts with two pockets, when he and his wife, Harriet, began
their collection with three Klees bought from the Museum of
Modern Art's 1930 exhibition. Perhaps it was on Sidney's ad-
vice that his brother, Martin, commissioned the radical Vien-
nese designer Frederick Kiesler to create a striking Modernist
façade for his Main Street shoe store. Certainly Sidney offered
advice on collecting art, and Martin ended up with a valuable
collection, including Picasso, Gromaire, Gorky, and Mondrian.
Throughout the Depression decade Janis became increasingly
involved with the Museum of Modern Art, organizing several
exhibitions there. In 1944 he wrote *Abstract and Surrealist Art in
America* to accompany a show organized by Betty Parsons at the
Mortimer Brandt Gallery in New York; the show later toured
around the country. In the book he mentioned many of the
artists who would later be called Abstract Expressionists: Pol-
lock, Rothko, Motherwell, de Kooning. While all of them first
exhibited at galleries more idealistically avant-garde and less
oriented to cash flow—like those run by Samuel Kootz, Martha
Jackson, and Betty Parsons—Janis profited the most from their
subsequent success.

Quitting the shirt business, he opened his gallery on Fifty-
Seventh Street in 1948, just after he and his wife published a
book about Picasso's recent work. Unsuccessful in this ploy to
represent Picasso in the United States, he opened with an
exhibition of nineteen Légers, priced around $1,000 each, of
which he sold but two. Later in the season he showed Kan-
dinsky and sold not one, but by 1950, he was successful with a
show of the more lushly attractive Fauve painters. His connec-

tion with the Museum of Modern Art attracted a flock of wealthy collectors who were also active at the museum, including William A. M. Burden, Edward Kaufmann, Jr., Nelson Rockefeller, John Hay Whitney, and Blanchette Rockefeller, as well as wholesale buyers like Joseph Hirschhorn and alert investors like Ben Heller. Later he would acknowledge that his first duty was "to advise collectors, especially newcomers."

To this end Janis organized exhibitions at his gallery that firmly anchored the Abstract Expressionists (and, later, even the Pop artists) to the European avant-garde of the first three decades of the twentieth century. "When Sidney Janis had those first exhibitions of Pollock or de Kooning, there was always a Brancusi or a Mondrian in the back room," recalled the dealer Joan Washburn. "It gave a great sense of continuity, one thing leading to the next." In 1960 Alfred Barr, also a great believer in the great chain of artistic evolution, called him "the most brilliant new dealer, in terms of business acumen, to have appeared in New York since the war."

In 1952 Janis lured Pollock and Rothko away from Betty Parsons, who had taken them up, along with Clyfford Still, after Peggy Guggenheim abandoned her New York gallery, Art of This Century, in 1946. Parsons's was "an artist's—and critic's gallery," wrote Clement Greenberg, in the sense of "a painter's painter or . . . a poet's poet . . . a place where art goes on and is not just shown and sold." Parsons herself was a painter, with a discerning eye but little head for business. She would often scribble records of sales on old envelopes, giving the artists one-third of the sale price. When the critics began to take them seriously, the Abstract Expressionists became restive at Parsons's casual style and low prices, mostly in three figures. Pollock's defection was particularly galling to Parsons because she had acceded to his urging to give his wife, Lee Krasner, a one-person show in October 1951, from which not a single picture was sold. After Janis, whose gallery was on the same floor as Parsons's, picked off some of her brightest stars, many others departed. One after another, Bradley Walker Tomlin, Herbert Ferber, Seymour Lipton, Alfonso Ossorio, Hans Hofmann, Richard Pousette-Dart, Theodoros Stamos, Richard

Lindner, Ellsworth Kelly, and even Barnett Newman, a close adviser, went to other galleries. "How can you make money pioneering?" she despairingly demanded of one interviewer.

It did not take long for Janis to figure out the answer to that question. In the case of Pollock, he immediately jacked up the prices, selling *One* in 1952 for $8,000, the highest price paid for a Pollock during the artist's lifetime. Janis sold only two works from de Kooning's first show in 1953, but far more important was that one of these, *Woman I*, went to the Museum of Modern Art. Added notoriety came courtesy of supermarket heir Huntington Hartford, who took a full-page ad in the *New York Times* to broadcast his philistine views of the picture and denounce its acquisition. The delayed effect was that de Kooning's third show sold out on the morning of the opening. Like most successful dealers, Janis hewed to no rigid pricing formulas. When Franz Kline joined the gallery, Janis decided that $3,000 was too much for a new collector to pay for three or four broad, swift, black brushstrokes on an unprimed canvas. He cued regular customers toward a bargain, and soon prices doubled and redoubled; by the time Kline died in 1962, his prices had reached $20,000.

Janis's astute merchandising combined with a sharpened appetite among collectors for vanguard art to bring undreamed-of wealth to his artists. When they complained that he was not doing enough to sell them in Europe, Janis replied that business was too good at home: "We did not have to leave our chair here." After years or even decades of scrimping, the artists swiftly discovered the joys of money; soon they also discovered high taxes and began to limit their output. Some years, Rothko would stop producing as early as February to cut down on his income; de Kooning also limited his output for tax reasons. Franz Kline, who faithfully kept on slathering with his ideographic brush, earned about $300,000 in the single year before his death.

When Janis certified Pop Art as the next new wave with the "New Realists" show of 1962, he was still careful to underline the European roots of the garish new art. Half the painters in the show were Europeans, and the catalog introduction was

written by a French critic who had launched *Nouveau Réalisme*, a group including Yves Klein, Arman, Daniel Spoerri, and Jean Tinguely. In his essay Pierre Restany connected the Europeans as well as the Americans to Marcel Duchamp and Dada, saying that their work was essentially a protest against mass culture. It was not Restany's mistaken assumptions about the Pop artists' motives that infuriated the Abstract Expressionists. Rather, they resented "their" dealer's promotion of a rival art movement. With the exception of de Kooning, not a single Abstract Expressionist attended the "New Realists" opening, and Janis later accused them of boycotting the arrival of Pop Art at his gallery. Soon the Janis gallery was bereft of all Abstract Expressionists; the only remnant of the 1950s was Josef Albers. Nevertheless, Pop Art caught on with unprecedented speed. In four years the new style had achieved the eminence—not to mention the prices—that it had taken Abstract Expressionism ten years to reach. Ironically, the ninety-year-old Sidney Janis, interviewed on his birthday in 1986, complained bitterly about how fast even newer art movements were emerging: "A new generation every two or three years," he lamented, when in his own heyday "there was a new generation every thirty years."

A brisk walk to the east of the Janis Gallery, high in a Lexington Avenue skyscraper, is the headquarters of a new generation in art sales, a concept that threatens art dealers even as it offers a new, frankly investment-oriented option for art collectors. The Citibank Art Advisory Service is a division of Citicorp's private bank. Only those whose net worth exceeds $25 million can take advantage of its comprehensive services; it is "a product," as its administrator, Henry King, describes it, "one of ten that we offer to individuals." For those who meet the bank's means test, the service deals with every aspect of forming an art collection and makes loans with art as collateral. King insists that the bank does not want "a lot of clients. We want people who are really collectors, not investors."

Tall, lanky, handsome, genial, a team worker, King is

thrilled to have landed his job after thirty years with the bank and a year of negotiating to move from another division. He lives in Princeton, New Jersey, where in June 1989 his son became the third generation to receive a Princeton University degree. King's father, Edward, spent his whole career as an art historian, retiring after many years as director of the Walters Art Gallery in Baltimore. The son heads a team of seven art historians, each of whom is a specialist in a particular field: Old Masters, Oriental art, Impressionists, Moderns, decorative arts, European furniture and art, contemporary art. Most of the service's clients pay the bank an annual retainer, and the staff does the rest: setting what King calls "a strategic direction for the collector," finding works to buy, negotiating the price, registering them, packing, shipping, insuring, restoring, and cataloging. "The advantage is total confidentiality. We act like a private curator," says King. "We combine art history with the art market."

The service's specialists also provide Citibank's account officers with valuations of art offered to the bank as collateral. The bank lends up to 50 percent of the art's value "as determined by us," King stresses, "but we expect the client to have enough net worth and cash flow to pay off the loan. We don't want to foreclose." Unlike Sotheby's, Citibank makes loans only on art the client already owns and does not accept prospective purchases as collateral. Though only a tiny arm of the huge Citicorp and the smallest of the private bank's ten divisions, the Art Advisory Service has a stable client base. "Most collectors can't stop," says King, smiling.

J. Patrick Cooney is the only one of the service's seven specialists who was in on its founding in 1979. Slim and serious, with glasses and a trim beard, Cooney looks as though he has just emerged from a seminar room. Indeed, he spent years on the curatorial staff at the Frick Collection before joining Jeffrey Deitch to help the bank "understand" the art activities of its wealthy clients. While the bankers were familiar with real estate, stocks, and bonds, they wanted staff people who could "relate to the art assets." They discovered that although some clients were consumed with a passion for col-

lecting art and were spending more than $1 million each year on it, many also lacked the time to follow the market or to investigate the history of particular pieces they wanted. Some were leaving important decisions to a secretary, especially in such crucial details as insurance, framing, and restoration. In addition, the bank was handling estates with substantial art holdings. Here the challenge was to avoid depressing prices by flooding the market, and instead doling out works over a period of two or three years.

Cooney finds his position between collectors and bankers "most exciting," partly because the job gives him a chance to see and evaluate lots more art than a curator normally sees. His associate, Jennifer Josselson Vorbach, enthusiastically agrees. She spent six years as a specialist in contemporary art at Christie's, where there was obviously no dearth of art to see and appraise but no time to enjoy it. She doesn't in the least miss "rushing past the art on the way to my department with a cup of coffee." Now she luxuriates in the chance "to really see objects, to discuss them with my colleagues." A vivacious, energetic young woman, Vorbach was amused when she first arrived at the bank and "someone spoke to me obliquely . . . about my skirt being too short for a bank vice president." She quietly stood on the rights of art-world people to dress individualistically, and nothing more was said. All the specialists work together, much like an academic department, and occasionally they retreat to a conference room for spirited scholarly discussions. They spend about one-third of their time traveling, and like triumphant veterans, they swap war stories of, for example, one-day forays to Geneva, arriving at 6:30 A.M. and taking the 2:30 P.M. flight back. "That's not enough time to develop jet lag," observes Cooney.

On the forty-eighth floor of the Trump Tower, the founder of Citibank's art activities now dashes frantically into a studio apartment decked out as an office. Jeffrey Deitch is a brisk and knowing blend of stockbroker, banker, and trader. Young

enough to display the vestiges of acne, he wears a gray pin-
striped suit, longish black curls, and fashionable Armani horn
rims. After a full day of who knows what astronomical art
deals, he breezes in at 7:00 P.M. and spends half an hour sipping
hot tea with milk while returning phone calls at a glass confer-
ence table that serves as his desk. Dusk is falling over the
skyscraper panorama to the west, an awesome scene reflected
in a glass mirror covering one wall of the narrow room. "I
work all the time," he admits. "It's my natural state. I work
when I'm not sleeping, . . . and sometimes when I'm asleep I
wake up thinking of art deals."

Jeffrey Deitch spent some years as a museum curator in
Massachusetts but found it a dead end and began to search out
"a way to participate in the center of the art market." In 1979
he made the rounds of several New York banks with his notion
that they get involved in lending money on art. Chase Manhat-
tan was interested enough to hire him to make a study. But
Citibank, which had already been working with Sotheby's on
cooperative loans, hired him to establish its art consulting
service. "It was a natural activity for banking to move into
lending in the art world," he says. "It's a matter of understand-
ing values." After nine years Deitch set up an independent
practice as an art consultant and now has clients all over the
world and an associate in England; he also "takes a position in
the art market" for himself.

One contemporary artist he vigorously supported was
Jean-Michel Basquiat, the graffiti artist who died of a drug
overdose in 1988. Deitch first visited the artist at his dilapi-
dated digs in 1980, where a battered refrigerator covered with
Basquiat's desperate scribbles struck him as "one of the most
astounding art objects I had ever seen." He picked up five
drawings on typewriter paper from the floor and paid $250
cash for them. Two years later Deitch wrote an admiring re-
view of a Basquiat show at the Annina Nosei Gallery and an
article about the artist in *Art in America*. In the fall of 1984 five
paintings by the twenty-four-year-old artist were consigned by
an anonymous owner—was it Deitch?—for auction at Sotheby's
in London and brought such high prices that Henry Geldzahler,

for one, announced he could no longer afford Basquiats.

Today Jeffrey Deitch is a familiar figure in auction rooms around the world and is often quoted in newspapers and magazines on the state of the art market. When the Getty Museum bought Jacopo Pontormo's *Halberdier* in May 1989 for $35.2 million, Deitch stayed in the bidding until the price surpassed $30 million. For a client? For himself? No outsider knows. He calls auctions "good theater . . . high-level sport" and professes bafflement as to why the media and the public are so fascinated with high auction prices for art. The amounts involved are piddling, he points out, compared with the amounts at stake in big-city real estate deals, leveraged buyouts, or corporate raiding.

Dealers may denounce auction houses with red-faced rage, but the most important of them could hardly do without the heart-pounding, thrilling environment in which, at last, a firm—and, above all, public—price is established for a given work of art. Far from being enemies, as they are often depicted in the popular press, dealers and auctioneers have a symbiotic relationship. When the dealer André Emmerich was laboring to maximize the Hans Hofmann estate, for example, auctions played a crucial role in the process. In 1975 the dealer publicly announced that he would bid $50,000 for a Hofmann coming up in an auction. That set up a floor price for Hofmanns, protecting the value of the scores of other works by the artist still in Emmerich's stock; the painting actually sold for $70,000. Later that year Emmerich bought another Hofmann at auction for $65,000 (although he denies it) and resold it to a private client, pushing Hofmann's price still higher. By 1977 a Hofmann went for $220,000, setting a world record for all Abstract Expressionist works.

For most of the two centuries during which auction houses have been knocking down art, dealers found them useful adjuncts in buying and selling art and even essential as the arbiters of prices. But when the public discovered the fun and

profit of shopping auctions and the media began describing glittering, celebrity-strewn evenings with millions dropped at the fall of the hammer, dealers began to worry. Landmark auctions, such as the Gabriel Cognacq sale in 1952, the William Weinberg sale of July 1957, the Georges Lurcy sale just a few months later, and the Goldschmidt sale of 1958, drew what were then considered stunningly high prices for Impressionists, even those of the second rank. They also attracted jet-setters who enjoyed the status derived from publicly spending large sums. Gone was "the old gentlemanly deal, in which the seller was satisfied with a reasonable price that made it possible for the dealer to sell at a reasonable price and so make another of his clients happy," wrote one observer in the mid-1960s. Instead, the public seemed eager to don evening clothes to witness "a cutthroat duel in the sale room." Ever since, dealers have been distressed to see the growing ranks of their rightful customers crowding into auction rooms for an evening's festival of acquisitiveness. Historically, dealers comprised 70 or even 80 percent of auction house clients, but in recent years that percentage has dropped to around 40 percent. Between 1984 and 1987 alone, the percentage of sales at Sotheby's to private individuals went from 40 to 60 percent. When the American Art Dealers Association responded to these baleful numbers by organizing a special joint exhibition in February 1989, participants were delighted that $30 million worth of art was sold. But on a single evening at Sotheby's the following May, forty-four works, each worth more than $1 million, changed hands.

With the art-buying public—and the media—increasingly following the drama within auction rooms, dealers are hard-pressed to react. Peter Goulds, who owns the L. A. Louver galleries in Los Angeles and New York, tells about a Jasper Johns print that sold at auction for twice its previous price. A client who owned another of those prints immediately called Goulds, expecting to sell it at the new price. Goulds had to explain that at least seventy-five of these prints had originally been sold and, while perhaps 10 percent of them were in museums, the rest could force the bottom out of the price if they all emerged onto the market at once.

Why the rich elect to dedicate evenings in November and May, when the major sales are held, to jamming themselves into a stuffy room in order to bid on art remains a mystery. To the nonbidder such an evening offers as much amusement as a three-hour session of contemplating an inert pile of someone else's money. Those in the media who decide what interests the public seem to consider the spectacle riveting enough to send reporters and television crews into the crowded room to capture the scene. It may be that what whets their appetites is the inordinate secrecy surrounding most other art transactions. When dealers discreetly avoid marking the price on what they sell, when museums maintain utmost silence on the financial details of their acquisitions, the public's curiosity is aroused. Despite the crassness of the spectacle, an auction at least produces hard, bottom-line numbers.

As a result of their growing dominance since the Second World War, the auction houses have moved from being simply pricemakers to also acting as tastemakers. Through advertising, promotion, and publicity, they "enlarged our ideas of what constituted marketable art," writes one chronicler of Sotheby's. "Each work of art, however sentimentally important, now invariably has a price-tag attached to it." In the eyes of the public, and within the art world as well, aesthetic value increasingly matches monetary value, so that "the market has become the major authority, leaving the tastemakers to follow, to explain its dictates." Because auction results are the only publicly available source for art prices, museums rely on them for insurance valuations and dealers adjust their prices to conform with the latest sales figures. As prices for big-name art have lifted off toward the stars, wealthy but ignorant buyers get a sense of security from bidding at auction. They reason that "what lots of people want to buy for lots of money must be worth a great deal."

The very atmosphere inside a leading auction house impresses the art investor. "Art history at its best" is how Martin S. Ackerman describes the 1974 London Sotheby's in his *Smart Money and Art*. Ackerman liked the casual atmosphere, the faded elegance, the open displays of valuable pictures. "It had

the ambience of a hobby-house for eccentrics," or perhaps of "a million-dollar junk shop." By contrast, John Russell of the *New York Times* was appalled by the New York auction circus in May 1989. The sales offered a setting in which "every last instinct of greed and cupidity and ostentation was let loose." The "gladiatorial scenes" of bid and counterbid and the applause which greeted the (often anonymous) winner struck him as deplorable proof that in such a world "money is the measure of all things, great art not excepted."

The author of Sotheby's current financial success is Adolph Alfred Taubman, who took over the ailing firm in 1983 and subsequently made a fortune taking it public. He owns some nineteen shopping malls and reportedly told a *Wall Street Journal* interviewer that "selling art has much in common with selling root beer. People don't need root beer and they don't need to buy a painting, either. We provide them with a sense that it will give them a happier experience." The homely air of a soft drink stand, however, bears little resemblance to the particularly electric ambience at Sotheby's on the night of a big sale. Stretch limos cruise up to the canopy at York Avenue and Seventy-Second Street like sharks, while a floodlit crowd gapes at the arrivals. So these are the multimillion spenders, sleek-looking men with prosperous paunches draped in expensive pinstripes, elegant women out to be amused, slender Japanese bustling soberly. The mob crushes into the lobby and, when the doors of the sale room on the second floor open at last, tramples up in undignified haste.

The salesroom is crammed with perhaps five hundred cushioned folding chairs, slowly filling. The auctioneer's podium resembles a Victorian pulpit, all dark wood and trefoil moldings; from here the materialistic sermon of the evening will emerge. There is endless testing of microphones to amplify the homily into the room and, more important, to the television crews poised at its narrow margins. There the rest of the press also stands pressed into an unseemly knot; a strained camaraderie prevails. The regulars from art magazines struggle to conceal the angle they may have devised to make their story unique. But how can they write unique stories, when the

events about to unfold have played out the same way hundreds of times before? Unlike real art, which offers a unique message to each viewer and freshly reveals itself each time it is seen, this spectacle offers variations only in the amounts bid and the identity (if it is revealed at all) of the bidder.

Inside this room the art so reverently hung in a museum or a private home is devalued to goods. Large works by well-known artists hang carelessly around the perimeter, and people brush unseeingly against them. A couple of Calders this evening tremble overhead in the breeze created by so many moving bodies. Meanwhile, the Sotheby staff women trip about on mid-heels, preoccupied with last-minute errands. They are all dressed in classic, very good clothes that look unaffordable on the typical modest Sotheby salary. They have pulled their shiny, healthy hair back into black velvet bows and wear important glasses that indicate they have studied somewhere expensive.

By 6:40 P.M. the Japanese are already seated, and by 7:15 the auctioneer, amiable and urbane in evening clothes, mounts the pulpit/podium and begins. In front, where the altar would be in a church, earnest-looking staff people guard a bank of telephone connections to the outside world and a second room housing the overflow crowd. Above, an electronic tote board replaces the eternal flame, instantly translating the bid into French francs, lira, British pounds, Swiss francs, deutsche marks, and yen. Those unable to glimpse the actual object currently being auctioned may view it in a slide projected, all too appropriately, right next to the tote board. The white blur must be the Jasper Johns, the inky square the Ad Reinhardt.

At Christie's the following night, the entrance at Fifty-Ninth Street and Park Avenue does not lend itself to the grand arrivals of Sotheby's and the ride up the elevator seems paltry, quotidian. The press rushes into the salesroom like a pack of rampaging dogs, jostling to stand where something—what?—can be seen. A young Englishman with longish hair, glasses, and in evening dress is the auctioneer; the women standing to his right scan the room for bids. It resembles a religious ritual, and perhaps, in this temple of mammon, it is.

Someone has spent many thoughtful hours in orchestrating this sale. Always at first, there are a few cheaper items deemed likely to exceed their estimates; possibly the estimates on these are set deliberately low to pique the crowd's competitive frenzy. This particular evening a Joseph Cornell box goes for $400,000, a record and almost four times the high estimate of $120,000. Polite applause. The buzzing begins when a Jasper Johns hardly bigger than a sheet of typing paper reaches $2.3 million in $100,000 increments. Hands are poised to clap as the gavel descends . . . but an injured voice from the rear cries out another $100,000 raise, and the bidding rapidly mounts to the ultimate price: $3.2 million. Then a Warhol goes for almost twice the top estimate, bringing heartfelt applause. For what? The dead artist? The record price for his work? The subject of the painting, Marilyn Monroe? The historic bullet-holes inflicted by a would-be assassin? Or just for the $4.7 million?

Ben Heller, who has bought and sold pictures for several decades, says that only amateurs suffer from nervousness that may cause them to overbid: "People want to buy something and sometimes they're swept away and go beyond the amounts they planned to spend." Not so professionals: "They have their limits." He also says that the notorious special signals, millions of dollars turning on the wink of an eye or the twitch of a finger, are used today, in perhaps only one sale in a thousand. Instead, he says, people bid on the phone, even at the risk of losing "the feel of the room." Aaron Berman, another auction room veteran, cautions bidders to get expert advice in advance. "The truly knowledgeable person," he says, "would do best to go against fashion and buy art with substance; that [Jeff] Koons tank of water with three basketballs in it will dry up."

Vertiginous prices at auction continue to astound regulars at the salesrooms. Deborah Drier of *Art & Auction* magazine observes that sales of so-called contemporary art really feature artists who emerged at least a generation ago or who, like Warhol, are dead. "Certain names," she writes, "crop up over and over again in a litany that takes on a misleading hierarchy and legitimacy." Souren Melikian identified the week in November 1989 when a de Kooning reached more than $20 mil-

lion as "a historic turning point in our culture, as sharp as
when the legendary Goldschmidt sale . . . enshrined the Im-
pressionists." He was referring to a London sale in October
1958, when Sotheby's first issued engraved invitations asking
bidders to wear black tie for the sale of seven choice paintings
at an unusual hour, 9:30 P.M. The veneer of a society event
encouraged record bids, including $369,600 for van Gogh's
Public Gardens at Arles. The buyer, Henry Ford II, then was
considered a reckless plunger; twenty-two years later, he sold
the same picture for $5.2 million. These were the kinds of
profits that lured the investment-minded into the auction whirl.

At first blush the auction scene appears to illustrate the
purest operation of a free market: a seller publicly offers an
item; buyers openly bid on it; the highest bidder takes it home.
But just as in the stock market, when large sums are at stake
creative minds scheme to manipulate the system. And there is
no Securities and Exchange Commission to formulate and en-
force rules. During the years when dealers predominated in
auction rooms, they sometimes formed "rings" in which one
dealer could buy a particular item at a bargain price because all
the others refrained from bidding. Afterward the "ring" would
conduct its own private miniauction to determine the final
buyer, with the difference in price shared among the under-
bidders. Rings are now illegal, but many other maneuvers have
emerged. Most of them rely on the secrecy auction houses
guarantee to both sellers and buyers. A dealer anonymously
places into an auction a few works by an artist he or she
represents, then anonymously bids up the price, thereby creat-
ing a new, illusory, higher price for all the other works by the
same artist. Even those waving bidding paddles in the room
may be agents for unknown ultimate buyers. "A minor conse-
quence," writes Melikian, "is that anyone sufficiently deter-
mined could choose to run up the price of any work without
being seen to break the law."

Despite the reality that auctions are strictly business, many
outsiders somehow expect decent respect for the merchandise,
which comprises, after all, some of the finest expressions of
human genius. The refined language of scholarship and con-

noisseurship pervading auction house publicity and, especially,
catalogs veils what is basically commerce. No wonder that
newcomers to the auction game suffer from shock at the inti-
mate intercourse between art and money, not to mention the
auction houses' peculiar practices. Some complain that guaran-
tees of authenticity inadequately cover items sold for less than
$5,000. In such cases the purchaser must give notice within
seven days that the work is "counterfeit" and has only fourteen
more days to prove it. Others protest that the only notice of an
unsold item comes verbally from the auctioneer, "at the fall of
the hammer." In the price lists issued by the auction house
after the sale, only the last bid is given, with no hint of
whether the item was actually sold. With 99 percent of bidders
unidentified and often bidding on the phone, there is, in fact,
no way of knowing if there was any real bid at all. The possibil-
ity exists that phone bids are all fictitious until the price reaches
a predetermined high level, at which time a real bidder will
have to pay the inflated price in real money.

When some of the secret arrangements made by auction
houses leak out to the media, great indignation sweeps the art
world. In 1989 angry moralizing followed Sotheby's $27 mil-
lion loan to Australian beer king Alan Bond to buy van Gogh's
Irises. Dealer Richard L. Feigen spluttered that "it's like buying
securities on margin without SEC controls." In fact, Sotheby's
had been arranging such loans for almost a decade; the only
change came in 1988, when Sotheby Financial Services took
over what had previously involved an outside bank. That SEC
rules would ever apply to auctions seems a remote possibility
and may not be desirable: regulating the art market would
validate and perhaps encourage more undesirable speculation in
the extraordinary products of human genius.

While heavy news coverage dwells almost exclusively on
auctions of high-priced art by well-known artists, most So-
theby's and Christie's transactions involve items from an end-
less attic full of far more mundane objects. At Sotheby's per-
manent auction rooms in New York, London, Geneva,
Amsterdam, Monaco, and Hong Kong (and in temporary loca-
tions for special items), the hammer regularly falls on ten

categories of books and manuscripts, eleven categories of furniture and decorative objects, on coins, stamps, guns, musical instruments, arms and armor, wines, carousel animals, toys, scientific instruments, and rock and roll memorabilia. These sales take place with little fanfare, attended only by a small band of specialists who are unheralded and unscrutinized. The Hong Kong branch features sales of Oriental jade, art, ceramics, and furniture, and various other locations specialize in Near Eastern art, six kinds of jewelry and other jewel-encrusted precious objects, judaica, antiquities, or ethnographic art. For each category Sotheby's issues a separate catalog before the sale and a sheet listing results afterward. Dealers and connoisseurs find these catalogs invaluable as the only public, reasonably reliable measure of value in all these areas. A subscription to all sixty-one catalogs, which also includes a quarterly newsletter, costs almost $6,000 per year.

Sellers often have to pay extra for catalog illustrations, especially those in color. But when the auction house wants to handle a particularly choice collection, it may include the production of a handsome book illustrating all the works to be sold and featuring scholarly essays about the merchandise. The catalog for the May 1989 sale of works from the estate of Edwin Janss, Jr., for example, included a touching memoir from his daughter, Dagny Janss Corcoran, as well as an admiring account of his collecting habits by Walter Hopps, curator of the prestigious Menil Foundation Collection in Houston. Opposite a faded photo of the eleven-year-old Janss posing astride a camel with his family in front of the Egyptian pyramids, a note from his daughter revealed that the man who developed vast acreages of Southern California real estate liked to dress "like van Gogh on the road to Tarascon." She goes on to write that her father "had a kind of spiritual essence, like the [Sam] Francis, tinged with mystery like the [Joseph] Cornells." She had learned a great deal from her father's collection, she wrote, especially "what my father always knew: these paintings have the answer. We must look, and think, and ask the questions." There was not a clue in this high-minded prose as to why this extremely wealthy heiress now wished to disperse her father's

treasures on the market. In his florid tribute facing a color snapshot of Janss in a worn red knit shirt with his wife smiling over his shoulder, Hopps asserted that "art accumulated in his living quarters and habitats as naturally as gear and tools accumulate in a ranch house." Such personal touches introduced the reader to a living personality while enveloping the meaning, and ultimately the value, of the art pictured in rich color in the remaining pages in a misty haze of insignificant trivia.

What were the qualities that beguiled the feverish bidders for item 20D in the catalog, a Francis Bacon *Study for a Portrait of Van Gogh* to thrust its final price to $5.8 million? Was the anonymous buyer impressed by Janss's winning personality and zestful lifestyle, or the affection expressed by his family? Was it Francis Bacon's touching determination to restore, as best he could, van Gogh's *The Painter on the Road to Tarascon*, burned during the Second World War, presumably by an air raid on Magdeburg? Was it the work's provenance—that Janss had acquired it from the Marlborough Gallery in London in 1964—or the fact that the painting had been in fourteen museum exhibitions in London, Paris, Amsterdam, Zürich, São Paolo, San Francisco, and the like and illustrated in eleven magazine articles and books? Was it the oblique association with an auction superstar, van Gogh, that gave this picture such a value? Was the buyer impressed by Bacon's obsession with van Gogh, which prompted the painter to create seven versions of the same picture during 1956–1957? Was it that this series formed a turning point in Bacon's style? That six other versions were in prestigious places, including two in the Hirschhorn and one in the Tate?

All these facts were known to the faceless arbiter who estimated that this picture would bring $2 to $2.5 million, and this raises further questions. Was the estimate set deliberately low in order to trigger headlines when the work finally fetched more than twice as much at the sale? Was it low because of the other versions? Was it low in order to attract bargain-hunting bidders? Was the high bidder a collector, or a dealer bidding on behalf of a client? Was there really an underbidder, or simply a

dummy driving the price up? These kinds of complicated speculations sweep through the art world in the wake of every auction. The answers may turn up years later . . . or perhaps never. Meanwhile, the gossip mills grind.

In order to obtain consignments of valuable collections like Janss's, auction houses usually assign several specialists to woo the owners (or heirs). In some instances Sotheby's gives cash advances on consignments; in others it guarantees a minimum price. Often, underwriting the publication of a lavish catalog clinches the deal. All too frequently the mellifluous catalog prose seeps into news reports both before and after the sale so that code words such as "important," "rare," and "museum-quality" stick to the object as though they were objective judgment rather than sales hyperbole.

There was a time when the auction houses bought magazine pages wholesale to advertise their sales. The April 1970 issue of *Auction Magazine* included a long-playing record of the bidding for van Gogh's *Cypresses and the Flowering Tree*, knocked down to a mystery bidder the previous February for an incredible $1.3 million. A typical issue of the stodgy British *Burlington Magazine* (November 1976) included ninety-three pages of advertising for Sotheby's worldwide sales. Today public interest in auctions is so intense that reporters cover the salesrooms in considerable detail. Advertisements are far more modest, and the promotion money is spent instead on blizzards of news releases and tender care for the most important journalists. Both Sotheby's and Christie's have staff people whose sole purpose is accommodating Rita Reif, the *New York Times* reporter on the auction scene. They hand-deliver news releases for her twice-weekly columns and are available evenings and weekends to answer her queries.

The gigantic returns easily justify the costs of such solicitude. In the 1988–1989 season Sotheby's sold well over $2 billion worth of goods, almost 50 percent more than in the previous season. Christie's sales approached the $2 billion mark, with sales in New York alone up by 94 percent. In a world almost as rife with outré statistics as is baseball, the auction houses reported that twenty of the thirty-five art-

works ever sold for more than $10 million had passed through
either Christie's or Sotheby's during that season, ten in each.
Especially striking is the increasing share of contemporary art
in the sales totals. From 1984 to 1988 Christie's total auction
sales of art tripled, but contemporary increased fivefold. At
Sotheby's, worldwide sales during the same period tripled, but
contemporary sales multiplied ninefold. In 1990, Sotheby's
second-quarter profits were up by 26 percent, and Christie's
broke through the $2 billion barrier. However, both houses
faced sales drops in the rest of the year, and investors demon-
strated their apprehension by driving the stocks of both compa-
nies to record lows. Yet, analysts believed that the drop was an
overreaction, and Sotheby's board of directors planned to buy
up three million of the company's shares.

No one would complain if such a roaring business took
place in any other goods except art. But when the auction
market drives art prices beyond the reach of almost all muse-
ums and also diverts collectors into selling their treasures
rather than giving them for public benefit, many art world
observers become nervous. They are responding to a long
history of dizzy rises in the art market followed by precipitous
drops. World economic conditions no less than changes in taste
quickly affect prices. In 1926, for example, Lord Duveen paid
the equivalent of more than $1 million for Sir Thomas Law-
rence's endearing portrait called *Pinkie*. He soon resold it to the
California financier Henry Huntington for the equivalent of
$1.3 million. Today few Lawrences come on the market because
prices would not be anywhere near such a level. If one did, it is
questionable whether it would fetch much more than Lawrence
received during the 1820s when he charged the equivalent of
about $15,000 for a portrait. In view of such price gyrations,
the dealer Allan Stone understandably worries about specula-
tors and investment-oriented foreigners shopping for art with
fifty-cent dollars. He warns that someday soon "they'd better
get the ambulances for those people." Even the head of Chris-
tie's operations in the United States, Christopher Burge, be-
lieves that "a comeuppance will come. Some people will get
caught and hurt, and panic and get out."

In reaction, one veteran auction-reporter has compiled a lighthearted list of descriptions and remarks that, alas, are unlikely to appear in the breathless media reports from the salesroom:

> "Nobody brought any money to this sale, so it was fortunate that nothing was worth buying either."

> "At the end of the sale, the unidentified telephone bidder [for the record-price Jasper Johns] stepped forward and said, 'I didn't think it was the greatest painting he ever did, but, boy, what fun it is to show off a Johns in my new Park Avenue triplex.'"

> "This crowd refused to get excited," said auctioneer B. T. Gavel. "Nobody was willing to spend real money. They all sat on their hands and, frankly, they were right."

> "I'm saddened," said seller D. M. (Daddy Mega) Bucks. "I bought this picture for $563 million two years ago and now it brought 59 cents."

> "This particular [fill in the name . . . Picasso, Cézanne, Warhol, Pollock, Bacon, Hockney] was just a third-rate example," said auction house specialist Brenda Eagle-Eyes in a telephone interview from Aspen, Colorado. "I'm not surprised—and maybe even pleased—that it did poorly."

Although the auction houses offer an easy target for high-minded critics, dealers have also contributed to the fever of speculation in art. Former San Francisco Museum of Art director Henry Hopkins calls them the principal villains as he describes the system: "Dealer X convinces collector Y to buy the works of a particular artist," he says. "When three or four own

the work, they spread the word among their peers." Soon
museum trustees, who now are mostly collectors, pressure
curators to exhibit and perhaps buy works by the same artists.
"They're like dope dealers," Hopkins says bitterly, "spreading
the word that owning this stuff is entrée into this little circle."

Such games reduce art to the level of fashionable designer
clothes and threaten dealers who refuse to play, perhaps even
more in the long run than the competition from auction houses.
Many buyers who might in the past have relied on a dealer's
recommendation are now fearful that they are not "insiders"
enough to merit insider-quality advice. Many new art buyers,
both individuals and corporations, feel the need for unbiased
advice on what to buy. Their need has brought forth a whole
new profession: independent agents who operate like decora-
tors, working either on retainer or on commission from the
sellers. The housewife who wants just the right painting to
match her living room couch, or the corporation president who
desires to link his company's image with high culture, can turn
to an art consultant. The Association for Professional Art
Advisors claims more than forty members nationally, although
several hundred advisers probably exist; a hundred and fifty or
so have been counted in Los Angeles alone.

Leo Castelli speaks of them with evenhanded diplomacy.
Art consultants are costly because they collect commissions
(usually 10 percent), and few of them are competent; yet he
admits that "they get collectors to come to your gallery." One
New York consultant, Estelle Schwartz, told the *New York Times*
that her clients do not mind paying more because "they know I
have ferreted out extraordinary pieces." She is gratified that
some of her "discoveries," such as Jeff Koons, Peter Halley, and
Meyer Vaisman, have also enjoyed museum recognition and
massive price increases since she began recommending their
work. She has no qualms about the assumption that art is a
commodity. "The value of an artist's achievement is in dollars,"
she says. "That's the way the system works."

Michelle Rosenfeld sometimes finds her work as an art
consultant "too exciting . . . like going to the racetrack. My
husband and I talk about art day and night." When she finished
her training as a speech therapist Rosenfeld decided to give

herself a year to try dealing in art. Now, more than two decades later, she has five people working full-time, an office in Ramsey, New Jersey, a two-thousand-square-foot branch in Manhattan, and some two hundred items in her personal art collection. When her husband retired as chief executive of a large sporting goods firm several years ago, he went back to Columbia University to obtain a master's degree in art history and then joined the business. Now the Rosenfelds' two children are both in college studying art history in preparation for joining the family firm. Meanwhile, the parents frequently fly to Europe, attending auctions, visiting artists, and shopping at galleries. "We haven't had so much fun since we were first married," she says.

The Rosenfelds' clients, says Michelle, are typically people who have worked hard all their lives and had little time to enjoy art. Older, perhaps retired, they might have taken a few courses in art history. "They come to me and say they've always loved Sam Francis or some other artist and they ask, 'What's the best I can buy? How much should I pay? Can you find one for me?' " Her clients are impressed by her own collection, and some have been with her firm since the beginning. "I'm like a surgeon. If I don't make mistakes, they come back."

"People, by their ability to buy works of art, get to think of themselves or their collection as more important than the works of art or the artists," observed the collector and private dealer Ben Heller. However, "because they have the good fortune to have the money and perhaps the better fortune to have the instinct, or the eye, or the opportunity to buy something, they shouldn't mistake the one for the other." Paul Brach, an artist who interested Heller in the Abstract Expressionists during the early 1950s, says "his response to their work was focused and dependent on close friendships with the artists." But Brach also noticed how Heller applied his businessman's skills to art; always conscious of value, Heller worked hard to maximize it, says Brach.

The Hellers had been nibbling at the edges of the art

market for several years when they spotted a huge painting, *One*, during a visit to Jackson Pollock's studio in 1952. They talked about it all the way home from East Hampton and finally bought it, for $8,000, after Pollock threw in another painting and gave them four years to pay. At that time the price was substantial, but so was the painting—nine feet tall and eighteen feet wide. In order to fit it into the Hellers' dining room, five inches from the top and bottom had to be rolled around dowels; even then it had to be tilted outward at the ceiling. Nevertheless, Heller was so thrilled after the work was installed that he spent several hours that evening contemplating it and then sent Pollock a night letter describing how profoundly it had affected him.

In the minuscule art world of that time, the purchase created considerable excitement because it showed that private houses or even city apartments, not just museums, could accommodate such big pictures. The installation was featured in the *New York Times*, and *Interiors* ran an article about it: "Art as Decor and Daily Fare." Henry Geldzahler found this title particularly ironic, writing about Heller in 1961 that "in an age in which the *act* of painting has been sanctified, what the collector is collecting is the ashes of the experience, the residue, for an act cannot be collected." To describe art as decor, Geldzahler wrote, "domesticates the collecting further, removes it still further from action and involvement." However the Pollock in the dining room may have diluted the Hellers' aesthetic experience, they continued to add paintings to their collection; by 1959 what they owned was of such quality that six of the seventy-odd pictures in the MOMA's "New American Painting" exhibition were theirs. In 1961–1962 an entire show composed of their holdings toured to Chicago, Baltimore, San Francisco, Portland (Oregon), Los Angeles, Cincinnati, and Cleveland under MOMA sponsorship. It filled three hundred running feet of wall space.

By then Heller was convinced that American art was worth paying high prices for and had paid $32,000 for Pollock's *Blue Poles*, a painting Janis had sold only seven years earlier for $6,000. In 1971 Heller would create a sensation in the art world by selling the painting to the National Gallery of Austra-

lia for $2 million. When this work left the Heller apartment, the couple held a "Farewell to *Blue Poles* Party"; in the center of the festive table was a cake decorated with a replica of the painting in sugar frosting. "I'm not going to be embarrassed by or walk away from or apologize for the fact that [the works I owned] became worth more money," said Heller. "It's done very well by my family. . . . But I have returned every ounce of love in kind that I possibly could."

His track record as an investor more than his passion for the art motivated those who somewhere along the way started asking him to join or form syndicates to buy pictures or asking to take 50 percent of what he was buying. So he became a private dealer. In his office lined with art books on the second floor of an East Side town house, Heller is wearing a casual knit shirt and sharply pressed blue jeans. A powerful-looking man who is aging gracefully, he gruffly barks into his telephone, applying the kind of ruthless bargaining that brought him success in the family's fabric business to deals in another kind of fabric—canvases worth many millions because of the pigments an inspired individual applied to them. His role, says Heller, is "strictly telling people what to buy. I present the possibilities as forcefully as possible" while trying to follow "rules of fair dealing and morality." Love for the art, in his view, mitigates the profits he reaps from it. He deplores the art world's fixation on money and all too common frauds and fakes, such as the bogus Jackson Pollock he saw only eighteen months after the artist died.

Almost twenty years ago Heller was already lamenting the intrusion of promotion and fashion into the realm of art. He would sneak into galleries early in the day, he said, "because by two o'clock . . . it became a big social thing. . . . It really got to be like the fashion business: is the skirt up or . . . down this season." Now he looks back fondly to that time, "when the museum became a cathedral," nostalgically comparing it with today's "floating crap game, loaded with trivia."

The person who feels a consuming need to hang van Gogh's

Irises in the living room but lacks the $53 million or so to buy it can purchase an excellent framed reproduction in a shopping mall for about $125. Although this buyer probably derives as much aesthetic pleasure as the affluent collector making acquisitive rounds of SoHo or Fifty-Seventh Street on a busy Saturday, he or she should not expect approval from museum professionals or art historians. Serious experts frown on reproductions. They also scoff at signed and numbered original silk screens as well as more costly original paintings featuring a vaguely familiar style and a totally unfamiliar signature. Nevertheless, many shoppers appear thrilled to pay perhaps $5,000 for a framed oil faintly reminiscent of, say, German Expressionism or a framed silk screen (one of three hundred) that reminds one of a John Singer Sargent. Despite the disdain of museum people and of more exalted dealers, most art buyers acquire original works from either a local art store or, more likely, an outlet of Dyansen Galleries, Circle Galleries, or Martin Lawrence Galleries, three publicly traded chains selling prints by well-known artists and paintings by unknowns working in a familiar style. The largest, Martin Lawrence, has almost forty locations and plans to open ten or twelve new locations each year for the foreseeable future, mostly in shopping centers. In 1988 earnings were $5.8 million on sales of more than $34 million. The company's founder, Martin Blinder, lent Warhol's *210 Coca-Cola Bottles* to the MOMA's 1989 Warhol retrospective and now enjoys the enhanced value this exhibition brought to all the artist's works. Bought for $1 million in 1988, the picture is now worth close to $4 million, says its owner.

In addition to pictures that offer imitations of famous styles executed by unknown artists, the shopper who wanders into a chain gallery will find signed, limited edition silk-screen prints by well-known artists—Robert Rauschenberg, Andy Warhol, Robert Indiana, Keith Haring—priced at $1,000 to $10,000. These are usually made in editions of 250, which means that a typical print sold for $5,000 will bring in $1.25 million. The chain galleries also have developed their own stars, artists whose work never appears in major museums or in prominent private collections, but who command a sizable following and surprisingly high prices.

Virtually everyone in the high art world considers these galleries beneath contempt, purveyors of a product rather than guardians of the sacred flame of art. Bruce Davis, curator of prints and drawings at the Los Angeles County Museum of Art, said that "the whole commodity aspect of art has little to do with culture." The MOMA's director of the department of prints and illustrated books, Riva Castleman, deems the chain galleries "just different." Their first priority, she complained, is "to find something that is very salable." In this regard, she believed they differed from most art galleries, which "are committed to the object made by the artist as an original idea, and very frequently salability is a little lower on the list of ideas that made them go into the gallery business."

One survivor from an earlier day of idealistic gallery directors is Terry Dintenfass, who came to New York as a gallery assistant to Edith Halpert at her Midtown Gallery soon after the Second World War and opened her own space in 1954. "It was then considered a polite business suitable for a woman," she says, "even though it's really the roughest, toughest kind of business." During her long career she has watched the representational artists she has nurtured, among them Philip Evergood, Jacob Lawrence, and Robert Gwathmey, pushed aside during the 1950s by the Abstract Expressionists and overshadowed by subsequent waves of new art.

Dintenfass feels intense loyalty to her artists; more than just a business relationship, she enjoys the closest of social ties with them. "When I came to New York, I had no friends," she says. "The artists made my life." She made many of their lives comfortable, if nothing else, believing in their individuality as artists even as fashionable vanguard art surged past them. Her gallery has also been a financial success, relying on a small, devoted following among collectors and control of the estates of some important American modernist pioneers such as Arthur Dove. As the prices of American art escalated in recent years, her artists, dead and alive, have also enjoyed significant appreciation. In 1989 Dintenfass sold for $350,000 a painting by

Horace Pippin, a black artist who brought unusual emotional overtones into his primitive images; she had sold it a few years earlier for $20,000.

Despite such success, Dintenfass remains pessimistic if not · cynical. Many galleries, she says, are just stores; the current art business "has very little to do with art." In the modest office of her Fifty-Seventh Street gallery, in a building filled with art dealers, this ladylike, patrician-looking woman says, "I feel I wasted thirty years of hard work." While regional museums are some of her best customers and also encourage individual collectors, Dintenfass keenly resents the failure of the nation's leading museum of American art, the Whitney, to bring the works of her artists out of the basement into public view. Her artists are substantially represented at the Whitney, and time after time, she says, she has tried to persuade officials there to exhibit some of the many works in its collection by such artists as Philip Evergood and Jack Levine. The public is not interested in this kind of art, they tell her; her artists are not "box-office." Dintenfass mourns that "first comes publicity, then comes art." She also blames herself. "Where the hell was I?" she asks bitterly. "Why can't I live to see my painters shown in museums?"

Two blocks to the east, in another building devoted to art galleries, another style of dealing prevails. From beyond the vertical blinds comes the hiss and splash of traffic five stories below on this wet and windy fall afternoon. Buses are groaning to and from the curb, and somewhere far away something mechanical beep-beeps, backing up. Out there is one of the world's most brilliant intersections of elegance and money: Fifty-Seventh Street and Madison Avenue. Inside the preferred client room at the André Emmerich Gallery, the spareness of the furnishings emphasizes the velvet couch with its rich sheen of old ivory and liquid gold, the sturdy sinuousness of two Louis XV *bergères*, the black slate chunk of a square coffee table, the worn beige velvet of the empty viewing stand. It is a rich

and intimate room, carefully illuminated by a square of track lights on the ceiling and spotlights as well, all controlled by seven dimmer switches. The blank white walls and the superb lighting cry out for something decorative, something beautiful . . . of course! Almost palpably missing is a great work of art.

In the work area outside the door, gallery assistants bustle like mice in spike heels on the waxed wood floor while the telephone discreetly buzzes. The edges of pictures, unframed, paint-flecked, call tantalizingly from their racks. That one, with its bold black slash on a thick stretcher—what dream or nightmare lives there? And that other one . . . and that other one, too? The wish to see and savor blends easily here into the wish to own, the passion to possess. On the coffee table in the viewing room is a foot-high welded steel construction by Mark di Suvero. Placed just so under a spotlight, a gemlike gleam flickers along one edge of the tormented metal while a luxurious, velvety warmth exudes from the rusted surfaces. To a visitor seeing this work for the first time in this self-indulgent privacy, it seems a first-rate meal prepared exclusively for her delectation. But the room also offers a sense of isolation, perhaps even abandonment. Left alone in Ali Baba's cave, one's cool judgment crumbles; perhaps the sorcerer who has conjured up this room will carry off not only one's money but a piece of one's soul.

The couch gleams like gold as a soft step at the door announces one of New York's most experienced and successful dealers. Handsome, gray-haired, soft-spoken André Emmerich has been selling art since 1954 and has gathered a glittering stable of art stars, including Helen Frankenthaler, Sam Francis, David Hockney, Al Held, Kenneth Noland, Jules Olitski, and Larry Poons. He also represents the rich estates of such artists as Morris Louis, Hans Hofmann, and Burgoyne Diller. Until recently he also dealt in pre-Columbian art, but gave it up as export restrictions, looters, and fakery muddied up the field.

Emmerich looks back with some nostalgia on the early days of his gallery, when he had one graduate student as a part-time assistant and spent all his time with art. Now, he says with some regret, he is an executive for a staff of twenty and

spends most of his time managing artists, installing exhibitions, preparing catalogs, working with museums, and, of course, dealing with the most important collectors. Like almost all dealers, he deplores the entry into the art market of speculation-minded investors, but he optimistically claims that high prices for art also prompt buyers to educate themselves about art. "A collector may buy badly once or twice," he says, "but when committing serious money, he or she suddenly begins to compare, to study, to read, to *look* with more discernment."

Robert Miller's is somewhat typical of the route taken by dealers on the way to having their own gallery. His twelve years working for André Emmerich were "like an extended graduate course in selling art." After opening a gallery of his own at 724 Fifth Avenue, yet another building devoted largely to galleries, he moved into a space he had coveted for many years, the second floor corner of the Fuller Building at Madison and Fifty-Seventh Street, the same building where the Emmerich Gallery occupies space on the fifth and sixth floors. Like many who open their own galleries after working for years for someone else, Miller now scorns his former employer for running "a Greenbergian operation." Many of Emmerich's artists rose to prominence by attracting the critic Clement Greenberg's seal of approval, a practice Miller now calls "one of the most sinister aspects of the art world."

In sharp contrast to such methods, says Miller, he operates like an old-fashioned banker, expending special concern for artists, expecting the art he shows to find buyers because of its uncompromising quality, and assuming that his clients will appreciate fair dealings. "I want the gallery to make its way on my own terms. . . . The audience I most hope for is the audience of artists, critics, and writers." Miller is convinced that "money will never make art. . . . The speculator-investor will never make art stand up in the future." The current scene appalls him; he calls it "a group sport" that exerts its worst effect on artists: "How do artists deal with the abuse of art by money?"

John Cheim, who manages the Miller Gallery, agrees yet is confident that "good art will surface."

To make it happen, Miller is willing to work with artists for years, if necessary, without selling much of their work. Expounding such faith, Miller is standing up painfully in the showcase corner room of his gallery; for ten years he has been battling a crippling disease which makes it difficult for him to sit down. The din and color of the city just outside intersect poignantly with the quiet room furnished in neutral mushroom colors. In Miller's high-ceilinged sanctuary, the city's hubbub and its threat appear manageable, even interesting, exotic. Since his gallery opened in 1983, it has developed a reputation, according to a *New York* magazine article, "for chic, for scholarly revisionism, for its careful selection of high-priced, blue-chip art, and for its disdain for the macho school of painting"—Julian Schnabel's work, for instance. It has also managed to attract important artists from several generations—Louise Bourgeois, now the grand old lady of vanguard art; Larry Rivers, Al Held, and Alex Katz, also aging heroes of an earlier avant-garde; Rodrigo Mynihan, Jedd Garet, and Robert Graham, younger artists of particular style—and important estates that will yield profits for many years to come: the photo portion of the Warhol estate and the estates of photographers Robert Mapplethorpe and Diane Arbus and painters Lee Krasner and Alice Neel.

Miller's delicate maneuvers to attract Alice Neel to the gallery illustrate how taste and persistence sometimes lead to profits. John Cheim had admired Neel ever since his student days at Rhode Island School of Design. She then showed regularly at the Graham Gallery, where her paintings sold for $5,000 to $10,000. In 1977, when she was seventy-seven years old, Cheim and Miller spotted her at an art school benefit and persuaded her to send one picture to their summer group show. Then Cheim, Miller, and his wife, Betsy, all sat for Neel portraits and got better acquainted with her. Neel was still loyal to Graham, but she did let the Miller Gallery assemble a group of still lifes, interiors, and landscapes, more of which were sold at higher prices than ever before. After Neel moved completely to

Miller, the gallery helped to finance a Harry Abrams mono-
graph about her. When she died in 1984, the stage was set for
posthumous appreciation of an artist who had spent most of
her life doggedly clinging to her unfashionable figural style.
Roberta Smith in the *New York Times* raved, "Neel may qualify
as one of the country's most important and singular artists."
Now Miller manages the whole Neel estate, several hundred
paintings and drawings. Currently her paintings sell for more
than $100,000.

Miller has particularly cordial ties with museums. He
showed Ralston Crawford in 1983, and a Whitney show for the
artist followed in 1985; the 1982 Miller exhibition of Lee
Krasner's work from the late fifties preceded a MOMA exhibi-
tion two years later; Jan Groover was featured at Miller's
gallery in 1985, and a MOMA retrospective followed in 1987.
John Cheim basks in "the high moment . . . when a museum
acquires work by one of our artists" and attributes such success
purely to the gallery's persistent support, sometimes over more
than a decade.

An intricate relationship exists between dealers in contempo-
rary art and museums. Dealers benefit because a museum
exhibition validates an artist's work and thereby handsomely
enhances its monetary value. Furthermore, since the specific
works in a museum exhibition are often for sale, dealers can
make important contacts among regular buyers of art as well as
commissions on actual sales. Trustees and other museum insid-
ers have no qualms about inquiring whether a work lent for
exhibit is for sale. Indeed, some exhibitions are entirely
snapped up by those who attend the previews, before the show
opens to the general public. Lending art to a museum exhibi-
tion earns dealers gold stars as benefactors and displays the
work before the most likely customers.

Museums in turn rely heavily on dealers to find and pro-
mote new artists, provide documentation and illustrations for
exhibition catalogs, and, perhaps most important, to lend key

works by their artists or from their personal collections. Of the one hundred nineteen paintings and sculptures in the 1989 Whitney Biannual, for example, dealers supplied fifty-three; Mary Boone provided eight items, and Robert Miller and the Sonnabend Gallery supplied four each.

So important are the major dealers to museums of contemporary art that they are often courted by directors and trustees. When the Museum of Modern Art held its first Jasper Johns exhibition in 1958, Leo Castelli not only supplied most of the works in the show but also helped to arrange and hang them; everything but one item in the exhibition was sold to museum benefactors. Three years before the Los Angeles Museum of Contemporary Art had its first exhibition, its prime mover, Eli Broad, considered Leo Castelli vital enough that he held a large cocktail reception in his honor, followed by an intimate dinner. Sidney Janis was a trustee of the Museum of Modern Art during the 1940s, and after he opened his gallery in 1948 he was also a member of the acquisitions committee. "While collectors tend to invest in names, museums . . . relish . . . obscure links in art history," observed the dealer Joan Washburn. Perhaps such scholarly niceties fascinate some specialist curators, but major museums forget about obscure links when they are offered big names. In 1967 the MOMA jubilantly fêted Sidney Janis when he gave the museum one of the most substantial gifts in its history: one hundred works by three generations of Modernists including Picasso, Mondrian, Braque, Léger, and Miró. All these artists were already so well represented in the museum's collection that many of their works remained in storage. At the same time, Janis retained many of their works in his gallery's stock, waiting for the higher prices museum exposure would inevitably bring.

Few dealers, however, actually do command the prestige to impress museums. Castelli says that only twenty out of more than five hundred dealers selling serious contemporary art have any influence; in the past there were even fewer, possibly three or four. John Cheim of the Robert Miller Gallery also believes that only twenty New York galleries show what he calls "interesting things." One such dealer, interviewed anon-

ymously by a sociologist, said that he sees himself "as the art world's gatekeeper, or as an explorer, picking through uncharted territory in advance of the critic and curator." Vanguard dealers hate to be viewed simply as "money-changers in the temple of the Muses" and strive instead for an image as patrons, independent connoisseurs dedicated to the welfare of art and artists. The artist Saul Steinberg noticed "a Faustian quality about dealers because of their having to deal with fame and money. They become strange," he said, "like swans or giraffes. . . . The best are like Nibelungs, keepers of the treasure." A lawyer who advises art investors sees dealers cynically as the centerpiece of "a commercial distribution system[,] . . . middlemen who want to regularize the relatively unstable and erratic production of the artists, or circulate the art work back through the system." Somewhere among these views there glimmers the archetypical dealer.

"There is no state law," says Ivan Karp, "that requires dealers to take a test to prove their expertise." The best dealers shelter their artists like magnanimous parents, making their rent and car payments and smoothing their divorces. "Artists always hope that they will find their Kahnweiler," wrote the artist Jules Olitski. "But the truth is that there are no Kahnweilers. Even Kahnweiler wasn't Kahnweiler, at least not as he has been pictured in retrospect."

6
MUSEUMS:
WELFARE FOR THE WELL-OFF

Since the Second World War, Americans have been on a museum-building binge; more than half of all museums in the United States were founded after 1950. Some twenty-five hundred museums opened between 1950 and 1980, more than one in every five days. During these years Americans built 10.2 million square feet of space devoted to visual arts, the equivalent of a paved highway six feet wide from New York to California or 13.6 Louvres. The half billion dollars spent on museums during this time was probably more than Americans had spent on museums during the previous 150 years.

From the refurbished inner cities of the East to the suburban sprawls of the Sun Belt, the drive to build new art museums continues, along with the pressure to add to existing institutions. In downtown Pittsburgh an independent arm of the Carnegie Museum of Art will open in 1992 in a renovated industrial building. Its seventy thousand square feet will be devoted to a native son, Andy Warhol, housing more than seven hundred paintings, masses of drawings, prints, photographs, sculptures, films, and videotapes, and twelve hundred boxes of miscellaneous papers that make up the Warhol Archives. It will be the most comprehensive single-artist museum in the country. In Atlanta the High Museum of Art, which opened in 1983, is planning a new wing. In Newport Beach, California, the Newport Harbor Museum, which opened in 1961, is already raising a $50 million endowment to construct an eighty-seven-thousand-square-foot addition, designed by

Renzo Piano, on a ten-acre site donated by a giant local developer, the Irvine Company. This ambitious project will rise not fifty miles from the Los Angeles County Museum of Art, the Getty Museum, the Norton Simon Museum, and the Museum of Contemporary Art, not to mention a dozen or more smaller museums.

On September 9, 1980, a leading Los Angeles entrepreneur described his vision for a new museum to a Town Hall gathering of local civic and business leaders. If the experience of other cities that had built cultural institutions in redevelopment areas were any guide, he indicated, the contemporary art museum to be included in the last phase of the Bunker Hill redevelopment would be a bonanza. Lincoln Center, he told the crowd at the Biltmore, had attracted $2 billion worth of new buildings to its neighborhood; cultural activities accounted for 25 percent of all tourism in New York, bringing more than $3 billion each year into the city's economy. Obviously, he told the audience, "Art is good for business."

That speaker, Eli Broad, is a fundamentally optimistic man, and with good reason. Unpretentious, pragmatic, patient, and doggedly industrious, he represents a certain kind of California pioneer who transformed the West Coast—and their own lives—after the Second World War. In 1957, he and his wife, Edythe, arrived in Los Angeles with little more than their baby son and their ambitions. Eli had been twenty-one years old when he and Edye were married in 1954, back home in Detroit, Michigan. In the same year he had graduated cum laude from Michigan State University and began to practice as a public accountant.

The Broads arrived in a city that was already sprawling, with subdivisions tramping north over the hills into the San Fernando Valley, east past Pasadena, and south toward the orange groves of Anaheim and the oil refineries of Long Beach. Channeled by an expansive network of freeways, the city draped over the landscape like a smothering quilt: block upon block of single family houses shot through by neon-bright

commercial strips. Where was the center of this agglomeration, a metropolis that even in 1950 had claimed almost two million inhabitants? Much to the amusement of Easterners and Europeans, "downtown" appeared to be little more than a ratty palm-fringed square ringed by a few gray high rises, a "weirdly inflated village," as Carey McWilliams described it in the mid-1940s.

While the city's physical heart was barely discernible, the heart of its political and cultural powers was compact, towering, and obvious indeed. The interlaced fortunes produced by oil, the movies, real estate, and banking flourished under the ferociously friendly umbrella of the archconservative, union-hating *Los Angeles Times*, itself the basis of a major fortune. The Second World War, however, had drastically and irreversibly changed the pattern of the city's growth. Industrial jobs in all of California increased from four hundred thousand to one million, with five thousand new industrial plants in southern California. A quarter of the eight million servicemen who were trained in or traveled through the state eventually returned. By 1980 the vast mosaic of lights greeting nighttime arrivals at LAX encompassed almost thirteen million inhabitants.

The power structure within this agglomeration had also changed drastically; Los Angeles was the largest and fastest-growing city in the country to elect—and re-elect—a black Democrat, Tom Bradley, as mayor. One of Bradley's staunchest supporters, Eli Broad was also one of the many new tycoons in industry, banking, real estate, and entertainment who had toppled the grip of Old Money on the city's political and economic throat. Over the previous quarter century, the accountant from Detroit had ridden the wave of California's explosive growth to the summit of a Fortune 500 corporation—the biggest home builder in the state, with massive interests in insurance and financial services. While building his fortune, Broad had also pursued a career of public service; half his résumé consists of unpaid services to the likes of the United Crusade and City of Hope, Claremont College and UCLA, the Los Angeles Chamber of Commerce, the YMCA, and the National Brotherhood of Christians and Jews.

During the late 1970s his extracurricular interests began

to include the world of art as his wife, Edye, her children grown, expanded her long-standing interest in collecting modern art. A member of the Los Angeles County Museum's Contemporary Art Council since 1973, Eli joined the board of trustees' acquisitions committee five years later. By the summer of 1979 Broad was familiar with the discontents of all those who deplored the sad plight of contemporary art in the nation's second largest city: the few galleries showing it, the general population's disinterest in it, the disaster at the Pasadena Museum of Art, where an inept though progressive board and its provocative programs and collection had been ignominiously tossed out by Norton Simon.

Listening to contemporary art patrons' litany of humiliations, Broad concluded that they were "longer on verbiage than on ability to make it happen." Nor were the County Museum's trustees, remnants of the city's old guard elite, likely to make room inside either the board room or the museum itself for substantial representation of new art. "Let's talk economics," Broad told a small social gathering of the art progressives in the spring of 1979, as they aired the old grievances one more time. Quickly scribbling figures on scratch paper, he outlined the costs for a new, separate museum of contemporary art: $10 million for land, $15 million for a one-hundred-thousand-square-foot building, $15 to 20 million for endowment. "What with acquiring a collection as well," he concluded, "we were looking at $100 million." Always the pragmatic fund-raiser, he added, "For that, we needed seven-figure gifts."

As it happened, Broad learned in the summer of 1979 from his friend Mayor Bradley that the city's Community Redevelopment Agency was preparing guidelines for construction on its last downtown holdings, an 11.2-acre parcel on Bunker Hill. It adjoined the Music Center, built in 1964 at the behest of the doyenne of Old Money culture in Los Angeles, the *Times'* matriarch Dorothy Chandler. Now, said Broad, "the mayor wanted life downtown beyond eight to five on weekdays. He was searching for a new cultural component." Prospective developers were already obligated to spend 1½ percent of their total bid on art, and Broad suggested to Bradley that this percentage be used to build a new museum.

When the Request for Proposals for Bunker Hill Redevelopment Project went out some weeks later, it included the museum and was buttressed by Appendix A: a letter from Eli Broad as head of a committee "composed of persons who share a deep appreciation for modern art and who believe that Los Angeles suffers a tremendous cultural deprivation for lack of a museum of modern art." The museum would lend "a distinctive image and identity to the overall development," he wrote, enhancing its appeal to retail tenants such as galleries, bookstores, restaurants, and theaters while adding a cultural amenity for residents and a measure of snob appeal for office lessees.

It was not the first time that art had been hitched to the wagon of real estate development. The Rockefellers' generosity to the Museum of Modern Art during the 1930s had a clear though unspoken connection with their development of Rockefeller Center; indeed, the original plans called for the center's private street, Rockefeller Plaza, to lead straight to the museum's front door. Nor were those who wanted to cure Los Angeles's cultural deprivation with a new museum very different from the late-nineteenth-century founders of museums in Chicago, St. Louis, Detroit, Cleveland, or Buffalo. According to sociologist Judith H. Balfe, they were "generally first- or second-generation self-made successful businessmen . . . competitive, assured, and activist." Motivated as much by local boosterism and civic pride as by affection for art, they also subscribed to what are now considered old-fashioned notions about spiritual and moral uplift through art and about its power to socialize the lower classes and lift their standards of taste. "In no case," writes Balfe, "was the museum to be merely a monument to vanity or a plaything for the idle rich."

As he began proselytizing for the new museum Eli Broad expressed equally lofty values, but he also appealed to his listeners' self-interest as business leaders. Eight other cities, including Los Angeles's archrival, San Francisco, already had museums of modern art, he told a business and community leaders' luncheon on March 24, 1980, hardly a fortnight after the proposed museum corporation had achieved nonprofit status. The new museum, he said, would "clearly make downtown Los Angeles the business, civic, and cultural center of southern

California." The museum would draw the fifteen million people within the region, plus "millions of others from around the United States and abroad," to Los Angeles's still elusive center.

Meanwhile, Broad was feverishly calling in markers from hundreds of contacts he had accumulated through years of philanthropic activities. The admission ticket to the new Los Angeles establishment was the same as it was to the old—a substantial check. With a $13 million endowment to raise before construction could begin, Broad himself set the example by giving the first $1 million. The next million came from the Arco Foundation, followed by another million from the chairman of the building committee, Max Palevsky. The bulk of the money, however, came in far more modest amounts; six hundred individuals, for example, gave $10,000 each. "They were young people who wanted to get involved in the arts," said Broad. Unlike the County Museum or the Philharmonic, where older donors were entrenched, the new Museum of Contemporary Art gave younger people and newcomers a fresh ladder to social prominence.

Early in its deliberations the founding committee surveyed other museums to learn what titles were bestowed on big givers. In Chicago becoming a distinguished benefactor cost $1 million. At the Whitney $1,000 bought a membership in the Whitney Circle. Elsewhere the walls of museum entryways teemed with friends, benefactors, patrons, sponsors, donors, fellows for life, and even fellows in perpetuity.

Public recognition for donors went hand in hand with a massive public relations campaign orchestrated by a firm with experience in publicizing such giants in the arts as IBM and Exxon. Even before the founders' committee received nonprofit status in March 1980, Richard Lippin, executive officer of Stone Public Relations, provided Broad with a detailed seven-page scenario for announcing the museum. He proposed visuals for TV and outlined strategy for interviews with major newspapers, especially the *New York Times*. Almost immediately a blizzard of letters flew from Broad's office: to local corporations for money, to dealers for donations of art, to other museums for advice on how to run the new institution, to arts

publications expounding the MOCA's grand plans, to politicians to gain support, and to prominent individuals to report progress. Broad's letter campaign went on for years, with each succeeding flurry including not only snippets of optimistic news and personal greetings but also a flattering selection from hundreds of articles about the museum.

As Broad later put it, the MOCA would be "the most exciting entrepreneurial undertaking in American art history . . . a world-class museum with primacy in contemporary art," the first new cultural enterprise in Los Angeles since the Music Center opened in 1964. "Overflying New York," as Broad liked to describe it, the museum would become a magnet for the world's most experimental new art. As the endowment drive neared its goal in October 1981, he unveiled an economic impact report by the prestigious Stanford Research Institute asserting that the MOCA would also attract floods of new money to downtown Los Angeles. Nearly two million people would visit the museum each year, spending $8.2 million in nearby stores. They would spread an extra $41.2 million in the rest of downtown. The golden tide would flow throughout the city, generating a $99.9 million increase in retail trade each year. Broad sent the report to Mayor Bradley along with an enthusiastic letter pointing out that the museum deserved even more support since it would bring more revenues to the city's businesses (and, via sales tax, to the city itself) than a National Football League franchise.

Even before all the endowment funds were in, and while the building committee was combing the world for the most innovative architect on seven continents, the trustees also cast about for a museum director who would fulfill the "world-class . . . overflying New York" promise. There was little need for hype to gain headlines when the right man was found: the name alone, Pontus Hultèn, electrified everyone with even a passing interest in avant-garde art. The ignorant could not help but be impressed by his background as the virtual inventor of Stockholm's Moderna Museet and later the first director of Paris's Beaubourg, where the population mobbed one stunning exhibition after another. The museum's big business contribu-

tors could also be awed by private revelations of his starting
salary: more than that of the men who directed the Metropol-
itan or the MOMA—$90,000 a year in cash, plus fringe bene-
fits worth many thousands more.

Perhaps some of Hultèn's prospective employers were en-
chanted by a 1978 *New Yorker* profile describing his feats of
museum building. The 1963 exhibition called "The Museum of
Our Dreams" in Stockholm was accompanied by a televised
appeal for money that resulted in a $1 million gift from the
Swedish government plus enough more to buy all twenty-
seven works in the show, a roll call of modern masters—Pi-
casso, Magritte, Miró, Mondrian, di Chirico, Kandinsky,
Calder, Giacometti, Pollock, Rauschenberg. In the Beaubourg
lobby he allowed four artists to build the 150-foot long *Croco-
drome*, "which devours children and sends them out again eat-
ing chocolates." Such brilliant successes perhaps blinded the
trustees to Hultèn's remark elsewhere in the profile: "I am
profoundly against private museums," he said. "Art belongs to
everybody."

The excitement over Hultèn diverted public attention from
the stalled redevelopment project. The consortium that won
the bid, Bunker Hill Associates, was reorganizing to raise more
funding in the face of an inflationary spiral in construction
costs. The building committee, which had finally awarded Jap-
anese architect Arata Isozaki his first museum commission,
was erupting into increasingly noisy dissension over the design.
By December of 1980 weighty memos and reports were flying
among the offices of the Community Redevelopment Agency,
the mayor and other city council members, the architect and
his Los Angeles associates, and the builders, who niggled end-
lessly over details of construction and financing. Meanwhile,
interest rates were vaulting toward 20 percent.

By now Broad was spending more than half of his working
hours on MOCA business, while an assistant, Sharon
McQueen, was working on MOCA virtually full-time. Long
before Hultèn was expected to take up his duties in March
1981, the museum's public relations counsel sketched grandiose
plans for marketing him as a celebrity. A talent agency like

William Morris should be called in, he advised, to sell video productions to inflight film programs; a major cable programmer might even devote an entire video channel to art-related materials originated by MOCA. "With proper training," he suggested, Hultèn could serve as narrator/commentator, with his fees going back to the museum. Until he took up his duties full-time, the trustees meanwhile would trot out Hultèn as a subtle centerpiece for fund-raising whenever he passed through Los Angeles. "It was agreed," the minutes state, "that these events should be very 'classy' affairs, with no overt solicitations being made."

Whether Hultèn ever intended to stay permanently in Los Angeles remains a mystery. Certainly, he paid just five quick calls before arriving shortly before his official hiring date of March 24. Even then, he fled for a long weekend in New York March 15 through 17. A man who was raised in a "real" city like Stockholm and had lived for many years in the urban heart of Paris may well have been dismayed by the disheveled appearance of Los Angeles—a perfunctory downtown overwhelmed by strip-commercial boulevards slouching in seeming aimlessness toward a smog-smudged horizon . . . where more strip boulevards began. Perhaps the stationery Hultèn designed for himself conveys the feelings of this urbane European among the American barbarians. Embossed in the upper left corner was a tiny flag with *Hultèn* in tiny navy-blue letters. The flagpole grew out of a tiny blue barrel, and the address, in Santa Monica, was printed below. The little flag fluttered bravely, a tiny banner of European civilization planted in a trash bin on a heathen shore. Or was it a distress signal . . . Robinson Crusoe marooned in a cultural desert wigwagging desperately for rescue?

Hultèn had been on the job for only three months before rifts opened between him and the trustees. The trustees system is practically unknown in Europe; there museum directors are civil servants, exercising unquestioned powers within their bureaucratic fiefdom. In art Hultèn was a radical populist, but when it came to administrative style he was more like Louis XIV. On July 1 he complained to Broad in a telex from Europe

about "the way the board of trustees has taken decisions that
are the responsibility of the director." A few weeks later
Hultèn demanded a seat on the board and a vote in the acqui-
sitions committee. Furthermore, he insisted on being "the sole
spokesman for all matters pertaining to the museum's program
and administrative activities."

Soon after that, Hultèn outlined for the board two con-
trasting visions for the museum. One "concentrated on and
around a building [where] the museum is somehow the build-
ing . . . the fashionable and social life it provides, openings, the
value of the collection, acquisition and de-acquisition." The
other focused on "the rhythm of the programs, the relations
with artists, the more or less hidden philosophy behind what
the museum is doing, its radiance, its specificity, even its
magic." Hultèn obviously favored the second, even as the board
was moving toward creating what he termed "a mere shadow of
the [Los Angeles] county museum [of Art]."

The tug-of-war between Hultèn and the board intensified
throughout the following year, exacerbated by interminable
delays in getting the building under way. Anxious to have some
kind of concrete activity in time for the summer Olympics in
1984, the board had moved to remodel a warehouse elsewhere
downtown as the "Temporary Contemporary," and the tussle
over its programs began. In January 1982 Hultèn eased out
Carl Covitz, the board's representative at weekly senior staff
meetings, saying "it is unnecessary for you to extend yourself
. . . by dealing with internal activities." The upshot was that
Covitz, president of a large home-building company, quit work-
ing for the museum altogether. A month later the board ap-
proved a three-month master calendar surrounding the unveil-
ing, at last, of Isozaki's model for the new museum. The social
whirl included a corporate lunch and reception on March 18, a
fund-raising cocktail party on March 24, a dinner for donors of
$100,000 or more on March 25, a brunch at the MOCA site on
March 28, an afternoon party at the new Temporary Contem-
porary office on April 25, and an Isamu Noguchi celebration on
May 12. Clearly it was a building rather than Hultèn's dynamic
alternative visions mesmerized most of the trustees.

By May of 1982 Marcia Weisman, one of the museum's most ardent backers, was bemoaning the "crisis for the lack of trust and support shown" Hultèn. "If we lose him, I shudder!" she wrote. "We must allow him his head in directing all museum activities." Dominique de Menil, who had lent her prestige to the organizing trustees, agreed. Six months later the museum's public relations expert was counseling Broad on how to counter negative reactions to Hultèn's departure. The press conference announcing it should "stress Mr. Hultèn's continued involvement with MOCA" while drawing attention to new details about progress in financing and construction. "In short, we want to get across a sense of continued forward motion."

To Richard Koshalek, Hultèn's assistant and successor, the clash between the trustees' and Hultèn's expectations seemed apparent well before the famous European arrived in Los Angeles. Over lunch near the Pompidou Center in Paris, Koshalek had presented Hultèn with a schedule for his first visit to Los Angeles. It included appearing as guest of honor at a series of cocktail parties that trustees had organized for donors of $10,000 or more. "I won't do it," Hultèn told Koshalek. "I don't speak to more than six people at a time." Koshalek convinced him to appear at a few of the parties, but Hultèn was genuinely puzzled by the powerful role trustees played at American museums. "What is this all about?" he would ask Koshalek. "Do I talk to them or do I run a museum?"

The tension represented by this question never eased, but the resolution came abruptly and unexpectedly in November 1982. Hultèn was named chief organizer of the arts events planned for the 1989 bicentennial of the French Revolution. He asked to be relieved of MOCA duties as quickly as possible. To cushion public shock at Hultèn's hasty departure, the trustees paid the museum's public relations counsel an extra $5,000 for a one-month period, near the end of 1982. By March 1983 Hultèn was working only half-time, with his assistant, Richard Koshalek, stepping in as the Temporary Contemporary moved quickly toward its opening the following November. "The First Show" featured eight private collectors, four of them trustees.

The opening festivities sealed the triumph of exactly the

museum concept Hultèn deplored: a building, a collection, social hoopla. The colossal five-day opening extravaganza began with a Shinto purification ceremony (to mollify the museum's neighbors in Little Tokyo) and went on to cocktail parties, receptions, lunches, dinners. Aside from all the events at the museum, the Broads hosted a cocktail party for 130 and cohosted a dinner for 100 at the fashionable La Toque restaurant. Others among the directors hosted other dinners. A minor crisis erupted when Douglas Cramer, producer of "The Love Boat" and an avid art collector, invited some people to a dinner party who had also received invitations from the Broads. Cramer wrote Broad an indignant three-page letter about the problem and followed up with a personal visit to Broad's office. A committee of trustees meeting two weeks later to evaluate the opening events recommended that at future receptions "one spectacular food," like the raspberry cake featured at one of the parties, be served in place of more mundane fare.

Even more magnificent were the six-day festivities held when the MOCA finally opened in December of 1986. A reception for trustees and staff was followed by the dedication ceremony and a press preview. Three gigantic black-tie events for politicians, major donors, cultural leaders, press, and art people followed, while the museum's twenty-one thousand members were entertained at three additional frolics. At their house in Brentwood, the Broads held open house on December 3 and 4 for such long hours that the caterer started with bagels and coffee in late morning, went through tea and cookies, and concluded with wine and cocktail nibbles as dusk was falling.

Almost lost in the social whirl was the inaugural exhibition: "Individuals: A Selected History of Contemporary Art, 1945–1986." It featured loans of some four hundred works by seventy-seven artists, including eight commissioned especially for this show. IBM financed it. Some eight hundred journalists converged on Los Angeles from all over the world to cover it. Hultèn did not attend. The endowment had reached $30 million. Is art good for business? Maybe, although the final figures are not in. Perhaps a more pertinent, though shocking, question is whether museums, despite the patently altruistic labors of people like Eli Broad, are good for art.

"Think of it ye millionaires of many markets, what glory may yet be yours . . . to convert pork into porcelain, grain and produce into priceless pottery, the rude ores of commerce into sculptured marble." Thus did Joseph Choate exhort his listeners at the opening of the Metropolitan Museum of Art's first building in New York's Central Park in 1880. "Ours is the higher ambition to convert your useless gold into things of living beauty that shall be a joy to a whole people for a thousand years." Such spacious visions express two attitudes characteristic of Americans today as well as in that expansive age— optimism and the conviction that art embodies a divine value. The art dealer René Gimpel was stunned by Americans' pious devotion to the visual arts when he toured the country in 1923. "It gives an idea of the fervor that convulsed the Middle Ages when its churches were erected," he wrote.

Since Gimpel's observations, Americans' idolization of art has, if anything, intensified. Indeed, 300 new museums were founded in the United States between the two world wars; by 1973, 745 American museums were devoted entirely to art. The millionaires who founded museums such as the Met during the late nineteenth century concentrated on amassing ancient art and Old Masters. They voraciously canvassed Europe for masterpieces triggering fears there that all the best works would end up in America, much like current worries about the Japanese. Today's American millionaires are more likely to be converting takeover profits into Julian Schnabels and real estate fortunes into Frank Stellas; the rationale for displaying such prizes remains the same.

If museums are, as André Malraux observed, the cathedrals of America, the religion they house is the American cult of amassing valuable goods: "acquiring all the best things," as Henry James put it. "These very American tendencies toward gluttonous acquisition and virtuous justification for art are still with us," wrote Rémy Saisselin in 1983. Americans, he noted, pose old religious questions as aesthetic questions: What is art? How does art relate to society? Is art corrupted by money? Can the artist maintain integrity in the marketplace? Is art perhaps

even a species of salvation? "In this secular age, many people have never been to church and we do not usually have big cathedrals, but people do wander into museums and this helps them spiritually," observed Robert Rowan, a MOCA trustee and major lender to its first exhibition.

Because of Americans' idolatry of art and artists, the pressure to build more museums and expand existing ones will continue into the foreseeable future. The vast quantities of art being produced and the burgeoning number of serious collectors who insist on showing what they own in a museum setting add to the urgency. The Department of Labor estimates that more than two hundred thousand artists are at work in America today. If each of them creates only forty works in a year, annual art production in the United States alone comes to eight million pieces; within a century a billion more paintings, sculptures, drawings, prints, and photographs would be seeking a safe home. Such a glut frightens many museum observers. Henry Hopkins, a former director of the San Francisco Museum of Art, warns that if collectors and museums continue to amass art at the current indiscriminate rate, within forty years "a museum would exist on every street corner." Even if museums continue to expand as briskly as they have in recent years, he says, there will still not be enough space to show all the art they buy or receive as gifts.

As with icebergs, only a tiny percentage of the bulk of artworks already owned by most museums is visible to the public. Of the five-thousand-odd items in the Guggenheim Museum's permanent collection, the Frank Lloyd Wright wedding cake on New York's Fifth Avenue can display only 3 percent. Even with its eleven-story addition, containing 25,000 square feet of exhibition space, the museum can only double the number of works on display—from 200 to 400. All the rest must continue to dwell in a gigantic warehouse, silent and dark. Like humans who fall into a persistent vegetative state, these artistic expressions that once quickened the hearts of their creators and

viewers now linger in a cramped, temperature-controlled limbo where the twilight is but occasionally disturbed by a stray curator or scholar. Recently they came not to contemplate or conserve but to cull, seeking candidates for deacquisition in the spring of 1990. From among the many possibilities, including Francis Bacon's *Three Studies for a Crucifixion*, early works by Kandinsky and Mondrian, Brancusi's *King of Kings* and *Seal*, Giacometti's *Nose* and *Spoon Woman*, the axe fell on just three . . . this time. Shipped off to Sotheby's in March 1990 were Kandinsky's 1914 *Blue Fugue*, Modigliani's 1916 *Boy in a Blue Jacket*, and Chagall's 1923 *Birthday*.

The glut at the Whitney Museum of Art is of similar proportions. The permanent exhibition includes only 72 works; proponents of a proposed addition say it would allow as many as 450 works to be shown. That would still leave more than two thousand paintings and sculptures and countless works on paper languishing in an entire floor of a lower Manhattan warehouse. There they stand, row after row, paintings by Jack Levine and Philip Evergood, sculptures by Alexander Calder, Marisol, Mark di Suvero, and Duane Hanson, Joseph Cornell boxes; all merely costly goods waiting to be transmuted into art by an appreciative human gaze. In 1949 the Whitney sold all its eighteenth- and nineteenth-century paintings in order to purchase contemporary works—most of which are now in storage. In 1954 the museum disposed of a cluster of 1932 Thomas Hart Benton murals for $500, less than the cost of materials. When they were exhibited in 1989 as part of a mammoth Benton exhibition sponsored by the Nelson-Atkins Museum in Kansas City, the curator estimated their worth at $5 million— about 10,000 times what the Whitney had received. Exactly what additional treasures or dross these warehouses contain is difficult to assess, since neither the Guggenheim nor the Whitney maintains a current catalog; like most other museums, they have not published a complete list of their holdings for many years.

In the face of such massive and virtually inaccessible hoards, sophisticated collectors hesitate to donate more art. Burton and Emily Tremaine, for example, coolly repelled the

ardent courtship of several museums vying for their first-rate collection of modern, Pop, and Minimalist pieces. They were wary after having lent Mondrian's *Victory Boogie Woogie* to the Museum of Modern Art for seventeen years. Frequently it was not on view, Emily Tremaine said, and artists who asked to see it in the "study collection" (warehouse) reported they had difficulty getting in. "I couldn't bring myself to give it to the Museum of Modern Art," she told an interviewer in 1973. In 1980 the Tremaines sold Jasper Johns's *Three Flags* to the Whitney for $1 million, then the highest price ever paid for the work of a living American. They could easily have afforded to give the painting—and received a handsome tax deduction for their generosity—but Emily Tremaine said she noticed that the *Three Flags* were always flying when she visited the Whitney. "If a museum pays $1 million for a painting, it won't wind up in the basement," she said. The dealer who handled the transaction, Arnold Glimcher, agreed that while "the transaction was tainted by commercialism at the moment," museums seemed to attach more value to works they had bought at high prices.

The congestion in museum basements has built up over many years and there are no easy ways to deal with it. For avid collectors there is no more felicitous final resting place for their treasures than a museum. It validates the passion for accumulation that is the hallmark of the true collector and offers him or her a tiny share of immortality. Having bought widely though not always well, collectors present museums with hoards that vary wildly in quality; even the suavest curator has difficulty rejecting Aunt Tillie's watercolors while teasing the early Braque into his institution. Like miners picking through tons of earth for the occasional nugget, museums, especially the smaller, newer ones, often accept an atticful of mostly marginal art, in hopes of culling later. If the donor also happens to be a trustee or part of a prominent local family, "later" might be decades away. Meanwhile, the basement overflows.

As early as 1959 Alfred H. Barr, Jr., bemoaned the lack of space to exhibit the MOMA's treasures, of which he was chief custodian. Only one-eighth of all the museum's paintings and

only one-quarter of 1 percent of its prints could then be exhib-
ited. "Ironically, although the museum pioneered by including
industrial design and photography among its collections," he
wrote in a plea for a larger building, "no space is available for
their continuous display." During the 1960s the museum's
policy appeared to be to acquire one example of every impor-
tant artist's work and later collect certain artists in depth. As a
result, wrote Roberta Smith, the museum owned "just as much
miscellany by forgotten artists as any other museum." Yet the
basement also housed an Ali Baba wonderland of treasures,
equally inaccessible. In his study of art museums, Karl E.
Meyer asserted that two first-rate museums could be estab-
lished by excavating the storerooms. Thomas B. Hess, who
served briefly as curator of modern art at the Met, enviously
surveyed the rich pledges to the MOMA: "Cellarsful of Cub-
ism, silos of Surrealism, acres of abstractions." As of the mu-
seum's fiftieth anniversary in 1979, he wrote, "curators at the
MOMA look grave as they tell you how they are bracing them-
selves against the imminent influx of masterpieces." Barr's
successor, William Rubin, worried about finding space to dis-
play what was pouring in. Crassly put, the museum already
owned forty-five hundred square feet of Picassos when there
was room to show only two thousand square feet. An extra
three thousand square feet would have been needed to show
the two-thirds of the museum's Mirós then in storage. Rubin
estimated that three thousand works deserved permanent dis-
play, but only five to six hundred could be shown. No outsider
can fathom how much more art has come to rest at the MOMA
in recent years, since the museum's most recent catalog is dated
January 1, 1977.

No matter what the quality, however, art in the basement
also seems to inhabit the lower depths of curators' esteem,
especially if it was acquired free or at a bargain price. In 1968,
for example, the Met bought nine boxes of Erté costume draw-
ings for less than $100,000. They sank directly into the base-
ment and were never shown again. Furthermore, when a Ph.D.
scholar in costume design asked to consult them, it took almost
a year to gain access, and then permission was granted only

after the researcher wrote directly to the museum's president. Outside the Met, ironically, the news of its Erté purchase drove prices for his work to fresh heights. When William Lieberman took over as curator of modern art at the Met, among the treasures he unearthed were Max Beckmann's triptych, *Beginning*, a gift that had been languishing in the basement limbo for twelve years, and Fernando Botero's *Night in Colombia*. Because the glut is so widespread, the International Council of Museums in 1986 adopted a code of ethics providing that "museums should not, except in very exceptional circumstances, acquire material that the museum is unlikely to be able to catalogue, conserve, store, or exhibit, as appropriate, in a proper manner."

One reason for museums' cavalier attitude toward such a vast preponderance of their holdings is that they do not consider them assets, at least on their balance sheets. While carrying the value of their buildings on the books, museums act as though their collections were free. This encourages them to accumulate more and more items, even if they are never shown. "To act as if a thing were free when it has a cost as art has," writes the economist William D. Grampp, "is to increase unduly the amount of it demanded or to make an inefficient use of it or both." He cites the example of a $500,000 Renoir hung above the desk of a museum administrator. Grampp computed that if the interest rate is 5 percent, the cost of hanging it there is $25,000 per year. "Would the museum consider borrowing $500,000 at 5 per cent in order to buy a painting to hang in the office of an administrator?" Grampp asks. "Would she prefer to receive an additional $25,000 in money instead of its equivalent in esthetic satisfaction?" Because museum people fail to ask such questions and act as though the most important part of their capital is free, he writes, the number and size of museums will continue to swell.

During the early 1960s, Grampp relates in his fascinating study, *Pricing the Priceless*, the National Bureau of Economic Research attempted to take an inventory of the nation's wealth and naively asked museums to estimate the value of their collections. Impossible, replied museums, first because what they owned was priceless, and second because it was irreplace-

able. This attitude Grampp considered "a droll notion. . . . Since some works are obviously valued above others (those on exhibit above those in storage) one must conclude that . . . some are more priceless than others." Also, if works in museums were truly irreplaceable, he asked, why did museums insure them? Doing so, he argued, "implies that the actual values are known." When the National Bureau of Economic Research insisted that museum collections could not be entirely omitted from its inventory, museums came up with vague estimates and a declaration that "the need for public support of the cultural and educational activities of museums must not be de-emphasized by the publication of the value of museum collections."

When the Museum of Modern Art in 1989 sold or exchanged seven works from its permanent collection for van Gogh's *Portrait of the Postmaster Roulin, Time* magazine art critic Robert Hughes found it a bad omen. Doing this, he wrote, "encourages the trustees to think of the permanent collection as an impermanent one, a kind of stock portfolio that can be traded at will." In making this exchange, the museum seemed to be perfectly aware of what all the paintings were worth. Nevertheless, the current director of painting and sculpture, Kirk Varnedoe, deplored "the crazy sense of disproportion in the world that puts an extra glow on the art object." The Chicago Art Institute's James Wood asserted that when a work enters his museum's portals "it should leave the world of economics. . . . You have to educate people to grasp that the money paid for a work of art is utterly secondary to its lasting value, its ability to make them respond to it." Museum directors insisted to Grampp that the money value of an artwork was unrelated to its artistic value. Pressing one director as to why the value of his museum's collection was not carried on the balance sheet, Grampp was told: "Because it is not for sale." When Grampp asked why, then, the value of the building was shown, the museum man replied that "what is most wrong about the art world today is the attention it pays to money values." However, retorts Grampp, if museums were really as aloof from the market as they claim, ignoring or even disdaining the cash value of paintings, "they would not know where to

place their guards, if they had any at all."

Museums have come quite honestly by their ambivalence about money. Founded by the wealthy, they continue to subscribe to an aristocratic Old Money ethos, even as their trustees embrace corporate raiders, real estate moguls, and other New Money types. Indeed, association with an art museum confers elite social status almost instantly upon the newly rich and blurs the sharp business practices by which some of the fortunes were amassed in the benevolent glow of philanthropy. Art cleanses filthy lucre. It did so for the Morgans, Fricks, Carnegies, Mellons, and Whitneys, who emerged from the era of the robber barons, and it continues to ennoble the more recent fortunes amply represented today on museum boards of trustees. Old Money people seldom buy anything; they "find" it, writes Nelson W. Aldrich, Jr., in his insightful study of his own milieu, *Old Money.* "The process is one of ingestion, not purchase. . . . The whole point of inculcating the peculiar aesthetic of the class is to lift its habitat above the quick and nasty transactions of the cash nexus to the exalted plane of disinterested delight."

The author is the great-grandson of Nelson W. Aldrich, the longtime Republican senator from Rhode Island whom Lincoln Steffens called "the Boss of the United States" and who mythologized the fortune he made around the turn of the century with a false patina of long-standing aristocratic breeding. His fourth-generation namesake writes that for the New Rich who want to become Old, "collecting is a way of making oneself socially attractive to custodians of the extended patrimony." Because giving is part of the Old Money ideal, a collection in a museum allows the collector "to enter history arm in arm with beauty." While everyone knows that lots of money has gone into the collection, mentioning dollar values is considered poor form. "It reminds everyone of a hundred different vulgarities that the presence of art was meant to dispel. It reminds them of the art world's flagrant commercialization: the noisome rabble of greedy dealers, spoiled painters, corrupt critics, and unctu-

ous museum directors that the art market spawns whenever, as in the last two decades, *art moves*. . . . Mentioning dollar values around a work of art . . . amounts to a massive return of the understated. It spoils the careless effect. It will not do."

It does not take long for the New Money trustees of art museums to pick up their colleagues' Old Money ways, especially since most of them have had previous exposure at school, at the country club, or in church. A 1969 survey by the Twentieth Century Fund found that 60 percent of art museum trustees had attended Ivy League or Little Ivy League colleges; nearly one-third worked in banking or finance, and one-fifth were lawyers; 60 percent were more than sixty years old; and 38 percent listed their religion as Episcopalian. Another survey added that 85 percent were white and 63 percent were male. Since then the demographics have changed only slightly, with the addition of a few blacks or other ethnic minorities. More conspicuous recent additions are chief executives of large corporations striving for recognition as art patrons, just like other New Money individuals.

The boards of art museums can be urban equivalents of country clubs, where social connections that bring in customers or clients are made, and membership confers social status. During the 1980s Tom Armstrong, the director of the Whitney Museum, made a special effort to attract corporate leaders to the board. Joining some of the heirs of the museum's founder, Gertrude Vanderbilt Whitney, they added considerable heft not only financially but in the realm of modern management. So eager were these powerful businessmen to streamline the museum's operations that in a series of secret maneuvers in the spring of 1990 they fired their original sponsor, director Armstrong.

Shortly before those events unfolded, Armstrong and two of his curators candidly expressed their assessment of the museum world's obsession with money in the introduction to the catalog for the Whitney Museum's 1989 Biennial. "We have moved into a situation where wealth is the only agreed upon

arbiter of value," they wrote. "Capitalism has overtaken con-
temporary art, quantifying and reducing it to the status of a
commodity. Ours is a system adrift in mortgaged goods and
obsessed with accumulation, where the spectacle of art con-
sumption has been played out in a public forum geared to
journalistic hyperbole." Why professionals ostensibly concerned
with the civilizing power of art would want to dwell in the
cesspit they so eloquently described remains puzzling. But
there is little question that they formed their pessimistic view
of the contemporary art scene during long sessions in the
museum's boardroom, where the money-minded executives
brought in by Armstrong himself handily overwhelmed the
more philanthropically oriented connoisseurs of an earlier day.

The new men—people like Sotheby's president Adolph
Alfred Taubman, cosmetics prince Leonard Lauder, retailing
genius Leslie Wexner, tax lawyer Joel Ehrenkranz, and Amer-
ican Can Company president William S. Woodside—had been
brought in because they had access to great hoards of money,
enough to lift the museum's budget from $2 million when
Armstrong arrived in 1974 to almost $11 million in 1989–
1990. Like the older trustees, they were mostly collectors, but
unlike the older trustees, their collections focused on trendy
artists and quick turnover, and soon the Whitney's exhibitions
likewise featured the big names of the moment. Increasingly
the museum was functioning "as a kind of cheerleader," wrote
one *New York Times* critic, "indecorously rooting for one com-
mercial star after another." It gave glowingly uncritical retro-
spectives to Yoko Ono, Cindy Sherman, Donald Judd, Julian
Schnabel, and David Salle, while the Whitney Biennials, sup-
posedly devoted to new artists unknown in New York, featured
all too many who had already been established by powerful
dealers.

Just like a business building the bottom line by developing
new outlets, the museum opened four branches in corporate
offices in New York and Connecticut, where special exhibitions
helped swell attendance to more than six hundred thousand per
year. With the trustees' full backing, Armstrong also super-
vised the design of an eighty-four-thousand-square-foot addi-

tion by Michael Graves that would tower over the Whitney's handsome Marcel Breuer headquarters on Madison Avenue and Seventy-Fifth Street. He increased the permanent collection from two thousand to more than eighty-five hundred items. His acquisitions include older works by such artists as Arthur Dove, Maurice Prendergast, and Georgia O'Keeffe, as well as contemporary art by Jennifer Bartlett, Neil Jenney, Nancy Graves, and other current stars. Yet even with the satellite spaces and the prospective addition (which has been delayed by controversy for five years), less than 10 percent of the museum's collection could ever be displayed.

By all accounts Armstrong is an affable man, at home in the sedate, clubby realm of the moneyed as well as in the gritty, mock-bohemian sphere inhabited by artists. Like many museum directors, he favors a small token of sartorial eccentricity—in his case, natty bow ties. He came to the Whitney from the Pennsylvania Academy of Fine Arts and quickly introduced a more flamboyant style than had been customary with his predecessors, Lloyd Goodrich and John I. H. Baur. Both of them had been respected scholars, publishing widely in the history of American art. Armstrong liked adding a touch of whimsy to serious museum business; he relished choosing mechanical toys for party favors and donated the proceeds from selling tomatoes he had cultivated on the museum's roof. One Thanksgiving he dressed up as a clown and marched in the Macy's parade in order to raise money for the purchase of Alexander Calder's ingenious wire *Circus*. But all these gentle foibles came to an abrupt stop one afternoon in the fall of 1989 when museum president Woodside called him in for a chat. Armstrong was tired, said Woodside, and a consensus of the board agreed that he should resign. Stunned, the museum director made fourteen quick phone calls and found only two trustees who had even heard of Woodside's plan. In short order Armstrong mustered support, in particular from among the artists whose careers he had promoted so diligently in the past. The trustees soon received letters of protest from David Salle, Al Held, and Richard Serra. Also among the dozen protest letters was one from the art historian Robert Rosenblum and

others from Fiona Miller, the daughter of Whitney board chairman Flora Biddle, and Michael Ward Stout, executor of photographer Robert Mapplethorpe's estate. Stout hinted that the Whitney could lose a grant of up to $1 million from the Mapplethorpe Foundation if Armstrong were forced out.

All to no avail. In February 1990 Armstrong was dismissed, ironically for reasons similar to those which had led to his being hired sixteen years earlier. While the trustees' specific deliberations remain cloaked in darkest secrecy, word trickled out that his opponents found him too trendy, that too many exhibitions depended on powerful dealers, that he deemphasized scholarship, and that he favored superficial shows of living artists. After the fact, the *New York Times'* John Russell mourned Armstrong's departure: "Worldwide, it is now the manager and the moneyman who rule, while the creative people . . . are discarded."

The tenure of museum directors is rickety indeed; in the six years before 1975, the ninety largest American museums dismissed thirty-eight directors. Turnover at the top has continued briskly, especially at newer or newly expanded museums. Kevin E. Consey set a record of sorts when he hung on for nine years at the Newport Harbor Museum in California, following three previous directors who had lasted a grand total of five years. In 1989 Consey moved to the Chicago Museum of Contemporary Art, where the director's office had also come to resemble a revolving door. One key to Consey's pattern of longevity, appears to be his belief in a collection using "a sampling of works that in most cases are determined by the tastes of collectors in the city." In Newport Beach he facilitated a $50 million endowment drive for expansion. In Chicago the museum, which was set up in 1967 as a *Kunsthalle*, a space for temporary exhibitions, is trying to raise $50 million for a one-hundred-thousand-square-foot building in which to display what inevitably became a permanent collection. Since 1974 the Chicago MCA has already accumulated an assortment of about

three thousand items by artists ranging from Surrealists like Max Ernst and Magritte to Minimalists like Richard Serra and Robert Morris and including examples of Dubuffet, Marisol, and Warhol. "Board members who have major collections have been very active in formulating plans for the new museum," outgoing president John D. Cartland told the *New York Times'* Grace Glueck.

Since the Los Angeles MOCA organized its first exhibition in 1980, one director and three chief curators have departed. When the fourth chief curator arrived in April 1990, the *Los Angeles Times* art critic remarked that "the museum has yet to establish a distinct profile" and wondered whether its "seemingly erratic direction" was caused by staff problems or by the trustees' impossibly conflicting demands. Sherman E. Lee, whose long and distinguished career at the Cleveland Museum of Art is something of a museum piece in itself, calls "burnout" among museum directors "the entirely predictable consequence of the misapplication of corporate thinking to the nonutilitarian functions of art." He charges that the business world does not want a symbiotic relationship with museums but instead wants to force its own standards of performance upon them.

A disillusioned observer of such events is Henry Hopkins, a veteran of museum wars at the Los Angeles County Museum of Art, the Fort Worth Art Museum, and the San Francisco Museum of Art. Currently he directs the Frederick Weisman Foundation in Los Angeles, which lends contemporary art to museums and sponsors art seminars all over the United States. Not professional directors but trustees are running art museums today, he says, and they are no longer people interested in art or in genuine philanthropy. There was a time when trustees were "deeply committed to the community and to its museum—if there was a deficit, these people would make it up. . . . Museums were run something like a Catholic parish: the staff and director operated the institution and the trustees funded the deficit." With the advent of blockbuster exhibitions, however, expenses for insurance, shipping, and security grew with cancerous rapidity; small shortfalls easily repaid by appeals to the trustees' civic spirit mushroomed into giant deficits. To

cover them, trustees were drawn from among wealthy entre-
preneurs. "Many boards," says Hopkins (including the one that
fired him in San Francisco), "are dominated by self-made per-
sonalities, people who have never served as trustees before.
They can't tell the difference between a museum board and a
business. So we have people who are fixated on the bottom
line."

Another former museum director, who wishes to remain
anonymous, bitterly described the result when the majority of
his board of trustees tipped from a group of dedicated connois-
seurs to ambitious social climbers. "The men demonstrate their
executive ability by speaking from deep in their lower chests.
The women do it by wearing muted, low-key clothes that say
money, style, class. They wear gold chains. When this lady
[who engineered his ouster] rattled her bracelets a bit, every-
body listened." From representing the community in the ad-
ministration of its local treasure house, the board's dynamics
moved to dispensing patronage: "Who will run this party or
that event? It's all professional busywork." Meanwhile, muse-
ums in many localities where those who paid for membership
had the right to vote for trustees changed their by-laws to
exclude all members from voting. New trustees now are
chosen by the board itself, an arrangement guaranteed to pre-
vent new people with new ideas from raising embarrassing
questions or upsetting the status quo.

Such incestuous boards pressure museum directors to
arrange popular shows that will increase attendance and mu-
seum membership at the expense of exhibitions that demon-
strate scholarship or educate the public. Even more pernicious
to museum scholarship is the ignorance many such trustees
bring to their museum task. Having come to art late in an
acquisitive life, their knowledge of art is sketchy if it exists at
all, says Hopkins, and usually limited to contemporary art. "So
you get Trustee Smith on the X Museum board and he will
push for a Stella exhibition . . . because he owns Stella. And all
over the country, museum exhibitions reflect what the trustees
are collecting." Because they tend to collect art by fashionable
artists, the costs of borrowing works for exhibitions skyrocket.

Lenders refuse to contribute what they own unless the catalog contains a color reproduction of the work. "That, of course, enhances the value of the painting," says Hopkins. "It's good business, but it's also very expensive." Meanwhile, a development officer devises ways to pay for such costs. Often this involves opulent museum parties; when the bills for cunning invitations and lavish food, decor, and entertainment are paid, the net is pitifully small. For a typical $150 dinner, says Hopkins, a museum might gain $50.

While there are still many museum trustees who are knowledgeable about art and take their responsibilities seriously, the chance to profit personally from their positions overwhelms the scruples of many. Because they are privy to their museum's long-range plans, some succumb to what can only be described as insider trading. That most museum trustees are also collectors is no longer shocking. That some quietly invest in art galleries also appears to be acceptable. But when one trustee at the Museum of Modern Art began buying up works by Andy Warhol when the museum started planning five years before its 1989 Warhol retrospective, even the tolerant art world was buzzing.

The governing boards of American art museums have always been laden with wealthy men, most of whom also collected art, because they were willing to pay for status with philanthropy. European museums are largely government supported, but the dependence of American museums on gifts of money and art has always affected their development and operations. Until the mid-twentieth century most museum collections concentrated on the art of the remote past, and museum directors generally were able to impose the prestige of their expertise on the trustees: the director and staff recommended purchases and prepared exhibitions; the trustees supplied the funds. But with the new dominance of American art in the world and of contemporary art in the museum scheme, this arrangement began to decay. Suddenly museums were swept from the quiet back-

waters of scholarship and contemplation into the turbulent surf
of entertainment. Museum news that once had been confined
to a weekly art column or page migrated to the regular news
columns and occasionally onto the front page. Stylish maga-
zines followed, with coverage limited almost exclusively to
contemporary art—its producers, its dealers, its collectors, its
exhibitors, and, of course, its extravagant prices. The evening
news on television about record auction prices or thefts of
valuable paintings inevitably welded monetary values to aes-
thetic worth.

The change was manifest at New York's Museum of Mod-
ern Art. A dedicated band of wealthy devotees had founded the
museum in 1929, hoping to interest Americans in what the
museum's first director, Alfred H. Barr, Jr., called "the art of
our time." Understandably, the new museum's trustees were all
collectors of such art, although the idea of profiting from the
museum's exhibitions of what they collected then seemed re-
mote. While works by the artists in the museum's first exhibi-
tion—van Gogh, Seurat, Cézanne, and Gauguin—had appre-
ciated handsomely over the decades, the works of living
masters remained speculative buys. Picasso and Matisse, not to
mention Mondrian, Klee, and Dali, were all producing prodi-
giously even as the worldwide depression dampened discretion-
ary spending among the rich. Moreover, the trustees were not
at all certain that the museum should have any permanent
collection. They were still considering the notion of concentrat-
ing on temporary exhibitions in 1934 when one of the MOMA's
founders, Lillie P. Bliss, bequeathed her valuable collection to
the museum.

The debate among the trustees then shifted to how old a
work in the museum's collection could be and still be consid-
ered "modern." This raised a number of vexing questions that
continue to haunt museums of contemporary art: At what age
does a contemporary work slip into history? How to dispose of
aging works? How to deal with works by a living artist or the
collectors, dealers, and eventually heirs who all have intense
financial interest in keeping the art safely off the market inside
a prestigious museum? How to assure donors that their pre-

cious legacy will not be unceremoniously dumped, and relatively quickly?

The trustees' debates on these matters continued throughout the 1930s and 1940s. Early in their deliberations, the eager devotees of Modernism settled on forty years as the age at which, as with human beings, the freshness begins to fade. Then they settled—again briefly—on an age of fifty and concluded an agreement with the Met that such elderly art would be sold to the Met at some price to be negotiated. But as the 1950s began, the trustees were facing the immediate loss of some of their most precious holdings: Cézanne's *The Bather*, painted in 1885; Seurat's *Port en Bessin, Entrance to the Harbor*, painted in 1888; and van Gogh's enchanting *Starry Night*, for which several of Miss Bliss's treasures had been traded in 1941. If the agreement with the Met were implemented, the march of the masterpieces uptown would in a very few years become a stampede: Rousseau's 1897 *Sleeping Gypsy* should already be slumbering at the Met, and Picasso's landmark of 1907, the *Demoiselles d'Avignon*, would have to go in 1957.

Furthermore, Alfred Barr had ingeniously dealt with his lack of acquisition funds by a strategy of diligently advising his trustees on their purchases with the understanding that they would generously remember the museum in their wills. As the years took their toll, the museum would be inundated with great masterpieces, many of which would be more than fifty years old the day they arrived at the museum. Confronted with such problems, the trustees in 1954 abruptly announced that henceforth the museum would harbor a permanent collection of recognized masterpieces of modern art, no matter what their age.

Barr's generous aid to trustees forming their private collections, while begun in relative innocence, initiated a system with questionable benefits: the trustees were interested in exhibitions of what they were collecting, and the museum staff helped them to collect what it was interested in showing. Even within the first generation of trustees, such an arrangement brought unusual profits to some. Nelson Rockefeller, for example, had begun collecting art in the mid-1930s under Barr's

tutelage. Over the years he gave the museum a number of European masterpieces, including Rousseau's *The Dream* of 1910, given in 1954, and Matisse's *Dance* of 1909, given in 1963. At the same time he amassed an extraordinary personal collection; for many years Barr routinely selected works for Rockefeller's approval whenever he visited an art dealer. If Barr bought, Rockefeller received at least the same discount as the museum or perhaps even a more favorable price because of his influence over the other trustees. Rockefeller also bought profligately from exhibitions organized by the MOMA. When the Abstract Expressionists were given their first major show there, he acquired at least one example of each artist's work, including a Baziotes, a Gorky, a Motherwell, three de Koonings, and a Pollock. Such favors, however, did not in the end bring the Rockefeller treasure to the MOMA. In 1969 the museum exhibited his entire collection of American art, a step that often flatters collectors into expanded generosity. Rockefeller, however, simply took advantage of the enhanced value conferred by such a prestigious exhibition; in 1970 he sent the entire collection, even then worth more than $1 million, to be sold by the Marlborough-Gerson Gallery.

Since Rockefeller's day every other president of the Museum of Modern Art has benefited from the staff's expert ministrations. Wherever he traveled, Rockefeller's successor, William A. M. Burden, carried a list prepared by Barr of galleries to visit and artists to watch. Barr found paintings for Burden to buy, appraised their value, and beat down the price. He also advised Blanchette Rockefeller and her husband, John D. III, both of whom served terms as the museum's president, and helped to form the splendid collection of the Rockefeller-dominated Chase Manhattan Bank. The museum's current president, Donald B. Marron, continues to command the ardent cooperation of the museum's staff. The chief executive officer of PaineWebber, Marron is so passionate a collector that he employs a curator and "shopping partner," Monique Beudert, who also advises him on the extensive PaineWebber corporate collection. The company sponsored the MOMA's 1987 retrospective for Frank Stella, for which Marron gave one example from his personal collection. However, the corporate collection

contains many other examples of the artist's work, and Paine-Webber commissioned Stella to create four additional paintings for its corporate headquarters on Sixth Avenue in New York. The dealer handling this transaction was Lawrence Rubin, the brother of the MOMA's then director of painting and sculpture, William Rubin.

The keen commercial relationship between museum professionals and trustees pioneered by the Museum of Modern Art has spread to many other museums. During the late 1970s, for example, the Guggenheim accepted custody of Evelyn Sharp's forty-five-piece collection, which Grace Glueck described in the *New York Times* as "of far less interest in itself than as a case study in how museums add to their own holdings." Sharp had previously hired a professional publicity firm to write news releases describing the collection and its owner's eye as "remarkable." After the Guggenheim exhibited her property, its value rose, and Sharp at the very least got increased tax deductions for her "gift."

Revelations about the market advice curators give museum insiders has touched raw nerves in many cities. When Henry Hopkins lectured on the subject at the La Jolla (now San Diego) Museum of Art in 1988, the audience quietly took in his points—that staffs sometimes "train" trustees to buy what the museum wants; that dealers entice trustees into purchases that act "like a chain letter": the artist is talked about, the prices rise, the dealer gains influence, and the trustees return to the museum saying, "Gee, have you noticed all this flurry of activity about artist X? We really should have a show, shouldn't we?" Because the fiscal resources of many museums of contemporary art are so slender, Hopkins said, "you now have a situation . . . where the art dealers and trustees are running the institution and the curators are simply pawns." Leah Ollman, art writer for the *Los Angeles Times*, tied these remarks to the museum's current exhibition of works lent by its members. She wondered mildly if this show, "Local Color," trod "on shaky ethical ground. Is the museum accommodating some of its prized patrons with the offer, 'I'll scratch your back if you scratch mine.' "

The response to Ollman's article suggests that she had

touched on an embarrassing subject. "Shamefully unprofessional," charged trustee Michael L. Krichman; the staff "consistently and openly . . . discouraged members . . . from approaching art as an economic investment." Rather than examining motives, he added, Ollman should stick to evaluating artistic criteria. Museum director Hugh M. Davies wrote that Ollman was "derelict in her responsibility to research a subject before making accusations." The article reflected "her own ignorance and naïveté," he added; Davies "hoped that in future she have her facts straight before pontificating with such assurance." Ollman did not retract or modify her remarks, but it was the last time she wrote on anything but aesthetic matters.

Despite massive financial support from the public through federal, state, and local grants, museums feel no obligation to reveal any details of their financial transactions. In her impressive scholarly study of American museums, *The Institutionalization of the Modern Image,* Judith H. Balfe perused 450 "museum years" of annual reports and bulletins published by major American art museums. She found only one account, dating back to 1932, of a disagreement among trustees or staff over acquisitions. This involved a British curator at the Boston Museum of Fine Arts who used $10,000 in museum funds and another $5,000 raised privately to acquire thirty-two then controversial European paintings. To avoid alienating the museum's conservative clientele, they were listed as "reserve accessions" and remained in storage, available only to persistent scholars. Many years later the museum showed some of these works, and they were revealed to include several Surrealists, two Severinis, a Braque, and a Matisse.

Balfe found that all details about acquisitions of individual works were permanently sealed in minutes of trustees' meetings, that museums universally and notoriously exaggerated attendance figures, and that they omitted such figures entirely when it might have embarrassed the trustees to reveal them.

They evaded reporting membership totals that looked sparse. Balance sheets disclosed only the sketchiest details about total operating budgets, with deficits disguised by such vague euphemisms as "extraordinary expenses." There was no credible data about spending on acquisitions, while endowment funds were manipulated in devious ways. Museums also reported casually, if at all, on works that had been unceremoniously sold off from the collections. Furthermore, Balfe found it "impossible to keep track of which works were kept on fairly permanent display once acquired and which spent most of their museum tenure in storage or were quietly deaccessioned."

William D. Grampp encountered a similar black hole while researching his 1989 book, *Pricing the Priceless*. "Where, in fact, the important art of the world is," he writes, "in private hands or elsewhere—is a question for which there is not much information." Occasionally even museum curators are in the dark. Grampp cites the 1978 theft of several Impressionist paintings from a broom closet at the Chicago Art Institute, where they had been stored. The thief was an employee with access to the closet. In 1990 the Guggenheim became embroiled in a mortifying lawsuit over a Chagall watercolor that had been stolen from its basement in 1967. Only three years later did the staff realize it was missing, after taking inventory. Then it took sixteen more years to discover that the picture was now owned by Mr. and Mrs. Jules Lubell. The Lubells had bought the painting, *Le Marchand des Bestiaux*, from a reputable New York dealer, Robert Elkon, long before the museum even realized that it was missing. The museum is suing the Lubells to get it back; the Lubells are suing Elkon's estate; and the estate is also suing the Gertrude Stein Gallery, from which Elkon originally bought it. Grampp attributes such casual treatment of the museum's patrimony to the fact that the value of collections is not carried on the museum's balance sheet. If this were required, he asks, "Would they not maintain a complete record of what was in their collections and would they not think it cavalier to be ignorant of what works were in it and where they were?"

Following the scandals about the Metropolitan's secret

disposition of works from the Adelaide de Groot bequest during the early 1970s, the College Art Association condemned "instances of secretive disposal of art." Such transactions, the professional organization of art historians announced, "seriously tried professional trust." It urged museums to direct deaccessioned works to other public collections and at the very least to disclose all details of their sales. For a 1977 survey by *American Artist* magazine, few museums deigned to reveal their acquisitions budgets, even though most of them receive public money for such purchases.

At present, museums continue to treat such information as though revealing it would compromise national security. The card catalog of the Metropolitan Museum's ample library contains not a single item relating to its own trustees, acquisitions, donors, or finances. The Museum of Modern Art keeps all information concerning its acquisitions or sales outside its library, under red alert secrecy, unavailable to serious researchers. Nor does its library offer any archival material about its own exhibitions, such as correspondence relating to loans, prices of the many works exhibited that were also for sale, or presumably innocuous drafts of exhibition catalogs. Virtually all museums store the vast preponderance of their holdings in the "basement," ostensibly available to scholars. However, without a current catalog few scholars know who owns what. Moreover, the heavy tomes, frequently the major source for information about a particular artist or movement, generally lack an index.

Museums offer few explanations for the secrecy surrounding their internal operations, their finances, or the extent of their collections. Nor do they account to the public in any meaningful way on how they have spent the substantial sums of public money they receive, either from state and local agencies or from the National Endowment for the Arts and the Institute for Museum Services. Indeed, the researcher attempting to penetrate their veil may suffer severe consequences. When Russell Lynes published his friendly though unofficial history of the Museum of Modern Art in 1973, *Good Old Modern*, his book was not sold at the museum bookstore. Years

after it was out of print, some museum departments continued to pass out illegal photocopies of it to new staff members, said Lynes. Yet almost two decades later, some insiders were still enraged by Lynes's mild revelations.

In pursuing research for my own biography of the museum's guiding spirit during its first thirty-nine years, *Alfred H. Barr, Jr.: Missionary for the Modern,* I received scant cooperation from those still connected with the MOMA. However, Barr's voluminous papers, more than sixty rolls of microfilm available through the Archives of American Art, offered invaluable, rare glimpses behind the treasures on display at 11 West Fifty-Third Street, and more than sixty interviews filled in further details. The resulting book, published in 1989, portrayed a brilliant museum man who dedicated his entire life to the furtherance of modern art and the institution that became the world's premiere showcase for it. Yet the museum's bookstore did not sell this book either and all requests for explanation went unanswered.

One reason for the reticence of museums is that they do not wish to acknowledge their central role in the art market. Far from being simple conclusions based on scholarship and connoisseurship, curators' notions of quality and relevance inevitably affect the values of similar works in the marketplace. "What a museum chooses to exhibit," writes Brian Wallis, "influences our definitions of these criteria and pre-establishes the parameters of a historical field, often narrowing the focus to an elite canon of masters and masterpieces." Conversely, the "charming euphemism" of the study collection in the basement tempers the reality that this is "what they judge to be the dregs." An undeniable red thread runs directly from inside the temple of art that is the museum to the moneychangers outside. Robert Wraight in 1966 called museums the Fort Knoxes of art, whose contents "control the price of art outside them just as surely as the value of money is governed by those obscene, illogical hoards of gold." The College Art Association

passed a resolution in 1974 urging museums "not to allow judgments [about purchases or sales] to be swayed by fluctuations of market values or changing tastes." Furthermore, it demanded that museums routinely report such transactions.

British museums have strict rules forbidding curators from collecting in their own fields, as at the Victoria and Albert, or requiring that they first offer anything they want to sell to their own institution at the price they paid, as at the Tate. There are no such regulations in the United States. The officials at American museums sometimes collect for themselves art by the very same artists whose works they also exhibit. While Henry Geldzahler was curator of twentieth-century art at the Met, he acquired works by Hans Hofmann, Ellsworth Kelly, Andy Warhol, and Frank Stella. "It was only natural," wrote one observer, "that he should feature the same artists in his shows and galleries at the Met and commend them to such clients as the Stanley Woodwards who paid him a monthly retainer for the service." The dealer André Emmerich said he was "disturbed" by this practice, yet "every museum person I know who has the *means* to collect *does* so."

When the art critic Thomas B. Hess served as guest curator for the MOMA's one-man show for Willem de Kooning, virtually no one commented on Hess's long-term friendship with the artist, his outspoken critical support for him, and his ownership of several important de Kooning paintings, whose value the exhibition enhanced. While William Rubin was curator of painting and sculpture at the MOMA, he arranged for a retrospective for Frank Stella, an artist represented by his brother, the dealer Lawrence Rubin, whose gallery was originally backed by another brother, Richard. For Stella it was the second one-man show at the MOMA, the only artist so honored except for Picasso. Rubin had been strongly influenced by the notions of Clement Greenberg and viewed the history of modern art as "the progressive purification of form, culminating in Stella," wrote William Grimes. "With Stella, art history more or less stopped."

Karl E. Meyer's study of museums, published in 1979, noted that "the art museum's entanglement in the flypaper of

commerce" had been exacerbated by escalating prices of art and the arrival of a vast and ignorant throng of potential buyers in the art market. Such collectors depend far more heavily on the opinions of art professionals, so that "curatorial opinions have become a vital ingredient in the ever-changing consensus about the real worth—aesthetic and monetary—of objects or the work of individual artists." What had been a specialty market for a few rich connoisseurs had been radically transformed into "a mass consumer market with a profit potential emblazoned in headlines." The role of museums in this, he wrote, "cannot be overemphasized."

Even at a local level, museums play a central role in the success of contemporary artists. A Chicago dealer counseling artists on how to market their work marveled at the acute influence on the local art market of the Museum of Contemporary Art. Through its curators and collector–board members, she said, many previously unknown artists had been discovered, with rewarding results. Also helpful was the Borg-Warner Company, which had endowed two galleries, at the MCA and the Art Institute of Chicago, reserved for local artists.

Although they do not state it overtly, museums are well aware that they do not operate in an economic vacuum; otherwise there would be no need for their extreme reticence about the details of purchases, sales, and trades. The sketchy account of the MOMA's acquisition in the summer of 1989 of van Gogh's hundred-year-old *Portrait of Joseph Roulin* is a case in point. "No sooner had a painting by van Gogh fetched a [then] record-breaking price of $53.9 million [*Irises*] than MOMA, it turned out, had suddenly developed a rabid desire to add another van Gogh to its collection," wrote Hilton Kramer about this transaction. The museum's curator of painting and sculpture, Kirk Varnedoe, went on at length to the *New York Times* about the van Gogh's crucial importance as "the starting point for a whole vein of twentieth century art," its influence on Matisse in the use of color to reveal the personality of the sitter, how it filled in "a missing chapter" in the story of modern art as told by the museum. Conspicuously missing from

the account were the identity of the seller, who had purchased it only two years earlier; details about how the seven pictures deacquisitioned to pay for it were chosen; and, above all, the price paid. "Not a raging fire-sale bargain," Varnedoe owlishly suggested; the owners had turned down higher offers to allow the museum to buy it.

Sent to Switzerland in partial trade for the van Gogh were Renoir's 1902 *Reclining Nude*, given by the dealer Paul Rosenberg in 1956, and three paintings that were not even known to be in the museum's collection, since they were acquired after the most recent catalog (1977) was published: Kandinsky's 1908 *Autumn Landscape, Murnau*; Monet's 1920 *Corona (Water Lilies)*; and Picasso's 1943 *Striped Bodice*. In addition, the museum auctioned off three other paintings on November 15, 1989: Mondrian's 1913–1914 *Blue Façade (Composition 9)*, given by Mr. and Mrs. Armand P. Bartos in 1957; di Chirico's 1916 *Evangelical Still Life*, given by Harriet and Sidney Janis in 1967; and Picasso's 1956 *Studio in a Painted Frame*, given by Mr. and Mrs. Werner E. Josten in 1957. An unstated portion of the auction proceeds, $10.67 million, and the four pictures went to two Swiss dealers, Thomas Ammann and Ernst Beyeler, who represented the van Gogh's seller and who may have had an interest in it themselves. Varnedoe explained that the pictures sold or traded had languished in storage for years and dismissed their value because they lacked "enormous singularity within the careers of these artists." Ironically, the prices of other paintings sold that evening made the MOMA's proceeds resemble a mere pittance: Picasso's *Au Lapin Agile* sold for $40.7 million, his *Mirror* garnered $26.4 million, and Mondrian's *Façade in Tan and Grey* brought $9.6 million.

Such transactions and comments indicate that museums are not purely scholarly institutions, insulated from the marketplace. For one thing, their trustee-collectors look to the museum to validate the artists and schools they own and thereby enhance their value. For another, their enormous power to shape public taste often reaches backward into history to lend importance, itself a euphemism for monetary value, to more recent schools of art. Repeatedly during the last half century major museums have adjusted their official viewpoint

and their collections to underline judgments made by the art market. When the Impressionists of the late nineteenth century began their steep ascent into the price stratosphere during the early 1950s, widespread museum exhibitions of Pissarro, Monet, Renoir, Bonnard, and Vuillard added to the prestige conferred by high auction prices. Reinforcing the effect, museums also acquired many important Impressionist paintings, among them Monet's triptych of *Water Lilies* in 1959. Against this backdrop the Abstract Expressionists found validation for their art; suddenly the art audience saw the connection between the watery pools of color painted by Monet and the misty effusions of Mark Rothko. In the second generation of Abstract Expressionists, the connections were even more overtly drawn. "Where a Monet began by observing lily pads and ended up with a near-abstract of subjective sensation," wrote Irving Sandler, "a [Philip] Guston . . . started with the more or less unpremeditated process of painting and arrived at allusions to landscape."

Trained as they are in the history of art, where the great chain of influences stretches forward unbroken from the Renaissance, museum curators tend to locate the art of their own time on precise links in the chain. At the MOMA the permanent collection presents "a historical narrative, a theology, and a guide to right thinking all rolled into one," wrote William Grimes in 1990 in a *New York Times Magazine* profile of Kirk Varnedoe. "The museum is the Good Book, chronicling the Good Fight: the struggle of a misunderstood avant-garde against reactionary forces to achieve one radical victory after another. Cubism, Constructivism, Abstract Expressionism— these were the crucial battles in a religious war that's raged for a century or more. The winners are on the walls. The losers— well, who cares about the losers? They're out there somewhere, but not in MOMA."

When museums assemble shows of works by living or recently deceased artists, the effect on the market can be devastating. Consequently, their judgments are a source of endless discus-

sion in the art world. Henry Geldzahler's 1969 "New York Painting and Sculpture 1940–1970" at the Met still evokes both cries of rage over his omissions and smug smiles of satisfaction over those included. To many, the fifty-two thousand square feet in thirty-five sky-lit galleries where 408 works by forty-three artists had been assembled hardly contained all the best art produced in the world's art capital during three decades. Even *Life* magazine, under the judgmental headline "Modern Masters Amid the Old" was dubious. Geldzahler's selections had stressed Abstract Expressionists, Color-Field Painters, and Pop artists but offered "no new insights," wrote the critic David Bourdon. Geldzahler's catalog, he observed, "brims with irrelevant prattle . . . and is alarmingly uninformative about the art." More space was given to Jules Olitski's gallery affiliation than to Olitski's art. "Where the tone is not glib it is authoritarian," wrote Bourdon, "substituting a simple fiat for explanation." John Canaday called the show "a boo-boo on a grand scale" and its organizer "the museum's Achilles heel." Harold Rosenberg called it "history-falsifying" and designed solely to further Geldzahler's career ambitions.

Geldzahler later explained to an interviewer that he had selected artists to be shown by making a list of all those he had encountered and then winnowing out those who no longer looked "interesting." He refined his list during consultations with Clement Greenberg, Frank Stella, the art historian Michael Fried, and museum curator Walter Hopps. Some artists, such as Clyfford Still, were left out because they refused to lend paintings. But this was scant comfort to the host of others who were excluded, among them William Baziotes, Cy Twombly, Al Held, Herbert Ferber, Seymour Lipton, Alex Katz, Philip Pearlstein, Alice Neel, Marisol, Robert Indiana, Louise Nevelson, Larry Rivers, Tom Wesselmann, Jim Dine, and Richard Pousette-Dart. To complain about his omissions, said Geldzahler nonchalantly, was like reviewing a movie by saying, "A glorious motion picture opened last night . . . but Walter Pidgeon wasn't in it, Mickey Rooney wasn't in it." In fact, a more accurate analogy would have been to a book about Hollywood's Golden Age that omitted the likes of Joan Crawford, Bette Davis, Humphrey Bogart, and Gregory Peck.

As he greeted a motley crowd of more than two thousand guests who attended the opening on October 18, 1969, Geldzahler wore a blue-velvet dinner jacket custom made to drape flatteringly over his chubby frame. In the crowd were Met director Thomas Hoving and its president, Arthur A. Houghton; artists Robert Rauschenberg, Frank Stella, and Jasper Johns; dealers Sidney Janis and Leo Castelli; Robert Scull and his wife, Ethel, whose Warhol portrait was on public exhibition for the first time. Chatting with Geldzahler at the top of the grand staircase, Warhol himself was accompanied by his new superstar, who struck the *New Yorker's* Calvin Tomkins as "a personage of indeterminate sex in a silver dress and silver-painted sneakers." Asked why he did not go inside to view the exhibition that had been universally dubbed "Henry's Show," Warhol cryptically mumbled, "I am the first Mrs. Geldzahler."

A cynical observer might have wondered what museum president Houghton thought about the scene inside. A dignified figure in black tie, Houghton was the quintessential patrician, representing a class that even then was beginning to lose its dominance on the boards of many cultural institutions. St. Paul's School prepared him for Harvard, which in turn prepared him for the presidency of a venerable company, Steuben Glass, and directorship of a multitude of corporations. Breeding and Old Money mores—and the Episcopalian church—also demanded a multitude of good works: trustee of the New York Philharmonic, overseer of Harvard, vice chairman of the Ford Foundation, president of the Shakespeare Society of America. And clubs: the Century, the Harvard, the Union, the Knickerbocker, the Grolier. Only the Old Money tradition of tolerant restraint, at least in public, could have fortified Houghton that evening as he contemplated the scene around him. To some, it betokened a ritual confirming that the American consumer economy had swallowed up the avant-garde. To others, it surely embodied a Gibbonian decline and fall. Here, wrote Tomkins, "the stately black-tie world of the Metropolitan trustees found itself mingling with tribal swingers dressed as American Indians, frontiersmen, Cossacks, Restoration rakes, gypsies, houris, and creatures of pure fantasy. The see-through blouse achieved its apotheosis that night and spectators lined

up three-deep to observe the action on the dance floor." Six
bars, a dance orchestra, and a rock group enlivened the muse-
um's stately halls, as "empty plastic glasses festooned works of
sculpture [and] the air reeked of marijuana."

For some years the artists left out of the exhibition feared
that prices for their works might suffer. As it turned out, the
growth in the market as a whole lifted them also to new
heights; but there was no doubt that those included benefited
financially, and so did those who lent works to the exhibition.
In the catalog Hoving claimed that all the works shown had
been borrowed from other museums or private collections.
Among the collectors who lent generously were the Sculls, who
were already planning the sale of some works shown. They
auctioned the first lot within a year and sold even more three
years later, establishing new highs for American art. Contrary
to Hoving's assertion, a great many of the other works shown
had been borrowed from dealers: thirty-two of forty-two Ells-
worth Kelly paintings from Sidney Janis; fifteen of forty Jasper
Johns paintings from Leo Castelli; ten of twenty-two David
Smith sculptures from Marlborough, selected by Geldzahler's
adviser, who was also Smith's executor, Clement Greenberg;
five of nine Ad Reinhardt paintings from Marlborough, which
also planned a large Reinhardt exhibition the following March.
These details emerged some years later, but an inkling of such
subterrannean arrangements prompted Canaday at the time to
describe the exhibition as "an inadequately masked declaration
of the museum's sponsorship of an esthetic-political-commer-
cial power combine."

Geldzahler's ill-conceived exhibition marked the beginning
of a downturn in museums' prestige as tastemakers in contem-
porary art. Two years earlier Alfred Barr and René d'Harnon-
court had retired from their key posts as arbiters of taste at the
Museum of Modern Art, and their successors were embroiled
in unseemly power struggles. Neither the Guggenheim nor the
Whitney was strong enough to pick up the baton. Since then
powerful dealers supported by powerful collectors have in-
creasingly imposed their choices on the art world. Ironically,
the decline of museum professionals' sway has coincided with

a tremendous increase in their numbers. Their ranks have swelled from about seventy-five hundred in 1939 to about seventy-five thousand in the ensuing fifty years. In 1989 there were some 325 college-level opportunities for training students in museum work, ranging from graduate-level programs to workshops and symposia. Eighteen universities grant degrees based on at least 50 percent of course work in museology. Yet many if not most museum professionals are not graduates of such programs, nor has the American Association of Museums been able to develop standards of training for them. Museum workers' conferences and publications repeatedly agonize over what constitutes professionalism at museums without arriving at any conclusions.

If professionalism includes scholarship, says Henry Hopkins, their jobs offer little time or opportunity for it. Even exhibition catalogs usually are written by outsiders, he says, because curators just don't have the time. Compared with salaries in positions of equal responsibility, the pay of museum professionals remains low. Even the directors of major museums receive salaries that seem miserly in comparison with the munificent incomes of the trustees they are supposed to advise. In 1980 the directors of the Whitney, the Guggenheim, and the San Francisco Museum of Art earned only $60,000; the MOMA and Los Angeles County Museum directors earned $75,000; and the Metropolitan's director was paid $80,000. Current salaries, like so much else about museum finances, are shrouded in secrecy.

"Museums are staffed by idiots," says the dealer Allan Stone. They devote themselves to "party-time esthetics and other tricks to raise money." Always on the lookout for new art, they promote what they find "with no logic or sensitivity." Stone looked back nostalgically to the Barr era at the MOMA and contrasted contemporary curators with this rosy memory as suffering from "a Columbus complex—they all want to discover the next great artist." Stone blames the trustee-collectors for this disturbing development: "They want breakthrough art and egg the curators on."

The dealer Ivan Karp, who did not cavil when the Met

promoted such of his discoveries as Andy Warhol under Geld-
zahler's sway, calls the current crop of curators "a consensus of
the misinformed. . . . [They are] Jewish kids with thick glasses
who have read everything about art, but don't know how to
look at it." He deplored the choices for the Whitney Biennial,
particularly since not a single one of his artists had been chosen
for it in thirteen years, and complained that such established
figures as Tom Wesselmann, Wayne Thiebaud, and Milton
Resnick had never been given a retrospective. Even some col-
lectors frankly question museum professionals' advice. Freder-
ick Weisman, who owns one of the most admired collections in
Los Angeles, believed that "museum directors are the last
people you go to, to find out what the values are."

The restless throngs that today surge through America's major
museums know or care little about who has assembled what
they are looking at, by what standards, or from what source.
Despite admission charges that usually lag just behind the price
of a movie ticket and the difficulties of communing with great
art in the midst of a jostling mass, Americans are flocking to
major museums in growing numbers. Almost the entire popu-
lation loves museums, it appears, including those who never
visit them. In a mid-1970s survey three-quarters of respon-
dents disagreed with the statement "Museums are such stuffy
and depressing places that I don't enjoy going to them," includ-
ing 52 percent of those who never go to any cultural events
whatsoever. Two-thirds agreed that "a lot of museums are
doing many imaginative things to make them more interesting
places to visit," including 42 percent of those who never go.
Almost two-thirds agreed that "there's so much exciting new
talent in the visual arts that one should really go to museums
and art shows often," including 41 percent of those who never
go. Nearly two-thirds agreed that going to museums gave
them a pleasant feeling of doing what well-educated, sophisti-
cated people do, including 52 percent of those who never go.
Two-thirds disagreed that "unless you know a lot about art or

art history you don't get much from visiting a museum," in-
cluding 41 percent of those who never go.

How many do go voluntarily remains surprisingly difficult
to assess. At most museums huge flocks of schoolchildren
shepherded through the turnstiles (or past guards with click-
counters) by teachers inflate the attendance totals. The director
of a leading New York museum estimated that one-third of his
visitors were schoolchildren; of the rest, only half visited the
museum more than once a year. A survey in New York State
indicated that 7 percent of residents went to an art museum
more than five times a year. Even if museums exaggerate the
numbers, attendance figures have grown impressively. The
million who visited the Met in 1940 doubled by 1950; in 1980
attendance there amounted to 3.7 million, and by 1983 it was
4.6 million. At the Whitney annual attendance averaged only
70,000 before 1954; since then the average has grown to well
over 500,000. The Guggenheim claims a similar number. The
MOMA attracted more than 500,000 in 1939, when its new
building opened with a series of landmark exhibitions; during
the 1960s attendance averaged 900,000, and in 1980 it was
more than 1.2 million.

The visitor attempting to view the landmarks of Modern-
ism at the MOMA on a Saturday afternoon might be persuaded
that the entire world is trying to do the same thing. Annual
attendance there now hovers around 1.5 million. On the other
hand, most smaller art museums, especially those featuring
contemporary art, do not attract throngs of visitors. On a
typical weekday, for example, about fifty people pay $4 to enter
the La Jolla (now San Diego) Museum of Contemporary Art.
Over the years art museum attendance has grown almost
twice as fast as the population, but the largest crowds still turn
out for the most famous, the most romantic, and especially the
most valuable masterpieces. At the Met in 1979, King Tut's
golden coffin attracted 1.2 million; at the MOMA, Picasso in
1980 lured 954,000 in almost four months and the Warhol
exhibition in 1989 attracted 300,000 in just over three months.
But the all-time record remains the Mona Lisa's; her 1963 visit
to the Met of a little more than a month drew 1,770,000. Those

attempting to follow museum director James Rorimer's recommendation to spend at least a half hour communing with Leonardo's enigmatic lady were rudely awakened from their contemplation by guards asking them to move on after ten seconds. Famous works, especially works whose high purchase price has hit the headlines, often account for leaps in attendance. During the year after the Met's 1961 purchase of Rembrandt's *Aristotle Contemplating the Bust of Homer* for $2.3 million, attendance rose by more than 40 percent.

Nevertheless, the vast majority of Americans do not include an excursion to any type of museum at all in their leisure plans. Only one-fifth of Americans over eighteen attended a museum of any kind during 1980, the National Endowment for the Arts reported, even though the definition of "museum" was so broad as to include landmarks like the Washington Monument and the Empire State Building and a mass of local historic sites. Of all kinds of museums—science, history, technology, and art—the smallest segment of museumgoers is interested in art. Within this small segment the vast majority remain pitifully ignorant of what they are looking at beyond, perhaps, its great monetary value and a preferably lurid fact or two about the artist. Some, of course, simply consider the museum a convenient meeting place or a refuge from inclement weather. Others go as tourists, visiting the world's great repositories of art as they might Disneyland or Sea World. Still others seek the moral or spiritual uplift said to emanate from great art. One of the few studies of museumgoers' behavior indicates most visitors speedily attain whatever they are seeking: they stay relatively briefly and move fast. A psychologist who tracked them found that the average visit lasted less than a half hour and the average time spent before a particular work—if the person stopped at all—could be reckoned in seconds. Furthermore, the typical museumgoer had no idea that curators were treating each room as a unit and instead glanced at the art in a linear fashion; almost all of them turned to the right after entering a room or went directly to the middle of the wall opposite the entry.

While art museums place considerable emphasis on out-

reach and education when appealing for funds, they persistently fail in attracting substantial new kinds of audiences. "There is no evidence," writes William D. Grampp, "that the increase between 1959 and 1988 in the proportion of the population having an interest in art was any greater than could be accounted for by the increase of purchasing power and the average number of years of education."

From their earliest days America's public museums have struggled with the contradiction between their charter as public institutions, tax-supported at the least by being tax-exempt, and the nature of art as an expensive enterprise whose appreciation also requires a certain amount of education. Unlike performing arts, museum exhibitions embody great monetary value; indeed, the local founders of American museums have generally been self-made successful businessmen. "In no case was the museum to be merely a monument to vanity or a plaything for the idle rich," writes sociologist Judith H. Balfe. "High public moral and educational purpose affected even the occasional artist who infiltrated the Founders' Committees."

However, the public to be uplifted by the museums strenuously resisted. To be candid, the museums themselves had decidedly mixed views about their educational function, and despite all protestations to the contrary, this ambivalence persists today. In a landmark 1942 study Theodore L. Low castigated museums for their elitism and their worship of valuable art. He charged that serving the "vital and practical interests of working millions" engaged neither the curators, as "custodians and purchasing agents; nor the directors, who traditionally cherish collections and scholarly prestige; and not even the trustees, who should represent the community but instead guard funds and endowments."

Low quoted an earlier critic of museums, John Cotton Dana, whose 1917 The Gloom of Museums accused them of shirking their educational role. "They buy high-priced paintings and spend vast sums for rare brocades, pottery, ancient wood carvings, and whatnot, and then set these . . . before their constituents, saying, 'Look, trust the expert, and admire.' " Low was disheartened that twenty-five years after

Dana's tract had been published museums were still "failing miserably" in their educational role. A Harvard graduate student in fine art, Low pursued his study with a grant from the General Education Board of the Rockefeller Foundation. He had spent two years in New York as field representative of the American Association of Adult Education, funded by the Carnegie Corporation. The resulting book, *The Museum as a Social Instrument*, was published by the Metropolitan Museum of Art, a model of self-criticism that today would be unthinkable.

Low urged museums to expand their educational programs, especially to make themselves relevant to the mass public. "The museums must come down to earth and realize that democracy and popular culture are synonymous," he wrote. "That necessitates an effort to reach the public whom they have kept at arm's length by their own stupidity. It is, in fact, a penance for past omissions which all museums today should gladly pay." In the half century since Low's clarion call for reform, little has changed. Museum educators had the least prestige and lowest pay among all museum professionals, one sociologist reported in 1984. Most of them were dropouts from Ph.D. programs in art history; they spent most of their time organizing volunteers who then dealt with the public, especially schoolchildren delivered by bus for a day's outing. While European museums remained frankly elitist, their American counterparts were perhaps overly idealistic in expecting the wide public to respond meaningfully to art.

Yet their approach to exhibitions is, if anything, more elitist than the Europeans'. A parade of masterpieces confronts the American museumgoer, and the viewer, lacking any other explanation, assumes these are the most valuable works in the house. American curators often do not deign to explain to their public why they exhibit certain works at all times and others seldom or never, how a particular work ranks in the artist's oeuvre, or the purpose of presenting works by different artists side by side. Such matters are the subject of lively discussion within the curatorial world, but they seldom reach the museum audience. While curators fervently debate among themselves the quality of various items in a museum's collection, most

docents and others who provide gallery talks purvey an inces-
sant stream of admiring superlatives, handing down awesome
tablets of received truth without ever engaging the audience's
critical faculties. A striking exception was a tour I joined on
impulse during a visit to the Metropolitan. For an hour James
B. Spann briskly led a flock of visitors from New Orleans on a
jaunt through the immense galleries to see only twelve works.
He had chosen these particular works especially for this tour
and had checked the day before to make sure they were all on
view. While Spann's knowledge was encyclopedic and scholarly,
his attitude toward the art remained casual, occasionally skep-
tical, and sometimes, to the delight of all, gossippy. The Met
had come a long way indeed in its educational efforts from the
bad old days Low described in 1942, and even from its hippie
phase of the 1960s and 1970s.

In most instances, however, museums' efforts at public
education are "doled out in doses sufficient only to create re-
spect for the symbolic goods which dominant status groups
control," writes one sociologist. By contrast, museums devote
generous resources to educating those who yield the largest
material return. Prospective donors may well command the
personal attention of curators and even directors, receiving
serious schooling in connoisseurship in the hope that they will
donate money or art. In 1984 American museums were spend-
ing only 13 percent of their budgets on instruction. In 1987
Smithsonian staff attorney Stephen E. Weil deplored museums'
continuing dedication to their collections to the detriment of
education. "We have too often taken what is a necessary condi-
tion to the work of museums—the existence of carefully ac-
quired, well-documented, and well-cared-for collections—and
treated that necessary condition as though it were a sufficient
condition," he told a conference of museum officials. "Museum
theology" enshrined education, but in all too many museums it
continued to be "a limping afterthought about how a collection
might be employed instead of the motivating forethought that
would determine just what should be collected in the first
place."

When it comes to planning retrospective exhibitions for

artists, museums find themselves inordinately dependent on cooperation from the artist and his or her collectors and dealers. The result all too often describes a career that develops in a steadily ascending curve from youthful talent to mature success—and the catalog prepared by the artist's critical supporters echoes the same sunny story. In retrospectives artists do not explore blind alleys or suffer from dry spells. Harold Rosenberg called premature retrospectives "a primary obstacle to critical evaluation," because public money and the museum's prestige "reinforce a promotional apparatus." John H. Merryman and Albert Elsen, who examined museum ethics in 1987, found that in dealing with living artists "the museum appears less a receptacle for cultural products and more an amalgam of the interests held by trustees, directors, and curators." Because the recent work is still under the control of the artist and dealer, it presents "the triumphant climax of the show," writes the Smithsonian's Weil. In some instances the museum staff must bow to the artist's and dealer's demands as to who will be the exhibition's curator and how the show will be installed. Weil finds it disturbing that "where the museum should be taking a responsible and critical stance, it has been perverted into a super art gallery." Such practices are all the more disturbing when, as frequently happens, some or all of the art shown is for sale. For trustees and potential donors the price list is accessible via a quick phone call to the museum administration; for the public it does not exist.

Although the balance sheets that museums offer their "members" would never pass muster on Wall Street, they do indicate that museums are spending far more money than ever before. The Guggenheim, for example, had a $2 million budget in 1974-1975; in 1988-1989 the museum posted a $2 million deficit on an operating budget of $11 million. American museums (of all descriptions) currently are spending well over $1 billion. These figures do not include donations of art or private underwriting of special exhibitions, nor do they always include the substantial benefits derived from their tax-free status. At

the Met 1989 sales from four catalogs and nine retail shops amounted to $69 million, almost half of the entire annual budget. At the MOMA two shops and a catalog brought in $16 million of the museum's $42 million gross income. Unlike in a private business, sales from some two thousand museum shops are not subject to federal, state, or local income tax. Even at smaller museums, the gift shop yields substantial revenues: the Norton Simon Museum in Pasadena, California, reported income of almost $320,000 in 1979, nearly as much as the combined revenues from admissions and contributions.

Despite their profitable gift shops, their expensive trips to faraway places (which generally include a hefty donation in the total price), their lavish fund-raising parties, the surge of corporate support, and sizable grants from the National Endowment for the Arts and the Institute for Museum Services, as well as state and local grants, museums regularly complain that they are poor. During his tenure at the Met in the 1960s, Thomas Hoving declared that "any trustee should be able to write a check for at least $3 million and not even feel it." In those years Old Money rectitude and responsibility still prevailed on museum boards. To those aristocratic museum trustees, the increasing popularity of the "beautiful artifacts of the gift culture," as Nelson W. Aldrich, Jr., describes them, was "like the sound of bugles to Theodore Roosevelt." But at another level, he adds, the crush of new visitors was a disaster. The large museums turned to extravagant blockbuster exhibitions, and their immense costs called for hard cash, "not time or talent, not 'character,' just money, more and more money, and this in turn has forced open an ever-growing corner of the temple to the marketplace. The money changers have had to be let in to set up shop—called, with bitter irony, the 'gift' shop."

Also admitted into the inner circles were some whose ample checkbooks substituted for scant social credentials. The Met was the setting in 1988 of a $3 million wedding extravaganza for the offspring of two of New York's newly minted moguls, Jonathan Tisch and Laura Steinberg. It featured fifty thousand French roses, gold-dipped magnolia leaves, a dance floor handpainted for the occasion, and a ten-foot wedding cake costing $17,000. At least one party takes place on each of the

three nights every week when such precious spaces as the Temple of Dendur, the Blumenthal Patio, the Great Hall, and the Engelhard Court are available for such events. Marvin Traub, the miracle man of Bloomingdale's, had a dinner party for the then–department store magnate Robert Campeau; financier John Guttfreund and his wife, Susan, hosted a cocktail reception; takeover specialist Henry Kravis and his wife, the designer Carolyne Roehm, sponsored a sit-down dinner for 140 guests. A new perfume was launched in one of the halls. At one party actors and actresses were costumed to resemble the figures depicted by Degas on the walls. To prepare for such parties, caterers arrive at noon and the party site is closed to the public by 3:00 P.M. "The nouveau riche . . . run amok in [the Met's] halls," wrote John Taylor in a scathing *New York* magazine article describing these fêtes. The museum, he wrote, had acquired such nicknames as "Parvenu Venue" and "New York's Rent-a-Palace."

During the 1970s the museum allowed dignified gatherings only after a written request to the board. The event had to be art related, and its sponsors had to donate at least $5,000 to the museum. By the mid-1980s anyone who gave $30,000 could have a party. Museum officials defended their party policies as a sensible way to make ends meet. Museum board chairman and *New York Times* publisher Arthur O. Sulzberger told Taylor that "if it's going to be dark and someone's going to pay tens of thousands of dollars to open it up, why not open it up?" Without the partygivers' funds, he said, the museum would have to turn elsewhere or reduce hours, galleries, or programs. Met director Philippe de Montebello suggested that "if we had the Getty's endowment, we wouldn't need to have parties." Those who criticized them were just expressing a coded dislike for the party hosts, he said. However, the Met did raise its rental fee to $50,000.

Cultural institutions, like their nonprofit religious and educational counterparts, have had perpetual funding problems, especially in the United States, where government support is

relatively sparse. A study from the early 1970s indicated that while American theaters, for example, covered 70 percent of their costs from gifts and admissions, museum earnings covered only 40 percent of their budgets. A scholar specializing in arts funding reported in 1985 that America's cultural establishment supported itself to a greater extent than any other in the Western world. To earn large sums, these institutions regularly schedule conservative crowdpleasers such as *The Nutcracker* ballet, the staging of *A Christmas Carol*, and pops concerts. Cultural organizations justify such aesthetically dubious enterprises as efforts to interest the wide public in more serious offerings. At museums the search is always on for another exhibition of Picasso or Matisse, yet another display of Impressionists or of that all-time romantic hero—beautiful art, tragic life, and maximum money irresistibly intertwined—van Gogh. Whatever it takes to attract an affluent audience to pay more— for tickets on the way in and for costly souvenirs on the way out.

Understandably, the Met makes much of its position as the number one tourist attraction in New York, with more than five million visitors each year who contribute many millions to the city's economy. Now museums all over the country are also promoting themselves as more than citadels of culture, as potent contributors to the local economy. In San Diego, for example, the Museum of Art commissioned a detailed economic impact report after an eleven-week exhibition of Fabergé eggs at the end of 1989. Some 88,100 out-of-town visitors had been among the 252,000 who had gazed upon the czarist confections, works that a local wit said related to great art as *Cats* related to great theater. While the city had spent $3 million to bring in the exhibition, the visitors had pumped more than $15 million into the local economy, including $2.3 million into restaurants and stores, $1.3 million for lodging, and $203,000 for alcoholic beverages.

Many critics assert that because museums rely on expensive "safe" exhibitions to bring in the extra money they need for swollen budgets, they are slighting such important responsibilities as scholarship, exhibitions of local artists, and display of their own collections. "You get an O'Keeffe show . . . you get

a King Tut show . . . the objects are interesting, but the packaging and promotion are like a business," says former San Francisco Museum of Art director Henry Hopkins. "If a proposed exhibition doesn't promise to make 'the nut,' you can't do it." Peter Goulds, who runs art galleries in Los Angeles and New York, says that connoisseurship has become "a victim of the art boom." Blockbuster exhibitions, he says, do make art more available to a wider audience, but at the cost of serious study. Museums are so desperate for money that they cater to the needs of corporations eager for the financial benefits of sponsoring shows. "What criteria does this process present to the museum staff?" Goulds wonders. "Insight or profit?" Sherman E. Lee, former director of the Cleveland Museum of Art, finds that blockbusters seldom offer viewers a chance for the meaningful comparisons essential to the art experience. Using an exhibition as theater, he writes, "in which defenseless pictures become part of a jazzed-up dumb show, the exhibition à la mode, the exhibition as a history of things, or the documentation of history by an unselective juxtaposition of inferior and superior works of art—all are a confusion of the value of works of art."

When a young public relations woman with an art background, Nina Kaiden Wright, first dreamed up corporate sponsorship in 1958, museums were shocked by the vulgarity of mingling commerce and art. Wright, who had worked at the American Federation for the Arts, first took her idea to her old boss at the Guggenheim, Thomas Messer. Aghast at such a notion, he refused. However, Wright persisted and soon established Ruder and Finn Fine Arts to provide matchmaking services between corporations interested in influencing an affluent public and museums, which appealed to precisely such people. Through the expertise of Ruder Finn, which now has offices in New York, Toronto, and Los Angeles, corporate sponsorship of museum exhibitions grew from casually acknowledged contributions during the early 1960s to highly structured commercial arrangements not just with museums but with all sorts of cultural organizations. For museums corporate funding paid for expansions and made up perpetual budget deficits.

With hordes of new artists arriving, the art market blaz-
ing, and dealers creating museum-quality exhibitions complete
with lavish catalogs, there seemed little more that museums
could do. "If they just settle back into being an old-hat repos-
itory," observed the dealer Ben Heller in 1973, "they're not
being fresh and innovative and exciting and alive and can't stir
up the museum board." In the 1967–1968 season the Whitney
Museum held only only 14 corporation-sponsored shows; in
1980–1981, it had 159. At the Museum of Modern Art corpo-
rations sponsored 90 exhibitions during the 1965–1966 season
and 201 in 1981–1982. By 1976 corporate sponsors were major
players in the arts; twenty-nine thousand corporations were
arts contributors. Those giving more than $1 million included
Exxon, IBM, CBS, Corning Glass, Dayton Hudson, and Philip
Morris. In 1979 Exxon alone was giving $4 million for the arts;
and oil company support for public broadcasting was so lavish
that PBS was dubbed the Petroleum Broadcasting System.

Nowadays a contract spells out precisely what a corporate
sponsor is to receive in exchange for its "donation": how many
catalogs will be printed bearing the sponsor's name; the size of
the sponsor's name in advertising, at the exhibition entrance,
and on invitations to the opening and other social events con-
nected with the exhibition; use of the sponsor's name in all
radio and television advertising; and how often and to what
extent the museum's facilities will be available for the sponsor's
own promotional activities. Caroline Goldsmith, who has su-
pervised Ruder Finn's relations with cultural organizations for
some twenty-five years, considers it a personal triumph that
her clients' names are now routinely mentioned in news reports
about the events they sponsor: "Now even the *New York Times*
has made it mandatory that any arts review must mention the
name of the sponsor."

All over the country museums are making their own spe-
cial deals with potential sponsors. At the Los Angeles MOCA,
Citicorp, which was anxious to enter the rich California
market, committed $165,000 during 1982–1984 to hook into
the museum's opening activities. This included "prominent
recognition and participation in a press conference announcing

the Temporary Contemporary, credit on fifteen radio programs about contemporary art, mention of Citicorp in all Temporary Contemporary brochures, posters, and catalogs and on the wall at the museum's entrance, mention in all press releases, and a chance to host dinners, receptions, tours, and the like during the museum's opening festivities. For the 1989 version of the San Diego Museum of Art's annual glorified flower show called "Art Alive," sponsors could link their names to galleries and events for fees ranging from $500 (for the smallest gallery) to $8,000 (for a lunch). Other underwriting opportunities included the opening night reception, $6,000; three lectures, $5,000 each; invitations, $3,000; T-shirts to be sold, $2,000; and luncheon centerpieces, $800.

Like all donors, corporations are far from neutral in selecting what they will support. When corporations first began to proliferate as sponsors in the 1970s, Los Angeles County Museum director Kenneth Donahue admitted that decisions about future exhibitions were "very much determined by their ability to get grants." He denied that his curators' independence had been compromised, even though an exhibition proposed by Maurice Tuchman on modern art and mysticism had been put aside because it was considered "too literary" to attract corporate funding. "We plan a show with full professional integrity," Donahue insisted. "If it finds a sponsor, fine. If not, we plan another show with full integrity." The MOMA's William Rubin, however, conceded that corporate sponsorship had introduced "a host of new, non-esthetic considerations into the planning of museum programs." Henry Geldzahler frankly declared that exhibitions were selected on the basis of their appeal to corporate sponsors. "There are, for instance, very few people interested in ancient Near East art, even though it's a very important discipline," he said in 1981. "So if you're going to . . . try to bring in a corporate sponsor like Xerox, or Exxon, or the phone company, you get endless Impressionist shows and . . . endless Picasso shows."

The public also gets many exhibitions that quicken interest in whatever the sponsor is selling. United Air Lines funded "Hawaii: The Royal Isles" at the Chicago Art Institute in 1980

and sent the exhibition on a tour of other museums; Champion International, a maker of fine paper, paid for an exhibition of shopping bags at the Cooper-Hewitt and other venues. Beginning in the 1970s American Express generously supported exhibitions that might sell trips to exotic places: "Treasures of Tutankhamen" in Toronto; "The Vikings" at the Met; "Circles of the World: Traditional Art of the Plains Indians" in Denver and other places; "Silk Roads/China Ships" in Toronto and elsewhere; and "El Greco of Toledo" at the Prado, the National Gallery, and other museums. In 1990 one of the exhibitions sponsored by American Express was a collection of atmospheric photos by Mexico's famous photographer Manuel Alvarez Bravo.

Despite such obvious connections between the business interests of corporations and the art exhibitions they sponsor, the soul-searching over the moral aspects of corporate arts support has died down considerably and museums have courted corporations even more hungrily than they ever courted individual donors. The Met published a booklet in 1984 titled "The Business Behind Art Knows the Art of Good Business." It described the many public relations opportunities the museum offered its corporate sponsors. "These can often provide a creative and cost-effective answer to a specific marketing objective," said the text, "particularly where international, governmental, or consumer relations may be a fundamental concern." A letter the museum sent to potential sponsors in 1989 urged them to "learn how you can provide creative and cost-effective answers to your marketing objectives by identifying your corporate names with Vincent van Gogh . . . Canaletto . . . Remington, Fragonard, Rembrandt, or Goya."

A disheartening example of corporate sponsors' influence over museums came in September 1988, when the Guggenheim exhibited forty-seven paintings and drawings titled "Andy Warhol, Cars." In fact, all the cars were Daimler-Benz, the company which sponsored the exhibition and paid for the catalog. In the introduction the company's chairman, Edzard Reuter, asked: "Does this then amount to patronage of the arts as a form of advertising by alternate means?" He concluded his

homily by writing, "A company's encounter with an artist is as complex as the perfect presentation of perfect products." The *New York Times* reviewer, Roberta Smith, confessed her embarrassment for the Guggenheim and suggested that the museum "seems to have once more succeeded in raising questions about museum practices." But she then went on with a serious review of the show covering fifty-seven column-inches. So pervasive is the drive for government, foundation, and corporate funding for museums that the independence of museums has perhaps already slipped irrevocably into subservience to those who pay the bills. Said one dispirited participant in a 1984 conference on public policy and the arts: "The tail is not wagging the dog now. The tail *is* the dog."

The zeal museums have devoted to courting corporations once was directed in similar measure at donors. But the 1986 tax reform brought to an abrupt end the system that had built the massive collections in American museums and indirectly contributed to the immense growth in the number of new museums. Until the reform it was more rewarding to many collectors to give art away than to sell it. So long as the values of art were growing, the benefits of giving it away also grew. This came about because the donor could deduct the current value of a work from income taxes even though he or she had originally bought it for only a fraction of that amount. Until 1964 this provision even permitted the donor to keep the work until he or she died while still taking a tax deduction in the year the work was signed over to a museum. Later, the work had to be handed over to the museum immediately, but the museum could still appraise donated works, a system that led to many extraordinarily inflated appraisals. In 1984 this loophole narrowed considerably when the IRS began insisting on a written outside appraisal for every donated work. In the following year the tax authorities also began to consult their own panels of experts to check up on taxpayers' deductions for donated art. The 1986 reform allows deductions for donated art only up to

the original price, a provision that outraged museums and produced some unintended consequences.

For one thing, "grandiose pledges of vast collections to the Met, Minneapolis, or Philly vanished," wrote Thomas Hoving. For another, the reform deregulated the art market. "Within six months," Hoving added, " 'distinguished' art philanthropists became mere hawkers." The 90 percent or so of all museum acquisitions that had come from donations dwindled to a trickle; the collectors instead sent their treasures to the auction salesroom and cheerfully gave one-third or so of the proceeds to the tax man while keeping the rest. Cash donations to museums also fell off sharply as the maximum federal tax rate for the wealthy fell from 50 percent to 28 percent. The American Association of Museums reported that 126,264 fewer objects were given in the year after the tax reform, and their dollar value dropped by more than 30 percent; in 1988 the number of donated objects dropped another 18 percent. While museums received objects worth $143 million in 1986, their 1988 gifts were worth only $67.1 million. During 1989 donations to all the arts increased only by an inflation-adjusted 5.4 percent. But the executive director of the American Association of Museums, Edward H. Able, said that museums experienced no increase whatsoever. Potential donors were selling their art to Japanese and foreigners instead, he lamented, and "America's cultural patrimony is hemorrhaging."

Although museums mourned their losses, the charitable deduction for appreciated art had been under attack for a number of years and by a variety of critics. Karl E. Meyer in 1979 found in museums' perennial pleas of poverty "an absurdity . . . that might have appealed to a Daumier. There is no institution more redolent of establishment wealth and power." In 1983 a careful study of museum economics and tax policy suggested that the large deductions taken by museum donors came at the expense of other taxpayers, who had to make up the amounts the donors had avoided paying. The authors recommended that instead of giving donors deductions the government give some of the extra taxes it collected from the wealthy to museums, which could then purchase works chosen by professionals to

enhance their particular collection rather than merely accept something chosen by the donor. This would eliminate the unseemly competition among museums for private collections. "The tradition of public philanthropy disguised in private garments has produced a generation of art professionals so conditioned to play the role of toadies and courtiers . . . that they have lost all hope for any other possibility." So wrote Alan Feld, Michael O'Hare, and J. Mark Davidson in a study for the Twentieth Century Fund, *Donors Despite Themselves*. The system had transformed ignorant but wealthy private collectors into spurious connoisseurs, they wrote, who take "credit for taste and perception that rightfully belongs to the curator who advised them and enjoy reputations as philanthropists by giving away public money." Moreover, art professionals were dissipating their education and talents "by spending time buttering up collectors so they will in the end make the contribution the museum has banked on—but cannot require." William D. Grampp contended in 1989 that gifts of art, whether tax deductible or not, nevertheless are costly to museums. While accumulating their art, potential donors make heavy demands on curators to verify attributions and advise on purchases as well as how to care for collections. Donated works increase expenses for storage, conservation, insurance, and possibly restoration.

The drought in donations caused by tax reform has set museum curators rummaging through their basements with unprecedented energy. They are searching not for unappreciated masterpieces that the public might wish to glimpse, but rather for works that have appreciated in the marketplace that they can sell. Most controversial among the art hustled off to the auctioneer under the mealy-mouthed rubric of "deaccessioning" was the Guggenheim's disposal in May 1990 of Kandinsky's 1914 *Fugue*, Modigliani's 1916 *Boy in a Blue Jacket*, and Chagall's 1923 *Birthday*. The sale price, $47 million, was more than the museum's entire endowment of $28 million. Some $30 million of the proceeds reportedly went to Italian Count Giuseppe

Panza di Biumo to pay for two-hundred-odd pieces of Minimalist art from the 1960s and 1970s. The count agreed to give the museum his villa near Milan, where he now displays some of his collection, and 140 more works by the same artists. Many of these creations by such artists as Donald Judd, Dan Flavin, Carl Andre, Bruce Nauman, and Robert Morris exist only as sketches on paper; to display them the Guggenheim would have to pay the artists hundreds of thousands of dollars for authorized constructions.

Nor was this the first time the museum had mined its basement for salable art. In 1964 the museum had sold 50 of the 170 Kandinskys it owned—perhaps the world's most comprehensive array of this artist's work—to raise $1.5 million. At that time Harry F. Guggenheim, then museum president, announced that it was "not in our interest ever to sell other works by Kandinsky in our collection again." Questioned about the 1990 decision to dispose of yet more recognized masterpieces of early Modernism for recent works untested by time, Guggenheim director Thomas Krens assured the *New York Times'* Grace Glueck that the loss of the three modern paintings would not "impair or harm the fundamental integrity of the collection." The Minimalists were "classics of postwar art," he asserted, "and hardly speculative."

The Guggenheim is not alone in attempting to dig gold out of its storage space. Many of the nation's museums have for years been selling parts of their collections, either quietly through private auctions and dealers or more conspicuously at public auctions. But the pace appears to be quickening. During the 1985–1986 season Christie's handled twenty-eight museum properties; in 1988–1989, eighty-eight went under the hammer. In one month in the spring of 1989, Sotheby's and Christie's together sold off works from fifteen museums, including thirteen from the Met for $12 million, six from the Philadelphia Museum of Art for $2.9 million, and three from the Chicago Art Institute for $4.6 million. During the following November and December, fifteen Impressionists and other works from the Getty sold in London auctions for $18 million, including a Monet landscape, a Degas dancer, a Gauguin land-

scape, and a Bonnard nude. Other museums decided to take advantage of record prices to drastically alter their orientation. The Walker Art Center in Minneapolis dumped its entire collection of nineteenth-century Americans and gave Sotheby's twenty of the best. The sale brought in more than $10 million, including a record $8.25 million for Frederick Church's *Home by the Lake*. While the art lovers in Minneapolis now can view a wide array of contemporary art, they can no longer savor a single major American painting from the nineteenth century.

Since 1971 the Association of Art Museum Directors' guide to ethics and standards has required that deaccessioning "be related to policy rather than to the exigencies of the moment and funds obtained through disposal must be used to replenish the collection." To comply, many museums require that replacements be as close in period and medium as practical to the work they are selling. Thus the Chicago Art Institute sold two lesser Monets and several Renoirs in order to buy two Monet *Haystacks*; the museum already owned several examples of this series of the artist's experiments with depicting light. At the MOMA William Rubin avoided auctions because "it's not good publicity. . . . If the work doesn't meet the reserve, it's publicly burned and then becomes virtually unsalable." Still, the museum steadily disposed of art through dealers or through private sealed-bid auctions. So anxious was the museum to obtain the van Gogh *Portrait of Joseph Roullin* in 1989, however, that three paintings were sold at auction and four more traded to the dealers handling the sale. The MOMA director of painting and sculpture, Kirk Varnedoe, called in his predecessor, Rubin, to help select what would go. They went through twenty possible candidates, said Varnedoe, and selected seven with "commercial appeal" and "that we felt we could live without."

Despite loss of tax benefits, many collectors still want their art to end up in a museum. Great art will "inevitably move to museums," says the collector and private dealer Ben Heller, "because donors want to give. Their reasons are true goodwill, ego, upward mobility, love, and thankfulness." Nor is the art investment advisor Jeffrey Deitch pessimistic: "Collectors like

to have their names associated with museums." However, when museums raid their own collections to buy other art, they risk losing the confidence of their most important donors as well as tarnishing their public image as ultimate, timeless tastemakers. Judgments about the value of art are notoriously volatile; what strikes one generation as a masterpiece may strike another as second-rate or even kitsch. The history of the art market is littered with revaluations, devaluations, and rediscoveries. For every van Gogh scorned in his own day and later treasured, there are countless artists whose works brought record prices in their own day only to fall ignominiously into the category "unsalable at any price." One of the central purposes of museums is to present the long view; to show the public as complete a picture as possible, free from the vagaries of the marketplace. Sadly, museums are currently so entangled in the money side of art that they appear likely to fail in this endeavor.

7

SPECULATIONS

The shift of the art market's capital from Paris to New York after the Second World War was of far more than mere geographic significance. It also meant a profound change of sensibility: from European elitism to American populism; from Old World suavity and discretion to New World merchandising and flimflam. European artists cherished the bohemian myth of the inarticulate, alienated avant-garde; American artists called press conferences and stormed the grand stairway of the Met. European dealers inhabited drawing rooms and wore morning coats; American dealers advertised and gave away free samples. European patrons discreetly bought works for private appreciation; American collectors flaunted their acquisitions in museum exhibitions and auction rooms.

Along with the new art made in America came cultural values unique to the New World: the democratic mingling of high and low arts; a yearning for superstars; flamboyant emphasis on money; zeal for self-improvement; uncritical affection for "art"; a conviction that bigger is better; and long-standing ties between commercial art and fine art.

The "triumph of American painting," as the art historian Irving Sandler described the success of Abstract Expressionists like Jackson Pollock and Mark Rothko, took place in an expanding art universe. Never before were so many Americans interested in contemporary art. The fifties and sixties saw explosive growth in the size and numbers of museums and galleries, in college departments and courses devoted to art, in spending on

art, in media attention to art and, more significantly, to the personalities and antics of artists. The "art boom" seething today is not fueled by the aesthetic quality of the art, since all standards for judging art have long ago been abandoned as philistine, but by a sophisticated market.

The Art Biz, which grew out of these changes, imposes a system derived from an age of visual scarcity onto an era of visual glut. Art today is by no means rare. It is abundant. But because the aesthetic value of art is locked so firmly to monetary worth, the Art Biz constantly attempts to limit production. Carefully handled, a photographic negative could yield thousands of prints, all of equally excellent quality. But that would undermine a market based on a hundred or so copies, signed and numbered, hung and sold in expensive galleries, exhibited in important museums . . . in other words, artificially rarefied. There was a time when photographers did their own darkroom work, so what emerged came from the artist's hand. But today a laboratory specialist (sometimes even a machine) does the printing. Dealers and museum curators are constantly fulminating against mass editions of lithographic or silk-screen prints, not because of inferior quality, but because large numbers endanger their structure of high prices based on scarcity. There was a time, in the age of visual scarcity, when the quality of a lithograph or silk screen deteriorated after a small print run, but not in this age of visual glut. In fact, a reasonably sophisticated printer could turn out a hundred thousand or a million examples of the same print with no discernible loss of quality. A gallery on Rodeo Drive in Beverly Hills recently exhibited a charming David Hockney silk screen about the size of a sheet of typing paper. Signed in pencil by the artist, it was one of one thousand and the price was $13,000. The buyer, I suggest, is paying such a sum not for this attractive image of a Los Angeles swimming pool but for the snob appeal of the signature.

The vast market for the "art" now sold in shopping mall chain stores indicates that a substantial public understands this. One could argue that those buyers are more truly art connoisseurs than the buyer of the $13,000 Hockney. The shopping

mall customer puts $100 or $500 into an image (perhaps also created by David Hockney) that gives aesthetic pleasure, period. The Rodeo Drive customer's aesthetic pleasure mingles with snobbery—false pride in ostentatious spending—and greed—hope that the value of this "investment" will grow.

In the last two hundred years, those who decided what was art have suffered under constant pressure to expand their canon. When Aloys Senefelder discovered lithography in 1798, the process was considered commercial, useful for producing handbills, posters, or illustrations, but not art. Only years after Honoré Daumier had died blind and destitute did his lithographic art attract critical acclaim. When J. Nicephore Niepce and L. J. M. Daguerre developed photography during the 1820s and 1830s, the process was considered scientifically interesting but not art. It would be many decades before their work and that of William Henry Fox Talbot, Julia M. Cameron, and so many other pioneers attracted the admiration of the arbiters of the aesthetic. When Thomas Edison, the Lumière brothers, and others began producing motion pictures during the 1890s, their product was deemed amusing mass entertainment but not art. Despite the elaboration of motion pictures by a multitude of talented performers and directors, the consensus among taste-makers was that silent films were not art . . . until the talkies came along during the late 1920s. It was then that the best of the silents began to achieve art status, while the talkies were dismissed as kitsch.

The pattern appears clear: the art establishment of the day resisted each new art form tooth and claw and only admitted each to the aesthetic canon with great reluctance long after the pioneers were dead. What made it so difficult to accept these kinds of work as art was that the technology used to create them permitted many copies to be widely distributed and appreciated by great masses of people. All the debates and doubts over whether these products were art represented a desperate rear-guard battle by the conservative minions of visual scarcity against the advancing tide of visual glut. Absurdly enough, the battle continues. The Boston Museum of Fine Arts now has a room-size Polaroid camera that can make full-size replicas of

paintings, complete, says the museum's marketing director, with "every brushstroke, crack, and paint chip." A 20-by-24-inch image sells for $1,100; a 40-by-80-inch photo costs $1,980. Art professionals understandably have mixed feelings about this new process. Art history professor Paul Tucker believes that the replica "will only demonstrate how mute and distant a reproduction is from the original." The inventor of the process, Edwin H. Land, observed poetically that "the glass of wine that a lover's lips have touched is different from any other glass."

<center>✦</center>

The confrontation between new technologies and artists began early in the nineteenth century, as photography inexorably began to replace many of the age-old practical functions of the artist. What art historians describe as the artist's growing alienation from an earlier system of aristocratic patronage paralleled the takeover by photographers of portraiture and landscape. Deprived of his mundane function as a limner of people, places, and events, the artist retreated into pursuing art for art's sake. The bohemian image of the artist as a hungry genius pursuing inspiration while living in picturesque poverty reflected a technological reality: structural unemployment. To the rescue came the rising bourgeoisie, whose aristocratic strivings included patronage of this superfluous being, much as wealthy people today patronize custom cobblers and Paris designers.

So the disappearance of a utilitarian function for art impelled artists toward a perpetual probe for the new, a search for a creative product where technology could not follow. In this quest we find the origins of the avant-garde. Meanwhile, industrial and commercial wealth flowing to new segments of society created the customers. Science and technology also aided artists: the invention of tubes gave them portable pigments to paint landscapes outdoors, from life; the development of aniline dyes lent unheard-of brilliance to their canvases; photography itself suggested snapshotlike compositions and the

subject matter of modern urban life. Motion pictures gave a fresh impetus to avant-garde artists' perpetual search for new ways of depicting reality. If photography still dwelled in a black-and-white world, why not exploit brilliant color, as the Fauves did? If the motion picture camera could travel around and across the subject, why not mimic such movement on a static canvas, as the Futurists and Cubists did?

In the background, however, lurked a perpetually nagging question: what to paint? Photography had already stolen portraiture and solemn events. Beaumont Newhall, the founding curator of the MOMA's department of photography, wrote that "so-called abstract art is, in large measure, the painter's reaction to the camera." He was amazed that "the simple fact that photography revolutionized painting . . . seems to be generally overlooked by critics and art historians." In the face of films, the still life appeared to be, well . . . too still. Landscapes, urban scenes, and depictions of faraway places seemed none too marketable to an audience that increasingly was turning to tourism to see—and photograph—for itself. An even larger audience traveled only as far as the corner movie house to take exotic voyages. Yet artists continued to paint still lifes, portraits, and landscapes, relying on inventive distortions to convey an image of the avant-garde while also providing a status symbol for the purchaser.

By the time the heart of vanguard painting and sculpture moved to the United States, the most powerful instrument of visual glut was already on the horizon and looming closer every day—television. When the electronic screen pours forth an infinite variety of dynamic visual images, how can a static image engage anyone's attention? What to paint? When some Abstract Expressionists founded an art school, they named it the Subject of the Artist. Clement Greenberg's theoretical foundation for their work stated that the subject matter of painting was painting. Franz Kline explained in 1950 that his slashing black brushstrokes on a white canvas represented "experiences. I don't decide in advance that I'm going to paint a definite experience," he said, "but in the act of painting, it becomes a definite experience for me." Abstract Expressionism,

wrote John I. H. Baur, "was based on the premise that the gesture of the hand, the very action of painting, could embody emotional and psychological impulses more autobiographical than esthetic in nature." In 1960 Ad Reinhardt developed his "ultimate picture," a five-foot-square canvas subdivided into almost identical black squares. He repeated this motif until he died in 1967, all the while explaining that he was trying "to repeat and refine the one unform form again and again. Intensity, consciousness, perfection in art come only after long routine, preparation, and attention." Could such defiant obsessiveness be considered a step forward toward a new, more refined sensibility? Or is it a final cry of despair over the irrelevance of painting in a world of visual glut?

Henry Geldzahler noted in 1968 that artistic innovation in the twentieth century could be seen as "the progressive inclusion of images and techniques previously unassociated with art": the drawings of children and the insane, found objects, dream imagery, automatic writing, the art of the commercial world. "The authority of artists" made it art, he believed. Along with sanctioning new kinds of art, however, Modernist painting and sculpture demanded constantly fresh sensations. Rushed to its consumers by ramified networks of galleries, museums, books, and publications, the new aged with increasing rapidity. When it comes to Postmodernism, the kaleidoscope of art movements shifts with blinding speed. Cobra emerged in 1948 and was gone by 1952; Happenings lasted for seven years around 1960; Op Art appeared in 1960 and lost its vitality five years later. Fed into the pipeline in the 1960s and dead before 1980 were Process Art, Los Angeles Look, Funk Art, Photorealism, Arte Povera, Body Art, and New Realism. Launched after 1970 and gone by 1990 were Bad Painting, Sound Art, Pattern and Decoration, New Image, Fabricated Photography, Graffiti Art, Neoexpressionism, Transavant Garde, East Village Art, and Neo-Geo.

While a number of artists within these movements continued working after they officially became history, such a profusion of eye-catching names is more suggestive of a supermarket display of breakfast foods than of sublime expressions

of the human imagination. Just one token of the decreasing vigor of painting and sculpture during these decades is the careless sobriquet under which it operates—Postmodernism. The definition matches the sponginess of the name. What is it? The art historian W. D. Bannard in 1984 wrote that compared with the "aspiring, authoritarian, self-critical, exclusive" attitudes of Modernism, Postmodernism is "aimless, anarchic, amorphous, self-indulgent. . . . The market is the driving force; the concept is the rationalization for it." He deplored "the inane spectacle of a fat, rich, and powerful establishment system affecting mightily to despise itself as it clambers and wheezes its way up the cozy barricades of radical chic." The sociologist Daniel Bell in 1987 declared that the practitioners of Postmodernism "have substituted pastiche for form and cleverness for creativity."

As early as 1958 the English critic John Berger diagnosed "absolute decadence" after visiting the Venice Biennale; many of the works supposedly showing the best contemporary art produced in the Western world, he wrote, "had one image in common: the image of muck, of garbage." Gallery after gallery featured "forms of decay and the dirt of putrefaction . . . open holes . . . gauze stuffed into their gashes . . . overlaid with cement." Nor could many of these works survive physically more than a few years, Berger believed. "They are not objects that have been made, they are objects that have been used . . . cigarette butts, broken bottles, . . . contraceptives." Soon after writing this despairing review, Berger, one of the most perceptive critics of his age, gave up writing on art entirely.

By 1990 few critics had any kind words for the Venice Biennale. To the *New York Times'* Michael Kimmelman the exhibition was showing its age—almost one hundred years—and the costly American installation of one-line slogans by Jenny Holzer, which had won first prize, was typical of the whole show's exhaustion. The West German entry—"tall vitrines . . . showing children's stools and surrounding a grand marble-walled room"—left at least one jaded gallerygoer wondering whether the "stools" were furniture or feces. *Time's* Robert Hughes, who returned to the exhibition after the opening hoopla on a sunny Sunday morning at the height of the tourist

season, found the grounds deserted and wondered, "Where is the audience for the new?"

Certainly, there is profound irony in the decline of respect and enthusiasm for contemporary art during a period of feverish building of contemporary art museums; of astronomical auction prices for works by the "Old Masters" of contemporary art such as Jasper Johns, Frank Stella, Francis Bacon, David Hockney, Andy Warhol; of flourishing galleries where some of today's art stars are earning princely sums. The unease over where contemporary art was going has spread during the last few decades. Often it takes the form of obituaries for the avant-garde as a whole. "The contrasts between the avant-garde and bourgeoisie continue to loom large in the myth, but they are rapidly being abolished," wrote the anonymous author of an editorial in the *Times Literary Supplement* in 1964. "Most of us have come to regard the avant-garde as a band of hired entertainers, whose function is to astonish a passive and indulgent audience." In the same issue Jonathan Miller argued that the avant-garde was dying because it was based solely on novelty; its tricks were preempted by commercial art, animated cartoons, and films. Judith Adler, a sociologist who studied the status of the avant-garde, reported in 1975 that the line between fine and commercial art had blurred as the consumption of culture had become a popular middle-class activity. She noted that "the contemporary avant-garde, much as the so-called commercial arts, molds itself to the rhythm of a constantly shifting and unpredictable market."

Surveying recent art in 1979, Robert Motherwell speculated that the great tasks of Modernism had been completed: "Younger artists are reduced . . . to adding paragraphs or footnotes of great refinement, rather than whole chapters to the body of modernist art. . . . There does come a moment when one reaches the Pacific, so to speak." He mentioned television commercials, which he considered better than the programs, as representatives of new visual territory. The sculptor Carl Andre admitted in a 1980 interview that he regretted having no vocation for film, which he considered the strongest art of the twentieth century. "The art business is coming to an end," grieved Joe Maresca, who was nevertheless still striving

for a foothold in it in 1989. "We're at the end of the cycle of becoming, and now everything is nostalgia. This generation has no art of its own."

Emily Tremaine, a collector who had devoted more than thirty years to searching out the quality in contemporary art, confessed dismay at what she was seeing in 1973: "There's just a rehash, maybe very well done, but not saying anything very new. . . . I'm too bored to buy them." André Emmerich, who represents artists like Helen Frankenthaler and Sam Francis, believes that the glory days of contemporary art are over. He saw the 1980s as "a relatively sterile period in terms of emerging talent, new visual ideas, great painting being done by new people." The dealer Allan Stone painfully compares the current scene with the 1960s: "Then the art world was art," he said, "now it's a big bore. It's too much like business."

Gloomy as so many art insiders are about painting and sculpture, art in a wider sense is far from dead; many exotic plants are blooming in the jungle of visual glut. André Malraux was perhaps among the first to notice that the visual scene had changed drastically as the twentieth century moved into its second half. In a 1953 bestseller he eloquently described "the museum without walls." This was the vast gallery of art provided by photographs, magazines, books, slides, and other mass media. It made the art of every age and every place available to virtually anyone who cared. The lavish illustrations in his 661-page tome themselves demonstrated how the museum without walls was cutting across the specializations developed by art historians and museums. Side by side, Malraux illustrated how artists in diverse places and times had dealt with their gods, their superstitions, their flora and fauna, their fellow humans.

Such a glut imposed its own aesthetic standards; the photo of a detail, for example, took on meanings and values that might be quite different from those of the original object. This new kind of museum had already altered the role of traditional museums, Malraux argued, and was bound to shake them even further. Rather than embodying the ultimate aesthetic experience, museums had become a last pitiful refuge for art, Malraux believed. In them, all the living functions of art—as prim-

itive ritual, as religion, as portrait, as propaganda, as intimate communication of emotion, as sensuous delight—were systematically drained, as a body is drained of fluids by the embalmer. Dragged out of their original context, the museum's valuable possessions necessarily became part of a new, synthetic scheme that is almost totally intellectual. In Malraux's memorable phrase, museums had become "mausoleums of art." Seen in this light, the proliferation and elaboration of museums during the last half century could be viewed more as adjuncts to tourism or entertainment than as genuine aesthetic experiences. Malraux's concept undermines the very notion that a museum of truly contemporary art could even exist, and the impossible struggle of museums to remain contemporary while sliding inevitably into the past as valuable treasures accumulate in their collections bears this out.

Some years later, near the end of a distinguished career as a dealer in modern art, René Gimpel came to even more radical conclusions. Modernism had become "an empty vessel," he wrote. "The impulse to rebellion has been institutionalized . . . and its experimental forms have become the syntax and semiotics of advertising and haute couture." No longer fulfilling their original functions, the fine arts were becoming degenerate and "should disappear like prehistoric animals." He suggested that painting and sculpture "be ruthlessly excluded from the sanctuary of the arts" and replaced by the art forms typical of our own time—films and television. Films, not pictures or novels, he predicted, would survive into the next thousand years as the great works of art of our time. He considered television comparable with such vital cultural inventions as language, writing, and printing and called videotapes as notable in our time as illuminated books were in the Middle Ages. If Shakespeare were alive today, wrote Gimpel, he would write not for the theater but for television. Gimpel went on to castigate intellectuals as obstacles to wider acceptance of such ideas. He traced their long-standing opposition to new cultural notions as far back as Plato, who did not welcome writing when it began to replace the oral tradition. He found contemporary intellectuals similarly backward and predicted that by the time

they accepted television the medium would probably be out-dated, just as cinema was already in decline when scholars began to study it.

Harold Rosenberg's response to television was typical of what Gimpel deplored. Video turns the home into "a revel of animation in which art can find a place only if it runs, flies, scoots, climbs, wiggles, shakes or twinkles," he wrote in 1967. Among artists, the challenge of television inevitably demanded a response. Some withdrew into total rejection, producing, for example the huge monochrome canvases of the color-field painters. Others attempted elaborate multimedia gadgetry. George Segal at one point tried to create "total environments that incorporate everything, movement, smells, audience partic-ipation," he said in 1974, but "as I worked, I had to reject more and more. There's my contradiction." Nam June Paik, the most daring of "electronic" artists, built increasingly elaborate instal-lations; one 1989 creation featured two hundred TV sets and a computer to coordinate the images with earsplitting music. Fittingly titled *Fin de Siècle*, the work was shown at the Whitney Museum. "Video installations are at the heart of video's in-creasing presence and vitality in the art world," wrote Andy Grundberg in the *New York Times*, while artist-produced video-tapes remain on the periphery.

The reason for such an anomaly is that the Art Biz de-mands objects with a market value. "The art market requires scarcity," wrote Charles R. Simpson in 1981, "and it achieves this through a restriction of the artist to essentially artisan techniques." The more film, video, and printing contribute to visual glut, the more emphasis does the Art Biz place upon the unique creation of the artist. When the artist originates only a sketch and hires others to build the actual work, as frequently happens, the artificiality of the system becomes glaringly ob-vious. When the Guggenheim Museum bought an array of Minimalist sculptures from Count Giuseppe Panza di Biumo in 1990, an absurd wrangle broke out between the artists, who had agreed to sell sketches only to the count, and the museum, which intended to have the sketches built into full-size works. The artists insisted that unless the museum paid them to

supervise construction and used only the workshops they se-
lected, they would not allow their names to be associated with
the finished works and would denounce them as fakes. This is
like an architect selling plans and then insisting on selecting
the contractor and on being paid for supervising construction
of the building.

Meanwhile, on the shoreline between the surf of convoluted
theories spawned by the Art Biz and the endless dunes of visual
glut, an extraordinarily rich array of art is flourishing. It en-
compasses the work of tens of thousands of artists, the vast
majority of all artists in America, who steadily produce paint-
ings and sculptures for sale through cooperatives and local
galleries. These artists pursue every imaginable style and find
a multitude of buyers, not status-hungry collectors but individ-
uals who enjoy the art at home or in their offices.

The throng of second-tier artists includes a great number
who are extremely well trained and form a vibrant community
in every major city. These are not Aunt Tillies toying with
watercolors or painters on velvet but thoroughgoing profession-
als, graduates of leading art schools, winners of medals and
prizes, teachers of other artists. They are regularly exhibited in
respectable galleries. Some are young artists hoping for a break
into the big time, but most of them happily pursue their vision
and enjoy comfortable—even ample—incomes built on a re-
gional reputation.

This world of art thrives without ever being noticed in the
four New York zip codes where the Art Biz lodges. Its members
will rarely be reviewed in the art trade press, nor will their
work enter the collections of major museums. Occasionally an
art history graduate student desperate for a thesis topic will
"discover" such an artist or regional group, and the bulky
dissertation will languish in the stacks of a university library
awaiting a stray reader or two. Occasionally, too, a local mu-
seum will organize an exhibition of their work, although cura-
tors increasingly shy away from independent judgments and

prefer traveling exhibitions packaged far away by more prestigious institutions.

This teeming world of art occupies no place in the Art Biz because the work it produces is not at the cutting edge. Some of it is just beautiful, a descriptive almost as lethal as "derivative." Some elaborates on a style that once engaged the Art Biz—Abstract Expressionism, for example—but is now passé. Some does not fit into the developmental scheme by which art is supposed to evolve; it does not represent what critics and art historians consider an advance. In many instances the artist simply is not willing to tread the required steps to stardom: the move to Los Angeles, Chicago, and eventually New York; the sacrifice of time in pursuit of a more influential gallery and the inevitable pain of rejection; the need to change one's statement or style in order to gain attention; the pressure to produce more of what sells and less of what does not; the necessity for assistants to help turn out enough work for the next show; the wooing of collectors, critics, and curators.

Visual glut and new technology pose little threat to this world. Its artists crave not fame and fortune but rather the joy of making a good life by exercising their talent. Its galleries enjoy local reputations and steady sales. Its patrons do not lust for visual status symbols but rather desire an affordable work meaningful to them. This is a viable world, happy in its insulation from the new technology that is so clearly crowding the way the Art Biz operates.

To maintain values, to foster the kinds of art that collectors, investors, and speculators want, the Art Biz must squeeze out all the other kinds of art that modern technology can—and does—produce in great quantity. Such a synthetic system is immoral as well as untenable. It flies in the face of history, which shows that artists have always been in the vanguard in exploring new techniques, whether oil paints during the Renaissance or lithography, paint in tubes, and aniline dyes during the nineteenth century. It deprives artists of the chance to gain recognition for real experiments with video art, computer animation, and films. Instead, the Art Biz rewards sterile "investigations" of yet another slice of past art and drastic treatments

of the same static images. Because so many museums are dominated by collector-trustees, the Art Biz condemns the professionals at museums of contemporary art to demeaning reruns through the past and desperate searches for yet another artist or movement able to squeeze a paltry drop of innovation or insight out of a basically moribund tradition. Using dikes built of meaningless jargon cemented with shameless snobbery, curators, critics, and art journalists are desperately defending the sacred portals of the rare art tradition against the flood of exciting, innovative art that technology fosters.

Despite its defects, the Art Biz remains in many ways exciting, interesting, inventive, and even lovable. It includes many astute individuals who are honorable and genuinely know and esteem art. But, as the testimony of the many participants and observers quoted in this book—and my own extensive research—indicate, it has spiraled out of control into a terrain so tainted that many insiders recoil. It now dwells in a stratosphere where concerns about money are throttling the very creativeness it wants to foster. As a nourishment to the human spirit, as an expression of the best in our civilization, art is too marvelous to be abandoned to the high fliers, to the investors, to the speculators, to the sordid manipulators who would envelop it in their coarse embrace.

NOTES

AAA refers to Archives of American Art, Smithsonian Institution. Eli Broad Archive is located in Los Angeles, California. Unless another interviewer is cited, all interviews were conducted by the author. All quotations from interviews are cited after the first use in each chapter. Subsequent quotations from the same source are uncited, unless the source's name is not in the text.

CHAPTER 1: INTRODUCTION

Page 2. **"full of light and joy and goodness"**: James Danziger, "Miller Time: The Rise of a Gallery with the Long View," *New York*, Jan. 11, 1988, 37.

Page 5. **The private dealer Jeffrey Deitch**: Interview with Jeffrey Deitch, May 18, 1989.

Page 5. **Richard Koshalek**: Interview with Richard Koshalek, July 19, 1990.

Page 5. **a biography of this artist**: Alice G. Marquis, *Marcel Duchamp: Eros c'est la vie* (Troy, NY: Whitston, 1980).

Page 9. **a biography of Alfred H. Barr, Jr.**: Alice Goldfarb Marquis, *Alfred H. Barr, Jr.: Missionary for the Modern* (Chicago: Contemporary Books, 1989).

Page 11. **the National Endowment for the Arts**: William D. Grampp, *Pricing the Priceless: Art, Artists and Economics* (New York: Basic, 1989), 210.

Page 11. **Michael Straight**: Michael Straight, *Twigs for an Eagle's Nest* (New York: Devon, 1979), 14–15.

Page 11. **Nor did Karl Meyer**: Karl E. Meyer, *The Art Museum: Power, Money, Ethics* (New York: William Morrow, 1979), 74–75.

Page 12. **"It isn't as though a whistle blew . . ."**: Interview with Paul Brach, May 3, 1989.

Page 13. **By 1953 Alfred Barr could write**: Alfred H. Barr, Jr. to Dwight Macdonald, Dec. 2, 1953, Roll 2180, Barr Archive, AAA.

Page 13. **At the Whitney Museum**: Francis V. O'Connor, *The New Deal Art Projects: An Anthology of Memoirs* (Washington, D.C.: Smithsonian Institution, 1972), 112.

Page 13. **Goldberg was launched**: Marvin Elkoff in Milton C. Albrecht, James H. Barnett, and Mason Griff, *The Sociology of Art and Literature* (New York: Praeger, 1970), 316–18.

Page 13. **"Everyone seemed to know everyone else"**: John Bernard Myers, *Tracking the Marvelous* (New York: Random House, 1983), 238.

Page 13. **the first major show of Abstract Expressionists**: Irving Sandler, *The New York School* (New York: Harper & Row, 1978), 39–41.

Page 14. **Prices were still "reprehensibly cheap"**: Transcript of Samuel Kootz interview by Dorothy Seckler, Apr. 13, 1964, 11-12, AAA.

Page 14. **The price rise really steepened**: Annette Cox, *Art-as-Politics: The Abstract Expressionist Avant-Garde and Society* (Ann Arbor, MI: UMI Research, 1982), 159-60.

Page 14. **It was then that *Fortune* took note**: Eric Hodgins and Parker Lesley, "The Great International Art Market—II," *Fortune*, Jan. 1956, 122.

Page 14. **For the first time in auction history**: Nicholas Faith, *Sold: The Rise and Fall of the House of Sotheby* (New York: Macmillan, 1985), 3-4.

Page 14. **When the decade ended, an investment counselor**: Richard Rush, *Art as an Investment* (Englewood Cliffs, NJ: Prentice-Hall, 1961), 386.

Page 15. **armed Pinkerton guards**: Dore Ashton, *The New York School* (New York: Viking, 1972), 229-30.

Page 16. **"The avant-garde is in the public domain"**: Daniel Bell, *The Cultural Contradictions of Capitalism* (New York: Basic, 1976), 136.

Page 16. **"art is being normalized . . ."**: Quoted in Diana Crane, *The Transformation of the Avant-Garde: The New York Art World, 1940-1985* (Chicago: University of Chicago, 1987), 44-45.

Page 16. **The collector Ben Heller**: Ben Heller to Thomas B. Hess (copy to John Canaday), Feb. 2, 1965, Roll NYJC 5, John Canaday Papers, AAA.

Page 17. **Few exhibitions of a new artist**: John Russell Taylor and Brian Brooke, *The Art Dealers* (New York: Scribner's, 1969), 111.

Page 17. **An article in the serious *Art Journal***: Joseph Konzal, "Who Are the Tastemakers?" *Art Journal*, Spring 1969, 156.

Page 17. **Sherman Lee, the longtime director**: Sherman E. Lee, "Financial Perspicacity," *Art in America*, July 1970, 15.

Page 17. ***New York Times* art critic John Canaday**: John Canaday, *Culture Gulch: Notes on Art and Its Public in the 1960s* (New York: Farrar, Straus & Giroux, 1969), 156.

Page 18. **the art world collapsed in 1973**: Barbara Rose, "Profit Without Honor," *New York*, Nov. 5, 1973, 80.

Page 18. **The critic Harold Rosenberg**: Harold Rosenberg, "The Art World: Adding Up," *New Yorker*, Aug. 20, 1973, 76.

Page 18. **Calvin Tomkins noted widespread nostalgia**: Calvin Tomkins, "Profiles: Henry Geldzahler," *New Yorker*, Nov. 6, 1971, 59.

Page 18. **That the market increasingly was driving**: Charles R. Simpson, *SoHo: The Artist in the City* (Chicago: University of Chicago, 1981), 15.

Page 18. **George L. K. Morris, who had pioneered**: George L. K. Morris, "Then and Now," *Partisan Review* 4 (1975): 555.

Page 19. **In book form *The Painted Word***: Tom Wolfe, *The Painted Word* (New York: Farrar, Straus & Giroux, 1975).

Page 19. **"Art Stars for the 80s"**: Carter Ratcliff, "Art Stars for the 80s," *Saturday Review*, Feb. 1981, 12, 13, 20.

Page 19. **In a 1987 article in *Vanity Fair***: Anthony Haden-Guest, "The Art of Musical Chairs," *Vanity Fair*, Sept. 1987, 60.

Page 19. **an editorial in the *New York Times* suggested**: "Starving for Art," *New York Times*, May 10, 1989.

Page 20. **When prices reached yet another crescendo**: Robert Hughes, "Sold!" *Time*, Nov. 27, 1989, 65.

Page 20. **After the Guggenheim Museum waded**: Souren Melikian, "End of Round One," *Art & Auction*, July–Aug. 1990, 84-86.

Page 20. **Barbara Rose noted in 1969**: Barbara Rose, "The Politics of Art—III," *Artforum*, May 1969, 49.

Page 20. **Geraldine Keen, a journalist who published**: Geraldine Keen, *Money and Art: a Study Based on the Times-Sotheby Index* (New York: G. B. Putnam's Sons, 1971), 27.

Page 20. **Displayed in galleries decked out**: Waldemar Januszczak, "Art in the

Godless World," *New Statesman*, Aug. 14, 1987, 22, 24.

Page 21. **In California alone, some fifty thousand**: James Corcoran in Lee Evan Caplin, ed., *The Business of Art* (Englewood Cliffs, NJ: Prentice-Hall, 1982), 274.

Page 22. **they are often treated to a woolly mash**: It seems unfair to point out just one among hundreds of perpetrators of such pompous piffle, so the source remains uncited.

CHAPTER 2: ARTISTS: A HALL OF MIRRORS

Page 24. **"the wildness and virility . . ."**: Deborah Solomon, *Jackson Pollock* (New York: Simon & Schuster, 1987), 21–22.

Page 24. **"a rotten rebel from Russia"**: Annette Cox, *Art-as-Politics: The Abstract Expressionist Avant-Garde and Society,* Ann Arbor, MI: UMI Research), 85.

Page 25. **as though he were a disabled child**: Jeffrey Potter, *To a Violent Grave: An Oral Biography of Jackson Pollock* (New York: Putnam, 1985), 32–33.

Page 25. *How New York Stole . . .*: Serge Guilbaut, *How New York Stole the Idea of Modern Art* (Chicago: University of Chicago, 1983).

Page 26. **a group portrait of the Irascibles**: Irving Sandler, *The Triumph of American Painting* (New York: Praeger, 1970), 213.

Page 27. **the most famous member of it**: Solomon, *Jackson Pollock,* 201–3.

Page 27. **As early as 1945 the critic Clement Greenberg**: Dore Ashton, *The New York School* (New York: Viking, 1972), 155.

Page 27. **His talent was "volcanic, lavish, explosive"**: Stephen C. Foster, *The Critics of Abstract Expressionism* (Ann Arbor, MI: UMI Research Press, 1980), 39.

Page 27. **The more traditional critics either ignored**: Solomon, *Jackson Pollock,* 154.

Page 28. **The photographs presented an antiheroic figure**: "Jackson Pollock: Is He America's Greatest Living Painter?" *Life,* Aug. 8, 1949, 42–44; Solomon, *Jackson Pollock,* 192–93; Cox, *Art-as-Politics,* 91–92.

Page 28. **The cowboy associated with Marlboro cigarettes**: Stephen Fox, *The Mirror Makers* (New York: William Morrow, 1984), 223.

Page 29. **"The making of the illusions . . ."**: Daniel J. Boorstin, *The Image, or What Happened to the American Dream* (New York: Atheneum, 1962), 5, 47–48.

Page 29. **To women his favorite salutation**: Potter, *To a Violent Grave,* 122–23.

Page 29. **"the plastic qualities of American Indian art"**: Ellen H. Johnson, *American Artists on Art: From 1940 to 1980* (New York: Harper & Row [Icon], 1982), 2.

Page 29. **"references to American Indian art and calligraphy"**: Johnson, *American Artists on Art,* 2.

Page 29. **In 1947 the critic Clement Greenberg**: Solomon, *Jackson Pollock,* 170–71.

Page 30. **"I just don't think that was the scene"**: Potter, *To a Violent Grave,* 77–78.

Page 30. **Jackson would gruffly interrupt**: Solomon, *Jackson Pollock,* 176.

Page 30. **Robert Motherwell remarked**: Solomon, *Jackson Pollock,* 146.

Page 30. **"He just wanted it more"**: Solomon, *Jackson Pollock,* 198.

Page 31. **"Sir, no chaos . . ."**: Solomon, *Jackson Pollock,* 204–5.

Page 31. **A young freelance photographer, Hans Namuth**: Cox, *Art-as-Politics,* 89.

Page 31. **by gulping down a tumblerful of whiskey**: Solomon, *Jackson Pollock,* 213.

Page 31. **the alienated, misunderstood artist**: Steven Naifeh and Gregory White Smith, *Jackson Pollock: An American Saga* (New York: Clarkson N. Potter, 1990), 621.

Page 32. **ignominiously sent upstairs to bed**: Potter, *To a Violent Grave,* 182.

Page 32. **Will Wright describes the repetitive structure**: Will Wright, *Six-guns and Society: A Structural Study of the Western* (Berkeley, CA: University of California, 1975), 48–49.

Page 32. **Mark Rothko described him**: Solomon, *Jackson Pollock,* 176.

Page 33. **"In a fervor of subtraction"**: Harold Rosenberg, *The Anxious Object: Art Today and Its Audience* (New York: Collier, 1973), 41.

Page 34. **"Breathing or moving one's arms and legs . . ."**: Harold Rosenberg, *Art on the Edge: Creators and Situations* (New York: Macmillan, 1975), 247–48.

Page 34. **In New York during the early 1960s**: Bernard Rosenberg and Norris Fliegel, *The Vanguard Artist* (New York: Arno, 1979), 181.

Page 35. **to wrest a livelihood from making art**: John Russell Taylor and Brian Brooke, *The Art Dealers* (New York: Scribner's, 1969), 262; William D. Grampp, *Pricing the Priceless: Art, Artists, and Economics* (New York: Basic, 1989), 41; Charles R. Simpson, *SoHo: The Artist in the City* (Chicago: University of Chicago, 1981), 31, 58; Carey Lovelace, "Painting for Dollars," *Harper's*, July 1983, 68–69; John Henry Merryman and Albert E. Elsen, *Law, Ethics, and the Visual Arts*, vol. 1 (Philadelphia: University of Pennsylvania, 1987), 337; Richard Marshall, *50 New York Artists* (San Francisco: Chronicle Books, 1986), 7.

Page 35. **to succeed in the Darwinian struggles**: Robert Hughes in Martin S. Ackerman, *Smart Money and Art* (Barrytown, NY: Station Hill, 1986), 115.

Page 35. **"They resent the artists . . ."**: Interview with Joe Maresca, May 4, 1989. All Maresca quotations in this chapter are from this interview.

Page 35. **During the late 1950s artists began to occupy**: Simpson, *SoHo*, 2.

Page 36. **When the city legalized SoHo artists' lofts**: Simpson, *SoHo*, 233–34.

Page 38. **In a brief self-interview**: Mark Kostabi, *Sadness Because the Video Rental Store Was Closed* (New York: Abbeville, 1988), 171–72.

Page 39. **"mere artifacts of a conceptual performance,"**: Interview with Mark Kostabi, Sept. 20, 1989. All Kostabi quotations in this chapter are from this interview.

Page 41. **Barnes was instantly smitten**: Interview with Molly Barnes, Sept. 13, 1989.

Page 43. **"art and artists have no place in American life . . ."**: Steven W. Naifeh, *Culture Making: Money, Success, and the New York Art World* (Princeton, NJ: Princeton University History Department, 1976), 55–57.

Page 43. **"The unfriendliness of society . . ."**: Lee Seldes, *The Legacy of Mark Rothko* (New York: Holt, Rinehart & Winston, 1978), 25.

Page 43. **"That their paintings might be exhibited . . ."**: Diana Crane, *The Transformation of the Avant-Garde: The New York Art World* (Chicago: University of Chicago, 1987), 25–26.

Page 43. **For a few golden years**: William D. Barrett, "The Painters' Club," *Commentary*, Jan. 1982, 42–43; Irving Sandler, *The Triumph of American Painting* (New York: Praeger, 1970), 213–14, 216.

Page 44. **Jack Tworkov was amazed**: Stewart Buettner, *American Art Theory 1945–1970* (Ann Arbor, MI: UMI Research, 1981), 62.

Page 44. **gallery manager John Myers recalled**: John Bernard Myers, *Tracking the Marvelous* (New York: Random House, 1983), 106.

Page 44. **The origins of the artists who formed The Club**: Irving Sandler, *The New York School* (New York: Harper & Row, 1978), 322–25.

Page 44. **The backgrounds of artists shown**: Whitney Museum of Art, *1981 Biennial Exhibition*, "Artists' Biographies," 121–59; Whitney Museum of Art, *1989 Biennial Exhibition*, artists' biographies are scattered throughout.

Page 46. **First American Artists' Congress in 1936**: Sandler, *Triumph of American Painting*, 8.

Page 46. **But Harold Rosenberg termed the attempt**: Transcript of Harold Rosenberg interview by Paul Cummings, Feb. 7, 1971, 94–95, AAA.

Page 47. **Jackson Pollock was deferred**: Potter, *To a Violent Grave*, 63, 95.

Page 47. **Barnett Newman . . . refused induction**: Cox, *Art-as-Politics*, 72–73.

Page 47. **Barr would often cite these early acquisitions**: Alfred H. Barr, Jr., to Thomas B. Hess, May 23, 1961, Roll 2189, Barr Archive, AAA.

Page 48. **F. T. Marinetti had proclaimed**: Umbro Apollonio, ed., *Futurist Manifestos* (New York: Viking, 1970), 20, 23.

Page 49. **Surrealism meant "complete insubordination"**: André Breton, *Manifestoes of Surrealism* (Ann Arbor, MI: University of Michigan, 1969), 125.

Page 50. **man's primitive, atavistic nature**: Cox, *Art-as-Politics*, 44.

Page 50. **efforts to challenge Breton**: Robert C. Hobbs and Gail Levin, *Abstract Expressionism: The Formative Years* (Ithaca, NY: Cornell University, 1978), 18; Cox, *Art-as-Politics*, 43.

Page 50. **That they presented a philosophy**: Buettner, *American Art Theory 1945-1970*, 14.

Page 50. **All that changed in 1943**: Seldes, *Legacy of Mark Rothko*, 18-19.

Page 51. **"The Public Be Damned"**: Seldes, *Legacy of Mark Rothko*, 19-20.

Page 51. **Other New York artists marveled**: Barbaralee Diamonstein, *Inside New York's Art World* (New York: Rizzoli, 1979), 375-77.

Page 52. **"I had to start from scratch . . ."**: Emile De Antonio and Mitch Tuchman, *Painters Painting* (New York: Abbeville, 1984), 42-43.

Page 52. **"It was worse than that"**: De Antonio and Tuchman, *Painters Painting*, 43-44.

Page 53. **Robert Rauschenberg . . . Joseph Kosuth**: Jeanne Siegel, *Artwords: Discourse on the 60s and 70s* (Ann Arbor, MI: UMI Research Press, 1985), 153-55, 229.

Page 53. **A 1982 work by the German artist Joseph Beuys**: Judd Tully, "Fat Chance," *Art & Auction*, May 1989, 48, 50.

Page 54. **"which are absolutely beautiful to watch"**: Laura de Coppet and Alan Jones, *The Art Dealers* (New York: Clarkson N. Potter, 1984), 215-16.

Page 55. **the dealer Ivan Karp observed**: Transcript of Ivan Karp interview by Paul Cummings, Mar. 12, 1969, 57-58, AAA.

Page 55. **Henry Geldzahler recalled**: Henry Geldzahler, *New York Painting and Sculpture: 1940-1970* (New York: Dutton, 1969), 28.

Page 55. **Frank Stella insisted in 1960**: Sandler, *New York School*, 284.

Page 56. **New York Times critic Michael Brenson**: Michael Brenson, "Is Neo-Expressionism an Idea Whose Time Has Passed?" *New York Times*, Jan. 5, 1986.

Page 56. **"Originality is widely taken to be a synonym . . ."**: Rosenberg and Fliegel, *Vanguard Artists*, 46.

Page 56. **The quest . . . [end of paragraph]**: Simpson, *SoHo*, 77-78, 80.

Page 57. **Asked by one journalist**: Peter Plagens, "Zip: Another Magazine Article on Barnett Newman," *Art in America*, Nov. 1971, 66.

Page 57. **Newman issued a ringing indictment**: Edward Alden Jewell, "New Artists' Group Opens First Show," *New York Times*, Jan. 19, 1943.

Page 57. **In 1945, Mark Rothko wrote**: Mark Rothko to Barnett Newman, July 31, 1945, Roll 3481, AAA.

Page 57. **In a catalog essay for a 1946 exhibition**: Barnett Newman, "Northwest Coast Indian Painting," *Catalog of Exhibition at Betty Parsons Gallery*, Sept. 30-Oct. 19, 1946, unpaged.

Page 58. **"I do *not* come with a body of beliefs . . ."**: Harold Rosenberg, *Barnett Newman* (New York: Abrams, 1977), 56.

Page 58. **In explaining his own work**: Barnett Newman, "Four Paintings," *Catalog of Exhibition at Dia Art Foundation*, 1986, unpaged.

Page 58. **Newman's titles**: Plagens, "Zip," 66.

Page 58. **Despite the objections even of friends**: Rosenberg, *Barnett Newman*, 73.

Page 58. **Newman had "an authentic flair . . ."**: John Bernard Myers, *Tracking the Marvelous* (New York: Random House, 1983), 93.

Page 58. **"the hard work shouldn't show . . ."**: Jeanne Siegel, "Around Barnett Newman," *Art News*, Oct. 1971, 62.

Page 58. **"History has been deprived of . . ."**: Thomas B. Hess, *Barnett Newman* (New York: Walker, 1969), 16.

Page 59. **"I learned about the nature of plasticity . . ."**: Hess, *Barnett Newman*, 14-15.

Page 59. **"On the Need for Political Action . . ."**: Rosenberg, *Barnett Newman*, 229.

Page 60. **"sullen-minded materialists . . ."**: Cox, *Art-as-Politics*, 72.

Page 60. **Helen Carlson expressed her bafflement**: Helen Carlson, "Diversity in Style and Media," *New York Sun*, Nov. 4, 1949.

Page 60. **"The rectangle of the canvas . . ."**: Hess, *Barnett Newman*, 44, 49.

Page 60. **Clement Greenberg, who, like Hess**: Clement Greenberg, *Barnett Newman: First Retrospective Exhibition*, Bennington College, May 4-24, 1958, unpaged.

Page 60. **At the Cedar Tavern**: Hess, *Barnett Newman*, 49.

Page 60. **His first one-man exhibition**: Rosenberg, *Barnett Newman*, 59.

Page 61. **He described the artist**: Sandler, *New York School*, 13.

Page 61. **seven lean years**: Harold Rosenberg, "Barnett Newman," *Vogue*, Feb. 1, 1963, 166.

Page 61. **"For it is only the pure idea . . ."**: Ashton, *New York School*, 185.

Page 61. **Aesthetics, Newman told a forum**: Rosenberg, *Barnett Newman*, 43.

Page 62. **Harold Rosenberg continued to marvel**: Rosenberg, *Barnett Newman*, 237, and "Barnett Newman," *Vogue*, 166.

Page 62. **Only the "abominable No man"**: Hilton Kramer, "Month in Review," *Arts*, April 1959, 45.

Page 62. **Yet Meyer Schapiro, the academic guru**: Hess, *Barnett Newman*, 65.

Page 62. **Heller, too, gradually succumbed**: Transcript of Ben Heller interview by Paul Cummings, Jan. 8, 1973, 6-7, AAA.

Page 63. **Interviewed on film by Emile De Antonio**: De Antonio and Tuchman, *Painters Painting*, 29-30, 71-72.

Page 63. **"De was the first person . . ."**: Andy Warhol and Pat Hackett, *Popism: The Warhol '60s* (New York: Harper & Row, 1980), 3-4.

Page 63. **As an agent, De Antonio**: Tina S. Fredericks in Jesse Kornbluth, *Pre-Pop Warhol* (New York: Panache Press at Random House, 1988), 17-18.

Page 64. **So Warhol listened intently**: Warhol and Hackett, *Popism*, 4, 8-9.

Page 64. **De Antonio arranged**: Kornbluth, *Pre-Pop Warhol*, 18.

Page 64. **"the self, terrible and constant . . ."**: Rosenberg, *Barnett Newman*, 21.

Page 64. **Jasper Johns was one of many**: Leo Steinberg, "Jasper Johns: The First Seven Years," *Metro*, 1962, quoted in Patrick S. Smith, *Andy Warhol's Art and Films* (Ann Arbor, MI: UMI Research, 1981), 38-43.

Page 65. **Larry Rivers attracted**: Myers, *Tracking the Marvelous*, 120-21.

Page 65. **"the self-advertising . . ."**: Robert Wraight, *The Art Game* (New York: Simon & Schuster, 1966), 190.

Page 66. **"What hobbies do you have? . . ."**: "Andy Warhol," transcript of David Bailey's ATV documentary (London: Bailey Litchfield/Mathews Miller Dunbar, 1979), unpaged, MOMA Archive.

Page 66. **As a youngster, Warhol once confided**: Jesse Kornbluth, "Andy," *New York*, Mar. 9, 1987, 43.

Page 66. **one of the most perceptive books**: Patrick S. Smith, *Andy Warhol's Art and Films* (Ann Arbor, MI: UMI Research, 1981), 167-68.

Page 67. **"a survey of art and film criticism. . ."**: Smith, *Andy Warhol's Art and Films*, 109.

Page 67. *Thirteen Most Wanted Men*: Smith, *Andy Warhol's Art and Films*, 92-93.

Page 69. **"Frankly, I never understood . . ."**: Jeanne Siegel, "Around Barnett Newman," *Art News*, Oct. 1971, 43.

Page 70. **To Willi Bongard, a German journalist**: Willi Bongard, *Kunst und Kommerz: Zwischen Passion und Spekulation* (Oldenburg, West Germany: Gerhard Stalling, 1967), 84-85; quoted in Rosenberg and Fliegel, *Vanguard Artist*, 145.

Page 70. **Warhol gleefully observed**: Warhol and Hackett, *Popism*, 162.

Page 71. **"everyone was part of the same culture . . ."**: Warhol and Hackett, *Popism*, 220-21.

Page 71. **John Cage**: Calvin Tomkins, *The Bride and the Bachelors: Five Masters of the Avant-Garde* (New York: Viking, 1968), 6.

Page 71. **Claes Oldenburg**: Siegel, *Artwords*, 187.

Page 72. **Robert Miller**: Interview with Robert Miller, Sept. 16, 1989.

Page 72. **Indeed, the bohemian artist**: Marilyn R. Brown, *Gypsies and Other Bohemians: The Myth of the Artist in 19th Century France* (Ann Arbor, MI: UMI Research, 1985), 6–10; see also Jerrold Seigel, *Bohemian Paris* (New York: Viking Penguin, 1986), 31–58.

Page 72. **Thomas B. Hess was crying**: Fred McDarrah, *The Artist's World in Pictures* (New York: Dutton, 1961), 10.

Page 72. **A few years later, two sociologists**: Rosenberg and Fliegel, *Vanguard Artist*, 9.

Page 73. **While artists cultivate**: Judith Adler, "Innovative Art and Obsolescent Artists," *Social Research*, Summer 1975, 364–65.

Page 73. **Yet many . . . remained dissatisfied**: Naifeh, *Culture Making*, 119, 121.

Page 73. **In 1970 Harold Rosenberg looked back**: Transcript of Harold Rosenberg interview by Paul Cummings, Dec. 18, 1970, 75–76, AAA.

Page 73. **Barnett Newman deplored**: Rosenberg, *Barnett Newman*, 59.

Page 74. **Newman's contemporary, Adolph Gottlieb**: Siegel, *Artwords*, 35.

Page 74. **wrote one resident sociologist**: Simpson, *SoHo*, 67–68, 92–93.

Page 74. **William D. Barrett as an editor**: William D. Barrett, "The Painters' Club," *Commentary*, Jan. 1982, 43.

Page 74. **Marxist art historian Suzi Gablik**: Suzi Gablik, "The Art Job, or How the Avant-Garde Sold Out," *Art in America*, April 1980, 9.

Page 76. **a boutique on East Eighth Street**: Anthony Haden-Guest, "Burning Out," *Vanity Fair*, Nov. 1988, 185.

Page 77. **hiding in the back room**: Haden-Guest, "Burning Out," 186.

Page 77. **The artist posed defiantly**: Cathleen McGuigan, "New Art, New Money: The Marketing of an American Artist," *New York Times Magazine*, Feb. 10, 1985, cover, 23, 26.

Page 78. **his obvious addictions and illness**: Haden-Guest, "Burning Out," 188–90.

Page 78. **his high-school friend Zoe Leonard**: Phoebe Hoban, "Samo Is Dead," *New York*, Sept. 26, 1988, 40.

Page 78. **It took almost three months . . . [end of paragraph]**: Constance L. Hays, "Friends Recall Young Artist with Music and Verse," *New York Times*, Nov. 7, 1988; Haden-Guest, "Burning Out," 198; Ronny Cohen, "Art Is Priceless," *Art & Auction*, June 1989, 171; Nicholas Powell, "Fashion Victim," *Art & Auction*, Nov. 1989, 75.

Page 79. **"Money is very important . . ."**: Alan Solomon, *New York: The New Art Scene* (New York: Holt, Rinehart & Winston, 1967), 67.

Page 80. **A passionate embrace of the enemy**: Adler, "Innovative Art and Obsolescent Artists," 363–64.

Page 80. **"Groups self-label . . ."**: Barbara Rosenblum in Judith H. Balfe and Margaret Jane Wyszomirski, eds., *Art, Ideology, and Politics* (New York: Praeger, 1985), 70.

Page 81. **Packed into a labeled cubby hole . . .**: Dore Ashton, *American Art Since 1945* (New York: Oxford University, 1982), 97.

Page 81. **"The moment you label something . . ."**: Warhol and Hackett, *Popism*, 39–40.

Page 81. **By the 1980s, whole firms**: Interview with Paul Sarno, May 6, 1989.

Page 81. **a French sociologist of art**: Remi Clignet, *The Structure of Artistic Revolutions* (Philadelphia: University of Pennsylvania, 1985), 140.

Page 81. **Eli Broad, a Los Angeles collector**: Interview with Eli Broad, June 29, 1989.

Page 82. **Jules Olitski also believes**: Jules Olitski, "Then and Now," *Partisan Review* 4 (1975): 560–61.

Page 82. **Anthropologist Lewis Hyde poignantly describes**: Lewis Hyde, *The Gift: Imagination and the Erotic Life of Property* (New York: Vintage, 1983), 273, 276.

Page 83. **"A very special artist . . ."**: Theodore F. Wolff, "Exuberance Under Control," *Christian Science Monitor*, Dec. 16, 1985, 25.

Page 83. **The glossy red folder Weber has assembled**: *Idelle Weber*, catalog of exhibition April 3–28, 1984, Siegel Contemporary Art, New York; *Idelle Weber*, catalog of exhibition May 5–June 25, 1986, Arts Club of Chicago; *Idelle Weber*, catalog of exhibition Oct. 7–31, 1987, Ruth Siegel Ltd.; *Idelle Weber Gardens*, catalog of exhibition Feb. 11–Apr. 3, 1988, Squibb Gallery, Princeton, NJ.

Page 83. **"I don't have the stomach for it"**: Interview with Idelle Weber, May 5, 1989. All Weber quotations in this chapter are from this interview.

Page 84. **"Going up to 57th Street . . ."**: James Rosenquist in Lee Evan Caplin, ed., *The Business of Art* (Englewood Cliffs, NJ: Prentice-Hall, 1982), 25.

Page 84. **He had arrived . . . [end of paragraph]**: James Rosenquist in Caplin, ed., *Business of Art*, 23–24; Jacques Cattell Press, ed., *Who's Who in American Art* (New York: R. R. Bowker, 1978), 599–600.

Page 84. **The dealer Ivan Karp archly described**: Ivan Karp in Caplin, *Business of Art*, 268.

Page 85. **Advice in the tradition of Fuller Brush**: John Dowell in Caplin, *Business of Art*, 190, 192.

Page 85. **a career adviser such as Walter Wickiser**: Interview with Walter Wickiser, Sept. 18, 1989. All Wickiser quotations in this chapter are from this interview.

Page 88. **"The work of an artist . . ."**: Interview with Robert Kaupelis, Sept. 21, 1989. All Kaupelis quotations in this chapter are from this interview.

Page 90. **"to make ends meet . . ."**: Interview with Pia Stern, Dec. 25, 1989. All Stern quotations in this chapter are from this interview.

Page 90. **These are crassly described**: Ackerman, *Smart Money and Art*, 116–17.

Page 90. **wrote Stuart Greenspan**: Stuart Greenspan, "Bright Lights, Big Bucks," *Art & Auction*, May 1989, 221.

Page 91. **"The element of outrage . . ."**: John Russell Taylor and Brian Brooke, *The Art Dealers* (New York: John Scribner's Sons, 1969), 261.

Page 91. **"to dress more like an artist"**: Rosenblum, 67.

Page 91. **When Robert Rauschenberg**: Tom Toms, "Sketchbook: On the Prowl," *Art & Antiques*, Summer 1989, 26.

Page 91. **physically attacked a collector**: This incident is detailed in Chapter 4.

Page 91. **"Business is the step . . ."**: Quoted by Benjamin H. D. Buchloh in Kynaston McShine, ed., *Andy Warhol: A Retrospective* (New York: Museum of Modern Art, 1989), 40.

Chapter 3: Arbiters: Kitsch for Beginners

Page 92. **"a quality of Jewishness is present . . ."**: John O'Brian, ed., *Clement Greenberg: The Collected Essays and Criticism*, vol. 1 (Chicago: University of Chicago, 1986), 177.

Page 92. **The Talmud, he wrote**: O'Brian, *Clement Greenberg*, vol. 1, 157.

Page 93. **kitsch "is deceptive"**: Clement Greenberg, *Art and Culture* (Boston: Beacon, 1961), 10–12.

Page 94. **Greenberg began to write frequently on art**: Alexander Bloom, *Prodigal Sons: The New York Intellectuals and Their World* (New York: Oxford University Press, 1986), 159.

Page 94. **Industrial capitalism rampant is the cause**: Greenberg, *Art and Culture*, 12.

Page 95. **"Modernism," he would write**: Quoted in Hilton Kramer, "The Idea of Tradition in American Art Criticism," *American Scholar*, Summer 1987, 324.

Page 95. **Pollock "submits to a habit . . ."**: O'Brian, *Clement Greenberg*, vol. 2, 74.

Page 95. **in a review of School of Paris paintings**: Quoted in Irving Sandler, *The Triumph of American Painting* (New York: Praeger, 1970), 218.

Page 95. **an "extreme statement" of the color values**: Annette Cox, *Art-as-Politics: The Abstract Expressionist Avant-Garde and Society* (Ann Arbor, MI: UMI Research Press, 1982), 49.

Page 95. **significantly advanced toward "pure painting"**: Cox, *Art-as-Politics*, 155–56.

Page 96. **Greenberg seldom hesitated to batter**: O'Brian, *Clement Greenberg*, vol. 2, 42, 77–78, 118.

Page 96. **After flaying Georgia O'Keeffe's work**: O'Brian, *Clement Greenberg*, vol. 2, 87.

Page 97. **Greenberg considered it positively dangerous**: O'Brian, *Clement Greenberg*, vol. 2, 57–58.

Page 97. **For artists facing this crisis**: O'Brian, *Clement Greenberg*, vol. 1, 240–41.

Page 98. **The critic "seemed a combination . . ."**: Jeffrey Potter, *To a Violent Grave: An Oral Biography of Jackson Pollock* (New York: Putnam, 1985), 182–83.

Page 98. **Pollock responded**: Steven Naifeh and Gregory White Smith, *Jackson Pollock: An American Saga* (New York: Clarkson N. Potter, 1990), 549.

Page 98. **"It seemed clear that Louis . . ."**: Sanford Schwartz, "Clement Greenberg— The Critic and His Artists," *American Scholar*, Autumn 1987, 543.

Page 99. **Bush wrote to Greenberg's wife**: Jack and [his wife] Mabel Bush to Jennie Greenberg, Jan. 12 and 16, 1963, Roll N737, Greenberg Papers, AAA.

Page 99. **The following November . . . [end of paragraph]**: Jack Bush to Clement Greenberg, Nov. 18, 1963, Feb. 23 and May 25, 1964; Jan. 26 and Feb. 7, 1965, Roll N737, Greenberg Papers, AAA.

Page 100. **Six weeks later, Bush shipped . . . [end of paragraph]**: Jack Bush to Clement Greenberg, Mar. 24 and May 9, 1965, Roll N737, Greenberg Papers, AAA.

Page 100. **"from a cynical standpoint . . ."**: Bradford R. Collins, "Clement Greenberg and the Search for the Abstract Expressionists' Successor," *Arts Magazine*, May 1987, 38–39.

Page 100. **Indeed, so impressed was Art International**: Collins, "Clement Greenberg and the Search," 40.

Page 100. **By then Fitzsimmons was staying up all night**: James Fitzsimmons to Clement Greenberg, May 25, 1965, and undated 1964 or 1965, Roll N737, Greenberg Papers, AAA.

Page 101. **In his catalog essay**: Collins, "Clement Greenberg and the Search," 40–41.

Page 101. **Pollock told the artist Fritz Bultman**: Potter, *To a Violent Grave*, 115.

Page 101. **Krauss retailed a rumor**: Steven W. Naifeh, *Culture Making: Money, Success, and the New York Art World* (Princeton, NJ: Department of History, 1976), 88.

Page 101. **Greenberg eked out painfully small amounts**: Alton C. Morris to Greenberg, June 25, 1963, Roll N70-7; Hugh Scrutton to Greenberg, Feb. 8, 1965, Roll N737; Martin Hurtif to Greenberg, Dec. 3, 1965, Roll N70-7. All Greenberg Papers, AAA.

Page 102. **Meanwhile, Greenberg was taking every opportunity**: Robert Motherwell to Greenberg, May 11, 1957, Roll 70-7, Greenberg Papers, AAA.

Page 102. **The Stable Gallery's director**: Transcript of Eleanor Ward interview by Paul Cummings, Feb. 8, 1972, 13; Roll 70-7 Greenberg Papers, both AAA.

Page 102. **As early as 1955**: John Bauer to Greenberg, May 11, 1955, Roll 70-7, Greenberg Papers, AAA.

Page 102. **In 1964 he gave**: David Gibbs to Greenberg, Feb. 19, 1964, Roll N70-7, Greenberg Papers, AAA.

Page 102. **In an influential essay, Against Interpretation**: Quoted in Daniel Bell, *The Cultural Contradictions of Capitalism* (New York: Basic, 1976), 129.

Page 102. **In 1989 the art dealer Jeffrey Deitch**: Interview with Jeffrey Deitch, May 18, 1989.

Page 102. **"go and see Clement Greenberg . . ."**: Harold Rosenberg, *The Case of the Baffled Radical* (Chicago: University of Chicago, 1976), 265–66.

Page 103. **Philip Rahv, the magazine's coeditor**: William D. Barrett, "The Painters' Club," *Commentary*, Jan. 1982, 44–45.

Page 103. **two filmmakers arrived at Greenberg's apartment**: Emile De Antonio and Mitch Tuchman, *Painters Painting* (New York: Abbeville, 1984), 32.

Page 103. **"the responses that bring art into experience . . ."**: Clement Greenberg, "Art Criticism," *Partisan Review* 1 (1981): 37–39.

Page 103. **wrote Kay Larson recently in** *Artforum*: Kay Larson, "The Dictatorship of Clement Greenberg," *Artforum*, Summer 1987, 77.

Page 104. **John Coplans, whose exhibitionist photos**: Janet Malcolm, "A Girl of the Zeitgeist—I," *New Yorker*, Oct. 20, 1986, 52, 55.

Page 104. **Robert Pincus-Witten is a professor**: Malcolm, "Girl of the Zeitgeist—I," 55–56.

Page 104. **Concurrently, the busy professor**: Douglas C. McGill, "Advising Wealthy New Collectors on Buying Art," *New York Times*, April 22, 1987.

Page 105. **He writes frequently**: Malcolm, "Girl of the Zeitgeist—I," 65.

Page 105. **In 1989 he organized**: Jean Nathan, "Soviet Snoozer," *Art & Auction*, Dec. 1989, 27.

Page 105. **Willi Bongard, a financial writer**: Willi Bongard, *Kunst und Kommerz: Zwischen Passion und Spekulation* (Oldenburg, West Germany: Gerhard Stalling, 1967), 197–98.

Page 106. **Sam Hunter, who had been an art history professor**: Sam Hunter, "The Art Crowd," *New York Times Book Review*, Mar. 25, 1973, 5.

Page 106. **the tradition of "reciprocal appreciation"**: John L. Hess, *The Grand Acquisitors* (Boston: Houghton Mifflin, 1974), 99–100.

Page 107. **In 1976 the code of ethics**: "Additions to Code of Ethics for Art Historians," *Art Journal*, Fall 1974, 265; Barbara Rosenblum in Judith H. Balfe and Margaret Jane Wyszomirski, eds., *Art, Ideology, and Politics* (New York: Praeger, 1985), 76–77.

Page 107. **the venerable tradition of Bernard Berenson**: Meryle Secrest, *Being Bernard Berenson* (New York: Penguin, 1980), 232.

Page 107. **A sociologist who spent years studying**: Charles R. Simpson, *SoHo: The Artist in the City* (Chicago: University of Chicago, 1981), 11.

Page 108. **In 1984 the** *Annals*: "Paying for Culture," *Annals of the American Academy of Political and Social Science*, Jan. 1984.

Page 108. **The French critic Pierre Faveton reported**: Pierre Faveton, "Index 76," *Connaissance des Arts*, June 1976, 50, 53.

Page 108. **Christie's chief of public relations was delighted**: John Herbert, *Inside Christie's* (London: Hodder & Stoughton, 1990), 292.

Page 109. **"It is no longer offensive to mention art and money . . ."**: Jill Bokor, "*Art & Auction*: a Retrospective," *Art & Auction*, May 1989, 42.

Page 109. **In an article about art magazines**: Dinita Smith, "After Andy," *New York*, Jan. 29, 1990, 50.

Page 110. *Art News* **subscribers, for example**: "Reader Profile," "Demographics," and "Notable Subscribers," *Art News* brochure, Nov. 1989.

Page 110. **A 1988 survey showed**: "Subscriber Profile," *Art & Auction* brochure, undated 1988.

Page 111. *Arts* **magazine does make an effort**: Piri Halasz, "Art Criticism in New York: The 1940s vs. the 1980s," part 2, *Arts*, Mar. 1983, 73.

Page 111. **"There are lots of words written . . ."**: Interview with J. Patrick Cooney and Jennifer Vorbach, Sept. 19, 1989.

Page 111. **"Emily Tremaine, one of the heroic collectors**: Transcript of Emily Tremaine interview by Paul Cummings, Jan. 24, 1973, 28, AAA.

Page 111. **A leading dealer of the same period, Ivan Karp**: Transcript of Ivan Karp interview by Paul Cummings, Mar. 12, 1969, 101, AAA.

Page 111. **John Coplans, who edited** *Artforum*: Transcript of John Coplans interview by Paul Cummings, Aug. 4, 1977, 227–28, 237, AAA.

Page 112. **Cowles encountered the dealer**: Laura de Coppet and Alan Jones, *The Art Dealers* (New York: Clarkson N. Potter, 1984), 243.

Page 112. **Barbara Rose charged in 1981**: Barbara Rose, "State of Criticism," *Partisan Review* 2 (1981): 183.

Page 112. **An artist who works in a prominent SoHo gallery**: Interview with Joe Maresca, May 4, 1989.

Page 112. **Peter Goulds, who owns the L.A. Louver galleries**: Interview with Peter Goulds, July 10, 1989.

Page 113. **He had bought**: Barbaralee Diamonstein, *Inside New York's Art World* (New York: Rizzoli, 1979), 140.

Page 113. **the family journal of the New York School**: Irving Sandler, *The New York School* (New York: Harper & Row, 1978), 35, 261.

Page 113. **At Yale he was intrigued**: Diamonstein, *Inside New York's Art World*, 143–44.

Page 114. **In his office at *Art News***: Bongard, *Kunst und Kommerz*, 29.

Page 114. **in the grand Beekman Place house**: Transcript of Harold Rosenberg interview by Paul Cummings, Jan. 7, 1973, 12–13, AAA.

Page 114. **"the ideal editor . . ."**: John Bernard Myers, *Tracking the Marvelous* (New York: Random House, 1983), 195–96.

Page 114. **Largely because of Hess**: Sandler, *New York School*, 263.

Page 114. **the magazine demanded $400**: Elizabeth McFadden to Brian O'Doherty, May 6, 1963, Roll NYJC-6, John Canaday Papers, AAA.

Page 114. **Canaday wrote to the artist Aaron Bohrod**: John Canaday to Aaron Bohrod, undated Nov. 1961, Roll NYJC-3, Canaday Papers, AAA.

Page 114. **One correspondent who hated the work**: Sibley Smith to Canaday, Jan. 21, 1960; Canaday to Smith, Jan 22, 1960, both Roll NYJC-1, Canaday Papers, AAA.

Page 115. **"one day I looked at what I was painting . . ."**: Canaday to Tim F. Casper, May 3, 1961, Roll NYJC-6, Canaday Papers, AAA.

Page 115. **After teaching art history**: Bongard, *Kunst und Kommerz*, 192; Joseph Berger, "John Canaday, Former *Times* Art Critic, Dies," *New York Times*, July 21, 1985.

Page 115. **Canaday's inaugural column on September 6, 1959**: E. C. Daniel, Jr. to Canaday, Sept. 8, 1959, Roll NYJC-1, Canaday Papers, AAA.

Page 115. **"The best abstract expressionists . . ."**: John Canaday, *Embattled Critic* (New York: Noonday, 1962), 31–33.

Page 116. **"I have not come into the easiest situation . . ."**: Canaday to Herman Baron [ACA Gallery], Sept. 1959, Roll NYJC-1, Canaday Papers, AAA.

Page 116. **Canaday's immediate predecessors**: Myers, *Tracking the Marvelous*, 195.

Page 116. **When letters came in**: Alfred H. Barr, Jr. Archive, Roll 3155, AAA.

Page 116. **Canaday wrote to the artist**: Canaday to Philip Evergood, Oct. 16, 1959, Roll NYJC-1, Canaday Papers, AAA.

Page 116. **Canaday detested critical cant**: Canaday, "Is Less More and When and for Whom?" *New York Times*, Jan. 22, 1960.

Page 116. **a hilarious sendup**: Canaday to Glenn Ray, Oct. 23, 1960, Roll NYJC-2, Canaday Papers, AAA.

Page 117. **". . . it includes a minimum of jargon . . ."**: Canaday, "Odd Forms of Modern Criticism," *Embattled Critic*, 17, 19.

Page 117. **Judging by the enthusiastic letters pouring in**: The quotation from Goethe is actually from "The Sorcerer's Apprentice," B. Neumann to Canaday, Dec. 26, 1960, Roll NYJC-6; Carl Zigrosser to Canaday, Sept. 18, 1959; Lewis Mumford to Canaday, Oct. 22, 1959; Arnold Nicholson to Canaday, Oct. 26, 1959; Lee V. Eastman to Canaday, Sept. 21, 1959; Victor D. Spark to Canaday, Sept. 8, 1959. All Roll NYJC-1, Canaday Papers, AAA.

Page 117. **Even Clement Greenberg sounded a conciliatory note**: Clement Greenberg to Canaday, May 16, 1960; Canaday to Greenberg, May 19, 1960. Both Roll NYJC-1, Canaday Papers.

Page 118. **"Every poor broken-down realistic hack . . ."**: Canaday to Jack Levine, Sept. 30, 1959, Roll NYJC-1, Canaday Papers, AAA.

Page 118. **At the *Times*, support for Canaday**: A[rthur] H[ays] S[ulzberger] to Canaday, Sept. 4, 1959, Roll NYJC-1; Orville E. Dryfoos to Canaday, May 18,

1960; Canaday to Dryfoos, May 19, 1960, both Roll NYJC-6; Iphigene Ochs Sulzberger to Canaday, July 8, 1965, Roll NYJC-5. All Canaday Papers, AAA.

Page 119. **In October 1960 Howard Conant**: Howard Conant to Arthur Hays Sulzberger, Nov. 23, 1960; Sulzberger to Conant, Nov. 30, 1960. Both Roll 2192, Alfred H. Barr, Jr. Archive, AAA.

Page 119. **In January 1961 Canaday published**: Canaday, *Embattled Critic*, 219–23.

Page 119. **Irving Sandler described the ingrown relationships**: Sandler, *New York School*, 283.

Page 120. **In a letter Canaday defined an academy**: Canaday to William P. Reimann, undated Aug. 1962, Roll NYJC-4, Canaday Papers, AAA.

Page 120. **The Conant attack elicited an unprecedented avalanche**: Al Hirschfeld to Canaday, undated, Roll NYJC-6; Dwight Macdonald to Canaday, Jan. 4, 1962, Roll NYJC-3; Willard E. McCracken to Canaday, Jan. 6, 1961, Roll NYJC-6, all Canaday Papers, AAA; Canaday, *Embattled Critic*, 224–25, 231, 238.

Page 120. **a defender of the saccharine, sentimental sculpture**: Wheeler Williams to the editor, *New York Times*, July 26, 1965; Canaday to Williams, July 29, 1965, both Roll NYJC-5, Canaday Papers, AAA.

Page 121. **After describing a print show**: Canaday, "A Quiet Market," *New York Times*, Feb. 28, 1960.

Page 121. **the only media coverage that could draw attendance**: Bongard, *Kunst und Kommerz*, 194; Martha Jackson to Canaday, Roll NYJC-2, Canaday Papers, AAA; transcript of John I. H. Baur interview by Paul Cummings, Feb. 6, 1970, 65–66, AAA.

Page 121. **A 1975 survey indicated**: National Opinion Research Center for the Arts, *Americans and the Arts: A Survey of Public Opinion* (New York: American Council for the Arts, 1975), 18–19.

Page 122. **Overspecialized and underpaid, few critics**: Diamonstein, 197.

Page 122. **Karp's former colleague, Leo Castelli**: Interview with Leo Castelli, May 11, 1989.

Page 123. **The increasing use of photographs**: Cox, *Art-as-Politics*, 85.

Page 123. **The way paintings reproduce in photographs**: Wilhelmina Van Ness, "Tragic Dilemma of Modern Art," *American Scholar*, Spring 1974, 289.

Page 123. **Looking back on his career as an art critic**: Transcript of Harold Rosenberg interview by Paul Cummings, Feb. 7, 1972, 173, AAA; Harold Rosenberg, "The Art World: Adding Up," *New Yorker*, Aug. 20, 1973, 72.

Page 123. **Rosenberg's background**: Transcript of Harold Rosenberg interview by Dorothy Seckler, June 28, 1967, 24, AAA; Dore Ashton, *The New York School* (New York: Viking, 1972), 163.

Page 124. **It was among the non-Communist leftists**: Cox, *Art-as-Politics*, 130–32.

Page 124. **"Harold looked and shone like the Lion of Judah . . ."**: Seymour Krim, "Remembering Harold Rosenberg," *Commentary*, Nov. 1978, 66.

Page 124. **The dealer John Bernard Myers observed**: Myers, *Tracking the Marvelous*, 68–69.

Page 125. **"He was one of the most skeptical . . ."**: Krim, "Remembering Harold Rosenberg," 66.

Page 125. **Rosenberg told Paul Cummings in 1972**: Transcript of Harold Rosenberg interview by Paul Cummings, Feb. 7, 1972, 169–72, AAA.

Page 126. **Warhol was "insignificant," he thought**: Transcript of Harold Rosenberg interview by Paul Cummings, Feb. 7, 1972, 171–72, and Jan. 7, 1973, 11–12. Both AAA.

Page 126. **Rosenberg's spleen was even more inflamed**: Transcript of Harold Rosenberg interview by Paul Cummings, Jan. 7, 1983, 10–12, AAA; Rosenberg, "The Art World: Adding Up," *New Yorker*, Aug. 20, 1973, 77; transcript of Harold Rosenberg interview by Paul Cummings, Jan. 20, 1973, 51–53, AAA; Rosenberg, "Then and Now," *Partisan Review* 4, (1975): 565.

Page 127. **Barbara Rose, for one, complained**: Quoted in Malcolm, "Girl of the Zeitgeist—I," 60.

Page 127. **In 1967 she had published**: Barbara Rose, *American Art Since 1900: A Critical History* (New York: Praeger, 1967).

Page 127. **bemoaning the decline**: Quoted in Eleanor Munro, "Then and Now," *Partisan Review* 4 (1975): 562.

Page 127. **As late as 1962 Lloyd Goodrich**: Transcript of Lloyd Goodrich interview by Harlan Phillips, June 25, 1962, Roll 3197, AAA.

Page 128. **"in direct proportion to the decrease . . ."**: Jean Clay, "Interview with Denise René: A Leading European Gallery Owner," *Studio*, April 1968, 52.

Page 128. **The result was "intellectual porridge"**: Robert Wraight, *The Art Game* (New York: Simon & Schuster, 1966), 173–74.

Page 128. **Ivan Karp noted irreverently**: Transcript of Ivan Karp interview by Paul Cummings, Mar. 12, 1969, 101, AAA.

Page 128. **Henry Geldzahler, by contrast, lauded**: Henry Geldzahler, *New York Painting and Sculpture: 1940–1970* (New York: Dutton, 1969), 27–29.

Page 128. **A 1972 survey**: Naifeh, *Culture Making*, 115; Clay, "Interview with Denise René," 53.

Page 129. **The *enfant terrible* of art publications**: Malcolm. "A Girl of the Zeitgeist—I," 49.

Page 129. **The new editor, Ingrid Sischy**: Smith, "After Andy," 44–49.

Page 130. **counseled Martin S. Ackerman**: Martin S. Ackerman, *Smart Money and Art* (Barrytown, NY: Station Hill Press, 1986), 143.

Page 130. **The affectionate alliance**: Pierre Gaudibert, "Le marché de la peinture contemporaine et la crise," *La Pensée*, Oct. 1965, 72.

Page 130. **When Marlborough Gallery**: Lee Seldes, *The Legacy of Mark Rothko* (New York: Holt, Rinehart & Winston, 1978), 132–33, 260–61.

Page 131. **By 1986 Rose was wistfully harking back**: Malcolm, "A Girl of the Zeitgeist—I," 59.

Page 131. **one of its organizers, Robert Rowan**: Julia Brown and Bridget Johnson, eds., *The First Show: Paintings and Sculptures from Eight Collections 1940–1980* (Los Angeles and New York: Museum of Contemporary Art and The Arts Publisher, 1983), 104.

Page 131. **Harold Rosenberg had spent**: Transcript of Harold Rosenberg interview by Paul Cummings, Feb. 7, 1972, 164, AAA.

Page 132. **Accepting such gifts**: John W. English, *Criticizing the Critics* (New York: Hastings House, 1979), 178–79.

Page 132. **"the best sculptor . . ."**: Greenberg, *Art and Culture*, 204.

Page 132. **Smith's sales**: David Smith to Clement Greenberg, Dec. 12, 1947, and Jean Dubuffet to Greenberg, Feb. 13, 1950, both Roll N70-7, Greenberg Papers, AAA.

Page 132. **By the mid-1960s it seemed to be understood by artists**: Jules Olitski to Greenberg, June 24, 1965; Ann Truitt to Greenberg, Mar. 25, 1965; Howard Mehring to Greenberg, undated mid-1960s, both Roll N737; Allene Talmey to Greenberg, Dec. 10, 1963, Roll N70-7; Albert Vanderburg (Portable Gallery Color Slides) to Greenberg, April 16, 1964, Roll N737. All Greenberg Papers, AAA.

Page 133. **"To be an artist is to be pompous . . ."**: Naifeh and Smith, *Jackson Pollock*, 632.

Page 133. **from which it was sold**: Christie, Manson & Woods International, Inc., *Contemporary Art*, auction catalog, New York, May 3, 1989, 66–67.

Page 133. **Greenberg's influence remains "ubiquitous"**: Larson, "Dictatorship of Clement Greenberg," 79.

Page 134. **lamented Barbara Rose in 1981**: Rose, "State of Criticism," 182.

Page 134. **Paul Brach, an artist who was the founding chairman**: Interview with Paul Brach, May 3, 1989.

Page 135. **Reviewing the book in *Art News***: Sam Hunter, "Pollock *Catalogue Raisonnée*: A Vast, Impressive Panoply," *Art News*, Nov. 1978, 24, 27.

Page 135. **the most comprehensive and revealing biography**: Steven Naifeh and Gregory White Smith, *Jackson Pollock: An American Saga* (New York: Clarkson N. Potter, 1989).

Page 135. **Elizabeth Frank dismissed it**: Elizabeth Frank, "A Spattered Life," *New York Times Book Review*, Jan. 28, 1990, 3, 34.

Page 137. **a full color page in Rewald's book**: John Rewald, *The History of Impressionism* (New York: Museum of Modern Art, 1973), 383.

Page 137. **"one of van Gogh's most famous images"**: Peter Watson, "Sotheby's vs. Christie's: Uncivil War," *New York Times*, May 27, 1990.

Page 137. **"implied that it was presumptuous . . ."**: Gerald Reitlinger, *The Economics of Taste: The Art Market in the 1960s* (London: Barrie & Jenkins, 1970), 10.

Page 138. **"from the status of something half-suspect . . ."**: Bernard Rosenberg and Norris Fliegel, *The Vanguard Artist* (New York: Arno, 1973), 189–90.

Page 138. **Such an education, Edward C. Banfield notes**: Edward C. Banfield, *The Democratic Muse* (New York: Basic, 1984), 153–54.

Page 139. **The critic Leo Steinberg bridled**: Leo Steinberg, *Other Criteria: Confrontations with 20th Century Art* (New York: Oxford University, 1972), 263–65.

Page 139. **Thomas Hess, for example, opens his book**: Thomas B. Hess, *Barnett Newman* (New York: Walker, 1969), 7.

Page 140. **"People think about him quite differently . . ."**: Transcript of Harry N. Abrams interview by Paul Cummings, Mar. 14, 1972, AAA.

Page 140. **During the Mark Rothko trial**: Seldes, *Legacy of Mark Rothko*, 259–60.

Page 140. **financial help for books**: Joan Simon, "Art Book Industry: Problems and Prospects," *Art in America*, Summer 1983, 21.

Page 140. **museums have considerable advantages**: Simon, "Art Book Industry," 21.

Page 141. **his collected essays, published in 1975**: Frank O'Hara, *Art Chronicles: 1954-1966* (New York: Braziller, 1975), frontispiece, 3, 4, 7, 8, 10–11.

Page 141. **Harold Rosenberg decried such training**: Transcript of Harold Rosenberg interview by Paul Cummings, Jan. 20, 1973, 31.

Page 141. **Paul Brach, himself a veteran**: Interview with Paul Brach, May 3, 1989.

Page 142. **William D. Barrett, who wrote for *Partisan Review***: William D. Barrett, "The Painters' Club," *Commentary*, Jan. 1982, 54.

Page 142. **the art historian Piri Halasz wrote**: Piri Halasz, "Manhattan Museums: the 1940s vs. the 1980s," *Arts*, Jan. 1985, 125.

Page 142. **Frank O'Hara remarked**: O'Hara, *Art Chronicles: 1954-1966*, 45.

Page 142. **Robert Wraight deplored the adulteration**: Wraight, *Art Game*, 167, 169.

Page 143. **"What development?" growled Rothko**: Seldes, *Legacy of Mark Rothko*, 64–66.

Page 143. **personal reaction described by Leo Steinberg**: Steinberg, *Other Criteria*, 15.

Page 143. **reviews of current art are speckled**: Stephen Westfall, "Franz Erhard Walther at John Weber," *Art in America*, May 1989, 193; Holland Cotter, "Claudia Hart at Pat Hearn," *Art in America*, May 1989, 195.

Page 143. **Early in his career, in 1942**: O'Brian, *Clement Greenberg*, vol. 1, 35, 93.

Page 144. **"Chinese Menu for Art Lovers"**: Donald Holden, "P.S.," *Artist's Magazine*, May 1989, 96.

Page 144. **the brilliant intense life of a most remarkable artist**: Anthony Haden-Guest, "Burning Out," *Vanity Fair*, Nov. 1988, 183–84.

Page 145. **The 480-page catalog that accompanied**: Kynaston McShine, ed., *Andy Warhol: A Retrospective* (New York: Museum of Modern Art, 1989).

Page 145. **Harold Rosenberg called Warhol**: Harold Rosenberg, *Discovering the Present: Three Decades in Art, Culture and Politics* (Chicago: University of Chicago, 1973), 122.

Page 145. **Barbara Rose reacted with judicious alarm**: Carol Anne Mahsun, *Pop Art and the Critics* (Ann Arbor, MI: UMI Research, 1987), 87–88.

Page 146. **writes Herbert J. Gans**: Herbert J. Gans, *Popular Culture and High Culture* (New York: Basic, 1974), 63.

Page 146. **"What's so fine about *Life?*"**: Potter, *To a Violent Grave*, 114, 119.
Page 146. **only 20 of the 532 letters**: Piri Halasz, "Art Criticism in New York: the 1940s vs. the 1980s," part 2, *Arts*, Mar. 1983, 68.
Page 147. **"an art movement should be publicized . . ."**: Mahsun, *Pop Art and the Critics*, 87.
Page 147. **The widespread coverage of Pop Art**: Barbara Rose, "Twilight of the Superstars," *Partisan Review* 4 (1974): 566.
Page 147. **At a Museum of Modern Art symposium**: Henry Geldzahler, *Pop Art 1955-70* (Sydney: International Corporation of Australia, Ltd., 1985), 171.
Page 148. **Taylor and Brooke wrote that many dealers**: John Russell Taylor and Brian Brooke, *The Art Dealers* (New York: Scribner's, 1969), 203-6.
Page 148. **By the late 1970s Harold Rosenberg saw**: Simpson, *SoHo*, 40.
Page 148. **"hip and thigh struggle"**: Rosenberg and Fliegel, *The Vanguard Artist*, 209-10.
Page 148. **so many different styles**: Simpson, *SoHo*, 49-50.
Page 149. **A number of artists**: de Coppet and Jones, *The Art Dealers*, 200.
Page 149. **critics had been totally emasculated**: Barbara Rose, "Art as Money," *Partisan Review* 1 (1988): 23.
Page 149. **Peter Schjeldahl, who wrote on art**: Peter Schjeldahl in Deborah Drier, ed., "Critics and the Marketplace," *Art & Auction*, Mar. 1990, 175.

CHAPTER 4: COLLECTORS: THE ULTIMATE SHOPPING SPREE

Page 150. **Alfred H. Barr, Jr., had stepped in**: Alfred H. Barr, Jr. to George Rickey, June 3, 1968, Roll 2198, Barr Archive, AAA.
Page 150. **Born in Russian Lithuania**: Lee Seldes, *The Legacy of Mark Rothko* (New York: Holt, Rinehart & Winston, 1978), 13-14, 40.
Page 151. **punched his fist**: Eleanor Munro in "Then and Now," *Partisan Review* 4 (1975): 556.
Page 151. **mourners at Rothko's funeral**: Lee Seldes, *The Legacy of Mark Rothko* (New York: Holt, Rinehart & Winston, 1978), 5-6.
Page 152. **Also present was Robert Scull**: Jane Kramer, "Profiles: Man Who Is Happening Now," *New Yorker*, Nov. 26, 1966, 88.
Page 152. **"an incalculable loss"**: Grace Glueck, "Mark Rothko, Artist, A Suicide Here at 66," *New York Times*, Feb. 26, 1970.
Page 152. **"permanently impaired . . ."**: Seldes, *Legacy of Mark Rothko*, 83-85.
Page 152. **too many tax problems**: John Russell Taylor and Brian Brooke, *The Art Dealers* (New York: Scribner's, 1969), 259; Dore Ashton, *The New York School* (New York: Viking, 1972), 211; Seldes, *Legacy of Mark Rothko*, 76, 80, 97.
Page 153. **For the chapel**: Seldes, *Legacy of Mark Rothko*, 62-64.
Page 153. **"Visitors were given to understand . . ."**: Max Kozloff, "Mark Rothko (1903-1970)," *Artforum*, April 1970, 88.
Page 153. **a massive sale . . . [to end of second paragraph]**: Seldes, *Legacy of Mark Rothko*, 78-80; Herbert Ferber, "The Rothko Case," *Partisan Review* 1 (1984): 106.
Page 154. **Ben Heller, for one, was gratified**: Transcript of Ben Heller interview by Paul Cummings, Jan. 8, 1973, 12-13, AAA.
Page 155. **He could not trust anyone, he said**: Seldes, *Legacy of Mark Rothko*, 83.
Page 155. **"bad for the digestion . . ."**: Marvin Elkoff in Milton C. Albrecht, James H. Barnett, and Mason Griff. eds., *Sociology of Art and Literature* (New York: Praeger, 1970), 314.
Page 155. **Rothko raised the money**: Seldes, *Legacy of Mark Rothko*, 44-45.
Page 155. **when Ethel Scull said**: Doris Saatchi, "Keeping Up with the Johnses," *Vanity Fair*, May 1987, 56.

Page 156. **the unveiling of a new portrait of Queen Elizabeth II**: Alvin Shuster, "Stern Portrait of Elizabeth Includes Blemishes," *New York Times*, Feb. 26, 1970.

Page 156. **To the right of Rothko's obituary**: Sanka Knox, "2 Van Goghs Net $2.1 Million Here," *New York Times*, Feb. 26, 1970.

Page 157. **Richard H. Rush's *Art as an Investment***: Richard H. Rush, *Art as an Investment* (Englewood Cliffs, NJ: Prentice-Hall, 1961), 212-19.

Page 157. **At about the same time, Peggy Guggenheim rejoiced**: Peggy Guggenheim, *Confessions of an Art Addict* (New York: Macmillan, 1960), 110.

Page 157. **A French observer in 1962 blamed**: Jean Piel, "La fonction sociale du collectionneur," *Critique*, Aug.-Sept. 1962, 790.

Page 157. **The venerable dealer Maurice Rheims observed**: Maurice Rheims, *The Strange Life of Objects* (New York: Atheneum, 1961), 15, 110.

Page 157. **Even lesser works by lesser artists**: John Walker, *Self-Portrait with Donors* (Boston: Little, Brown, 1974), xiii.

Page 157. **some were already describing the art boom**: Taylor and Brooke, *Art Dealers*, 183.

Page 158. **According to one European dealer**: Jean Clay, "Interview with Denise René: A Leading European Gallery Owner," *Studio*, April 1968, 192-93.

Page 158. **These collectors were rushing to acquire**: Raymonde Moulin, *Le marché de la peinture en France* (Paris: Editions du minuit, 1970), 220-21.

Page 158. **Art collecting had become a substitute for religion**: John Bernard Myers, *Tracking the Marvelous* (New York: Random House, 1983), 244.

Page 158. **The Venice Biennale, wrote Robert Wraight**: Robert Wraight, *The Art Game* (New York: Simon & Schuster, 1966), 25-28.

Page 158. **the collector who telephoned**: George Savage, "Collectors, Dealers, and Salesrooms," *Studio*, Feb. 1961, 72.

Page 159. **those who could afford**: Steven W. Naifeh, *Culture Making: Money, Success, and the New York Art World* (Princeton, NJ: History Department, 1976), 105-6; Diana Crane, *The Transformation of the Avant-Garde: The New York Art World, 1940-1985* (Chicago: University of Chicago, 1987), 38-39.

Page 159. **Globalization and the growing dominance of auctions**: Stuart Greenspan, "Bright Lights, Big Bucks," *Art & Auction*, May 1989, 220-21.

Page 159. **Gerald Reitlinger, whose massive study**: Gerald Reitlinger, *The Economics of Taste*, vol. 1 (London: Barrie and Rockliff, 1961), 228.

Page 160. **Of the one hundred leading American collectors**: "The Top 100 Collectors," *Art & Antiques*, March 1989, 49-89.

Page 160. **Thulin paid $7.04 million**: Rita Reif, "Jasper Johns's 'White Flag' Gets Record Price at Auction," *New York Times*, Nov. 11, 1988.

Page 160. **the publishing tycoon S. I. Newhouse**: "Top 100 Collectors," 76.

Page 161. **"a splendid excuse for a person to buy what he loves"**: Rush, *Art as an Investment*, viii.

Page 161. **"a real challenge . . . almost like making an acquisition . . ."**: Jay McCormick, "Art Is Hot," *USA Today*, June 20, 1988.

Page 161. **When Hugh Hefner decided to dispose**: Rita Reif, "Hefner Selling a de Kooning and a Pollock from Holdings," *New York Times*, May 1, 1987; Reif, "De Kooning Painting Ties Auction Record," *New York Times*, May 5, 1987.

Page 161. **to stroll on gritty city streets in places like SoHo**: Charles R. Simpson, *SoHo: The Artist in the City* (Chicago: University of Chicago, 1981), 4-5.

Page 162. **some collectors indeed profited**: Rush, *Art as an Investment*, 79; Geraldine Keen, *Money and Art: A Study Based on the Times-Sotheby Index* (New York: G. P. Putnam's Sons, 1971) 48.

Page 162. **In the decade 1979-1989**: "Contemporary Art," *New York Observer*, Dec. 25, 1989.

Page 162. **The investor who in 1873 paid**: Gerald Reitlinger, *The Economics of Taste*, vol. 3 (London: Barrie & Jenkins, 1970), 165-66, 230.

Page 162. **The crockery Julian Schnabel glued**: E. Bingo Wyer, "Flaky Art," *New York*, Jan. 25, 1988, 42–48.

Page 163. **succumbed to severe crackling**: Deborah Drier, "Reviews: Contemporary," *Art & Auction*, Jan. 1990, 137; Mary Tomkins Lewis, "In the Galleries: Crazy Salads, " *Art & Antiques*, Summer 1989, 37.

Page 163. **In 1988 Harvard had to remove**: Michael Kimmelman, "Rothko's Harvard Murals Are Irreparably Faded by Exposure to the Sun," *New York Times*, Aug. 8, 1988, 15–16.

Page 163. **A Rand Corporation study**: John Picard Stein, "Monetary Appreciation of Paintings," *Journal of Political Economy*, Oct. 1977, 1035.

Page 163. **the price behavior**: Robert C. Anderson, "Paintings as an Investment," *Economic Inquiry*, Mar. 1974, 13, 15, 25.

Page 163. **the Economist Intelligence Unit**: Jean Skinner-Ross, "Art: How Good an Investment?" *Dun's Review*, May 1980, 60, 65.

Page 164. **the experience of the British Rail Pension Fund**: Bonnie Barrett Stretch, "Launching a $300 Million Art Fund," *Art News*, May 1989, 39.

Page 164. **Of all works sold in a given year**: Christine Brown, "Welcome, Suckers!" *Forbes*, June 25, 1990, 282–83.

Page 164. **"Art for art's sake has a firm grounding . . ."**: William D. Grampp, *Pricing the Priceless: Art, Artists, and Economics* (New York: Basic, 1989), 153–56.

Page 165. **a small "acquisitions budget"**: Interview with Edythe and Eli Broad, June 29, 1989; interview with Michele De Angelus, July 10, 1989.

Page 166. **About once a month**: Interview with Eli Broad, June 29, 1989.

Page 166. **The Broad Family Foundation**: Interview with Michele De Angelus, July 10, 1989.

Page 167. **Broad remains skeptical**: Interview with Eli Broad, June 29, 1989.

Page 167. **A French brain specialist examined**: Rheims, *The Strange Life of Objects*, 36.

Page 167. **A group of fifteen scholars**: Russell W. Belk, Melanie Wallendorf, John Sherry, Morris Holbrook, and Scott Roberts, "Collectors and Collecting," *Advances in Consumer Research* 15 (1988): 27, 28.

Page 168. **"collecting was our life"**: Interview with Frances and Eugene Gorman, May 11, 1989.

Page 170. **the motivations uncovered by the scholars**: Belk et al., "Collectors and Collecting," 29.

Page 170. **Nelson Rockefeller began collecting:** Francine du Plessix in Jean Lipman, ed., *The Collector in America* (New York: Viking, 1971), 26; transcript of Nelson Rockefeller interview by Paul Cummings, July 24, 1972, 21–22, AAA. For a full discussion, see Alice Goldfarb Marquis, *Alfred H. Barr, Jr.: Missionary for the Modern* (Chicago: Contemporary Books, 1989), 328–30.

Page 170. **In the provincial state capital**: Transcript of Nelson Rockefeller interview by Paul Cummings, July 24, 1972, 19–20, AAA.

Page 171. **not a lust for power**: Lipman, *Collector in America*, 26.

Page 171. **The scholars found that the simple act**: Belk et al., "Collectors and Collecting," 29–30.

Page 171. **Richard Brown Baker began collecting**: Interview with Richard Brown Baker, Sept. 20, 1989.

Page 173. **Because a collection is so intimately entwined**: Belk et al., "Collectors and Collecting," 31.

Page 173. **"a painting addict,"**: Allene Talmey, "Art Is the Core," *Vogue*, July 1964, 125.

Page 174. **"How come you have . . ."**: Richard Merkin, "A Scull Dozen," *Vanity Fair*, Dec. 1986, 146.

Page 174. **their vaulting social ambition**: John Duka, "Back on Top with the Mom of Pop Art," *New York*, June 9, 1986, 62; Talmey, "Art is the Core," 125; "At Home with Henry," *Time*, Feb. 21, 1965, 68; Kramer, "Profiles," 82.

Page 174. **The scenario cooked up**: Bernard Bina, "The Sculls Go Pop to the Top," *People*, May 20, 1974, 36–39.

Page 175. **"the folk heroes . . ."**: Bina, "Sculls Go Pop," 37.

Page 175. **Less charitably,**: Barbara Rose, "Profit Without Honor," *New York*, Nov. 5, 1973, 80–81.

Page 175. **"learned a lot"**: Transcript of Henry Geldzahler interview by Paul Cummings, Feb. 16, 1970, AAA.

Page 175. **The Met's director,**: "At Home with Henry," 68.

Page 175. **Alfred Barr confided**: Alfred H. Barr, Jr., letter to Robert C. Scull, Jan. 31, 1964, Roll 2187, Barr Archive AAA.

Page 175. **The apartment that the Sculls rented**: Duka, "Back on Top," 65.

Page 176. **"some turned out to be . . ."**: Kramer, "Profiles," 70–71.

Page 176. **"an adventure for the eyes."**: Talley, "Art Is the Core," 118.

Page 176. **a *New Yorker* profile**: Kramer, "Profiles," 64.

Page 176. **Even Warhol deemed them**: Andy Warhol and Pat Hackett, *Popism: The Warhol 60s* (New York: Harper & Row, 1980), 85–86.

Page 176. **"the guy who commissioned . . ."**: Kramer, "Profiles," 65.

Page 177. **While speculating**: Willi Bongard, *Kunst und Kommerz: Zwischen Passion und Spekulation* (Oldenburg, West Germany: Gerhard Stalling, 1967), 151.

Page 177. **He asked John Bernard Myers**: Myers, *Tracking the Marvelous*, 216–17.

Page 177. **"He likes our artists"**: Calvin Tomkins, "Profiles: A Good Eye and a Good Ear," *New Yorker*, May 26, 1980, 61.

Page 177. **Scull then settled**: Emile De Antonio and Mitch Tuchman, *Painters Painting* (New York: Abbeville, 1984), 106.

Page 177. **Ivan Karp watched**: Laura de Coppet and Alan Jones, *The Art Dealers* (New York: Clarkson N. Potter, 1984), 140–41.

Page 177. **"It was crazy"**: Kramer, "Profiles," 84.

Page 177. **wild phone calls**: De Antonio and Tuchman, *Painters Painting*, 110–12.

Page 178. **"a kind of magic . . ."**: Jerry E. Patterson, "The Scull Collection," *Arts*, Sept. 1973, 78.

Page 178. **the joy of buying art**: William K. Zinsser, *Pop Goes America* (New York: Harper & Row, 1966), 12.

Page 178. **"I don't presume to know . . ."**: "At Home with Henry," 68.

Page 178. **"My artists use me . . ."**: Kramer, "Profiles," 72–74.

Page 178. **Scull had already sold off**: Patterson, "Scull Collection," 78.

Page 178. **relatively cheap**: Wraight, *Art Game* 63–65.

Page 178. **To a continental critic**: Gregoire Müller, "Points of View: A Taped Conversation with Robert C. Scull," *Arts*, Nov. 1970, 37.

Page 179. **continued to buy prodigiously**: Kramer, "Profiles," 64, 84.

Page 179. **"They should be in a place . . ."**: Saatchi, "Keeping Up with the Johnses," 56.

Page 179. **"the most exhilarating of collectors . . ."**: Stephen Spector, "Auctions: The Scull Collection," *Art in America*, Sept. 1973, 25–26.

Page 179. **Scull spent $60,000**: Interview with Ethel Scull, May 20, 1989.

Page 179. **"Art is supposed to be . . ."**: Baruch D. Kirschenbaum, "The Scull Auction and the Scull Film," *Art Journal*, Fall 1979, 52.

Page 180. **mob of demonstrators**: Kirschenbaum, "Scull Auction," 50–51; E. J. Vaughn in collaboration with John Schott, *America's Pop Collector: Robert C. Scull—Contemporary Art at Auction* (New York: Cinema Five).

Page 180. **Months of careful planning**: Rose, "Profit Without Honor," 80–81.

Page 180. **Ethel elbowed Bob**: Karl E. Meyer, *The Art Museum: Power, Money, Ethics* (New York: William Morrow, 1979), 183.

Page 181. **As a documentary filmmaker's camera recorded it**: de Coppet and Jones, *Art Dealers*, 104; Walter Robinson, "Robert C. Scull Obituary," *Art in America*, Feb. 1986, 152; Kirschenbaum, "The Scull Auction," 51.

Page 181. **While Barbara Rose fumed**: Rose, "Profit Without Honor," 80–81.

Page 181. **the seven works shown**: Meyer, *Art Museum*, 184.

Page 182. **It "turned the corner . . ."**: Ronald Bailey, "The New-Issue Art Market," *Forbes*, April 18, 1988, 66.

Page 182. **With little other recommendation**: Bina, "The Sculls Go Pop," 39; Kramer, "Profiles," 84; Warhol and Hackett, *Popism: The Warhol 60s*, 86–87.

Page 182. **"people like you and me can meet the biggest names . . ."**: Suzanne Muchnic, "The Frenzy," *Los Angeles Times Calendar*, June 11, 1989, 88.

Page 182. **willing to spend Sundays**: "At Home with Henry," 68; Bernard Rosenberg and Norris Fliegel, *The Vanguard Artist* (New York: Arno, 1979), 158.

Page 183. **Henry Geldzahler shared with the readers of *Vogue***: Henry Geldzahler, "Los Angeles: The Second City of Art," *Vogue*, Sept. 15, 1964, 56, 64.

Page 183. **Consumption, say the anthropologists**: Mary Douglas and Baron Isherwood, *The World of Goods* (New York: Basic, 1979), 60, 65, 118.

Page 183. **says the incurable collector Frances Gorman**: Interview with Frances Gorman, May 11, 1989.

Page 184. **"With such a regulation in force"**: Taylor and Brooke, *Art Dealers*, 17–19.

Page 184. **so beneficial was this law**: Eric Hodgins and Parker Lesley, "The Great International Art Market," *Fortune*, Dec. 1955, 157.

Page 184. **nibbling away at the tax advantages**: Alexandra Peers, "It's Beautiful, but Is It a Tax Deduction?" *Wall Street Journal*, May 10, 1989; Martin S. Ackerman, *Smart Money and Art* (Barrytown, NY: Station Hill Press, 1986), 166–67.

Page 185. **These products, says Charles R. Simpson**: Charles R. Simpson, *SoHo: The Artist in the City* (Chicago: University of Chicago, 1981), 25, 29–30, 253.

Page 186. **Ivan Karp recalled that his first encounter**: Transcript of Ivan Karp interview by Paul Cummings, Mar. 12, 1969, 23–24, 28, 31–33, AAA.

Page 186. **gave both James Rosenquist and Claes Oldenburg**: Calvin Tomkins, *Off the Wall: Robert Rauschenberg and the Art World of Our Time* (New York: Penguin, 1981), 176–78.

Page 186. **Scull boasted that he was the first to collect**: Kramer, "Profiles," 84, 87.

Page 186. **Rosenquist asked $200**: Bongard, *Kunst und Kommerz*, 152; Zinsser, *Pop Goes America*, 12.

Page 187. **in the winter of 1964–1965**: Henry Geldzahler, "James Rosenquist's F-111," *Metropolitan Museum Bulletin*, March 1968, 280.

Page 187. **Scull dashed**: Kramer, "Profiles," 64; Geldzahler, "James Rosenquist's F-111," 280–81.

Page 187. **When the finished work was exhibited**: Robert C. Scull, "Re the F-111: A Collector's Notes," *Metropolitan Museum Bulletin*, Mar. 1968, 282–83.

Page 187. **The artist also was pleased**: Jeanne Siegel, *Artwords: Discourse on the 60s and 70s* (Ann Arbor, MI: UMI Research, 1985), 209.

Page 187. **It was "tremendous"**: Suzi Gablik, "Protagonists of Pop: Five Interviews," *Studio International*, July 1969, 11.

Page 188. **a two-year tour**: Meyer, *Art Museum*, 182–83.

Page 188. **"It speaks to all mankind"**: Scull, "Re the F-111," 283.

Page 188. **Rosenquist's masterpiece was sold for $2 million**: Douglas C. McGill, "At Auctions, a New Breed of Buyer," *New York Times*, Nov. 24, 1986.

Page 188. **"he [Rauschenberg] kissed me"**: Marie Brenner, "Latter Days of Ethel Scull," *New York*, April 6, 1981, 22, 24.

Page 189. **A bare light bulb dangled**: "At the Sculls, Bare Walls Do Not a Friendship Make," *People*, Nov. 3, 1975, 42.

Page 189. **They should never have married, Ethel later said**: Marie Brenner, "Latter Days," 26.

Page 189. **even though he was color-blind**: Interview with Ethel Scull, May 20, 1989.

Page 190. **"You fade away from the scene"**: Duka, "Back on Top," 67.

Page 190. **a New York judge heard [and next paragraph]**: John Henry Merryman and

Albert E. Elsen, *Law, Ethics, and the Visual Arts*, vol. 2 (Philadelphia: University of Pennsylvania, 1987), 615; interview with Ethel Scull, May 20, 1989; Duka, "Back on Top," 67.

Page 190. **struggled to reverse this judgment**: Duka, "Back on Top," 62; interview with Ethel Scull, May 20, 1989.

Page 191. **great November auctions**: Cathleen McGuigan, "A Pop Patron's Last Hurrah," *Newsweek*, Nov. 17, 1986, 97; Saatchi, "Keeping Up with the Johnses," 52, 54, 61.

Page 191. **Her first purchase**: Interview with Ethel Scull, May 20, 1989.

Page 192. **With some satisfaction, she describes**: Interview with Ethel Scull, May 20, 1989.

Page 192. **Among followers of the avant-garde . . ."**: Douglas and Isherwood, *World of Goods*, 198–99.

Page 193. **"a terrible fuss"**: de Coppet and Jones, *Art Dealers*, 103; Saatchi, "Keeping Up with the Johnses," 56, 58.

Page 193. **Emily refused to reveal how much she had paid**: Transcript of Emily Tremaine interview by Paul Cummings, Jan. 24, 1973, 6, AAA.

Page 194. **Born in Butte, Montana**: Grace Glueck, "Emily Hall Tremaine Dies in 80s; an Avid Collector of Modern Art," *New York Times*, Dec. 17, 1987.

Page 194. **"I wanted to have . . ."**: Transcript of Emily Tremaine interview by Paul Cummings, Jan. 24, 1973, 12–17, AAA.

Page 195. **"tired of all this angst"**: Transcript of Emily Tremaine interview by Paul Cummings, Jan. 24, 1973, 20–21, 29, AAA.

Page 195. **Dominique de Menil**: Stephen Jamail, "The Museum Boom," *Vanity Fair*, Jan. 1987, 54–58.

Page 196. **David Bermant**: "Top 100 Collectors," 50–51.

Page 196. **"rigor and purity"**: Dinita Smith, "Art Fever," *New York*, April 20, 1987, 39.

Page 196. **The takeover billionaire Asher Edelman**: Charles A. Reilly II, "Almost Home," *Art & Auction*, Feb. 1990, 135–36, 138.

Page 197. **Larry Aldrich, a successful New York dress manufacturer**: Interview with Larry Aldrich, June 5, 1986.

Page 198. **"I don't write and I don't paint . . ."**: Grace Glueck, "Wolfson's Warehouse: High Art to Pure Kitsch," *New York Times*, June 1, 1989.

Page 198. **Leon Kraushar**: Crane, *Transformation of the Avant-Garde*, 38–39.

Page 198. **Willi Bongard, a European journalist**: Bongard, *Kunst und Kommerz*, 156–57.

Page 199. **West Coast collector and dealer Betty M. Asher**: Transcript of Betty M. Asher interview by Thomas H. Garver, July 7, 1980, California Oral History Project, 87, AAA.

Page 199. **The New York dealer Terry Dintenfass**: Interview with Terry Dintenfass, Sept. 16, 1989.

Page 199. **Vera List**: de Coppet and Jones, *Art Dealers*, 205–6; "Top 100 Collectors," 70–80; Saatchi, "Keeping Up with the Johnses," 54.

Page 199. **plodding, meticulous, often stressful labor**: Simpson, *SoHo*, 37.

Page 199. **Donald Rubell . . . [to end of next paragraph]**: "Top 100 Collectors," 79–80.

Page 200. **Actor Steve Martin called it**: Tom Toms, "Sketchbook: On the Prowl," *Art & Antiques*, Summer 1989, 27; "Top 100 Collectors," 74.

Page 200. **She sued Guggenheim**: "Stallone Sues Broker over Art Purchase," *New York Times*, Dec. 28, 1989; Tom Toms, "Sketchbook: Fussing and Fighting," *Art & Antiques*, April 1990, 24.

Page 201. **Los Angeles Art Fair**: Grace Glueck, "Art Fairs: A Panel Surveys Them as Los Angeles Opens Its Fourth," *New York Times*, Dec. 9, 1989.

Page 201. **Elaine Dannheiser used a secret signal**: Paul Gardner, "How to Bid Like an Insider," *Art News*, Feb. 1987, 104; Smith, "Art Fever," 38.

Page 201. **Eugene and Barbara Schwartz**: "Top 100 Collectors," 53, 74; Toms, "Sketchbook: On the Prowl," 27; Ann Berman, "The Hangmen," *Avenue*, Feb. 1990, 100–101.

Page 201. **Paul Cummings, who has observed**: Interview with Paul Cummings, Sept. 22, 1989.

Page 202. **The big art buyers today**: Interview with Ivan Karp, May 3, 1989.

Page 202. **Another dealer, who wants to remain anonymous**: Interview with anonymous New York gallery owner, Sept. 15, 1989.

Page 202. **Harold Rosenberg frequently fumed**: Transcript of Harold Rosenberg interview by Paul Cummings, Jan. 20, 1973, 50, AAA.

Page 203. **Charles Saatchi, the advertising mogul**: Interview with Ethel Scull, May 20, 1989; A. D., "Saatchi Sells," *Art & Auction*, May 1989, 60; Hans Haacke, "Museums: Managers of Consciousness," *Art in America*, Feb. 1984, 15.

Page 203. **Through a shadowy middleman**: "This Little Piggie Went to Market," *Art & Auction*, May 1989, 259; Grace Glueck, "An Art Collector Decides to Sell. Why?" *New York Times*, Nov. 23, 1989.

Page 203. **The pioneers of corporate collecting**: W. G. Constable, *Art Collecting in the United States of America: An Outline of a History* (London: Thomas Nelson & Sons, 1964), 148–49; Simpson, *SoHo*, 253.

Page 204. **"art has come to resemble a system of humanistic prestige . . ."**: Simpson, *SoHo*, 26.

Page 204. **David Rockefeller was quick to remind them**: Peter Collier and David Horowitz, *The Rockefellers: An American Dynasty* (New York: Holt, Rinehart & Winston, 1976), 408–9.

Page 204. **At Minneapolis's First Bank System**: Faye Rice, "Big Payoff in Corporate Art," *Fortune*, May 25, 1987, 106, 108; Roslyn Bernstein, "Early Withdrawal," *Art & Auction*, Feb. 1990, 31–32.

Page 205. **Pepsico turned to art collecting**: Rice, "Big Payoff in Corporate Art," 107.

Page 205. **the sorts of art some corporations favor**: Bruce Serlen, "Projecting an Image—You Are What You Buy," *New York Times*, Feb. 12, 1989.

Page 205. **art consultant Mary Lanier**: Mary Lanier in Lee Evan Caplin, ed., *The Business of Art* (Englewood Cliffs, N.J.: Prentice-Hall, 1982), 340–41.

Page 205. **the delights of shopping for art**: Telephone interview with Mary Lanier, Sept. 29, 1989.

Page 206. **"the collector's chief interest in a painting . . ."**: Keen, *Money and Art*, 63.

Page 206. **professor John Dowell told a packed audience**: John Dowell in Caplin, *Business of Art*, 201, 203.

Page 206. **Artists have always been wary**: Rosenberg and Fliegel, *Vanguard Artist*, 205, 208.

Page 206. **A new kind of collector then appeared**: Thomas B. Hess, *Barnett Newman* (New York: Walker, 1969), 58.

Page 207. **The taciturn Jackson Pollock himself**: Deborah Solomon, *Jackson Pollock* (New York: Simon & Schuster, 1987), 196–97.

Page 207. **the oversize canvases perpetrated by**: David Sylvester, "Comment," *Studio International*, Sept. 1967, 79.

Page 207. **artists were deliberately creating eccentric, shocking works**: Achille Bonito Oliva, "Art Market as Art Work," *Domus*, Dec. 1974, 32.

Page 207. **Andy Warhol pushed collectors' fancy**: Victor Bockris, *The Life and Death of Andy Warhol* (New York: Bantam, 1989), 221, 256, 283–85; Patrick S. Smith, *Andy Warhol's Art and Films* (Ann Arbor, MI: UMI Research, 1986), 186, 193.

Page 208. **Being admitted to an artist's studio**: Simpson, *SoHo*, 19–21.

Page 208. **Long Island real estate developer Jerry Spiegel**: Smith, "Art Fever," 40.

Page 209. **The dealer Paula Cooper . . . [end of paragraph]**: Interview with Paula Cooper, Sept. 15, 1989; transcript of Roy Neuberger interview by Paul Cummings, Sept. 26, 1975, 13, AAA; Anthony Haden-Guest, "A New Art World

Legend: Goodbye, Bob and Ethel; Hullo, Dorothy and Herb!," *New York*, April 28, 1975, 48; Mario Amaya in Jean Lipman, ed., *Collector in America*, 224–25; Julia Brown and Bridget Johnson, eds., *The First Show: Paintings and Sculpture from Eight Collections 1940–1980* (Los Angeles and New York: MOCA and The Arts Publisher, 1983), 120; transcript of Joseph Hirschhorn interview by Paul Cummings, Dec. 16, 1976, 25–26, AAA.

Page 210. **Ben Heller is another flinty businessman**: Transcript of Ben Heller interview by Paul Cummings, Jan. 8, 1973, 5, AAA.

Page 210. **"My method," he replied, "is to go into a gallery . . ."**: Philip Hamburger, "All in the Artist's Head," *New Yorker*, June 13, 1977, 53.

CHAPTER 5: DEALERS: SELLING THE SUBLIME

Page 211. **a double-page Irving Penn photo in Vogue**: "Eight Gamblers on Young Artists," *Vogue*, Feb. 1, 1970, 176–77.

Page 212. **"They fill a void . . ."**: Emile De Antonio and Mitch Tuchman, *Painters Painting* (New York: Abbeville, 1984), 109.

Page 212. **new art movements since the Second World War**: Gerald Reitlinger, *The Economics of Taste: The Art Market in the 1960s*, vol. 3, (London: Barrie & Jenkins, 1970), 2.

Page 212. **"play more than an amusing social role"**: Henry Geldzahler, *New York Painting and Sculpture: 1940–1970* (New York: Dutton, 1969), 30.

Page 212. **For the fast-growing audience attracted by contemporary art**: Transcript of Ivan Karp interview by Paul Cummings, Mar. 12, 1969, 81, AAA.

Page 213. **"transform a tendency . . ."**: Charles R. Simpson, *SoHo: The Artist in the City* (Chicago: University of Chicago, 1981), 36; John Henry Merryman and Albert E. Elsen, *Law, Ethics, and the Visual Arts*, vol. 2 (Philadelphia: University of Pennsylvania, 1987), 380.

Page 213. **says the veteran Fifty-Seventh-Street dealer André Emmerich**: Laura de Coppet and Alan Jones, *The Art Dealers* (New York: Clarkson N. Potter, 1984), 58, 61–63.

Page 214. **"In the case of certain artists . . ."**: Barbaralee Diamonstein, *Inside New York's Art World* (New York: Rizzoli, 1979), 198.

Page 214. **Karp holds forth**: Interview with Ivan Karp, May 2, 1989. Unless otherwise cited, all Karp quotations in this chapter are from this interview.

Page 215. **little faith in newspaper reviews**: de Coppet and Jones, *Art Dealers*, 149.

Page 216. **"I spent more time in the movies . . ."**: Transcript of Ivan Karp interview by Paul Cummings, Mar. 12, 1969, 8, 10, AAA.

Page 216. **making the rounds of new galleries**: Transcript of Ivan Karp interview by Paul Cummings, Mar. 12, 1969, 15–17, AAA; Barbara Rose, "Living the Élan of Art Life," *Vogue*, Feb. 1, 1970, 179.

Page 217. **Karp goggled**: de Coppet and Jones, *Art Dealers*, 136–37.

Page 217. **whom Castelli still admires**: Interview with Leo Castelli, May 11, 1989.

Page 217. **Leo Castelli was born in 1907**: de Coppet and Jones, *Art Dealers*, 83–85.

Page 218. **Castelli protested to Life**: David Bourdon, "What's Up in Art? Follow the Clan," *Life*, May 1, 1970, 74.

Page 218. **The original capital**: Calvin Tomkins, "Profiles: A Good Eye and a Good Ear," *New Yorker*, May 26, 1980, 40, 48, 57.

Page 219. **seemed to be ubiquitous**: Suzi Gablik, "Protagonists of Pop: Five Interviews," *Studio International*, July 1969, 10; de Coppet and Jones, *Art Dealers*, 85.

Page 219. **a four-page proposal**: Leo Castelli to Alfred H. Barr, Jr., Oct. 26, 1955, Barr to Castelli, Dec. 7, 1955, both Roll 2181, Barr Archive, AAA.

Page 219. **Castelli sought to promote**: Transcript of Harold Rosenberg interview by

Paul Cummings, Dec. 18, 1970, 74–75, AAA; Dore Ashton, *The New York School* (New York: Viking, 1972), 218; Irving Sandler, *The New York School* (New York: Harper & Row, 1978), 32.

Page 220. **Castelli continued to feature**: Lil Picard, "Milestones & Comets," *Arts*, Feb. 1987, 17; Ingrid Rein, "Journal: Leo Castelli Gallery New York," *Du* 2 (1983): 91.

Page 220. **But far more exciting that year**: Gerald Marzorati, "Gallery Gala: Johns and Castelli," *Vanity Fair*, Feb. 1987, 103.

Page 220. **Thomas B. Hess**: de Coppet and Jones, *Art Dealers*, 90.

Page 220. **results were disheartening**: de Coppet and Jones, *Art Dealers*, 91.

Page 221. **"much more forward"**: Interview with Leo Castelli, May 11, 1989.

Page 221. **to discern the future by studying the past**: Barbaralee Diamonstein, "Pop Art, Money, and the Present Scene," *Partisan Review* 1 (1978): 82; Bourdon, "What's Up in Art?" 71.

Page 221. **"The aspirations of a new social class . . ."**: Brendan Gill, "A Contemporary Vision—Leo Castelli," *Architectural Digest*, April 1985, 260.

Page 222. **Only necessity forced him**: Barbara Rose, "Put Your Money Where the Talent Is," *Vogue*, Aug. 1977, 195.

Page 222. **Karp, by contrast, stressed**: Transcript of Ivan Karp interview by Paul Cummings, Mar. 12, 1969, 76–77, AAA.

Page 222. **a personal letter**: Ivan Karp to John Canaday, undated 1964, Roll NYJC-1, Canaday Papers, AAA.

Page 222. **it was uncommonly generous**: Willi Bongard, *Kunst und Kommerz: Zwischen Passion und Spekulation* (Oldenburg, West Germany: Gerhard Stalling, 1967), 201–4.

Page 222. **the gallery's deliciously intellectual ambience**: Transcript of Ivan Karp interview by Paul Cummings, Mar. 12, 1969, 73–75, AAA.

Page 223. **Henry Geldzahler recalled**: Transcript of Henry Geldzahler interview by Paul Cummings, Feb. 16, 1970, 45, AAA.

Page 224. **Tibor de Nagy**: de Coppet and Jones, *Art Dealers*, 45.

Page 224. **Robert Wraight described**: Robert Wraight, *The Art Game* (New York: Simon & Schuster, 1966), 150–51.

Page 224. **John Russell Taylor and Brian Brooke**: John Russell Taylor and Brian Brooke, *The Art Dealers* (New York: Scribner's, 1969), 260.

Page 224. **the Machiavellian element**: Tomkins, "Profiles: A Good Eye," 71; Bourdon, "What's Up in Art?" 74; Gill, "Contemporary Vision," 258; de Coppet and Jones, *Art Dealers*, 137.

Page 224. **"We enjoyed the adventure"**: Transcript of Ivan Karp interview by Paul Cummings, 58, AAA.

Page 225. **"You have to have a good eye . . ."**: Tomkins, "Profiles: A Good Eye," 41.

Page 225. **"An artist who hasn't got a personality . . ."**: Barbara Rose, "Put Your Money," 195.

Page 225. **Andy Warhol's colorless look**: David Bailey, *Andy Warhol*, transcript of an ATV documentary (London: Bailey Litchfield/Mathews Miller Dunbar, 1973), unpaged, MOMA Archive.

Page 225. **He referred Warhol**: Transcript of Eleanor Ward interview by Paul Cummings, Feb. 8, 1972, 3–4, AAA.

Page 225. **"like a college kid . . ."**: Andy Warhol and Pat Hackett, *Popism: The Warhol '60s* (New York: Harper & Row, 1980), 20–21.

Page 226. **On one occasion**: Interview with Irma Seitz, Dec. 12, 1986.

Page 226. **Paint cows**: Warhol and Hackett, *Popism*, 17–18, 83.

Page 226. **"Certain artists . . ."**: de Coppet and Jones, *Art Dealers*, 143–44.

Page 226. **a natural cycle**: Interview with Leo Castelli, May 11, 1989.

Page 227. **Castelli's true personality**: Transcript of Ivan Karp interview by Paul Cummings, Mar. 12, 1969, 120–21, AAA.

Page 227. **David Whitney**: Bourdon, "What's Up in Art?" 74.

Page 227. **"the magic of the Castelli Gallery . . ."**: Bourdon, "What's Up in Art?" 74.

Page 227. **artists receive a monthly stipend**: de Coppet and Jones, *Art Dealers*, 102; Tomkins, "Profiles: A Good Eye," 40.

Page 228. **"Holding an artist . . ."**: Interview with Leo Castelli, May 11, 1989.

Page 228. **many of the artists Castelli nurtured**: Edward Ball, "The Castelli Connection," *Avenue*, Feb. 1990, 87.

Page 228. **the intricate international web**: de Coppet and Jones, *Art Dealers*, 98–99.

Page 228. **Henry Geldzahler recalled**: Transcript of Henry Geldzahler interview by Paul Cummings, Feb. 16, 1970, 41–42, 45, AAA.

Page 228. **a boozy international trade show**: Wraight, *Art Game*, 26; Rein, "Journal: Leo Castelli Gallery, New York," 91; Remi Clignet, *The Structure of Artistic Revolutions* (Philadelphia: University of Pennsylvania, 1985), 139.

Page 229. **the art world buzzed briefly**: "Preview: The Brush Is Passed," *Maclean's*, Feb. 23, 1976, 13.

Page 229. **Nor did Castelli scorn**: Advertisement by Castelli Gallery, *Art in America*, Sept. 1967, 127.

Page 229. **Castelli was also spreading**: Laura Cottingham, "The Dandy Lion," *Art & Auction*, May 1989, 142, 144.

Page 229. **Larry Gagosian**: Ronny Cohen, "Art Is Priceless," *Art & Auction*, June 1989, 168.

Page 229. **in *Time* magazine Robert Hughes called**: Robert Hughes, "Sold!" *Time*, Nov. 27, 1989, 64.

Page 230. **"Great Collectors"**: Gerald Clarke, "Bio: Dealer Leo Castelli," *People*, Dec. 26, 1979, 37; Tomkins, "Profiles: A Good Eye," 68.

Page 230. **shah of Iran**: Joe Conason and Jack Newfield, "Remember the Greediest: 100 Cases of Avarice," *Village Voice*, Dec. 11, 1978, 11.

Page 230. **When he first discovered Frank Stella**: de Coppet and Jones, *Art Dealers*, 92–93.

Page 230. **Barr called on Castelli**: Alfred H. Barr, Jr. to William Paley, Jan. 31, 1963, Roll 2187, Barr Archive, AAA.

Page 231. **Museum people are notoriously inept**: Karl E. Meyer, *The Art Museum: Power, Money, Ethics* (New York: Morrow, 1979), 209.

Page 231. **"very remiss"**: Diamonstein, "Pop Art, Money," 87.

Page 232. **the number of galleries has grown immensely since 1945**: Steven W. Naifeh, *Culture Making: Money, Success, and the New York Art World* (Princeton, NJ: Princeton University Department of History, 1976), 81–83; Bongard, *Kunst und Kommerz*, 200; Elaine Cannell, *Good Taste: How to Have It; How to Buy It* (New York: David McKay, 1978), 69.

Page 232. **Of the 133 members of the Art Dealers Association**: Art Dealers Association of America, Inc., *1988–89 Directory* (New York: ADAA, 1988).

Page 232. **appraiser and sometime dealer Aaron Berman**: Interview with Aaron Berman, May 6, 1989.

Page 232. **Yet the market for all kinds of art is growing**: Bonnie Burnham, "As the Stakes in the Art World Rise, So do Laws and Lawsuits," *New York Times*, Feb. 15, 1987; Hughes, "Sold!" 63.

Page 233. **New York's East Village**: Douglas C. McGill, "Art Gallery Boom Slows for the East Village," *New York Times*, July 25, 1987.

Page 233. **even in SoHo the upward rent spiral**: Trish Hall, "SoHo Offbeat Personality Is Showing Signs of Middle Age," *New York Times*, Nov. 23, 1989.

Page 233. **Steven Naifeh named only six**: Naifeh, *Culture Making*, 85–86.

Page 233. **Emmerich's finesse in handling the estate of Hans Hofmann**: Gwen Kinkead, "Spectacular Fall and Rise of Hans Hofmann," *Art News*, Summer 1980, 89, 93–95.

Page 234. **would have been flabbergasted**: Marcia Bystryn, "Art Galleries as Gatekeepers: The Case of the Abstract Expressionists," *Social Research*, Summer 1978, 400–401; Bongard, *Kunst und Kommerz*, 88, 91; Ashton, *New York School*, 169.

Page 235. **enthusiastically supported American artists**: Irving Sandler, *The Triumph*

of American Painting (New York: Praeger, 1970), 32; transcript of Samuel M. Kootz interview by John D. Morse, Mar. 2, 1960, 1–2, AAA.

Page 235. **had he not arrived at Picasso's Paris studio**: Transcript of Samuel M. Kootz interview by Dorothy Seckler, Apr. 13, 1964, 13–14, AAA; Bongard, *Kunst und Kommerz*, 87–88; Ashton, *New York School*, 168–69, 178; de Coppet and Jones, *Art Dealers*, 16.

Page 235. **he dared to show**: April J. Paul, "Six Young American Painters of the Samuel Kootz Gallery: An Inferiority Complex in Paris," *Arts*, Feb. 1986, 65–68; "Paris Copies," *Time*, Apr. 1947, 75.

Page 236. **some success at marketing**: Bongard, *Kunst und Kommerz*, 87, 92–93; Lisa Phillips, *The Third Dimension: Sculptors of the New York School* (New York: Whitney Museum of Art, 1986), 34, 39; Bystryn, "Art Galleries as Gatekeepers," 402.

Page 236. **The career of Allan Stone**: Interview with Allan Stone, May 4, 1989.

Page 238. **Diana Crane, a sociologist who tried to analyze**: Diana Crane, *The Transformation of the Avant-Garde: The New York Art World, 1940–1985* (Chicago: University of Chicago, 1987), 116.

Page 238. **"A lot of collectors will buy the work speculatively"**: de Coppet and Jones, *Art Dealers*, 156–58.

Page 239. **After the November 1988 auctions**: Meg Cox, "Manic Market: Prices of Hottest Art Reach Stunning Levels as Boom Keeps Going," *Wall Street Journal*, Nov. 28, 1988.

Page 239. **The respected Paris dealer Paul Rosenberg**: Maurice Rheims, *The Strange Life of Objects* (New York: Atheneum, 1961), 105.

Page 239. **Less fortunate was Paul Durand-Ruel**: Taylor and Brooke, *Art Dealers*, 38.

Page 239. **cited as the model for Leo Castelli**: Tomkins, "Profiles: A Good Eye," 40–41.

Page 240. **"patrons of art too advanced for its time"**: Rose, "Put Your Money," 146.

Page 240. **Daniel-Henry Kahnweiler**: Daniel-Henry Kahnweiler with Francis Crémieux, *My Galleries and Painters* (New York: Viking, 1971), 62–63, 74.

Page 240. **he monopolized Picasso's prodigious output**: Bongard, *Kunst und Kommerz*, 88.

Page 241. **Mary Boone did just that**: Ball, "Castelli Connection," 84; Mary Anne Staniszewski, "Stepping Up the Pace," *Art & Auction*, July–Aug. 1990, 48; de Coppet and Jones, *Art Dealers*, 107, 199.

Page 241. **a strong opinion about his abilities**: Bongard, *Kunst und Kommerz*, 103–4.

Page 242. **"He showed Americans alongside Europeans . . ."**: Interview with Paul Cummings, Sept. 22, 1989.

Page 242. **his brother, Martin**: John Bernard Myers, *Tracking the Marvelous* (New York: Random House, 1983), 6; Melvin P. Lader, *Peggy Guggenheim's Art of This Century: The Surrealist Milieu and the American Avant-Garde, 1942–1947* (unpublished Ph.D. dissertation at the University of Delaware, 1981), 324; Bongard, *Kunst und Kommerz*, 83, 100, 103–4.

Page 242. **he opened his gallery**: Bongard, *Kunst und Kommerz*, 104–5; James Brooks, "Why Fight It?" *New Yorker*, Nov. 12, 1960, 65; Les Levine, "A Portrait of Sidney Janis on the Occasion of His 25th Anniversary as an Art Dealer," *Arts*, Nov. 1973, 54.

Page 243. **those first exhibitions of Pollock . . ."**: de Coppet and Jones, *Art Dealers*, 69.

Page 243. **"the most brilliant new dealer . . ."**: Brooks, "Why Fight It?" 59.

Page 243. **Betty Parsons**: Lee Seldes, *The Legacy of Mark Rothko* (New York: Holt, Rinehart & Winston, 1978), 23; Bystryn, "Art Galleries as Gatekeepers," 399, 401.

Page 243. **Pollock's defection was particularly galling**: Jeffrey Potter, *To a Violent Grave: An Oral Biography of Jackson Pollock* (New York: Putnam, 1985), 147.

Page 244. **"How can you make money . . ."**: Bongard, *Kunst und Kommerz*, 84–85.

Page 244. **he immediately jacked up the prices**: Bongard, *Kunst und Kommerz*, 104–5; de Coppet and Jones, *Art Dealers*, 39.

Page 244. **Janis's astute merchandising**: Bongard, *Kunst und Kommerz*, 110.

Page 244. **to underline the European roots**: Calvin Tomkins, "Profiles: Henry Geldzahler," *New Yorker*, Nov. 6, 1971, 90; Bongard, *Kunst und Kommerz*, 120–21; Crane, *Transformation of the Avant-Garde*, 39.

Page 245. **the ninety-year-old Sidney Janis**: Douglas C. McGill, "At 90, Janis Still in Step with Art," *New York Times*, Sept. 16, 1986.

Page 245. **its administrator, Henry King, describes it**: Interview with Henry King, May 19, 1989.

Page 246. **to help the bank "understand"**: Interview with J. Patrick Cooney and Jennifer Josselson Vorbach, Sept. 19, 1989.

Page 246. **While the bankers were familiar with real estate**: Lana Jokel, "Art and Money: A New Type of Financing at Citibank," *Journal of Art*, June–July 1989, 1.

Page 248. **"I work all the time"**: Interview with Jeffrey Deitch, May 18, 1989.

Page 248. **One contemporary artist he vigorously supported**: Cathleen McGuigan, "New Art, New Money: The Marketing of an American Artist," *New York Times Magazine*, Feb. 10, 1985, 32, 74.

Page 249. **often quoted**: Rita Reif, "Old Master Is Auctioned for a Record $35 Million," *New York Times*, June 1, 1989.

Page 249. **"good theater . . ."**: Interview with Jeffrey Deitch, May 18, 1989.

Page 249. **auctions played a crucial role**: Kinkead, "Spectacular Fall and Rise of Hans Hofmann," 96.

Page 250. **"the old gentlemanly deal . . ."**: Wraight, *Art Game*, 48; Peter Watson, "The Art Market: What Price Glory," *Manhattan, Inc.*, July 1989, 92–95.

Page 250. **dealers are hard-pressed to react**: Interview with Peter Goulds, July 10, 1989.

Page 251. **"enlarged our ideas . . ."**: Nicholas Faith, *Sold: The Rise and Fall of the House of Sotheby* (New York: Macmillan, 1985), 5–6; Sophy Burnham, *The Art Crowd* (New York: David McKay, 1973), 53.

Page 251. **"what lots of people want to buy . . ."**: "The Frenzied Art Market," *World Press Review*, Feb. 1989, 48.

Page 251. **"Art history at its best"**: Martin S. Ackerman, *Smart Money and Art: Investing in Fine Art* (Barrytown, NY: Station Hill Press, 1986), 55.

Page 252. **"every last instinct of greed . . ."**: John Russell, "Clapping for Money at Auctions," *New York Times*, May 21, 1989.

Page 252. **"selling art has much in common . . ."**: John Herbert, *Inside Christie's* (London: Hodder & Stoughton, 1990), 340.

Page 254. **"People want to buy some things . . ."**: Interview with Ben Heller, May 12, 1989; interview with Aaron Berman, May 6, 1989.

Page 254. **sales of so-called contemporary art**: Deborah Drier, "Reviews: Contemporary," *Art & Auction*, 136.

Page 255. **"a historic turning point . . ."**: Souren Melikian, "A Transparency Problem," *Art & Auction*, Mar. 1990, 148.

Page 255. **a London sale in October 1958**: Faith, *Sold*, 60–61.

Page 256. **some complain that guarantees of authenticity**: Joseph MacDonald and Graham Hallward to editor, *Art & Auction*, Feb. 1990, 16, 18; Rita Reif, "*Yo Picasso* Brings $47.9 Million at Sotheby's," *New York Times*, May 10, 1989.

Page 256. **"it's like buying securities . . ."**: Rita Reif, "Sotheby Lent $27 Million to the Buyer of *Irises*," *New York Times*, Oct. 18, 1989.

Page 257. **catalog for the May 1989 sale**: *Contemporary Art from the Collection of the late Edwin Janss, Jr.*, catalog for a sale at Sotheby's May 2, 1989.

Page 259. **a long-playing record**: Sophy Burnham, *The Art Crowd* (New York: David McKay, 1973), 54; *Burlington Magazine*, Nov. 1976.

Page 259. **In the 1988–1989 season**: Rita Reif, "Auction Records Predicted," *New York Times*, July 26, 1989.

Page 260. **increasing share of contemporary art**: Suzanne Muchnic, "The Frenzy," *Los Angeles Times Calendar*, June 11, 1989, 3.

Page 260. **In 1990**: Philip Coggan, "Too Early to Jump," *Journal of Art*, Nov. 1990, 57.
Page 260. **Lord Duveeen paid**: Reitlinger, *Economics of Taste*, vol. 3, 233–34; interview with Allan Stone, May 4, 1989.
Page 260. **"a comeuppance will come . . ."**: Cox, "Manic Market."
Page 261. **a light-hearted list**: from source requesting anonymity.
Page 261. **Former San Francisco Museum of Art director Henry Hopkins calls them**: Interview with Henry Hopkins, July 10, 1989.
Page 262. **Association for Professional Art Advisors . . . [to end of next paragraph]**: Douglas C. McGill, "Advising Wealthy New Collectors on Buying Art," *New York Times*, April 22, 1987; Elizabeth Venant, "Acquiring Minds," *Los Angeles Times Magazine*, June 19, 1988, 18.
Page 262. **"too exciting . . ."**: Telephone interview with Michelle Rosenfeld, Sept. 25, 1989.
Page 263. **"People, by their ability to buy works of art . . ."**: Transcript of Ben Heller interview by Paul Cummings, Jan. 8, 1973, 45, AAA; interview with Paul Brach, May 3, 1989.
Page 263. **The Hellers had been nibbling**: Transcript of Ben Heller interview by Paul Cummings, Jan. 8, 1973, 14–16, AAA.
Page 264. **"in an age in which the *act* of painting . . ."**: Henry Geldzahler, "Heller: New American-Type Collector," *Art News*, Sept. 1961, 28–30.
Page 264. **a painting Janis had sold**: Levine, "Portrait of Sidney Janis," 52.
Page 265. **"Farewell to *Blue Poles* Party"**: Myers, *Tracking the Marvelous*, 254–55.
Page 265. **"I'm not going to be embarrassed . . ."**: Transcript of Ben Heller interview by Paul Cummings, Jan. 8, 1973, 30, AAA
Page 265. **His track record as an investor**: Interview with Ben Heller, May 12, 1989.
Page 265. **Heller was already lamenting**: Transcript of Ben Heller interview by Paul Cummings, Jan. 8, 1973, 30, AAA; interview with Ben Heller, May 12, 1989.
Page 266. **Serious experts frown on reproductions**: Michael Lev, "Shopping? Don't Forget a Warhol," *New York Times*, July 4, 1989.
Page 267. **One survivor from an earlier day**: Interview with Terry Dintenfass, Sept. 16, 1989. All Dintenfass quotations in this chapter are from this interview.
Page 269. **Emmerich looks back**: Interview with André Emmerich, Sept. 19, 1989.
Page 270. **"like an extended graduate course . . ."**: James Danziger, "Miller Time: The Rise of a Gallery with the Long View," *New York*, Jan. 11, 1988, 36–37.
Page 270. **operates like an old-fashioned banker**: Interview with Robert Miller, Sept. 16, 1989; interview with John Cheim, Sept. 20, 1989. All Miller and Cheim quotations otherwise uncredited are from these interviews.
Page 271. **it has developed a reputation**: Danziger, "Miller Time," 39–40.
Page 271. **Miller's delicate maneuvers**: Danziger, "Miller Time," 40.
Page 272. **cordial ties with museums**: Danziger, "Miller Time," 39–40; interview with John Cheim, Sept. 20, 1989.
Page 273. **first Jasper Johns exhibition**: Simpson, *SoHo*, 38–39.
Page 273. **Eli Broad, considered Leo Castelli vital enough**: "The following mailgram . . . ," Sharon McQueen memo to Eli Broad, Feb. 9, 1981, Eli Broad Archive.
Page 273. **Sidney Janis was a trustee**: Levine, "Portrait of Sidney Janis," 51.
Page 273. **"While collectors tend to invest . . ."**: de Coppet and Jones, *Art Dealers*, 70.
Page 273. **the MOMA jubilantly fêted Sidney Janis**: Teri F. Wehn, "No Strings Attached: The Janis Gift," *Art in America*, Nov. 1967, 70.
Page 273. **Castelli says**: Interview with Leo Castelli, May 11, 1989.
Page 274. **"as the art world's gatekeeper . . ."**: Simpson, *SoHo*, 33.
Page 274. **"money changers . . ."**: Taylor and Brooke, *Art Dealers*, 40.
Page 274. **"a Faustian quality . . ."**: Calvin Tomkins, "A Keeper of the Treasure," *New Yorker*, June 9, 1975.
Page 274. **"a commercial distribution system . . ."**: Ackerman, *Smart Money and Art*, 91.

Page 274. **"There is no state law . . ."**: Ivan Karp in Lee Evan Caplin, ed., *The Business of Art* (Englewood Cliffs, NJ: Prentice-Hall, 1982), 269.

Page 274. **The best dealers**: Simpson, *SoHo*, 47–48; Jules Olitski, "Then and Now," *Partisan Review* 4 (1975): 560.

CHAPTER 6: MUSEUMS: WELFARE FOR THE WELL-OFF

Page 275. **a museum-building binge**: Stephen E. Weil, *Rethinking the Museum* (Washington: Smithsonian Institution Press, 1990), 3–4; Karl E. Meyer, *The Art Museum: Power, Money, Ethics* (New York: Morrow, 1979), 13, 126–27.

Page 275. **In downtown Pittsburgh**: Michael Kimmelman, "Pittsburgh May Get Warhol Museum," *New York Times*, Oct. 3, 1989; Grace Glueck, "A Museum for Warhol in His Hometown," *New York Times*, Oct. 3, 1989.

Page 275. **High Museum of Art**: Joseph D. Watson, "Art of the South," *Art & Auction*, Mar. 1989, 72.

Page 275. **Newport Harbor Museum**: Robert L. Pincus, "Art Museum Reveals Design for Building," *San Diego Union*, Aug. 2, 1989.

Page 276. **his vision for a new museum**: Eli Broad speech at Town Hall of California, "Angelenos and the Arts: Business Partners," Biltmore Hotel, Los Angeles, Sept. 9, 1980.

Page 277. **"weirdly inflated village"**: Carey McWilliams, *Southern California: An Island in the Land* (Salt Lake City: Peregrine Smith, 1983), 375.

Page 277. **interlaced fortunes**: McWilliams, *Southern California*, 371–72.

Page 277. **The Second World War**: Michael P. Malone and Richard W. Etulain, *The American West: A Twentieth-Century History* (Lincoln: University of Nebraska, 1989), 126.

Page 277. **half his résumé**: Eli Broad Biography, Broad Inc.

Page 277. **his extracurricular interests**: Interview with Eli Broad, June 29, 1989. All Eli Broad quotations in this chapter are from this interview unless otherwise cited.

Page 279. **Request for Proposals**: Appendix A to CRA Request for Proposals for Bunker Hill Redevelopment Project, Aug. 15, 1979, Eli Broad Archive.

Page 279. **"generally first- or second-generation . . ."**: Judith Huggins Balfe, *The Institutionalization of the Modern Image: Modern Art in American Museums 1913-1963* (New Brunswick, NJ: Rutgers University Ph.D. Thesis, 1979) 108–9.

Page 279. **proselytizing for the new museum**: Eli Broad speech at Business and Community Leaders' Luncheon, Security Pacific Plaza, Los Angeles, Mar. 24, 1980, Eli Broad Archive.

Page 280. **what titles were bestowed**: Sherri Geldin memo to Endowment Committee, Nov. 16, 1979, Eli Broad Archive.

Page 280. **a massive public relations campaign**: Richard B. Lippin to Jana Waring Greer, Mar. 3, 1980; Jana Greer memo to Eli Broad, Mar. 3, 1980; Lippin to Broad, Mar. 10, 1980; also miscellaneous letters and lists of recipients. All Eli Broad Archive.

Page 281. **"the most exciting entrepreneurial undertaking . . ."**: Eli Broad speech at the Dean's Forum, UCLA Graduate School of Management, Nov. 29, 1983.

Page 281. **economic impact report**: *An Economic Impact Study of the Los Angeles Museum of Contemporary Art*, Stanford Research Institute, 1981, 5–7.

Page 281. **an enthusiastic letter**: Broad to Tom Bradley, Oct. 9, 1981, Eli Broad Archive.

Page 282. **his starting salary**: Application for Alien Employment Certification, Oct. 29, 1982, Eli Broad Archive.

Page 282. **feats of museum building**: Calvin Tomkins, "A Good Monster," *New Yorker*, Jan. 16, 1978, 37, 43–44.

Page 282. **weighty memos and reports**: Tuttle & Taylor memo to William A. Norris, Dec. 19, 1980, Eli Broad Archive.

Page 282. **grandiose plans for marketing him**: Lippin to Broad, Nov. 20, 1980; minutes of MOCA board of directors' meeting, Sept. 24, 1980. Both Eli Broad Archive.

Page 283. **the stationery**: Pontus Hultèn memo to MOCA board of trustees, April 27, 1981, Eli Broad Archive.

Page 283. **rifts opened**: Hultèn telex to Broad, July 1, 1981; Hultèn to Broad, July 20, 1981. Both Eli Broad Archive.

Page 284. **two contrasting visions**: Pontus Hultèn, "A Need for a Balanced Commitment," undated 1981, Eli Broad Archive.

Page 284. **the tug-of-war**: Hultèn to Carl Covitz, Jan. 6, 1982; Covitz to Broad, Jan. 11, 1982; MOCA Development Office, Master Calendar of Events, Feb.–May 1982. All Eli Broad Archive.

Page 285. **"crisis for the lack of trust . . ."**: Marcia Weisman to Broad, May 24, 1982; Dominique de Menil to Broad, May 20, 1982; Saul Warshaw memo to Broad, Nov. 12, 1982. All Eli Broad Archive.

Page 285. **clash between the trustees' and Hultèn's expectations**: Interview with Richard Koshalek, July 19, 1990.

Page 285. **To cushion public shock**: Saul L. Warshaw to Eli Broad, Nov. 12, 1982, Eli Broad Archive.

Page 285. **The opening festivities**: Robert Bordaz to William F. Kieschnick, Nov. 8, 1982; Cynthia Fonte memo to Sharon McQueen, Nov. 1, 1983; Douglas S. Cramer to Broad, Nov. 9, 1983; report of meeting to review and evaluate events at MOCA, Dec. 5, 1983. All Eli Broad Archive.

Page 286. **the six-day festivities**: Proposed schedule of events inaugurating the MOCA, July 15, 1986; Michele De Angelus memos to Broad, Nov. 4 and Dec. 1, 1986. All Eli Broad Archive.

Page 287. **Thus did Joseph Choate exhort**: John Taylor, "Party Palace," *New York*, Jan. 9, 1989, 26–27.

Page 287. **The art dealer René Gimpel**: Meyer, *Art Museum*, 127.

Page 287. **300 new museums**: Robert S. Warshaw, "Law in the Marketplace," *Museum News*, May 1975, 22.

Page 287. **American cult of amassing valuable goods**: Remy Saisselin in Sherman E. Lee, *Past, Present, East and West* (New York: Braziller, 1983), 10–12; Julia Brown and Bridget Johnson, eds., *The First Show: Painting and Sculpture from Eight Collections 1940–1980* (Los Angeles and New York: MOCA and the Arts Publisher, 1983), 99.

Page 288. **The Department of Labor estimates**: Weil, *Rethinking the Museum*, 5; interview with Henry Hopkins, July 10, 1989.

Page 288. **Guggenheim Museum's permanent collection**: James Kaplan, "Tom Krens' Tall, Tall Plans," *Manhattan, Inc.*, April 1989, 122; Douglas C. McGill, "Museums Bringing a Mass of Art Out of Hiding," *New York Times*, Oct. 18, 1987.

Page 289. **The glut at the Whitney Museum of Art**: Kay Larson, "Heir Heads," *New York*, Mar. 30, 1987, 95; McGill, "Museums Bringing a Mass of Art Out of Hiding.".

Page 289. **the Whitney sold**: Transcript of John I. H. Baur interview by Paul Cummings, 68, AAA.

Page 289. **In 1954 the museum disposed of**: William Robbins, "Museums Make Peace with an Artist's Vision," *New York Times*, April 13, 1989.

Page 289. **sophisticated collectors hesitate**: Transcript of Emily Tremaine interview by Paul Cummings, Jan. 24, 1973, 10, AAA; Grace Glueck, "The Fine Art of Collecting Collectors," *New York Times*, May 3, 1987.

Page 290. **"the transaction was tainted . . ."**: Laura de Coppet and Alan Jones, *The Art Dealers* (New York: Clarkson N. Potter, 1984), 168–69.

Page 290. **lack of space to exhibit the MOMA's treasures**: Alfred H. Barr, Jr.,

"Toward the New Museum of Modern Art," 1959, MOMA Archive; Roberta Smith, "The Museum of Modern Art," *Art in America*, Sept. 1977, 95; Meyer, *Art Museum*, 197–98; Alicia Legg, ed., *Paintings and Sculpture in the Museum of Modern Art* (New York: MOMA, 1977).

Page 291. **nine boxes of Erté costume drawings**: Interview with John Hirsch, April 6, 1989; John Russell Taylor and Brian Brooke, *The Art Dealers* (New York: John Scribner's Sons, 1969), 195.

Page 292. **treasures he unearthed**: Kay Larson, "The Met Goes Modern," *New York*, Dec. 15, 1986, 47.

Page 292. **"museums should not . . ."**: Weil, *Rethinking the Museum*, 58.

Page 292. **they do not consider them assets**: William D. Grampp, *Pricing the Priceless: Art, Artists, and Economics* (New York: Basic, 1989), 174–78.

Page 292. **an inventory of the nation's wealth**: Grampp, *Pricing the Priceless*, 179–80.

Page 293. **a bad omen**: Robert Hughes, "Sold!" *Time*, Nov. 27, 1989, 65; Grampp, *Pricing the Priceless*, 24–25.

Page 294. **an aristocratic Old Money ethos**: Nelson W. Aldrich, Jr., *Old Money: The Mythology of America's Upper Class* (New York: Vintage, 1989), 80.

Page 294. **"collecting is a way of making oneself socially attractive . . ."**: Aldrich, *Old Money*, 3, 80–82.

Page 295. **A 1969 survey**: Alan L. Feld, Michael O'Hare, and J. Mark Davidson Schuster, *Patrons Despite Themselves: Taxpayers and Arts Policy* (New York: New York University, 1983), 122–23.

Page 295. **a series of secret maneuvers**: Kay Larson, "War at the Whitney," *New York*, Feb. 12, 1990, 34–36.

Page 295. **the museum world's obsession with money**: Whitney Museum of Art, *1989 Biennial Exhibition* (New York: W. W. Norton, 1989), 10.

Page 296. **"a kind of cheerleader . . ."**: Michael Kimmelman, "Which Way for the Whitney?" *New York Times*, Feb. 18, 1990.

Page 296. **four branches in corporate offices**: Larson, "War at the Whitney," 32–33.

Page 297. **By all accounts**: Larson, "War at the Whitney," 32–33; Grace Glueck, "Art Leaders Defend Whitney," *New York Times*, Feb. 3, 1990.

Page 298. **John Russell mourned**: John Russell, "Adding Up the Costs of Changes at the Top," *New York Times*, Mar. 18, 1990.

Page 298. **in the six years before 1975**: Feld et al., *Patrons Despite Themselves*, 163–64.

Page 298. **Kevin E. Consey**: Alan G. Artner, "Making a Move," *Chicago Tribune*, Aug. 27, 1989.

Page 299. **"Board members . . ."**: Grace Glueck, "Chicago Museum Is Expanding, Ready or Not," *New York Times*, July 18, 1989.

Page 299. **"the museum has yet to establish . . ."**: Christopher Knight, "Leaving a Safe Harbor for MOCA," *Los Angeles Times Calendar*, April 15, 1990, 8.

Page 299. **"burnout" among museum directors**: Patricia Failing, "Gloom at the Top," *Art News*, May 1989, 131.

Page 299. **A disillusioned observer**: Interview with Henry Hopkins, July 10, 1989.

Page 300. **"The men demonstrate . . ."**: Interview with source requesting anonymity, Feb. 15, 1990.

Page 300. **their knowledge of art is sketchy**: Interview with Henry Hopkins, July 10, 1989.

Page 301. **when one trustee**: Interview with Jeffrey Deitch, May 18, 1989.

Page 302. **The change was manifest**: For a full account of the MOMA's dilemmas , see Alice G. Marquis, *Alfred H. Barr, Jr.: Missionary for the Modern* (Chicago: Contemporary, 1989).

Page 304. **he sent the entire collection**: Lee Seldes, *The Legacy of Mark Rothko* (New York: Holt, Rinehart & Winston, 1978), 230. For a fuller discussion, see Marquis, *Alfred H. Barr, Jr.*, 255.

Page 304. **The museum's current president**: "The Top 100 Collectors," *Art & Antiques*,

Mar. 1989, 72; "America's Top 100 Collectors," *Art & Antiques*, Mar. 1990, 88.

Page 305. **PaineWebber commissioned Stella**: Paul Taylor, "Stellaaa!" *Fame*, Nov. 1988, 38.

Page 305. **the Guggenheim accepted custody**: Grace Glueck quoted in Lee Rosen-baum, "The Care and Feeding of Donors," *Art News*, Nov. 1978, pp. 100–103.

Page 305. **When Henry Hopkins lectured**: Leah Ollman, "Collectors' Clout Raises a Question of Ethics for Museum," *Los Angeles Times*, Oct. 28, 1988.

Page 306. **"Shamefully unprofessional"**: "Impropriety Not the Issue," *Los Angeles Times*, Nov. 5, 1988.

Page 306. **study of American museums**: Balfe, *Institutionalization of the Modern Image*, 112–13.

Page 307. **There was no credible data**: Balfe, *Institutionalization of the Modern Image*, 83–87.

Page 307. **a similar black hole**: Christie Brown, "Welcome, Suckers!" *Forbes*, June 25, 1990, 284; Grampp, *Pricing the Priceless*, 180–82.

Page 308. **"instances of secretive disposal . . ."**: "College Art Association Statement on Sales of Works of Art by the Metropolitan Museum of Art," *Art Journal*, Spring 1973, 280–81; Diane C. Hines, "How to Approach Museums," *American Artist*, Jan. 1977, 30–31.

Page 308. **without a current catalog**: The Guggenheim's *Handbook*, published in 1980, for example, lists only 252 works by 141 artists.

Page 308. **When Russell Lynes published**: Russell Lynes to Alice Marquis, Sept. 17, 1986.

Page 309. **"What a museum chooses to exhibit . . ."**: Brian Wallis, "Embarrassment of Riches Unveiled," *Art in America*, Mar. 1989, 23.

Page 309. **the Fort Knoxes of art**: Robert Wraight, *The Art Game* (New York: Simon & Schuster, 1966), 14.

Page 310. **passed a resolution**: College Art Association, "Resolution Concerning the Sale and Exchange of Works of Art by Museums," *Art Journal*, Fall 1974, 50.

Page 310. **British museums have strict rules**: John L. Hess, *The Grand Acquisitors* (Boston: Houghton Mifflin, 1974), 102.

Page 310. **"It was only natural . . ."**: Sophy Burnham, *The Art Crowd* (New York: David McKay, 1973), 148–49.

Page 310. **a retrospective for Frank Stella**: Paul Taylor, "Stellaaa!," 38.

Page 310. **"the progressive purification of form . . ."**: William Grimes, "MOMA's Boy," *New York Times Magazine*, Mar. 11, 1990, 61.

Page 310. **"the art museum's entanglement . . ."**: Meyer, *Art Museum*, 163–64.

Page 311. **A Chicago dealer counseling artists**: Rhona Hoffman in Lee Evan Caplin, ed., *The Business of Art* (Englewood Cliffs, NJ: Prentice-Hall, 1982) 293.

Page 311. **"No sooner had a painting by van Gogh . . ."**: Hilton Kramer, "Critic's Notebook: Disappearing Tricks," *Art & Auction*, Mar. 1990, 164–65.

Page 311. **the van Gogh's crucial importance**: Michael Kimmelman, "How a van Gogh Went to the Modern in a Deal Involving 7 Other Paintings," *New York Times*, Oct. 9, 1989.

Page 312. **partial trade for the van Gogh**: Kimmelman, "How a van Gogh Went to the Modern."

Page 313. **"Where a Monet began . . ."**: Irving Sandler, *The New York School* (New York: Harper & Row, 1978), 53–55.

Page 313. **"a historical narrative . . ."**: Grimes, "Moma's Boy," 31.

Page 314. **Even *Life* magazine**: David Bourdon, "Modern Masters Amid the Old," *Life*, Oct. 24, 1969, 12.

Page 314. **"a boo-boo on a grand scale"**: Calvin Tomkins, *The Scene: Reports on Post-Modern Art* (New York: Viking, 1976), 2; Harold Rosenberg, *The De-definition of Art* (New York: Collier, 1972), 189.

Page 314. **Geldzahler later explained**: Transcript of Henry Geldzahler interview by

Paul Cummings, Feb. 23, 1970, 64–65, AAA; Tomkins, *Scene*, 2; transcript of Henry Geldzahler interview by Paul Cummings, Feb. 16, 1979, 28, AAA.

Page 315. **the opening on October 18**: Tomkins, "Profiles: Henry Geldzahler," *New Yorker*, Nov. 6, 1971, 60, 62.

Page 315. **the scene around him**: Tomkins quoted in Meyer, *Art Museum*, 101–2.

Page 316. **borrowed from dealers**: Seldes, *Legacy of Mark Rothko*, 94–96.

Page 317. **Their ranks have swelled**: Weil, *Rethinking the Museum*, xv, 82, 91.

Page 317. **If professionalism includes scholarship**: Interview with Henry Hopkins, July 10, 1989.

Page 317. **In 1980 the directors**: Sherri Geldin memo to Eli Broad, July 28, 1980, Eli Broad Archive.

Page 317. **"Museums are staffed by idiots."**: Interview with Allan Stone, May 4, 1989.

Page 318. **"a consensus of the misinformed . . ."**: Interview with Ivan Karp, May 2, 1989; Fred Weisman interview in Brown and Johnson, *The First Show*, 119.

Page 318. **a mid-1970s survey**: National Opinion Research Center for the Arts, *Americans and the Arts: A Survey of Public Opinion* (New York: American Council for the Arts, 1975) 30–33.

Page 319. **one-third of his visitors**: Steven W. Naifeh, *Culture Making: Money, Success, and the New York Art World* (Princeton, NJ: Princeton University Department of History, 1976), 106–8.

Page 319. **attendance figures have grown**: Piri Halasz, "Manhattan Museums: The 1940s vs. the 1980s," *Arts*, Jan. 1985, 122.

Page 319. **the largest crowds**: Halasz, "Manhattan Museums," 122.

Page 319. **the all-time record**: Edward C. Banfield, *The Democratic Muse* (New York: Basic, 1984), 109–12.

Page 320. **the vast majority of Americans . . . [to end of next paragraph]**: Grampp, *Pricing the Priceless*, 54–56, 174–75.

Page 321. **"In no case was the museum to be . . ."**: Balfe, *Institutionalization of the Modern Image*, 108–9.

Page 321. **a landmark 1942 study**: Theodore L. Low, *The Museum as a Social Instrument* (New York: Metropolitan Museum of Art, for The American Association of Museums, 1942), 7–9, 11–12, 18–19.

Page 321. **an earlier critic of museums**: Low, *Museum as a Social Instrument*, 41.

Page 322. **Museum educators**: Vera L. Zolberg, "American Art Museums: Sanctuary or Free-for-All?" *Social Forces*, 386.

Page 323. **A striking exception**: Interview with James B. Spann, Sept. 13, 1989.

Page 323. **"doled out in doses sufficient . . ."**: Zolberg, "American Art Museums," 378, 387–88.

Page 323. **"We have too often taken . . ."**: Weil, *Rethinking the Museum*, 29–30.

Page 323. **retrospective exhibitions for artists**: Harold Rosenberg, *Art and Other Serious Matters* (Chicago: University of Chicago, 1985), 119; John Henry Merryman and Albert E. Elsen, *Law, Ethics, and the Visual Arts*, vol. 2 (Philadelphia: University of Pennsylvania, 1987), 397; Stephen E. Weil, *Beauty and the Beasts* (Washington: Smithsonian Institution, 1983), 15.

Page 324. **spending far more money**: Irving Pfeffer, "Insuring Museum Exhibitions," *Hastings Law Review*, May 1976, 1129; Grace Glueck, "The Guggenheim May Sell Some Art to Buy Collection," *New York Times*, Mar. 5, 1990; Weil, *Beauty and the Beasts*, 28; Alison Leigh Cowan, "With Catalogues and Cookies, Nonprofit Groups Seek Profits," *New York Times*, June 19, 1990; Norton Simon Museum, balance sheet, 1979, Eli Broad Archive.

Page 325. **"any trustee should be able . . ."**: Feld et al., *Patrons Despite Themselves*, 124.

Page 325. **"beautiful artifacts . . ."**: Aldrich, *Old Money*, 225.

Page 325. **The Met was the setting . . . [to end of next paragraph]**: Taylor, "Party Palace," 22–24.

Page 327. **supported itself to a greater extent**: Weil, *Rethinking the Museum*, 142–44.
Page 327. **exhibition of Fabergé eggs**: "Eggs' Impact: $15.49 Million," *San Diego Union*, Feb. 12, 1990.
Page 327. **expensive "safe" exhibitions**: Interview with Henry Hopkins, July 10, 1989; interview with Peter Goulds, July 10, 1989; Sherman E. Lee, *Past, Present, East and West*, 25.
Page 328. **Nina Kaiden Wright**: Interview with Caroline Goldsmith, Sept. 22, 1989.
Page 329. **"If they just settle back . . ."**: Transcript of Ben Heller interview by Paul Cummings, Jan. 8, 1973, 40, AAA.
Page 329. **In the 1967–1968 season**: Diana Crane, *Transformation of the Avant-Garde: The New York Art World, 1940–1985.* (Chicago: University of Chicago, 1987), 130.
Page 329. **twenty-nine thousand corporations**: Robert Metz, "The Corporation as Art Patron: A Growth Stock," *Art News*, May 1979, 40.
Page 329. **a personal triumph**: Interview with Caroline Goldsmith, Sept. 22, 1989.
Page 329. **committed $165,000**: Robert Sain to Wilford Fansworth, Nov. 9, 1982, Eli Broad Archive.
Page 330. **glorified flower show**: "Art Alive, 1989," underwriting opportunities, San Diego Museum of Art.
Page 330. **decisions about future exhibitions**: Lee Rosenbaum, "Scramble for Museum Sponsors: Is Curatorial Independence for Sale?" *Art in America*, Jan. 1977, 10.
Page 330. **appeal to corporate sponsors**: "Managing the Arts," *Wharton Magazine*, Spring 1981, 68.
Page 330. **whatever the sponsor is selling**: Biography of Caroline L. Goldsmith, senior vice president of Arts and Communications Counselors, Ruder Finn.
Page 331. **soul-searching over the moral aspects**: Hans Haacke, "Museums: Managers of Consciousness," *Art in America*, Feb. 1984, 15.
Page 331. **"learn how you can provide . . ."**: Taylor, "Party Palace," 29.
Page 331. **"Andy Warhol, Cars"**: Roberta Smith, "In the End, Warhol's Past Is Possessive," *New York Times*, Sept. 30, 1988.
Page 332. **"The tail is not wagging . . ."**: Weil, *Rethinking the Museum*, 145.
Page 332. **the 1986 tax reform**: Alvin H. Reiss, "Art and the IRS," *American Way*, Aug. 1, 1987, 76–77.
Page 333. **donations dwindled**: Thomas Hoving, "My Eye," *Connoisseur*, May 1990, 150; Wendy Smith, "Museums Pay the Price," *Art & Auction*, Nov. 1989, 108; Kathleen Teltsch, "Charity Contributions Increase, but Worries Linger," *New York Times*, June 7, 1990.
Page 333. **museums' perennial pleas of poverty**: Meyer, *Art Museum*, 60; Feld et al., *Taxpayers Despite Themselves*, 174–76, Grampp, *Pricing the Priceless*, 184.
Page 334. **the Guggenheim's disposal in May 1990**: Grace Glueck, "The Guggenheim May Sell Some Art"; Glueck, "Guggenheim to Sell Three Works to Obtain Money for Others," *New York Times*, Mar. 23, 1990; Glueck, "Guggenheim Spends Million for Art, a Lot of It Unfinished," *New York Times*, June 12, 1990.
Page 335. **selling parts of their collections**: Michael Kimmelman, "The High Cost of Selling Art," *New York Times*, Apr. 1, 1990.
Page 336. **deaccessioning**: Kimmelman, "High Cost of Selling Art"; Weil, *Rethinking the Museum*, 123–24; Carol Vogel, "Auctions: Museums Put Collections on the Block," *New York Times*, Aug. 30, 1986; Kimmelman, "How a Van Gogh Went to the Modern."
Page 336. **many collectors still want their art to end up in a museum**: Interview with Ben Heller, May 12, 1989; interview with Jeffrey Deitch, May 18, 1989.

CHAPTER 7: SPECULATIONS

Page 340. **a room-size Polaroid camera**: Steven Vincent, "The Big Picture," *Art & Auction*, July–Aug. 1990, 20–22.

Page 342. **"so-called abstract art . . ."**: Beaumont Newhall, untitled manuscript of an article for *Audience*; Newhall to John Canaday, June 13, 1962, Canaday Papers, Roll NYJC-4, AAA.

Page 342. **Franz Kline explained**: Irving Sandler, *The Triumph of American Painting* (New York: Praeger, 1970), 230, 256; John I. H. Baur, *Between the Fairs: 25 Years of American Art 1939-1964* (New York: Praeger, 1964), 10.

Page 343. **"the progressive inclusion . . ."**: Henry Geldzahler, "James Rosenquist's F-111," *Metropolitan Museum Bulletin*, Mar. 1968, 280.

Page 343. **the kaleidoscope of art movements**: Robert Atkins, *Art Speak* (New York: Abbeville, 1990), 8.

Page 344. **Postmodernism**: W. D. Bannard, "On Postmodernism," *Arts*, Feb. 1984, 69; Daniel Bell, "Modernism Mummified," *American Quarterly*, Spring 1987, 131.

Page 344. **"absolute decadence"**: John Berger, *Permanent Red* (London: Methuen, 1968 [1960]), 46–47.

Page 344. **Venice Biennale**: Michael Kimmelman, "Venice Biennale Opens with Surprises," *New York Times*, May 28, 1990; Robert Hughes, "A Sampler of Witless Truisms," *Time*, July 30, 1990, 66.

Page 345. **obituaries for the avant-garde**: "The Changing Guard," *Times Literary Supplement*, Aug. 6, 1964, 676; Jonathan Miller, "Jokers in the Pack," *Times Literary Supplement*, Aug. 6, 1964, 703; Judith Adler, "Innovative Art and Obsolescent Artists," *Social Research*, Summer 1975, 363–64.

Page 345. **"Younger artists are reduced . . ."**: Barbaralee Diamonstein, *Inside New York's Art World* (New York: Rizzoli, 1979), 249–50.

Page 345. **The sculptor Carl Andre**: Peter Fuller, *Beyond the Crisis in Art* (London: Writers' and Readers' Publishing Cooperative Society, 1980), 122–23.

Page 345. **"The art business is coming to an end . . ."**: Interview with Joe Maresca, May 4, 1989.

Page 346. **"There's just a rehash . . ."**: Transcript of Emily Tremaine interview by Paul Cummings, Jan. 24, 1973, 27, AAA.

Page 346. **"a relatively sterile period . . ."**: Laura de Coppet and Alan Jones, *The Art Dealers* (New York: Clarkson N. Potter, 1984), 59–60.

Page 346. **"Then the art world was art . . ."**: Interview with Allan Stone, May 4, 1989.

Page 346. **André Malraux . . . [to end of next paragraph]**: André Malraux, *The Voices of Silence* (Garden City, NY: Doubleday, 1953), 13–127.

Page 347. **"an empty vessel"**: René Gimpel, *The Cult of Art: Against Art and Artists* (New York: Stein & Day, 1969), 20, 158–61.

Page 348. **"a revel of animation . . ."**: Harold Rosenberg, *Art and Other Serious Matters* (Chicago: University of Chicago, 1985), 16.

Page 348. **"total environments . . ."**: Phyllis Tuchman, "Pop!" *Art News*, May 1974, 25.

Page 348. **"Video installations . . ."**: Andy Grundberg, "Video Is Making Waves in the Art World," *New York Times*, Nov. 24, 1989.

Page 348. **"The art market requires scarcity . . ."**: Charles R. Simpson, *SoHo: The Artist in the City* (Chicago: University of Chicago, 1981), 84.

Page 348. **an absurd wrangle**: Grace Glueck, "Guggenheim Spends Millions for Art, a Lot of It Unfinished," *New York Times*, June 12, 1990.

FURTHER READING

Ackerman, Martin S. *Smart Money and Art*, Tarrytown, NY, 1986.

Albrecht, Milton C., James H. Barnett, and Mason Griff. *The Sociology of Art and Literature*, New York, 1970.

Aldrich, Nelson W., Jr. *Old Money: The Mythology of America's Upper Class*, New York, 1989.

Apollonio, Umbro, ed. *Futurist Manifestos*, New York, 1970.

Ashton, Dore. *American Art Since 1945*, New York, 1982.

————. *The New York School*, New York, 1972.

Atkins, Robert. *Art Speak*, New York, 1990.

Balfe, Judith H., and Margaret Jane Wyszomirski, eds. *Art, Ideology, and Politics*, New York, 1985.

Banfield, Edward C. *The Democratic Muse*, New York, 1984.

Baur, John I. H. *Between the Fairs: 25 Years of American Art 1939–1964*, New York, 1964.

Bell, Daniel. *The Cultural Contradictions of Capitalism*, New York, 1976.

Berger, John. *Permanent Red*, London, 1960.

Bloom, Alexander. *Prodigal Sons: The New York Intellectuals and Their World*, New York, 1986.

Bockris, Victor. *The Life and Death of Andy Warhol*, New York, 1989.

Bongard, Willi. *Kunst und Kommerz: Zwischen Passion und Spekulation*, Oldenburg, West Germany, 1967.

Boorstin, Daniel J. *The Image, or What Happened to the American Dream*, New York, 1962.

Breton, André. *Manifestoes of Surrealism*, Ann Arbor, MI, 1982.

Brown, Marilyn R. *The Myth of the Artist in 19th Century France*, Ann Arbor, MI, 1985.

Buettner, Stewart. *American Art Theory 1945–1970*, Ann Arbor, MI, 1981.

Burnham, Sophy. *The Art Crowd*, New York, 1973.

Canaday, John. *Culture Gulch: Notes on Art and Its Public*, New York, 1969.

————. *Embattled Critic*, New York, 1962.

Caplin, Lee Evan, ed. *The Business of Art*, Englewood Cliffs, NJ, 1982.

Clignet, Remi. *The Structure of Artistic Revolutions*, Philadelphia, 1985.

Collier, Peter, and David Horowitz. *The Rockefellers: An American Dynasty*, New York, 1976.

Constable, W. G. *Art Collecting in the United States of America: An Outline of a History*, London, 1964.

Cox, Annette. *Art-as-Politics: The Abstract Expressionist Avant-Garde and Society*, Ann Arbor, MI, 1982.

Crane, Diana. *The Transformation of the Avant-Garde: The New York Art World, 1940–1985*, Chicago, 1987.

De Antonio, Emile, and Mitch Tuchman. *Painters Painting*, New York, 1984.

De Coppet, Laura, and Alan Jones. *The Art Dealers*, New York, 1984.

Diamonstein, Barbaralee. *Inside New York's Art World*, New York, 1979.

Douglas, Mary, and Baron Isherwood. *The World of Goods*, New York, 1979.

Faith, Nicholas. *Sold: The Rise and Fall of the House of Sotheby*, New York, 1985.

Feld, Alan L., Michael O'Hare, and J. Mark Davidson Schuster. *Patrons Despite Themselves: Taxpayers and Arts Policy*, New York, 1983.

Foster, Stephen C. *The Critics of Abstract Expressionism*, Ann Arbor, MI, 1980.

Fox, Stephen. *The Mirror Makers*, New York, 1984.

Fuller, Peter. *Beyond the Crisis in Art*, London, 1980.

Ganz, Herbert J. *Popular Culture and High Culture*, New York, 1974.

Gimpel, René. *The Cult of Art: Against Art and Artists*, New York, 1969.

Grampp, William D. *Pricing the Priceless: Art, Artists, and Economics*, New York, 1989.

Greenberg, Clement. *Art and Culture*, Boston, 1961.

Guggenheim, Peggy. *Confessions of an Art Addict*, New York, 1960.

Guilbaut, Serge. *How New York Stole the Idea of Modern Art*, Chicago, 1983.

Herbert, John. *Inside Christie's*, London, 1990.

Hess, John L. *The Grand Acquisitors*, Boston, 1974.

Hess, Thomas B. *Barnett Newman*, New York, 1969.

Hobbs, Robert C. and Gail Levin. *Abstract Expressionism: The Formative Years*, Ithaca, NY, 1978.

Hyde, Lewis. *The Gift: Imagination and the Erotic Life of Property*, New York, 1983.

Johnson, Ellen H. *American Artists on Art*, New York, 1982.

Kahnweiler, Daniel-Henry, with Francis Crémieux. *My Galleries and Painters*, New York, 1971.

Keen, Geraldine. *Money and Art: A Study Based on the Times-Sotheby Index*, New York, 1971.

Kornbluth, Jesse. *Pre-Pop Warhol*, New York, 1988.

Kostabi, Mark. *Sadness Because the Video Rental Store Was Closed & Other Stories*, New York, 1988.

Lee, Sherman E. *Past, Present, East and West*, New York, 1983.

Lipman, Jean, ed. *The Collector in America*, New York, 1971.

Low, Theodore L. *The Museum as a Social Instrument*, New York, 1942.

Mahsun, Carol Anne. *Pop Art and the Critics*, Ann Arbor, MI, 1987.

Malraux, André. *The Voices of Silence*, Garden City, NY, 1953.

Marquis, Alice G. *Marcel Duchamp: Eros c'est la vie*, Troy, NY, 1980.

Marquis, Alice Goldfarb. *Alfred H. Barr, Jr.: Missionary for the Modern*, Chicago, 1989.

Marshall, Richard. *50 New York Artists*, San Francisco, 1986.

McDarrah, Fred. *The Artist's World in Pictures*, New York, 1961.

McWilliams, Carey. *Southern California: An Island in the Land*, Salt Lake City, UT, 1983.

Merryman, John Henry, and Albert E. Elsen. *Law, Ethics, and the Visual Arts*, Philadelphia, 1987.

Meyer, Karl E. *The Art Museum: Power, Money, Ethics*, New York, 1979.

Moulin, Raymonde. *Le marché de la peinture en France*, Paris, 1970.

Myers, John Bernard. *Tracking the Marvelous*, New York, 1983.

Naifeh, Steven, and Gregory White Smith. *Jackson Pollock: An American Saga*, New York, 1989.

Naifeh, Steven W. *Culture-Making: Money, Success, and the New York Art World*, Princeton, NJ, 1967.

National Opinion Research Center for the Arts. *Americans and the Arts: A Survey of Public Opinion*, New York, 1975.

O'Brian, John, ed. *Clement Greenberg: The Collected Essays and Criticism*, vols. 1 and 2, Chicago, 1986.

O'Connor, Francis V. *The New Deal Art Projects: An Anthology of Memoirs*, Washington, D.C., 1972.

O'Hara, Frank. *Art Chronicles: 1954–1966*, New York, 1975.

Potter, Jeffrey. *To a Violent Grave: An Oral Biography of Jackson Pollock*, New York, 1985.

Reitlinger, Gerald. *The Economics of Taste*, vol. 1, London, 1961.

———. *The Economics of Taste: The Art Market in the 1960s*, London, 1970.

Rewald, John. *The History of Impressionism*, New York, 1973.

Rheims, Maurice. *The Strange Life of Objects*, New York, 1961.

Rose, Barbara. *American Art Since 1900: A Critical History*, New York, 1967.

Rosenberg, Bernard, and Norris Fliegel. *The Vanguard Artist*, New York, 1979.

Rosenberg, Harold. *Art and Other Serious Matters*, Chicago, 1985.

———. *The Anxious Object: Art Today and Its Audience*, New York, 1973.

———. *Art on the Edge: Creators and Situations*, New York, 1975.

———. *Barnett Newman*, New York, 1977.

————. *The Case of the Baffled Radical*, Chicago, 1976.

————. *Discovering the Present: Three Decades in Art, Culture, and Politics*, Chicago, 1973.

Rush, Richard. *Art as an Investment*, Englewood Cliffs, NJ, 1961.

Sandler, Irving. *The New York School*, New York, 1978.

————. *The Triumph of American Painting*, New York, 1970.

Secrest, Meryle. *Being Bernard Berenson*, New York, 1980.

Seigel, Jerrold. *Bohemian Paris*, New York, 1986.

Seldes, Lee. *The Legacy of Mark Rothko*, New York, 1978.

Siegel, Jeanne. *Artwords: Discourse on the 60s and 70s*, Ann Arbor, MI, 1985.

Simpson, Charles R. *SoHo: The Artist in the City*, Chicago, 1981.

Smith, Patrick S. *Andy Warhol's Art and Films*, Ann Arbor, MI, 1981.

Solomon, Alan. *New York: The New Art Scene*, New York, 1967.

Solomon, Deborah. *Jackson Pollock*, New York, 1987.

Steinberg, Leo. *Other Criteria: Confrontations with 20th Century Art*, New York, 1972.

Straight, Michael D. *Twigs for an Eagle's Nest*, New York, 1979.

Taylor, John Russell, and Brian Brooke. *The Art Dealers*, New York, 1969.

Tomkins, Calvin. *Off the Wall: Robert Rauschenberg and the Art World of Our Time*, New York, 1981.

————. *The Bride and the Bachelors: Five Masters of the Avant-Garde*, New York, 1968.

Walker, John. *Self-Portrait with Donors*, Boston, 1974.

Warhol, Andy, and Pat Hackett. *Popism: The Warhol '60s*, New York, 1980.

Weil, Stephen E. *Rethinking the Museum*, Washington, D.C., 1990.

————. *Beauty and the Beasts*, Washington, D.C., 1983.

Wolfe, Tom. *The Painted Word*, New York, 1975.

Wraight, Robert. *The Art Game*, New York, 1966.

Wright, Will. *Six-Guns and Society: A Structural Study of the Western*, Berkeley, CA, 1975.

Zinsser, William K. *Pop Goes America*, New York, 1966.

INDEX